KRIEGHOFF

1 *The Morning after Merrymaking in Lower Canada* 1857
$23\frac{5}{8} \times 35\frac{3}{4}$ in / 60 × 90.8 cm
The Hon. K.R. and Mrs Thomson

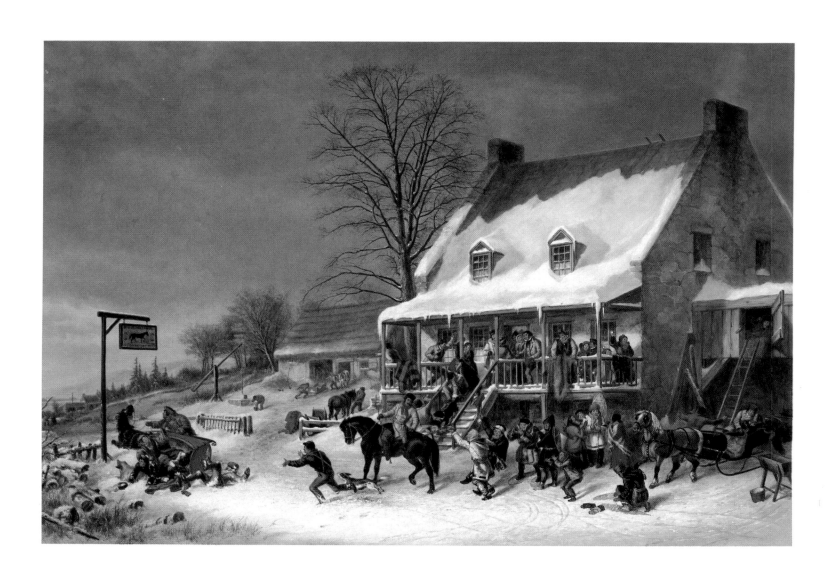

J. RUSSELL HARPER

Krieghoff

UNIVERSITY OF TORONTO PRESS
Toronto Buffalo London

© University of Toronto Press 1979
Toronto Buffalo London
Printed in Canada

Canadian Cataloguing in Publication Data

Harper, John Russell, 1914–
Krieghoff

Bibliography: p.
Includes index.

ISBN 0-8020-2348-7

1. Krieghoff, Cornelius, 1815–1872.
2. Painters – Canada – Biography.

ND249.K7H37 759.11 C79-094272-0

Contents

2 *The Steamship Quebec* 1853
$26\frac{3}{4} \times 36\frac{7}{8}$ in / 67.9 × 93.5 cm
private collection

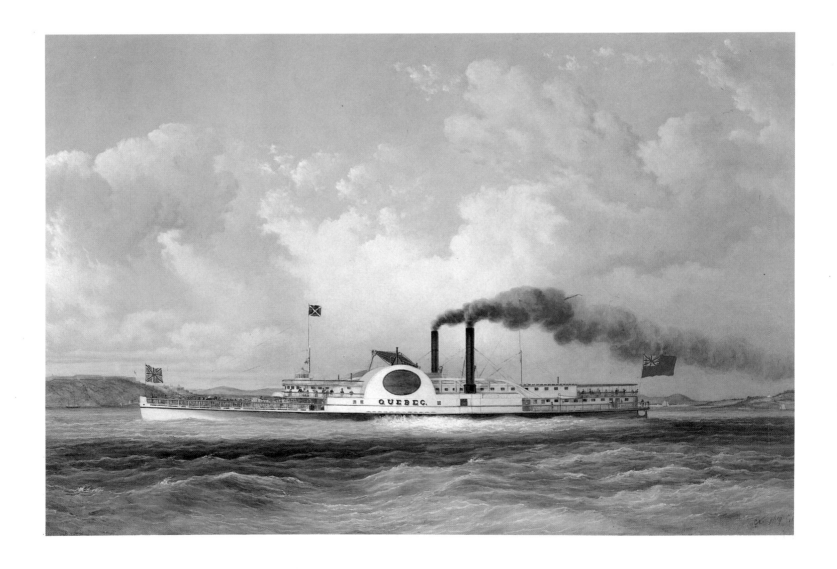

Illustrations

All paintings are by Krieghoff, in oil on canvas, unless otherwise noted.

CHAPTER 3:
Fulfilment, Quebec City, 1853–63

CHAPTER 4:
The final years, 1863–72

CHAPTER 5:
Misattributions, deceptions, and forgeries

3 *A Red Indian Woman outside the Artist's Studio*
late 1840s
12½ × 9¼ in / 31.8 × 23.5 cm
private collection

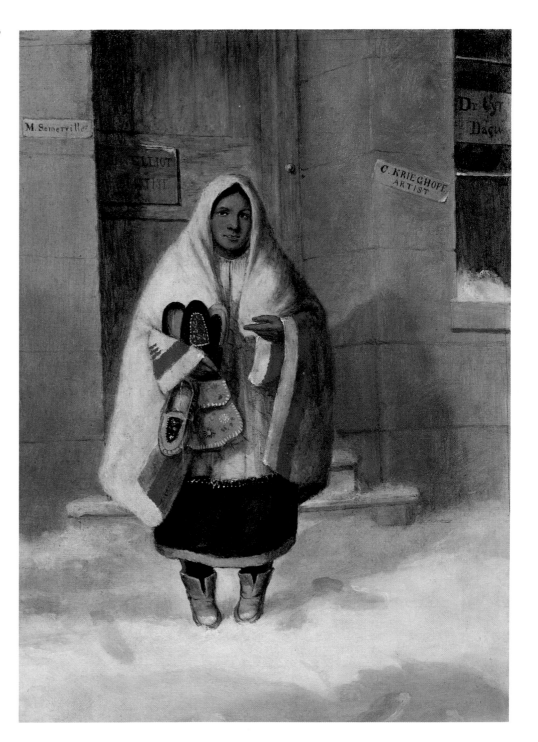

Preface

THE LIFE AND WORK of Cornelius Krieghoff have created much interest among the general public and posed exciting challenges to both art and social historians. Though of German background, Krieghoff spent much of his adult life as an observer and recorder of the Canadian scene, and his paintings emerge as significant historical documents of Canadian society in the mid-nineteenth century. At the same time, his canvases are entertaining and cleverly executed works of art, thanks to his wit and keen awareness of his surroundings. Krieghoff struck entirely fresh notes as a genre painter while infusing his work with new romantic and realistic overtones. His paintings of Canada – whether they record the habitants, the Indian people, the recreational diversions of city and army men, the breath-taking beauty of the landscape, or reflect his own personal enjoyment in life itself – have an intimacy, verve, and sense of quality that grips the attention as do no others by his generation of Canadian artists.

Today Krieghoff's canvases enjoy unprecedented popularity. One objective of this study has been to account for this continuing appeal, as well as to analyse his success in attuning his paintings to the tastes of his Victorian patrons. People loved them when they were painted, and they still admire them for their humour, sparkle, universality, and lusty portrayal of nineteenth-century life. A minority may castigate him because he was a pragmatist who sought the widest possible audience. A few criticized him in his own time. It is true that he directed his efforts to the amateur as opposed to the individual of purely aesthetic motivation; but one would be hard pressed to locate more than a baker's dozen of the latter in all of nineteenth-century Canada. Where could Krieghoff have found support, sympathy, and understanding if he had catered merely to an 'art for art's sake' approach in a colonial society? When the scales are balanced, he emerges as the first 'popular' artist in the Canadian art scene. And indeed his paintings have a measure of international significance, for they parallel widespread trends on both sides of the Atlantic.

A great deal has been written about Krieghoff and much confusion surrounds the details of his life. This study introduces new facts that have gradually accumulated through the years, examines many conflicting statements, and provides fresh information about his paintings. An attempt has been made to extract the man himself from the maze of highly coloured and contradictory stories about his origins and exuberant style of living. All too many tantalizing gaps remain in the narrative, despite half a dozen years of research.

At the beginning, the most promising, untapped source of biographical details seemed to lie with members of his family. The descendants of his brother Ernst were located in the United States, and they were most generous in providing family papers, which told much about Ernst but little about Cornelius. There *was* an interesting envelope among these papers, which proved to be a missing link. A letter had been addressed to one of the family in Detroit by a Frau Margaret Sattler, from a village near Schweinfurt, Germany, in 1945. Since Cornelius had described his youth in a castle near Schweinfurt, it seemed advisable to make a trip to this Bavarian city. Language proved an initial obstacle until a telephone call was made to Dr Charlotta Sattler. She was a descendant of Cornelius's sister, and the letter had been written by her mother from a rural retreat after their Schweinfurt home was destroyed in a thousand-bomber wartime raid. She proved a charming woman, and in subsequent talks reconstructed the cultural milieu and background from which Cornelius had emerged as an artist. It became evident that many interests in youth had triggered his artistic growth and had made a deep impression on his painting in Canada. Dr Sattler owned a portrait of Cornelius's vivacious sister, and also arranged a visit to his boyhood home in the castle's upper rooms. Herr Paul Ultsch, a local historian, provided details of

4 *Self-portrait* 1855
11½ × 10 in / 29.2 × 25.4 cm
National Gallery of Canada, Ottawa

the Krieghoff family and their associates. One real disappointment was the failure to locate any letters written from Canada by the artist to his parents; possibly they were not saved, or were destroyed during the war.

In Canada, the United States, and elsewhere, documentary material was checked systematically both to sort out the many contradictory statements about the artist and to add new details of his career. No paintings relating to his youthful Seminole War experiences were found; other assiduous researchers south of the border have been equally unsuccessful. There surfaced, however, a few newly discovered manuscripts and printed references. Rochester newspapers revealed something of his career in that city; the Louvre Archives documented his studies in Paris; and there were some unknown letters and broadsides in the Public Archives of Canada and in the Confederation Centre in Charlottetown. Published twentieth-century references were checked and re-evaluated in an attempt to discard fictional anecdotes. Few authors have documented their sources when writing about Krieghoff; as a result of this study certain of their statements remain suspect, some have been verified, and a number have been confirmed as false.

The paintings themselves must thus be the foundation for a book about him. How does one locate the works of an artist as prolific as Krieghoff? It is relatively easy to check the holdings of the National Gallery of Canada, other well-known art museums, and some noted private collections. Beyond this, unknown paintings were located through clues in the files of the National Museum of Man in Ottawa, the Smithsonian Institution in Washington, the Witt Library in London, the Art Documentation Centre in The Hague, and other public institutions. Many paintings hang unrecorded in private homes; some few remain with descendants of the artist's patrons. To find them it was necessary to advertise in newspapers, pester friends for clues, and employ the techniques of the sleuth. Integrity dictates the utmost discretion and confidentiality because owners of Krieghoffs are open to annoying intrusions by would-be buyers, if not to outright theft. The hunt was one of recurring excitement as more than two thousand paintings gradually emerged. Each new canvas studied, genuine or otherwise, added something to the Krieghoff story. Many works still remain unlocated. Reluctantly, the search must draw to a close, for the task is too large and complicated ever to arrive at a definitive conclusion.

The discovery of a painting is but the first hurdle to be crossed. Subject matter, the artist's technique, and signatures all must be examined. This is often difficult for many canvases hang in dark corners, reflect light, or are covered with brown varnish. If authenticity seems questionable, politeness prohibits the offense that would come from producing magnifying glasses, ultraviolet ray lights, and other technical aids. Despite this, it was possible to make some thorough examinations. The conscientious researcher ponders his obligations. When a painting is recognized as a forgery and he says nothing it may eventually be offered for sale with a verbal assertion that it has been examined by an expert, an implication of authenticity. If the 'expert' is goaded into expressing an unfavourable judgement, many owners refuse to believe the verdict – that a Krieghoff 'watercolour' is merely a tinted photograph, that a pencil drawing has obvious marks where an erased signature has been replaced by 'C. Krieghoff,' that his name has been freshly painted on an old canvas by another hand, or that a newly painted canvas in Krieghoff's style has been aged in a myriad ingenious ways.

Spurious works are surprisingly numerous. One soon develops a real sympathy for students of Corot paintings earlier in the century who are said to have found more of his canvases in America than the total of his entire output. Of the canvases examined in the course of this study that bear Krieghoff's name, well over half have an excellent chance of being authentic; but many of the others were never touched by his brush. His painting in watercolour remains a virtually unexplored field; some notes on this have been added, but they do not pretend to be an exhaustive treatment of the subject.

Krieghoff's work as a copyist of prints, superficially a simple matter, in fact creates some difficulty. One can never be certain at first glance whether a Krieghoff canvas is an original work or derives from a print based on another artist's work. Such copying must have been regarded as a handy means of providing bread-and-butter money. The print sources that have been traced, mostly European but sometimes Canadian and American, are usually found to be of obscure subjects, not necessarily still admired by twentieth-century art connoisseurs. They are indeed often minor works by artists who have been brushed aside as insignificant by the process of history. Krieghoff's copies have little value in their own right; but they do reflect the train of his creative thought,

and were important for the contribution they made to compositions that feature original subject matter. In addition, they suggest artistic attitudes in Canada at the time and his sense of what he felt would appeal to the local market.

Krieghoff's paintings demonstrate an amazing breadth of interests and bewildering versatility. An attempt has been made to look beyond Canada and place him in a larger context. Some references are made to his ultimate roots in seventeenth-century Dutch painting, a period that influenced many of his contemporaries. But very clear interconnecting links emerge to the art of his own period, particularly to painting in Germany, Holland, England, and the United States. In common with other artists, he tended towards anecdotal, narrative, and genre considerations and to a new brand of romanticism. This style was much attuned to materialism, to the preoccupations of industrialism, and the innate superficiality that surfaced in bourgeois society in the Victorian years.

The deeper my study of Krieghoff, the more bewildering became the diverse parallel threads of his interests. The pragmatic aspects of his nature came more and more to the surface. They were a necessity for artistic success in a colonial environment, and they went far beyond the numerous variations he painted on themes that had proven wide appeal. Krieghoff pioneered innovative methods of selling paintings, constantly searched for the potential in photography and other new scientific developments, and tapped the lucrative market for the sale of art prints.

One of the continuing goals in this study has been the completion of a *catalogue raisonné*. Additional details continue to pour in. The material already collected is so extensive that it would necessitate a second volume at this date. In this presentation, a summary of subjects has been worked out to give an indication of the frequency with which Krieghoff painted various themes. Appended to the text, it is intended to serve as a key to the amount of his output, its probable dates, and how it reflected the tastes of the Canadian public of his day.

This volume has grown out of generous aid by innumerable persons scattered over two continents. Their numbers make it impossible to name them individually, but I wish to thank all those who contributed in any way. In particular I should like to mention members of the artist's family, Ned Krieghoff, Dr Charlotta Sattler, and Mrs Elizabeth A. Taylor.

The co-operation of active staff in art galleries, museums, and libraries has been essential. In naming but a few, I would single out Mary Allodi and others at the Royal Ontario Museum, Jim Burant and Raymond Vézina of the Public Archives of Canada, André Juneau at the Musée du Québec, Ian Lumsden of the Beaverbrook Art Gallery, Dennis Reid and Mervyn Ruggles of the National Gallery of Canada, Scott Robson of the Nova Scotia Museum, S. Triggs of the McCord Museum, W.T. Sturtevant of the Smithsonian Institution, and Moncrieff Williamson of the Confederation Centre, Charlottetown. Aid came from many librarians, particularly those in the National Gallery of Canada, the Art Gallery of Ontario, and the Montreal Museum of Fine Art. Other data came from the city libraries of Buffalo, Cornwall, Denver, Hamilton, New York, Philadelphia, Rochester, and Toronto, and from the Witt Library in London, John Neustraten and the Centre for Documentation at The Hague, the National Museum of Man, Ottawa, and Morin College, Quebec. Enthusiasm, encouragement, and assistance came from many, particularly C. Brouillet, J.-P. Lemieux, John Russell, Elka Schrijver, William Tennison, Paul Ultsch, and the Canadiana devotee, Peter Winkworth. The staff and graduate students in art history of Concordia University have taken a lively interest, provided research aid, and offered suggestions. Absolutely essential to the project has been the co-operation by private owners of Krieghoff paintings who have provided access to their collections, supplied photographs, passed on documentation, and opened many doors; a few are mentioned in the text, but most prefer to remain anonymous. I cannot but mention the enthusiasm of the Honourable K.R. Thomson whose help was generous beyond mere courtesy, as was that of Mrs W. Pitfield, J.S. du Mont, and Mrs J.D. Eaton. Many gallery dealers provided details of paintings which had passed through their hands. In particular, help came from Paul Kastel, Walter Klinkhoff, Blair Laing, David Molson, Dr Max Stern, Williams & Son, and the auction firms of Christie's and Sotheby.

The Canada Council provided funds for the initial stages of the study. My thanks for assistance is also extended to the Allan Bronfman Family Foundation, the Cultural Affairs Branch of the Government of Ontario, and the assistance to writers program of the Ontario Arts Council. Publication has

5 *Mail Boat Crossing at Quebec*
17 × 25 in / 43.2 × 63.5 cm
private collection

been assisted by the Canada Council under its block grant program.

The staff of the University of Toronto Press have made suggestions, aided me, and worked unstintingly throughout. To each I owe an individual debt, but in particular to Ian Montagnes who has been a pillar of strength. Gerry Hallowell has played a key role; in his many months of painstaking work he has caught innumerable errors, smoothed rough patches, and transformed the volume beyond belief through his logical arrangement of material. The volume's superb design has been the work of William Rueter. Finally I should like to thank the members of my family: my wife Elizabeth who has checked, slaved, and hunted for lost papers, my sister who chauffeured me for many miles, and my daughter Jennifer and Brian Merrett who have borne the brunt of photographic details.

Named, unnamed, and omitted by oversight, I am grateful to all who helped.

J. RUSSELL HARPER
Alexandria, Ontario March 1979

All paintings reproduced in this book are the work of Cornelius Krieghoff unless identified otherwise and, unless otherwise noted, all were done in oil on canvas. Dimensions are given in the captions in both inches and centimetres when known; unfortunately it was impossible to measure every painting.

KRIEGHOFF

The Formative Years, 1815-46

CORNELIUS DAVID KRIEGHOFF began life in Amsterdam the day after Napoleon and his imperial regiments were defeated at the Battle of Waterloo near Brussels. He grew up in a town in Germany, emigrated to North America as an adventurous young man, and in his maturity became Canada's most notable artist of his time. His canvases portrayed French-Canadian habitants in rural Quebec, English gentlemen at leisure in the Canadian capitals, Indians in the forests, and maple trees in brilliant autumn colour beside the grandeur of slow-moving rivers and majestic waterfalls. The magic that flowed from his brush captivated his contemporaries; throughout the years since then his pictures have excited the imagination and dazzled the eye as have no other nineteenth-century Canadian paintings. The human overtones always present in his works make them as irresistible today as when they first took shape in his Montreal and Quebec studios more than a century ago. Because there are few reliable records many details in his personal life remain a mystery. It is largely through his art that we must come to know the man.

Krieghoff was born on 19 June 1815 at 191 Rokin in the old city of Amsterdam; the front door of the house opened onto a canal, on which a variety of boats and barges passed by. The building stood on the site of the present University of Amsterdam, and the canal, now filled in, is a heavily travelled street. Krieghoff's father, Johann Ernst, was a German expatriate whose forefathers had lived for generations just across the border from northern Bavaria in what is now the German Democratic Republic. There, in the little town of Ufhoven near Langensalza in Thuringia, Krieghoff's grandfather, Johann David, had been a court official. Johann Ernst was born in 1786 and left home as a youth to join the throngs, uprooted by war, then roaming Europe.[1] Many of these wanderers, like him, found a haven in Amsterdam: the canals of the old seaport were bustling with commerce despite battles

and blockades, and its streets were crowded with refugee craftsmen from all over northern Europe. Amsterdam was a turbulent and exciting city; it had been occupied by Napoleon who put his ineffectual brother Louis on the throne as a puppet king. There had been threats of attack by Cossacks in 1812, and a gradual return to normal living with the restoration of the House of Orange.

Johann Ernst worked in various hotels and coffee houses in the city. On 12 May 1811 he married a Flemish woman, Isabella Ludovica Wouters, who came from Ghent.[2] Though Isabella is described in official documents as 'working for wages' in a coffee house, presumably as a domestic, a photograph taken when she was an old lady shows a dignified, crisply groomed, and very proper, but kindly, woman, bearing no trace of a humble servant's origin. The young couple presumably had met during the course of Johann's wartime wanderings and were already living in the same house in Amsterdam when they were married. Their first child, a daughter named Frederika Louisa, was born in October; their marriage may have been delayed since it would have been a time-consuming task to secure the necessary documents to be married in wartime. A second daughter, Charlotta Sophia, was born on 13 September 1813: she would grow into a vivacious woman with a long thin face and bright eyes, and with hair as raven black as that of Cornelius; her life would be tinged with unexpected and remarkable happenings, and she would share with her brother an excitement in living.

Some time after the birth of Cornelius, the Krieghoff family moved from Amsterdam to Düsseldorf in the German Rhineland; presumably Johann Ernst was searching for opportunities in the new age of peace that followed the prolonged continental war. A second son, named after his father, was born on 20 August 1820. Like his elder brother he would spend much of his life in Canada, although the similarities

ended there: the younger Johann Ernst seems best described as a quiet family man while Cornelius was very much the man about town. At the registration of the birth in Düsseldorf, the father gave his profession as a manufacturer of wallpaper.[3]

The circumstances of the meeting are not known, but in Düsseldorf the elder Johann Ernst entered into a business arrangement with an enterprising German manufacturer named Wilhelm Sattler, who owned potteries, sugar refineries, and various industrial plants around the northern Bavarian city of Schweinfurt. Sattler had made a fortune producing goods to replace those cut off from the continent by the wartime British blockade. According to the agreement between the two men, Krieghoff moved his family eastward during February 1822 in order to establish a wallpaper factory as another branch of Sattler's operations.[4]

In order to reach Schweinfurt the Krieghoffs would have travelled first to Würzburg, a city dominated by its ancient hilltop monastery and the seat of the Roman Catholic archbishop, temporal and spiritual ruler of the surrounding state. From there they would have ascended the Main River, the banks of which were lined with vineyards on sloping terraces rising from the water and dotted with wayside shrines erected by a devout rural population. By contrast, Schweinfurt itself was staunchly Calvinist, a Protestant oasis of prosperous bourgeois businessmen in the midst of stolid Catholic farmers. There are parallels to the Quebec of Krieghoff's time when a community of progressive, strongly Protestant merchants, businessmen, and soldiers lived in Montreal and Quebec City surrounded on all sides by the conservative Catholic habitants.

Schloss Mainberg is a romantic twelfth-century castle perched on a rocky outcropping over the Main about five kilometres from Schweinfurt (fig. 6). Sattler had purchased this medieval stronghold and, two years after their arrival, gave Johann Ernst, his wife, and four children living accommodation there. For some twenty years members of the Krieghoff family would live in a few of its ninety-three rooms.[5] From the apartment windows high on the top floor, young Cornelius could look out and see Schweinfurt with its old church towers and picturesque city walls. Beyond was a great panoramic sweep of countryside, the valley of the Main. The Sattler family had living quarters in another part of the castle as well as a house in town; the business association of the

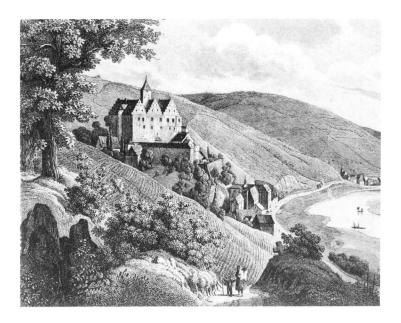

6 Schloss Mainberg: early nineteenth-century engraving

two older men developed into a lifelong friendship, ruptured only briefly by a family scandal in the late 1840s.

The new wallpaper factory was operated in a large room on the castle's lower levels; it had been the common hall where medieval soldiers and the servants of the counts congregated during the days of private armies. Here the elder Krieghoff supervised more than a hundred men at their task of printing high quality wallpaper. Many of the workers, such as Jan Steewig who had been brought from Flanders to cut stencils, were skilled craftsmen. Surviving examples reveal that their products were extraordinarily attractive and attuned to current bourgeois tastes. Floral pillars reach upwards out of baskets placed as if sitting on the floor; brilliant red, orange, and yellow flowers shine out against glowing blue backgrounds in emulation of Dutch floral paintings. Backing sheets of reinforcement added permanence and quality. The enterprise was a profitable one: some surviving sets of accounts show an ample margin when the year's income was tallied and divided between Sattler and Krieghoff. The manufacturer had a particular interest in the pigments used for the colour printing, since the making of paint was another

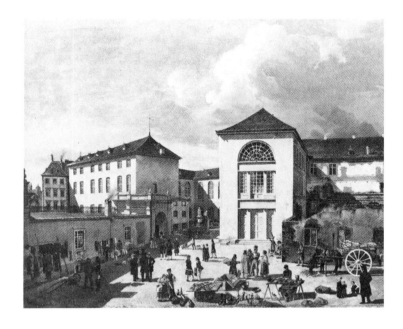

7 Andréas Achenbach, *The Old Academy in Düsseldorf* 1831
$25\frac{1}{4} \times 31\frac{7}{8}$ in / 64.1 × 80.8 cm Museum of Art, Düsseldorf

of his business ventures. Cornelius would later reminisce to his Quebec friends about a chemist named Schule, who developed in the castle the celebrated 'Sattler's' or 'Schweinfurt' green, a popular and very distinctive colour. Regrettably, the pigment was made from highly toxic arsenic and its use for wallpaper was discontinued after people living in rooms papered with 'Deadly Schule's Green' were poisoned. Sattler then cleverly adapted it for the manufacture of ship's paint.[6]

Life at Schloss Mainberg for young Krieghoff extended beyond a constant association with colours, paints, and designs at the wallpaper factory. The Sattlers were a cultured family and patrons of the arts: they were interested in music and philosophy, collected prints, and commissioned paintings; indeed, they were typical of the educated German town bourgeoisie of the period, with the tastes and concerns of people who lived in larger and more sophisticated urban centres. Sattler's wife, Margaret, was an amateur artist and filled enormous scrapbooks with collections of engravings and her own sketches;[7] she also designed some of the wallpaper patterns. Other members of the family were equally accomplished: Wilhelm, the son, who was only slightly older than Cornelius, was obviously an intellectual. He eventually married Charlotta Krieghoff and wrote books on philosophy, while his wife developed a passion for Wagnerian music. Commissioned portraits of family members accumulated through the years, including one of Charlotta after the marriage. The Sattler family retained their romantic castle until the 1920s.[8] It is now deserted except for fierce watchdogs trained to chase intruders from the grounds; a large lime tree, mentioned by a diarist in Krieghoff's day, still stands in the forlorn courtyard.

No art school existed in Schweinfurt where the future artist might have studied painting. There was, however, in the city centre an ancient and famous grammar school which maintained extremely high academic standards and was intended originally to be the forerunner of a university. Its distinctive ornamental façade still faces the square near the old Church of St Johannis. Krieghoff might well have spent time in this institution, studying classics, philosophy, and natural history, subjects that interested him in later years, but his name has not been found among the surviving student rolls.

It is likely that Krieghoff did study painting as well as music in Düsseldorf as a youth. His family had lived there at an earlier date and there would have been connections; as well, Krieghoff's own style and subject matter reveal a knowledge of the art movement then flourishing in that city. The Düsseldorf Academy was one of Europe's liveliest art schools and showed a tremendous interest in genre subjects. Young Andréas Achenbach (1815–1910), a virtual child prodigy born the same year as Krieghoff, painted the Academy in 1831 (fig. 7). The building, standing in a square paved with cobblestones, is surrounded by people of the town and countryside – pedlars selling their wares, a man pushing his wheelbarrow, children, students, and soldiers; a cart loaded with firewood driven into the square adds to the bustle. The scene, set down in astonishing detail, makes a lively stage tableau designed to delight the eye and amuse the spectator. This anecdotal content is typical of much of the painting of the time, and of one trend in Düsseldorf following the appointment of the dynamic Wilhelm Schadow (1788–1862) as director of the Academy in 1826. Subjects from everyday life were judged to be suitable for canvases, and a new generation of brilliant art teachers and students were putting fresh life into the school. Johann Peter Hasenclever (1810–53), an instructor, was one of those striking out in bold new directions as a genre painter;

later Krieghoff would copy his lively and popular canvas *The Wine Taster* (fig. 8), the original of which was burned in the Second World War. Hasenclever's light narrative subject matter was designed to amuse a bourgeois audience: a jolly rotund man, the taster, with cheeks red from too many similar functions, smacks his lips over the first trial glass of the latest vintage in a cellar filled with unopened barrels, and an expectant audience awaits his verdict. In time Krieghoff would similarly delight a Canadian audience with his own anecdotal compositions.

One readily appreciates why German genre paintings were widely acclaimed and fashionable following 1830. Incidents and events of everyday life amidst local surroundings were pictured in vignette form, set down in a small format suitable for hanging in the home. The light, secular subject matter – anecdotes based on peasant life or the doings of the more affluent – held a sense of immediacy, of actuality, and of informality, attuned in every respect to the affluent new bourgeois class. The genre paintings contrasted strikingly to the art of the previous generation, especially that of the Nazarenes, a serious quasi-religious German order based in Rome and dedicated to reviving the artistic objectives of Dürer and the young Raphael: their canvases, biblical in subject matter, rigid and antiquarian in mood, had a certain remoteness. In a similar way Canadian merchants would come to prefer Krieghoff's paintings to the more aloof, neo-classical canvases that preceded them.

This early nineteenth-century genre movement at Düsseldorf revived a type of painting which had blossomed in Holland during the seventeenth century, when a prosperous Dutch Protestant burgher and trader class had sought intimate subjects to provide colour and amusement in their homes. Ostade's laughing peasant women, Vermeer's living rooms and street scene, and Steen's peasant gatherings were but a few Dutch favourites of the time. Hogarth's rowdy life in London's 'Gin Lane' and Chardin's French women with their polished copper pots held similar interest. From the Düsseldorf school, students carried genre painting to Norway, Sweden, and England. Ultimately Americans such as George Caleb Bingham (1811–79), Eastman Johnson (1824–1906), and Thomas Worthington Whittredge (1820–1910) studied in Germany and introduced the Düsseldorf style into the United States.

Krieghoff's attendance at the Düsseldorf Academy must be

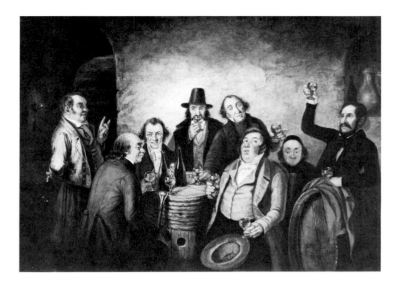

8 Krieghoff, after Johann Hasenclever, *The Wine Taster* undated 13½ × 19¼ in / 34.3 × 48.9 cm The Hon. K.R. and Mrs Thomson

assumed primarily because of his obvious familiarity with the work and the approaches to art prevalent there. In addition, a family tradition maintains that he studied music and painting in that city.[9] The detail cannot be checked in the school records, for these were removed for safekeeping in 1939 to a town now in East Germany; one of the mysteries of totalitarianism is the rationale behind the persistent refusal of the authorities to allow anyone to consult them.

Krieghoff's travels have been described so often that fact and fiction have become inseparably intertwined. Many writers have referred to his youthful 'Bohemian wanderings' around Europe,[10] but, as is often and frustratingly the case in tracing his life, there seems to be no supporting documentation. Certainly there is circumstantial evidence that he spent some time travelling about, as was the custom among the young men of Europe of his time. Yet, when one writer provides a detailed account of his life as a young traveller which lacks sources, it is perplexing to have to guess whether it is based on facts or is fabricated from bits and pieces.[11] His itinerary as postulated by earlier writers may have been reconstructed from a list of his paintings, which are copies of canvases in widely scattered European collections; but, if so, there is nothing to confirm that he worked from the originals

and not merely from engravings. G.M. Fairchild, a Quebec antiquarian writing in the early twentieth century, declared that Krieghoff had trained as a musician, performed on several instruments, and studied in Rotterdam;[12] but again the assertion cannot be verified.

Yet Krieghoff was musical, he did have a wide knowledge of continental painting, and he may well have wandered from city to city, visiting picture galleries in the Netherlands, France, Switzerland, and even Italy, and making music on the way. His European upbringing developed in him a wide range of interests which he continued during his later life in Canada. He was not only fascinated with painting and music but showed a love for the theatre, natural history, and enjoyed the company of intellectuals. John Budden, who became his closest friend in Quebec and companion for many years, noted that he was a 'Capital Musician & understood it in all branches, used to Play and Compose Music for hours Every day. He had the most wonderful faculty for Picking up Languages, Spoke & wrote English, French, Italian, Spanish, German & Dutch, Latin & Greek; was deep in Natural History – took away the finest Collection of Bird's Eggs, Skins & Coins which had ever been located at Quebec up to that time.' Christopher O'Connor, another good friend from Quebec days, remembered that Krieghoff was a 'brilliant conversationalist with his table talk about German literature, German manners, German [börchem] life and German scenery,' and that to listen to him was 'more like reading well written books than listening to ordinary conversation. I never met his equal as an entertaining companion and his mind was so well stored with varied and extensive reading that he was looked upon as an authority on everything connected with belles lettres.'[13]

Mankind was restless and ambitious following the Napoleonic Wars and in the next decades mass emigration took place on an unprecedented scale. In 1836 almost twenty-one thousand Germans left for the United States, doubling the number of the previous year. It was a time of economic depression in the homeland. Cornelius Krieghoff, then a young man of twenty or twenty-one years, and his younger brother Ernst, joined the many others sailing for the New World, landing in New York some time during 1835 or 1836. The brothers may have come simply because they dreamed of money lying in the streets, of free land, and limitless opportunities; there is a statement, however, of unknown origin, which affirms that Cornelius was commissioned by a German university to collect botanical specimens in America.[14]

They arrived at a time of great excitement, for war had erupted following the uprising of the Seminole Indians in 1835 in the new territory of Florida. The campaign against the Seminoles, a branch of the Creeks, was waged by the United States as a ruthless war of extermination. The government at Washington had negotiated a series of treaties with those Indians bordering the western limits of white settlement on the Atlantic seaboard. Various tribes had agreed to move to new lands further westward, thus vacating long-occupied native tracts for settlers, but obviously few of the Indians realized fully the implications of their concessions. The whole manœuvre had taken place as a huge and sinister public relations ploy. Red Jacket, chief of the Senecas, of whom Krieghoff was asked to paint a portrait years later, and other equally celebrated Indian leaders were brought to the capital as spokesmen for the many people living in tribal lands extending from the Menominees in Wisconsin to the southern Creeks in Georgia and Florida. They were flattered with donations of medals and other trinkets, housed in hotels, wined and dined, taken to the theatre, and even presented to the president in the White House. The artist Charles Bird King (1785–1862) painted their portraits.[15] Such unctuous and compelling posturing resulted in the signing of treaties, various tribes actually moved west, and settlers flooded in to fill the void.

Then trouble had erupted. The Florida natives had sober second thoughts about moving to Arkansas and refused to leave. They were a mixed group of Seminoles and escaped black slaves living under colourful chieftains such as Osceola, 'King Philip,' and others, including a fiery individual of mixed Scottish and Indian blood. Their sporadic attacks on white settlements generated hysteria throughout the country, and the army began to remove them systematically. To the consternation of the Americans, the resistance increased in intensity and developed into all-out war. Troops were still being killed in Florida in 1842. The Seminole tribe was virtually wiped out, but only after a shattering expense in American men and money, accusations of incompetent army leadership, a presidential enquiry, much heroism and much villainy.

In the meantime, young Cornelius Krieghoff, after his

arrival in the United States, evidently worked as a musician, wandering about the country, principally playing the guitar. Eventually he was drawn into the Florida military operation. In New York, on 5 July 1837, at the age of twenty-two, he enlisted in the American army for three years of service. A friend reported that he joined 'in order to observe and record the events of that sanguinary conflict in the Everglades of Florida.'[16] His enlistment papers bear a laconic recruiting officer's note declaring that on joining he was 'entirely sober.' One assumes that he probably joined up because he wanted to see Indians. It was a time when other adventurers and artists were going beyond the fringes of settlement for the same reason. Alexander Phillip Maximilian, prince of Wied-Neuwied in Germany, had visited the western prairies of the United States in 1833 and brought with him the Swiss artist, Karl Bodmer (1809–93), to make a pictorial record of various tribes. Captain William Drummond Stewart, son of a British nobleman, had made an American tour in 1837 and hired Alfred J. Miller (1810–74) to paint souvenir Indian pictures. The American artist George Catlin (1796–1872) was achieving fame through his great gallery of Indian portraits; he had begun to paint them in 1830 and considered them as an historical record of 'noble' savages worthy of preservation for posterity despite prevailing American attitudes. He would exhibit them in the United States and take them to England and France for viewing by royalty and the masses.[17]

Krieghoff was assigned to the '1st Artillery Unit' – presumably the First Regiment of Artillery, which had been decimated by disease contracted in the hot southern climate during 1836 and 1837. Life for the soldiers fighting in the Florida swamps was a living hell. There is a report of one particularly harrowing attack at New River in the Everglades. Here the First Regiment soldiers had to fill small boats with their cartridge boxes and muskets, and push the vessels through a maze of mangroves, wading through crocodile- and snake-infested mud and water to a remote island where the Seminoles had taken refuge.

Nothing has been uncovered about Krieghoff's battle experiences; supposedly he spent much time making 'several hundred drawings' of 'every phase of the campaign.' While these studies are mentioned in several accounts, none has been located despite an intensive search in both the United States and Canada. John Budden claimed that he owned the field sketches but that they were burned in Quebec during June 1881; this may be the simple answer to the problem. The United States War Department supposedly commissioned replicas which Krieghoff executed at Rochester during 1843. Although he held an exhibition of 'historical paintings' in that city,[18] nothing suggests that these were of the Seminole war. One would think that at least one example would have survived. Likewise, no Krieghoff paintings of Seminoles are mentioned among those canvases burned in the fire at the Smithsonian Institution in Washington on 24 January 1865 – a fire that destroyed Indian paintings by Charles Bird King completed for the War Department and others by John Mix Stanley (1814–72) which were on deposit in the expectation they would be bought by the American government.

Krieghoff was discharged from the army at Burlington, Vermont, on 5 May 1840. He re-enlisted for a five-year period on the same day, was given $33 in advance pay for a three-month period, and apparently deserted immediately.[19] At that moment marital affairs were obviously pressing. We know little about the circumstances of his marriage (or if, indeed, it ever took place) other than Marius Barbeau's statement that 'Krieghoff was very young when he landed at New York (from Germany). At the hotel where he had put up, he became acquainted with a young French-Canadian girl ... Louise Gautier dit Saint-Germain, and he married her.'[20] Nothing has been found to verify this assertion and it seems to contain at least one error: the wife's name, according to her death certificate, was 'Emily,' *not* 'Louise,' and her surname was 'Saintaguta.'[21] Emilie's family lived, it seems, at Boucherville just downriver from Montreal on the south shore of the St Lawrence. Did they adopt the name 'Gauthier' as being more acceptable in a little Quebec village? A son, Henry, was born a few days after his father left the army. The child was not baptized until 18 June 1840 and then in his mother's home parish of Ste Famille;[22] such delays were unusual in Catholic families. The parish records state that Cornelius was not present. Had the lateness of the father's return become such an embarrassment that the ceremony proceeded in his absence? It is pure speculation but it may be that he rejoined his young wife only to find that in those days of religious authoritarianism as a Calvinist father he was barred from participation in a Catholic ritual.

One senses that Cornelius and Emilie were a mismatched couple. Evidently she was of country stock, a simple and reticent woman, completely lacking in sophistication. Her

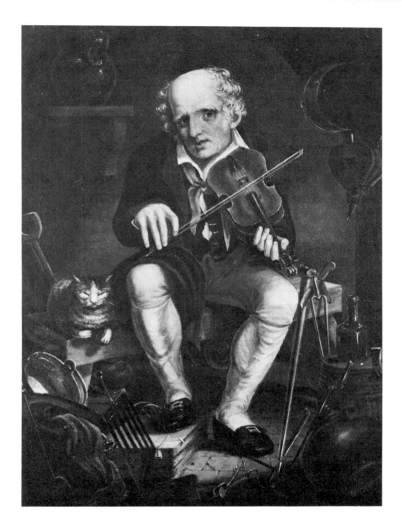

9 *The Fiddler* 1841
24 × 18 in / 61 × 45.7 cm Dominion Gallery, Montreal

shyness was in marked contrast to her cultured, much travelled, and very worldly husband who enjoyed companionship and was accustomed to easy pleasant living. Boucherville could have had few interests for a promising young artist, and the Krieghoffs were already living in Montreal during 1841 when their son died there on 13 June and was buried a day later according to the Notre-Dame parish church records.[23] Meanwhile, a daughter, named Emily after her mother, had been born in March of that year.

Krieghoff's profession is noted as a 'painter' in his son's burial certificate. Only one painting of that period has been discovered – appropriately, since he may have been still working as a musician, a picture of a violinist dated 1841 (fig. 9). In this canvas are those light narrative touches which Krieghoff would exploit repeatedly. The fiddler rests his shoe on a foot warmer, the cat dozes, a broken clay pipe lies on the floor, there is an accumulation of pots, pans, and miscellaneous domestic objects. The subject seems to be based on a painting by another artist such as the Scotsman Sir David Wilkie (1785–1841), who had gone to the Low Countries to paint continental peasant life and whose works Krieghoff would later copy. Wilkie's wide group of admirers included Montreal's wealthy Scottish merchants, bankers, and increasingly well-to-do bourgeoisie.

Sometime following the death of his son, Krieghoff left Montreal for Rochester. Did the family move to escape sad memories or had the artist not achieved the immediate success in Montreal for which he hoped? It has been suggested that he stopped in Buffalo to visit his brother.[24] The ultimate choice of Rochester reveals shrewd business sense. Money was flowing into upper New York State and prices had risen remarkably in the decades of expansion that followed the completion of the Erie Canal. Artists were flocking to the growing town in search of commissions. The American portrait painter Alvah Bradish (1806–1901) was working there. Thomas H. Wentworth (1781–1849) had arrived in the area from Saint John, New Brunswick, where sales had been so poor that he had had to supplement his income by selling stoves in his studio. James Bowman (1793–1842) had opened a Rochester studio in October 1841 after working in Toronto.[25] A close friendship sprang up between Bowman and Krieghoff, but it was broken abruptly by Bowman's death in May 1842. The older man had allowed Krieghoff to copy his famous canvas, a portrait of the Danish sculptor, Thorvaldsen. Bowman made such an impression that Krieghoff paid him a unique tribute. On 30 May 1843 the *Rochester Daily Advertiser* reported: 'We are informed, that Mr KRIEGHOFF, the artist, will open next week an exhibition of some splendid historical pictures in this city. Mr K generally intends to appropriate most of the proceeds of this exhibition to raise a monument to his friend, Mr Bowman, the distinguished artist, who died last year in our city. We hope that the friends of both Mr Bowman and Mr Krieghoff, and the public

10 Krieghoff, after Sir David Wilkie, *The Card Players* c. 1843
oil on panel 8 × 10 in / 20.3 × 25.4 cm
Art Gallery of Ontario, Toronto

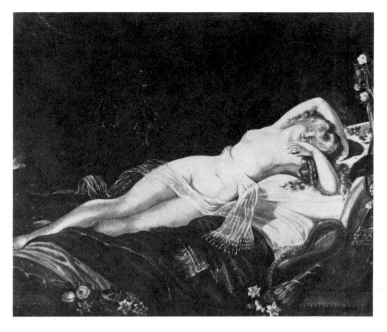

11 *Nude* 1844
25 × 34 in / 63.5 × 86.4 cm destroyed by fire

generally will do their share towards this benevolent act.'

John Budden was probably referring to the Rochester years when he noted that Krieghoff had spent some time in the United States teaching music, principally the guitar.[26] But, if so, he was also working diligently as an artist since several known canvases are dated 1842 and 1843. In an apparent effort to humanize references to his earlier paintings, art historians have described some of them, without confirmation, as picturing Emilie and her daughter.[27] It is equally possible that they were copies of prints whose circulation was reaching enormous proportions in a generation which made few discriminating demands for 'originals' and were delighted with copies or reproductions. Krieghoff painted a study of a notary, now in the Beaverbrook Art Gallery in Fredericton, which is identical to a Paul Kane canvas kept through the years by Kane's descendants; presumably both had a common source either in some print or in a painting by Bowman. Another Rochester painting is *The Card Players* (fig. 10), which is a copy of an 1838 engraving of a painting by Wilkie; it is in the popular genre tradition of Düsseldorf and other areas at the time. But Krieghoff's most

daring Rochester painting was of a young woman lying on a flower-strewn divan (fig. 11). 'Leda and the Swan' had been a subject that fascinated painters through the centuries. In an oblique reference to this old theme, Krieghoff has chosen to paint an arm rest which is carved in the form of a swan's head and has thrown a gauze-like scarf over the Leda in a graceful gesture to provincial modesty. A legend recounts how many years later the painting was discovered by a Canadian cabinet minister in a dark corner of the artist's studio.[28] Whether this is a reference to a mellow Sir John A. Macdonald or one of his bewhiskered colleagues has not been verified, and indeed the story may be as much a fabrication as the tale that Emilie was the model. The canvas was burned in an art gallery in a spectacular Ottawa fire during the early 1960s.

Current fashion dictated that ambitious North American artists have a period of European study and travel. Evidently Krieghoff felt a need for more prestigious training, despite having grown up in a European artistic milieu, for he joined those studying in Paris. According to the archives of the

12 *Portrait of Mrs. William Williamson and Her Daughter Jessie* c. 1845–6
42 × 33 in / 106.7 × 83.8 cm
Sigmund Samuel Collection, Royal Ontario Museum, Toronto

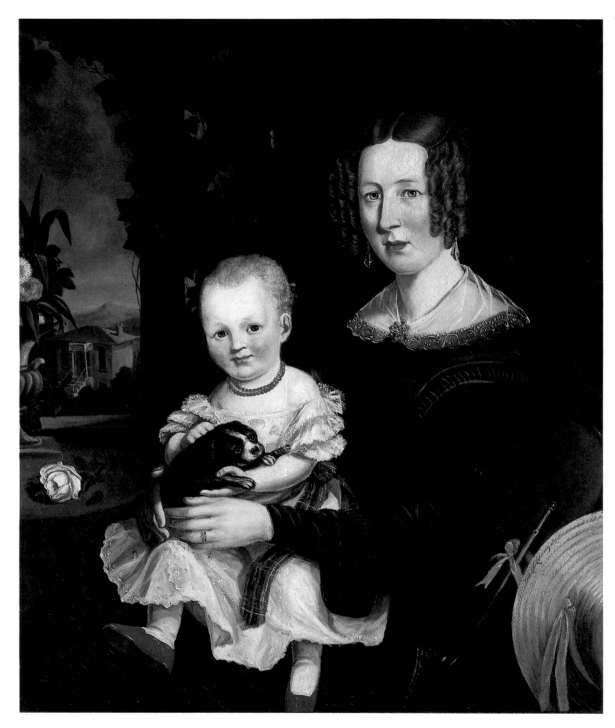

Louvre he was granted copying privileges there as a student on 29 October 1844, and was living at 102 rue de Bac in the neighbourhood of St-Germain-des-Prés.[29] His sponsor-teacher at the Louvre was the Parisian Michel-Martin Dröl-ling (1786–1851), a regular Salon exhibition contributor, recipient of the Legion of Honour, and painter of portraits and religious subjects, whose more famous father, Martin Dröl-ling (1752–1817), painted genre subjects and interiors and had come from Colmar on the Rhine's west bank south of Strasbourg. Whether Kreighoff took his wife and daughter with him to Europe is not known; they may have remained with her parents while Cornelius toured abroad as a stepping-stone to further American success.

European art teaching methods of the time were generally dull and unimaginative. Students supposedly achieved excellence as painters by copying the works of others. Those going to the French capital chose well-known members of the Académie des Beaux-Arts as their sponsors and by so doing were given copying permits in the Louvre. Actually the instructor might never see a single example of a student's paintings or offer any real criticism, but the formality permitted young artists to return home and shout loudly about the famous painters under whom they had worked. The Quebec artist Antoine Plamondon (1804–95), who had studied in Paris in the late 1820s, never lost a single opportunity after his return to impress Quebeckers with the fact that he had been taught by Paulin Guérin (1783–1855) who was in turn the pupil of the 'sainted' Jacques-Louis David; by implication Plamondon thus was confirmed as an artist of distinction.

In Paris Krieghoff copied a curiously eclectic group of works which seemingly had little relationship either to Dröl-ling's interests or his own. He brought some back to Canada where they could have had but slight appeal, though several survive in various collections. *Strolling Actors* by François-August Biard (1799–1882) and *Arrival of the Reapers in the Pontine Marshes* by Léopold-Louis Robert (1794–1835) had been sensations when first exhibited in Paris a few years earlier; despite praise heaped on them by Paris intellectuals at the time and continued public interest for years,[30] they were in reality rather stuffy academic works. It was more in line with his personal interests when Krieghoff made a copy of *German Forester Talking to Children in a Sleigh* from a painting by the Swedish artist, Petter Gabriel Wickenberg (1812–46),

who was well known in both Berlin and Paris. Krieghoff also made a graceful gesture of obeisance to the Old Master cult when he copied Rubens' *Lot and His Daughters*.

A familiarity with the new and fashionable Dutch and German painting, which emerges in Krieghoff's own work later, suggests that he may well also have examined current Northern school paintings. There is some suggestion that he set up a studio in Geneva, based principally on inscriptions appended to two oils purchased by a Montreal dealer which read: 'C. Krieghoff, Atelier, Génève.' The inscriptions do not resemble those of Krieghoff on any other work and their authenticity is questionable, despite the fact that members of the Krieghoff family were often in Switzerland at that time. During his travels he must also have visited his parents in Schweinfurt. Altogether, his stay in Europe seems to have been a short one, certainly no longer than a year; Denis Gale (1828–1903), a friend of Krieghoff's, maintained that he was overseas for only six months.[31]

Krieghoff returned to Canada with hopes of establishing himself firmly as a successful artist. But he paused before setting down roots. He made a brief visit to Toronto, possibly to see his brother who was apparently living there.[32] It is likely that he wanted to assess Toronto's artistic potential and hoped at the same time to pick up a little ready cash from work there.

Plainly Upper Canada's principal city in 1845 had little to excite him: it proved to be very provincial, with few wants for painting other than portraiture. His would not have been the first harsh assessment of this increasingly prosperous and growing town on the northern shores of Lake Ontario. The English writer and art critic, Anna Jameson, visited Toronto in 1836–7 and castigated the city for its lack of culture and its backward art scene; by contrast, during a visit to the United States she was astonished to find a virtual surfeit of artists there.[33] One must balance her acrid judgement of the city against an anti-Toronto bias rooted in personal problems; this British bluestocking, adulated for her knowledge of art affairs at home, was scarcely on speaking terms with her husband who was vice-chancellor in the colony.

The artistic atmosphere in Toronto was simply not appropriate for an ambitious and revolutionary young artist like Krieghoff. The darling of the city was George Theodore Berthon (1806–92), who secured the most lucrative portrait

commissions from patrons who ranged through the upper strata. At that very moment Berthon was painting an elegant canvas of the three daughters of the aloof chief justice, Sir John Beverley Robinson. Krieghoff must have observed during his visit that a steady stream of transient American portraitists like James Bowman, Samuel Waugh (1814–85), and others had executed profitable commissions and then returned home. Most resident Toronto artists were forced to paint small and cheaper watercolours and miniatures to eke out a modest living. Street scenes seldom sold; potential patrons seemed afraid to be reminded of their city's provincial character. James Hamilton (1810–96) and John Howard (1803–90) were painting landscapes, but the former depended on the banking world for his income and not on sale of paintings, while the latter was an architect and spent some of his week as an art teacher of Toronto's young gentlemen.

On the other hand, the visit did give Krieghoff an opportunity to meet such local artists as Paul Kane (1810–71) who had just returned from his protracted American and European tour the previous spring and in the interval had made a trial trip to paint the Indians of the upper Great Lakes.[34] The two men must have talked excitedly about Kane's plans to travel with the Hudson's Bay Company canoe fleet right across the continent to the new post at Victoria and to sketch the Sioux, the Blackfoot, the buffalo on the plains, and the formidable western mountains. Interest in painting Indians was in the very air. We are told that Kane offered advice to the newcomer, and Krieghoff developed such a rapport with Toronto painters that they invited him to exhibit at the Toronto Society of Arts exhibition held in 1847.[35]

Krieghoff stayed in Toronto long enough to complete one important commission, the portraits of Mr and Mrs William Williamson.[36] His trip to Europe had probably been costly and he needed money. Williamson was a prosperous clerk with his own carriage, who lived on Church Street and was the artist's host while the painting was in progress. He posed with one child dressed in eye-catching tartan sitting on his knee. In the pendant portrait Mrs Williamson, who died a few months later, proudly holds her daughter on her lap (fig. 12). There is nothing to suggest that Krieghoff truly enjoyed conventional society portraiture; presumably he regarded such painting as a means of making bread-and-butter money since a number of the earlier portraits he completed are lifeless, the faces resembling dull masks. By contrast there are a few exceptions – lively portraits of intimate friends like John Budden and the numerous paintings of habitant heads which are really an outgrowth of his genre interests.

The portraits of the Williamsons are among those exceptions into which Krieghoff willingly threw himself. They deserve close attention for they demonstrate new ideas and romantic elements acquired during his European travels. In painting them he spurned the ordinary academic treatment. Rather, he orchestrated compositions in which light focuses on certain passages made more brilliant by juxtaposition with dense black background. The sizzling red colours of the table top anticipate his brilliant autumn forests of later years. There is magnetic power in the woman's eyes. The whole is conceived deliberately as a romantic portrait. Despite certain awkward passages, clearly he was striking new notes in terms of light, shade, and colour as used by Canadian artists. It seems likely his innovative approach was not fully appreciated and was misunderstood by the Toronto public. But Krieghoff had a shrewd sense of knowing what pleased, and cleverly compensated for any lack of appreciation of his avant-garde approach by adding certain popular notes designed to appeal to local taste. He inserted a charming landscape background and a vase of flowers.

The latter was a touch appropriate to his interests between 1844 and 1846, during which he completed several still life and floral paintings in the Dutch manner. One of them was a flower painting, now in the Montreal Museum of Fine Arts, in which he borrowed heavily from a canvas by Jan van Os (1744–1808);[37] minor variations not found in the original, such as a cob of corn, are introduced in deference to the need for some North American flavour.

The time had come, perhaps, to settle down, to make a home for his family and build up a reputation for himself as an established artist. His training behind him, a promising career ahead of him, Krieghoff returned to Lower Canada. There he would spend the most productive years of his life.

Maturity, Montreal and Longueuil, 1846-53

KRIEGHOFF'S LIFE centred on Montreal during the eight years or so following his return from Europe. No place in Canada offered within such a small radius an atmosphere so suited to his temperament and aspirations, both as an artist and as a young man who enjoyed good company. The habitant villages of Longueuil and Laprairie, across the St Lawrence on the south shore, provided subject matter for his brush, as did the Indian settlement at Caughnawaga further west along the river. But Montreal itself had unique attractions. The most cosmopolitan of Canada's cities, it approached a level of sophistication to which he was accustomed by his European youth and travels. Above all, it supplied generous patrons and genial companions. Montreal poured adrenalin into the blood, and stimulated his creativity.

For the first few years Krieghoff led a will-o'-the-wisp existence. Though he lived in Longueuil, he commuted regularly across the river, in summer by the horse-powered ferries and in winter over the ice. While his wife and daughter remained in seclusion in the village, he spent long hours in the city at the foot of Mount Royal. Presumably he was renewing acquaintances made five years earlier, making new friends and fresh contacts, and trying hard to establish himself as an artist. Much time was spent promoting the sale of his canvases, both copies brought back from Paris and newly painted local subjects.

In the middle of the nineteenth century Montreal was a growing British colonial city, with a population approaching sixty thousand of which the English-speaking slightly outnumbered the French. There were economic difficulties in the late 1840s, associated with the repeal of the corn laws in Britain and the decline of the colonial preferential system, which had favoured the development of Montreal as a commercial centre. But the city retained a prosperous façade. Magnificent new structures were rising along the downtown streets, most notably, on the Place d'Armes, the stately twin towers of the Church of Notre-Dame and the imposing neoclassical Bank of Montreal. Both invited recording. Krieghoff's painting of the bank was issued as a lithograph in 1848 (fig. 13) and was hung in many Montreal homes as a symbol of the city's wealth.

As capital of the united Canadas since 1844, and the financial and commercial centre of the country, Montreal had its share of interesting people and colourful events. Queen Victoria's representative, Lord Elgin, often drove through the streets from Monklands, his official residence on the outskirts of the city, to the government buildings on Youville Square near the waterfront. Enthroned in his carriage or tucked comfortably into a fur-lined sleigh, the governor-general rode in splendour behind a coachman and four well-groomed horses. On Notre-Dame and Great St James streets the country's leading politicians, businessmen, merchants, and bankers rubbed shoulders with aristocratic British army officers in scarlet or blue uniforms. Pedestrians from all walks of life mingled in the passing parade: soldiers in kilts from the 71st Highland garrison, Irish immigrants just off the boats, a few remaining fur-trade voyageurs at the end of long journeys, habitants in traditional *Canadien* dress bringing farm produce from the countryside, busy housewives on domestic errands, and carters from the Jacques Cartier and Bonsecours markets. Indians lingering in the streets rounded off the spectacle.

Montreal also had many visitors: entrepreneurs and businessmen, travelling shows and circuses, and adventurers curious about the New World. The travellers arrived by railway from the south, by steamship up the river from Quebec, in less comfortable boats or over rough roads from Kingston and the developing hinterland to the west. Some of the visitors were distinguished. Charles Dickens stayed at Rasco's Hotel and sounded a sour note by criticizing the city's newness and lack of picturesque interest; he also bemoaned a city

13 *Place d'Armes à Montréal* 1848
coloured lithograph $13\frac{9}{16} \times 19\frac{1}{8}$ in / 34.5×48.6 cm
private collection

14 *Fur Trader in Toboggan* undated
private collection

council decree that permitted the demolition of the quaint spire of the older Church of Notre-Dame that had graced the Place d'Armes.[1] Jenny Lind's 'nightingale' voice thrilled enthusiastic Montreal audiences, her visit made even more remarkable by the attendant ballyhoo. Well-known Americans also came: John Wilkes Booth acted on the local stage; Henry Ward Beecher preached his evangelistic message; and his sister, Harriet Beecher Stowe, author of *Uncle Tom's Cabin* (1852), made a whirlwind tour of the city's churches, sampling one sermon after another to adjudicate the merits of the various divines.

Krieghoff thrived on the activity and revelled in the opportunity to meet people. The prosperous travellers, railway and canal builders, shipowners, army officers, and government officials would all buy his canvases. The subjects he painted in his early days in Montreal have about them a hit-and-miss nature, as if he were probing and experimenting in order to find ideas that appealed. Certainly his pictures of habitant life were popular, but his tastes were all-embracing and he sought wider horizons. Shortly after his return from abroad he painted at least two canvases picturing fur traders, as if in deference to the city's past: the skin of the beaver had been the lifeblood that transformed Montreal from a small village to a great commercial city, and in Krieghoff's day former partners of the old North West Company and the governor of the Hudson's Bay Company still lived there. So he painted a trader tucked into one of the curious toboggans with enveloping hood favoured in the industry (fig. 14). Three dogs decked out with tinkling bells and ornaments pull the sled, while a driver runs behind on snowshoes keeping the animals in order as they cross the river ice. It was a sight familiar to many who had travelled in the great northwest. In that same decade Paul Kane had sketched a similar subject in Edmonton when a factor's son, his bride, and an attendant retinue of nine men set out across the frozen prairie on their wedding trip.[2]

Another early experiment was a series of four canvases painted for the Hale family. Edward Hale, then head of the family in Canada and a prominent government official, was the son of the Honourable John Hale (brother-in-law of the Earl of Amherst), who had come to the colony in 1793 as the military secretary of the Duke of Kent, then governor-general. The Hales had remained in Canada. In 1846 they commissioned Krieghoff to paint their two local family

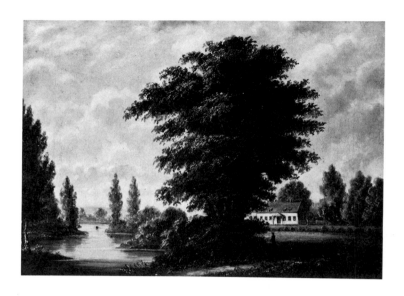

15 *Seigniory at Sainte-Anne-de-la-Pérade* 1846
11½ × 16 in / 29.2 × 40.6 cm Mrs V.J. McCrae

homes. One of them (fig. 15), the old seigneury at Sainte-Anne-de-la-Pérade,[3] had been purchased by John Hale. It was an historic house, for Madeleine de Verchères, who as a girl had defended her father's mill against the Indians and became a legend, had come there as a bride in 1706. The Hale's second house, 'Sleepy Hollow,' was near Sherbrooke. In addition, Krieghoff copied engravings of the family's two English ancestral homes. When hung in their Canadian living room, the paintings displayed their old and their new world roots. For Krieghoff, it was an important establishment connection.

It was fashionable at the time, for people of any distinction, to have paintings or 'portraits' of their comfortable houses. James Duncan (1806–81) was boosting his income by painting the houses of gentlemen in Montreal, and Joseph Legaré (1795–1855) was doing the same in Quebec City. The year after he finished the Hale canvases Krieghoff went to paint along the St Francis River in the Eastern Townships. There he lived briefly with the Terrill family and left behind a painting of the house in appreciation of their hospitality. Many years later, outside Quebec, he painted for a Captain John Walker a canvas of a neat white house nestling at the edge of autumnal maple woods, catching the garrison officer

16 *The Country House of Capt. John Walker* 1857
18 × 27⅛ in / 45.7 × 68.9 cm
Musée du Québec, Quebec City

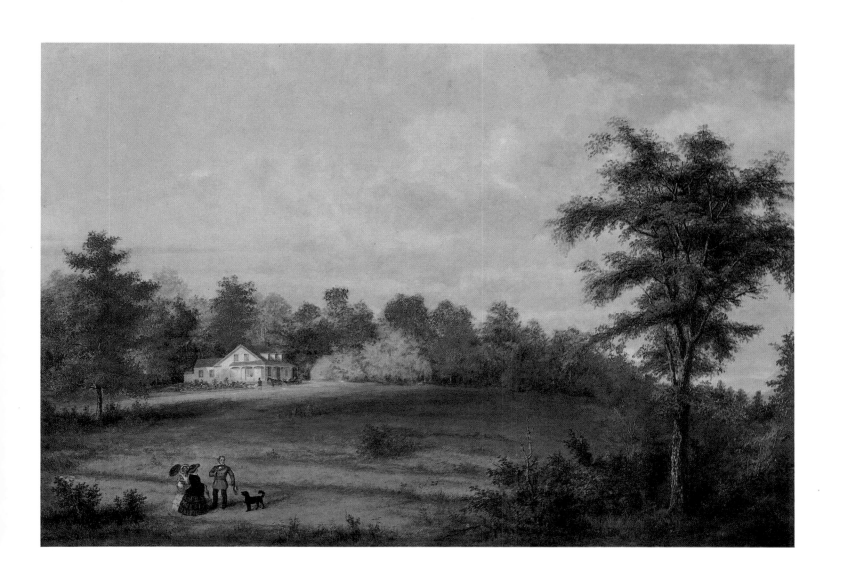

strolling on the lawn with friends as he considered its purchase (fig. 16). Evidently Walker commissioned the painting on the spur of the moment, though it seems he did not buy the house.

Montreal was developing as a centre for the arts, and Krieghoff rapidly integrated himself into the artistic community. Towards the end of 1846 the local painters organized themselves into the Montreal Society of Artists, the province's first professional artists' group. Most of the members were recent English, Irish, and Scottish immigrants. None were French-speaking, for established French-Canadian artists like Antoine Plamondon, Théophile Hamel (1817–70), and Joseph Legaré favoured Quebec City, where they could earn a living from religious art for the church and portraits for the old seigneurial families.

Though a newcomer to the city, Krieghoff, then thirty-one years old, was one of the most ambitious members of the new association. The group rented upstairs rooms on Great St James Street and converted them into an art gallery. The bleak walls were decorated pleasantly, paintings poured in for display, and early in January 1847 an exhibition known grandly as the Montreal Gallery of Paintings was opened to the public. A catalogue of the entries was prepared, but not a single copy seems to have survived the years. The details of this 'exhibition of the mind' which 'did honour to our province' come from descriptions in the *Montreal Gazette* of 15 January and the *Pilot* of 29 January 1847.

The exhibition provides a survey of the Montreal art scene at the time, and presents Krieghoff's friends and his competitors. The Scottish painter, Andrew Morris (active 1844–52), exhibited twenty-two portraits and landscapes: one of the latter was a view of the Chaudière Falls on the Ottawa River while others were scenes of Montreal which were criticized for their bad perspective. His painting of a pony, however, was declared to be realistic, 'alive and kicking.' William F. Wilson (active 1842–51) was a deaf English artist who had studied under Flemish artists and achieved fame by painting a portrait of the Duke of Wellington. Yet his canvas of the popular Colonel George Augustus Wetherall, a venerable garrison officer and friend of the local artists, was so bad that the *Pilot* critic suggested Wilson should read the volume *Burnet on Painting*. Martin Somerville (active 1839–56), whose studio was a few doors away, sent in twenty-one drawings and watercolours. Some of the latter

depicting Greek scenery looked back to the genteel classical world which was rapidly disappearing under the onslaught of the keenly ambitious new Victorian age. William Sawyer (1820–89) was essentially a portrait painter but he exhibited *As Happy as a King* after a painting by William Collins (1788–1847), the English academician; Krieghoff would later make his own copy of the same picture. Of the other artists, the most prominent was James Duncan, whose Quebec scene was described as 'too cold' though his oil views of Montreal were preferred by some to those by Krieghoff.

Although Krieghoff was probably the last of the exhibitors to arrive in the city, he exhibited a disproportionate number of canvases for a single artist, no fewer than forty-eight. The quantity far exceeded the contribution of any other exhibitor, and covered so much wall space that the journalists could not help but mention them in their news items. Many were copies painted in Europe and brought back for sale in a colonial society seeking an air of cultural sheen. The *Pilot* singled out his *View of Boulogne* as the best painting in the room because of its 'faithful and correct execution.' It was a time of much literary influence on art and in this mood Krieghoff had painted two canvases illustrating Sir Walter Scott's *The Abbot*. But reviewers were equally excited by the fresh new local note in his habitant paintings. The *Pilot* critic complained, however, of a certain unevenness in his painting. A present-day examination of some of these works causes one to wonder about their authenticity; but they may be the products of hours when Krieghoff was paying insufficient attention to the business at hand while sharing a bottle with friends.

Perhaps the most spectacular painting in the exhibition, and certainly one of Krieghoff's most interesting, was the *Officer's Trophy Room* (fig. 17).[4] The work had been commissioned by Dr A.A. Staunton, an assistant surgeon in the British army, as a memento of his stay in Montreal, and portrays his quarters in the Notre-Dame Street East barracks. Staunton had arrived in Montreal on 20 September 1845, following a tour of duty with the British forces in Arabia. He died shortly after the completion of the painting, which seems to have then passed into the hands of Lieutenant John Macdonnell of the 71st Highland Light Infantry, a fellow garrison officer.[5] The doctor's gloves, embroidered with the initials 'A.A.S.,' lie on the floor.

Many of the other articles illustrated in the canvas explain the widespread popularity of the regimental officers and

enlisted men, who were generally well liked and participated lustily in the city's social and cultural activities.[6] The 71st band provided music on festive occasions. The officers fished, went skiing and tobogganing in winter, and rode fine horses. They collected items they found strange and attractive to remind them of their North American posting: young British officers brought home similar collections from all over the world as tangible evidence of their life in the forces and the growing diversity of the empire. That Krieghoff was asked to do this painting within months of his arrival reveals how quickly he moved into Montreal's social circles.

The composition of the *Officer's Trophy Room* is an admirable example of Krieghoff's ability to solve difficult problems as a painter. In this one canvas he had to integrate a great variety of objects and at the same time achieve a pictorial effect that would entice further commissions from Staunton's friends. He found a typically pragmatic solution.

Previously he had made copies of two different paintings of a subject described as *The Antiquarian* (fig. 18). In each version an old collector sits in a room designed in the then-fashionable Gothic revival style. Beside him is a table hidden under elegant rugs; fine carpets lie on the floor; a fireplace casts a ruddy glow over walls lined with shelves of books, rows of paintings, ornamental busts, and various bric-a-brac. Krieghoff adroitly transformed the antiquarian's cloistered room into the barracks den, and the old scholar into a dashing young officer wearing a pillbox hat. The table is hidden under a Canadian fur rug, which did double duty as decoration for the room and as an eye-catching luxury item when tucked around his lady friend on a sleighing party (such furs cost more than £100). A dog warms himself near the fireplace. On all sides is a mélange of snowshoes, skates, a toboggan, fishing creel, paddle, and sporting gear. The Indian bags, moccasins, baskets, and pipes may have come from nearby Caughnawaga. There is a dazzling collection of harness for Staunton's horse. Many paintings hang on the wall. The whole is a rich documentary record. The colour is bright, the composition lively; an urbane and sophisticated air is achieved through judicious borrowing of ideas and juxtaposition of objects.

One wonders if Staunton actually owned all the paintings hanging on the walls or if Krieghoff introduced them for the purpose of self-advertisement. Seven of them certainly, and possibly nine, were canvases that Krieghoff had himself painted, and they demonstrate a random sampling of his first year's output in Montreal. There is the *Officer's Trophy Room* itself, probably his most ambitious work up to that date. A second picture documents an embarrassing moment when a soldier of the 71st is surprised making love to a girl in Longueuil (a companion subject to fig. 24); British soldiers the world over laughed at such incidents. One canvas depicts an Indian shooting the Lachine Rapids in his canoe while another shows Montreal as seen from Mount Royal with a group of Indians in the foreground.[7] In another, a habitant family sits in their sleigh at Longueuil. Three works are Krieghoff copies of sketches made by Staunton in Arabia;[8] two of these, which flank the Longueuil view, are portraits of a Bedouin and a Wahhabi chieftain. One canvas seems to be a copy of a picture of the Tigris River flowing through the desert, a painting that still survives in a Montreal collection. On occasion Krieghoff did copy portraits as well as working from life but no portraits on the walls except those of the Arabs can be distinguished with sufficient clarity to permit identification.

One way that Krieghoff furthered his Montreal social connections was by becoming a member of the prestigious (if eccentrically spelled) Shakspeare Club.[9] Staunton belonged, and a bust of Shakespeare is prominently displayed in the *Officer's Trophy Room*. Krieghoff had joined by at least 1847. Originally known as the Shakspeare Dramatic and Literary Club, organized in 1843 to sponsor plays at Molson's Theatre, the club had changed gradually into a literary and debating society. Krieghoff was at his sparkling best in such an atmosphere of politics, history, and literature. He would have enjoyed, too, the grand annual dinner at Tetu's Hotel, which stood at the corner of St James and Bleury streets, when course after course was topped off with sherry, claret, and champagne. The membership consisted of a solid backbone of business and political leaders augmented by a group of eager young men on the rise and a sprinkling of army officers. The members included John Young, who published the *Canadian Economist* (1846–7), E.A. Meredith, the youthful principal of McGill University, F.W. Torrance, a rising young lawyer and future judge, and William Kingsford, a pioneer Canadian historian. Sir Allan MacNab, then the opposition Tory leader, and the Honourable R.S. Jameson, vice-chancellor of Upper Canada and estranged husband of Anna, were two of the honorary members.

17 *Officer's Trophy Room* 1846
$17\frac{1}{2} \times 25$ in / 44.5 × 63.5 cm
Sigmund Samuel Collection, Royal Ontario Museum, Toronto

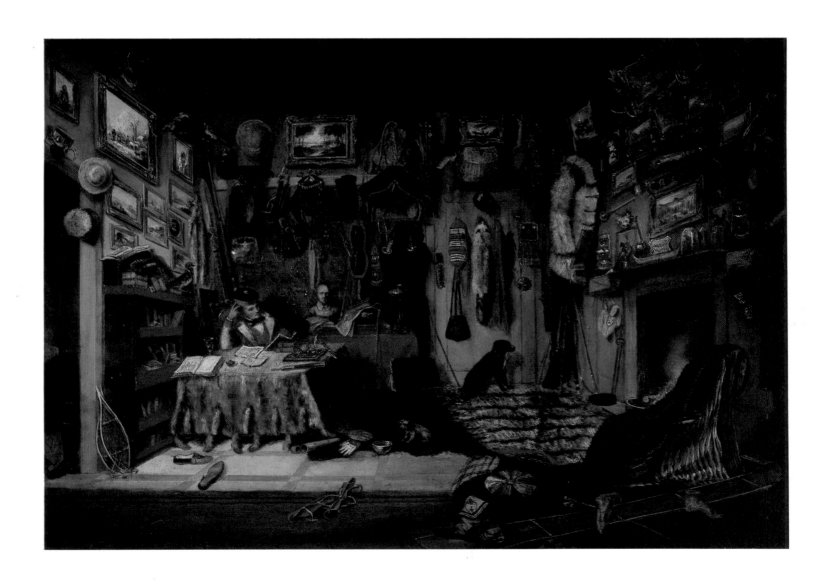

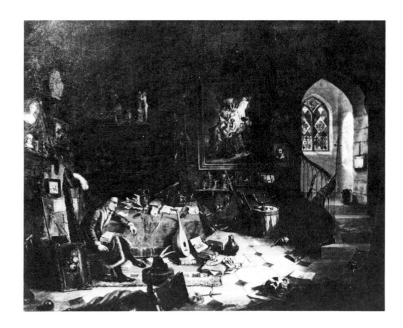

18 *The Antiquarian* 1845
19½ × 24¾ in / 49.5 × 62.9 cm private collection

Krieghoff had perhaps deliberately manœuvred his club membership. The sharp social distinctions of the period must have closed the doors to most. James Duncan, a quiet and reserved man, would likely have considered it an impertinence and felt out of place circulating as an equal with many of the members. Krieghoff, on the other hand, had no such qualms. He had had wealthy friends in Germany and radiated great personal charm. There was about him a shrewd sense of drive in his self-promotion, and he may well have secured a membership by placing the club under his obligation. Lord Metcalfe, the governor-general, had returned to England in 1845 from Montreal with a terminal illness, and when news of his death reached the city on 6 October 1846 the Shakspeare Club declared thirty days of mourning during which members wore crape hatbands and black gloves. Metcalfe's portrait had been painted in 1844 by Alvah Bradish, an American artist who had lived in Rochester at the same time as Krieghoff, and was exhibited at the prestigious National Academy of Design in New York two years later. Krieghoff painted a handsome oil copy from an engraving of Bradish's original and seemingly donated it to the club, for it hung in the meeting hall at the corner of St Paul and St Jean Baptiste streets. The portrait was both a tribute to Metcalfe's memory and mute testimony to Krieghoff's ability. Members, all potential patrons, could ponder it at each meeting. The portrait disappeared after the club's dissolution but emerged later in the Château de Ramezay collection where it remains.[10]

There were decided advantages in advertising one's talents by the exhibition of paintings and by associating with the rich and powerful. Towards the end of January 1847 Krieghoff was rushing to complete a copy of a portrait of Queen Victoria based on a famous painting by Sir George Hayter (1792–1871). He hoped to hang it in the Montreal Gallery of Paintings before the close of the society's first exhibition. Evidently he was successful in having it seen, for it was purchased by a nephew of James McGill, a fellow member of the Shakspeare Club. The portrait was donated to the government, and hung in the Assembly chambers of the Parliament Buildings on Youville Square. Other patrons were beginning to come forward. Judge John Fletcher commissioned two portraits, one featuring his wife and their niece, the other himself. Though faithful likenesses, they lack the colour and glamour of the Williamson portraits Krieghoff had painted in Toronto, and are much less ostentatious in size; these more conventional works were perhaps more appropriate for people in conservative professions like the judiciary.

Most of Krieghoff's portraits must be considered dull, but the must successful of all his portrait canvases was painted in 1847. Sometime following his return to the Montreal area he met John S. Budden of Quebec, a member of the auction firm of A.J. Maxham and Company. The two men struck up a friendship that lasted a lifetime, and later, when Krieghoff moved to Quebec City, perhaps at Budden's insistence, they became constant companions. The painting reveals that Krieghoff established contacts in Quebec City early in his years in Montreal; it demonstrates also that he carried on the highly romantic attitudes towards portraiture that he had brought back from Europe and had first expressed in his portraits of the Williamsons in Toronto.

The camaraderie and rapport between the two men is reflected in the portrait (fig. 19). Budden is dressed in his summer hunting outfit, checked trousers, a smartly tailored ochre jacket, and spats. He relaxes with his terrier during a leisurely ramble in the woods. A high hat, inside of which

19 *Portrait of John Budden* 1847
23 × 29 in / 58.4 × 73.7 cm
private collection

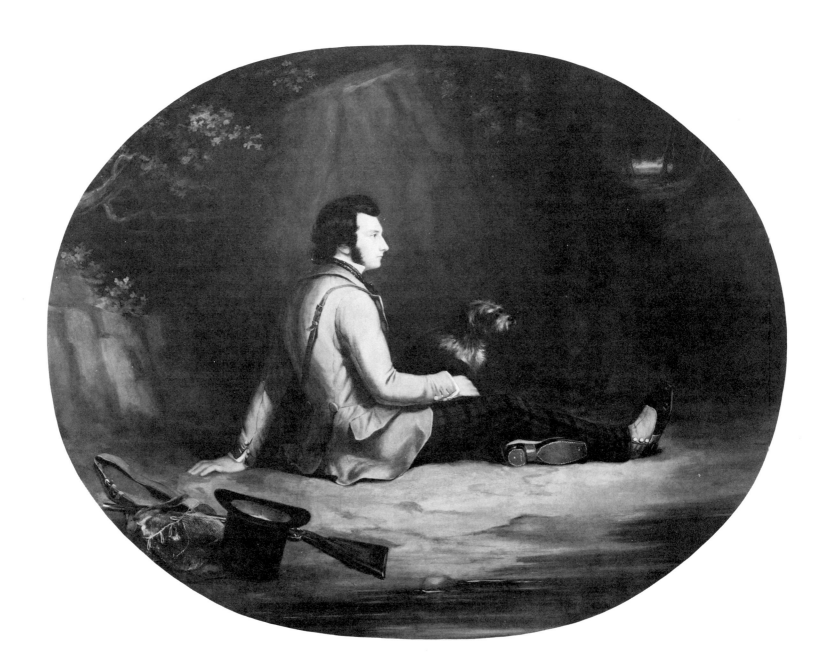

Krieghoff signed his name, lies on the rock beside him. The painting personifies the rebellious young men of mid-century who were making a daring bid to be fashionable, breaking with the dreary conventions of Victorian Englishmen and groping towards a flashy reincarnation of Beau Brummell. The most pre-eminent of the dandies in Britain at the time was the Comte d'Orsay (1801–52), a French portraitist adored by London socialites; his extraordinary portrait of Queen Victoria would also later be copied by Krieghoff. Budden and his crowd would have regarded the wearing of this latest style as an element in the transformation of a simple outing into a spirited event; it was a time when the leisured entered zestfully into life.

The opportunity to meet and fraternize with potential buyers of paintings drew Krieghoff to Dolly's, the 'most select and least pretentious bar in Canada,'[11] where Shakspeare Club members, dedicated sportsmen, and those fond of high living in general met for annual dinners and special events. Dolly, the English proprietor, held iron-clad opinions, and his 'personal appearance' was 'as singular as his eccentricities are remarkable.' His clientele were 'officers of the Guard, judges ... and ... some of the leading gentlemen of the city.'[12] The English-born artist, Frederick Lock (active in Canada from 1843 until his return to England in 1860), exhibited on Dolly's walls paintings of waterfalls, rivers, and lakes in a style conforming to prevailing romantic tastes. Krieghoff made replicas of several of Lock's views of Niagara Falls, acknowledging his debt by appending 'after Lock' below his own signatures on the copies. In the winter scenes great icicles like giant stalactites hold the attention; the summer views are more conventional. Alexander Simpson, cashier of the Bank of Montreal, bought Krieghoff's copies of Lock's scenes, which may have been less expensive or more attractive than the originals. On his retirement he took the copies as well as several of Krieghoff's original compositions of habitants and Indians back to Scotland as reminders of his Canadian success. Other businessmen began purchasing a variety of Krieghoff's genre subjects, particularly the pleasing and colourful studies of habitant life.

Business was prospering and on 11 September 1846 Krieghoff opened an account in the Montreal and District Savings Bank with an initial deposit of £6.5. By the end of the year the figure had grown to £63.5.9. He rented a studio at 26 Great St James Street, just along from Dolly's and the Bank of Montreal. In the same building was the studio of his friend, Martin Somerville, that of a daguerreotypist, and the office of a dentist, Dr W.H. Elliott. By that time Somerville had been giving private lessons in his studio for over a year;[13] he also taught freehand and perspective drawing classes in the school operated by the Misses Plimsoll on Bonaventure Street. Possibly at Somerville's suggestion, Krieghoff was engaged to teach oil and watercolour painting at the same school from about 1847 to 1849.[14] The Misses Plimsoll's young ladies may have prattled about their romantic art master. Their fathers would know him from meetings of the Shakspeare Club and from socializing in other downtown haunts.

True to his business instincts, Krieghoff noted commercial approaches in the United States and Europe that he could apply at home. He was struck by the tremendous sale of popular prints everywhere; Montreal newspapers regularly advertised prints for sale, and Krieghoff himself had painted a Yankee print seller peddling his wares at Longueuil. Envisioning the potential for lithographs of popular Canadian subjects, he commissioned a Munich lithographer to produce prints of his *Indians and Squaws of Lower Canada*, a canvas picturing Caughnawaga people in winter along the St Lawrence. The print was put on sale locally during 1848. By the late 1860s at least twenty of his paintings had been lithographed (see pages 195–6) and were being sold as coloured prints or in black and white versions, although the latter evidently sold less readily.[15]

There had been earlier sporadic efforts to sell locally produced lithographs, but these had portrayed either local celebrities or religious festivals and the response had been indifferent. By contrast, Krieghoff's pictures of Indians, habitants, and new city buildings were eye-catching and popular, for he had deliberately chosen them to appeal to the emerging class of independent tradespeople, army officers, and overseas businessmen who wanted economical souvenirs of Canada. His clientele was similar to the group who bought lithographs of the American scene in many centres south of the border; there, the New York print firms of Currier and Ives[16] and Sarony and Major carried on a thriving trade. Canadians bought the brightly coloured prints of Krieghoff's paintings, imported from Germany and the United States by the artist himself, to hang in their living rooms in emulation of the wealthy who could afford to buy his more expensive oils.

The first print was followed by a set of four dedicated to Lord Elgin. Perhaps, as an Elgin family tradition suggests, Krieghoff had met the governor-general when he stopped his carriage after noticing the artist sketching along the street. More probably, Krieghoff secured permission for the dedication through Lord Mark Kerr, the governor's aide, who undoubtedly was a friend of the garrison officers with whom the artist fraternized. Kerr was a colourful individual whom Krieghoff most certainly would have admired. On one occasion he rode his horse into the new Bank of Montreal and transacted his business on the main banking floor from the saddle.

The unorthodox Krieghoff also began to sell his canvases at auction, thus setting another precedent for Canadian artists. Auctioneers were important individuals in nineteenth-century Canada, knocking down everything from barrels of oysters and kegs of sugar to sailing ships and furniture. But Quebec's gentle and quiet Théophile Hamel or Toronto's reserved George Theodore Berthon would have shuddered at such commercialism when it involved their art. The pragmatic Krieghoff had no such scruples about merchandising and promotion techniques. Certainly the auctioning of paintings differed little from selling them by lottery, a practice that was already widespread in England and the United States and that would be introduced shortly in Canada. Krieghoff's logic was straightforward and elementary: he wanted to paint, and he wanted to sell paintings so that he could live well and paint some more. Yet while innumerable other Canadian artists must have desperately longed for a market, none had had sufficient courage to trust his paintings to the bidder's whims.

John Leeming, a professional auctioneer, was the logical man to handle this first painting sale since he was keenly interested in art and even supervised the provincial exhibition's fine art section when it was held in Montreal. He arranged the sale in January 1847 and it was an evident success.[17] Still, Krieghoff painted with such rapidity that canvases continued to accumulate much faster than private purchasers could absorb. Thirty more were ready for a second auction in February 1850. An advertisement in the *Morning Courier* of 15 February, like the display of paintings in the *Officer's Trophy Room*, detailed a sampling of his expanding range of subject matter, most noticeably his canvases of habitant life and Indians:

Approaching Storm, with Indian Hunting
Interior, (Lower Canada,) Candle-Light
Montreal, from the Mountain
Snow Storm
Indians Reposing
Winter Scene
Morning Effect, Indians Hunting
Backwood Settlement
Ice Cutting Opposite Montreal
Squaws in Great St James Street
Maple Sugar-Making in the Bush
Canadian Heads, Squaws, Habitants, &c.
Canoes ascending Rapids
Indians Trading
Winter Scene, *Habitans'* Sleigh, &c.
Indian Encampment and Dance by Moonlight
Indians Reposing, &c. &c.

The advertisement was directed to 'Connoisseurs and admirers of KRIEGHOFF'S PAINTINGS' and described the works as 'highly finished CANADIAN SCENES.' Subsequently, during 1852, Krieghoff's paintings were auctioned by the partners Fisher and Armour. By then his reputation had reached such a point that the main feature of the day's sale was the 'splendid collection of Mr. Krieghoff's works.'[18]

In the meantime, likely until 1849, Krieghoff continued to live and work across the river in Longueuil. It may have been Emilie who advanced strong arguments for residing there. Nearby at Boucherville were her relatives and friends, and in Longueuil itself lived an elderly woman who shared her unusual surname, Saintaguta. In the village Emilie would have been surrounded by people who spoke her native tongue, and could continue a style of living she had known from childhood.[19] Longueuil was not without its attractions for the artist. At the time of his arrival it had grown to a centre of just over 3500 people, but its character was still largely rural. The habitant community provided him with ideal subjects to paint.

Indeed the canvases themselves are the strongest evidence that the Krieghoffs spent some time in the village. Presumably they lived with their daughter in a squat, squared-log house with a large stone chimney and massive fireplace, located on the banks of the river. Krieghoff painted such a house repeatedly, though he made slight variations as was his custom when he composed several versions of the same subject. In many of these pictures a sleigh or wagon stands outside the door, which is sheltered by a small entrance porch. In one canvas the driver raises his whip in a lively

20 *Return from the Village* c. 1848
13½ × 20½ in / 34.3 × 52.1 cm
The Hon. K.R. and Mrs Thomson

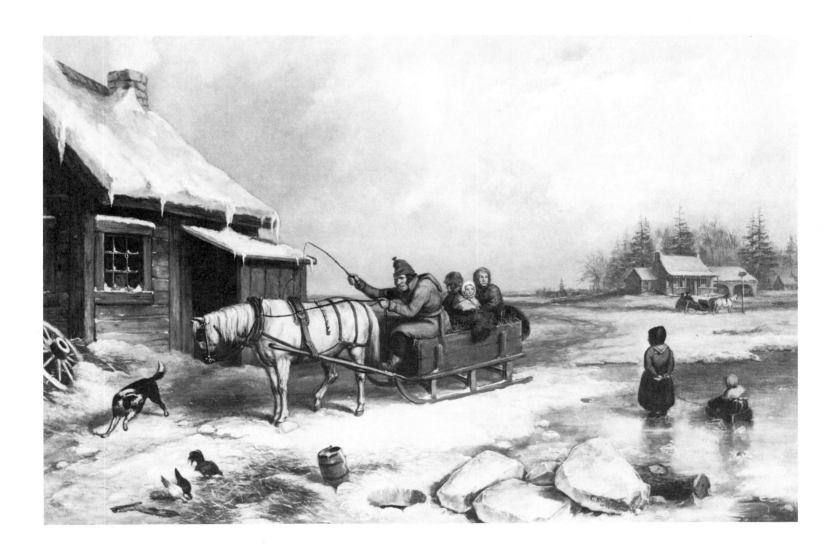

gesture over the white horse as the passengers sit in a red sleigh outside the neat little cottage (fig. 20). The family, possibly the artist's own, have returned from shopping in the village. The demure and quiet young woman sitting in the vehicle, her hair swept back, wearing a bonnet and enveloped in a colourful shawl, has been identified as Emilie, and the child beside her as her daughter (fig. 21). It has been suggested as well that the craggy faced driver is the artist's father-in-law.[20] Krieghoff has added homey touches: a dog and chickens, and tiny friends on the frozen pool waiting to play with the child. Vistas outlining the topographical details of the village appear in some of these works: there is the church of St-Antoine-de-Longueuil and the village green, the main road, the local inn, and the houses of neighbours. The church steeples of Montreal and the silhouette of Mount Royal are sometimes seen in the background across the St Lawrence.

The habitants in Longueuil, like country people in the other ancient seigneuries bordering the St Lawrence, were descended from the seventeenth- and eighteenth-century settlers who had come from rural France. They had arrived during the old French regime before the Conquest, had grown deep roots in Canadian soil, and lived a life of comparative freedom devoid of much of the drudgery and servitude associated with European peasantry at the time. They remained a distinct people, separated in large part from more recently arrived British immigrants by reason of their French language and Roman Catholic religion and by the retention of their unique ancestral ways. They were set apart too by their distinctive dress,[21] such as the sashes men wore around their waists, the *ceintures flechées*, and their colourful tuques. It has been said that the men preferred blue tuques in the Montreal region, white at Trois-Rivières, and red in the area around Quebec City, but in painting them Krieghoff varied the colours at will to suit his artistic ends.

Outsiders tended to like and respect the habitants, and were fascinated by their supposed quaintness and their conservative ways. Isabella Lucy Bird, a young English traveller in the 1850s, described the habitants as 'among the most harmless people under the sun': 'they are moral, sober, and contented, and zealous in the observances of their erroneous creed. Their children divide the land, and, as each prefers a piece of soil adjoining the road or river, strips of soil may occasionally be seen only a few yards in width. They strive

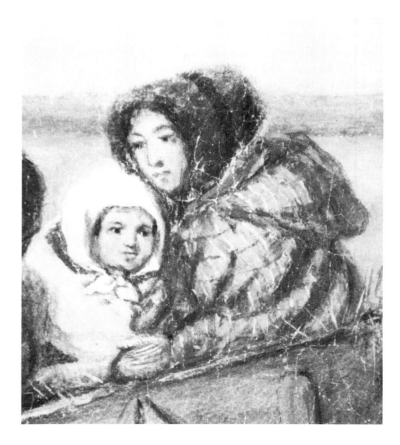

21 Detail of fig. 29, *The Ice Bridge at Longueuil*, showing the artist's wife and daughter

after happiness rather than advancement, and who shall say that they are unsuccessful in their aim? As their fathers lived, so they live; each generation has the simplicity and superstition of the preceding one. In the autumn they gather in their scanty harvest, and in the long winter they spin and dance round their stove-sides. On Sundays and saints' days they assemble in crowds in their churches, dressed in the style of a hundred years since. Their wants and wishes are few, their manners are courteous and unsuspicious, they hold their faith with a blind and implicit credulity, and on summer evenings sing the songs of France as their fathers sang them in bygone days on the smiling banks of the rushing Rhone.'[22]

In the five or six years after his return to Montreal Krieghoff painted nearly a hundred known canvases docu-

menting the village of Longueuil. Undoubtedly many others have been lost or destroyed. In later years he continued to record the life of the habitants, at work and at play, particularly in the area around Quebec and in the St Maurice River valley. He portrayed them so graphically and with such appeal that to mention the word 'habitant' still conjures up in the popular imagination a people visually based on Krieghoff's interpretations. The lively Longueuil record, when isolated as a unit, is one of the most introspective documentations of life, society, customs, and topography of any single Canadian village. As the husband of a habitant woman he was able to enter many of their homes, and his unique interpretation is that of an artist privy to the local comings and goings as well as that of a man with a remarkable insight and understanding of the life and customs of the people. Living among them, he was able to experience the warm-hearted intimacy of their life at home, a trait replaced by reserve and impassiveness when they made trips to the city and encountered strangers. As a result, his pictures of them have feeling and a decidedly human quality.

A canvas painted during 1846, the Krieghoffs' first year in Longueuil, foreshadows the intimate look at the people typical of this whole group (fig. 22). In a humble living room a Yankee peddlar in checked trousers dangles an attractive print enticingly before the housewife, while others are spread on the table before her and the eager children. Her distraught husband searches for scarce pennies to satisfy her whims, for he knows that failure to purchase will bring whines and recriminations. The painting is clever in several respects: Krieghoff has turned to subject matter that has high narrative value, but at the same time he has sharpened and enhanced its poignancy by freezing the tableau at its height. This is the precise moment when the print seller has poured out his most loquacious charms and honeyed words, it is the moment when the housewife has become the most covetous, and the husband is most wracked by doubts and remorse. The artist has used every trick to enhance the dramatic effect; the turbulence and guile within the house contrast with the serenity of the placid sun-bathed village and church seen through the open door. Krieghoff was consistently a master at isolating and catching such dramatic moments in his Longueuil works, whether painting a young soldier caught at love-making or a slow-witted card player agonized by undetected, if playful, cheating.

The painting is no summary execution; it goes beyond mere story-telling. It is the work of a man with a profound knowledge of his craft. As a skilled artist he knew about the bone structure of the head and the massing of muscles, even in small paintings. He knew about the use of light and colour, how the effects of brilliant sunshine and bright reds and blues can be accentuated against dark and gloomy patches (he had already used this technique in the portrait of Mrs Williamson). And he knew how to set down each detail to create a cumulative effect. The woman's face is a study in miniature of inner feelings. There are carefully drawn lines of anguish in the husband's worried brow. There is even a puzzled, suspicious look in the stance of the dog's head.

On two occasions Krieghoff painted a family eating forbidden meat at Lent (fig. 23). Father Brassard, the local curé, has walked in unannounced and holds his silver-headed cane like a badge of authority. He dominates the room in his outrage. The housewife tries to hide her serving of meat by turning a plate over the offending food. One member of the family slips his steak to the dog; the animal, quite incredulous at the unexpected generosity, bolts it greedily but not fast enough to escape notice. A young and hungry lad continues his meal, blissfully unaware of the indiscretion. Brassard was no friend of Protestants; years later his assistant at Longueuil, Father Charles Chiniquy, wrote how the priest had spent evenings thinking up ways to harass them.[23] Krieghoff, whose religious roots go back to one of the German Protestant Reformation groups, may have suffered at his hands, and his biting portrayal of the churchman's high-handed action is a measure of ironical retribution. Its satire must have been secretly appreciated by others who had been victims of Brassard's ways.

Emilie, however, must have been much chagrined when her husband made fun of the priest. She probably was equally uncomfortable about another turn of events. Father Chiniquy, then a novitiate with the Oblate Fathers, was not a conventional priest. He was a turbulent and impulsive individual, just the sort of person Krieghoff enjoyed. Earlier he had scandalized a flock downriver at Kamouraska by what was termed 'licentious living'; at this point he was a confirmed enemy of drink. Krieghoff painted his portrait on the understanding that there would be no talk of temperance during the sittings. The two men seem to have spent much time with Henry Jackson, an engineer on the south shore railway who lived in Longueuil, and future grandfather of A.Y. Jackson of

22 *The Picture Pedlar* 1846
12½ × 16½ in / 31.8 × 41.9 cm
private collection

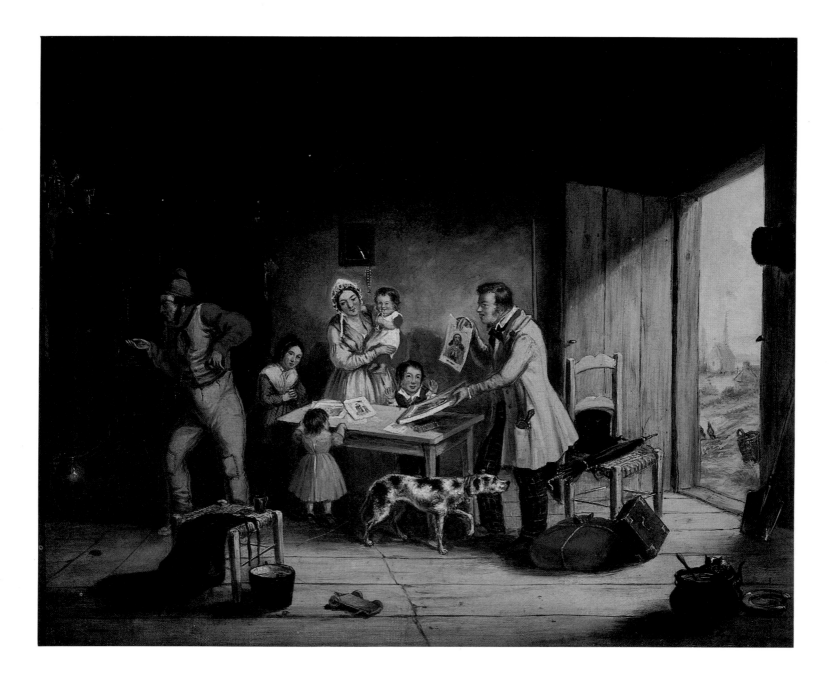

23 *Breaking Lent* c. 1845–8
14 × 21½ in / 35.6 × 54.6 cm
private collection

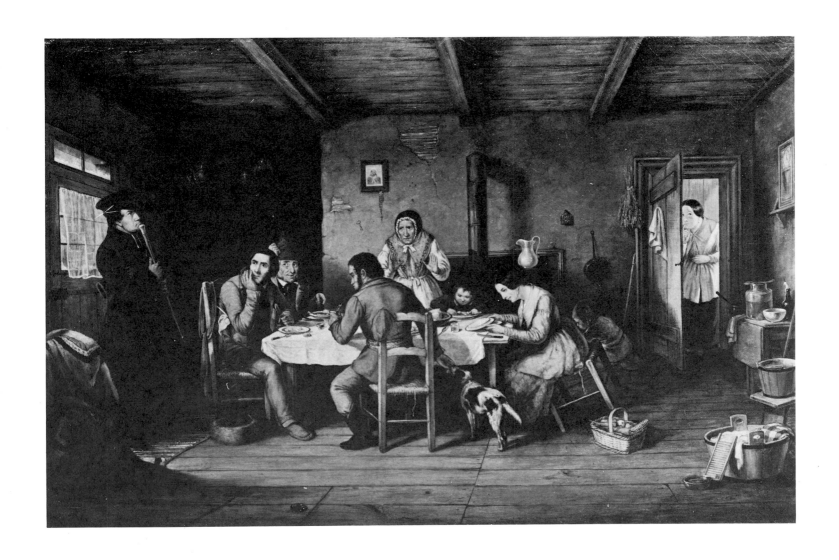

24 *The Jealous Husband* c. 1846–8
14 × 10½ in / 35.6 × 26.7 cm private collection

25 *Beware the Red Coat* late 1840s
oil on panel 13⅝ × 11⅛ in / 34.6 × 28.3 cm
Musée du Québec, Quebec City

the Group of Seven. Did Emilie find the association upsetting? Father Chiniquy left in 1847, preached some sensational temperance sermons in Montreal attracting droves, but was eventually banished to Chicago where he left the church, married, turned Presbyterian, and attacked Catholicism with the same vigour he had devoted to drink. Krieghoff's portrait of him seems to have been destroyed in the Catholic-Protestant controversies that raged in Longueuil.[24]

The British army also periodically disturbed the equanimity of village life. The 71st Highlanders were stationed nearby, some in the barracks on St Helen's Island and others in the old fort at Chambly, which Krieghoff once painted; it was a painting of interest to local antiquarians. Youths in the lower ranks sought to make service life agreeable by dallying with the local demoiselles. It was a situation with considerable humorous potential, and Krieghoff took full advantage of it. In one scene, painted repeatedly in slightly varying versions, a private flirts with a simple habitant girl in her home (fig. 24). An angry man at the door discovers the couple: while long identified as her husband, might he not in fact be her father? Krieghoff painted canvases of outdoor flirtations (fig. 25)

26 *The Game of Cards* 1848
10 × 12 in / 25.4 × 30.5 cm
Public Archives of Canada, Ottawa

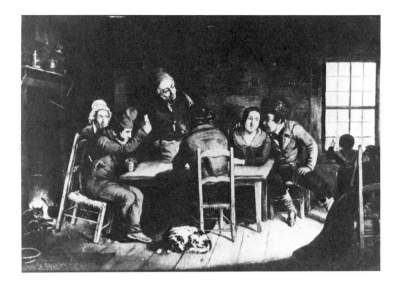

27 *Interior of a Canadian Home* c. 1846–8
oil on panel 8½ × 12½ in / 21.6 × 31.8 cm private collection

28 Adriaen van de Velde, *Winter Scene*
10 × 12 in / 25.5 × 30.5 cm
John G. Johnson Collection, Philadelphia Museum of Art

also: as the soldier boy says farewell to the daughter outside the cottage door, the moonlight shines from the heavens and her concerned mother keeps a sharp watch from the upstairs window. Krieghoff's portrayals of the incidents of army life were not unusual. Henry Liverseege (1803–32) and other English painters had turned out similar small genre paintings of incidents of the British soldier's life at home and abroad.

There are similar overtones of innocent humour in Krieghoff's paintings of his neighbours at cards or dominoes in idle moments during long winter evenings. In one canvas (fig. 26) a playful young dandy has extracted the ace from the deck and holds it for all to see except for the bewildered dupe who cannot understand why he has not won the hand.

Krieghoff's paintings of habitant life belong in a Northern tradition that flowered first in the Netherlands in the seventeenth century and was revived there in the nineteenth. His approach to painting and his concepts were reinforced by the popular artistic ideas postulated by the Düsseldorf and Munich schools in his day. They parallel the small anecdotal paintings of the Biedermeier period of Vienna dating from 1815 to 1848. He owed something as well to the narrative paintings of several nineteenth-century British artists, though he avoided the academic smugness that oozed from

the brushes of many Victorian painters. His works have little relationship to the French, Italian, or Spanish painting of his time.

His European prototypes are evident. An example comes from the work of the Scottish painter, Sir David Wilkie, a great admirer of peasant life who spent much time during the 1820s on the continent to absorb its rustic atmosphere. Wilkie's paintings of low life were revered by the British public, to the artist's own amazement. While in Rochester Krieghoff had copied an engraving of card players from a Wilkie canvas (fig. 10); at Longueuil he reworked it as a Canadian subject in a series of habitant interiors (fig. 27). Flemish furniture was replaced by habitant chairs and armoires, the card players are dressed in blanket cloth coats, tuques, and *ceintures flechées*. Small religious prints hang on the walls as in many Quebec Catholic homes. He added a child, for no habitant gathering was complete without its quota of playful youngsters, and he enhanced the painting's light narrative tone with a flirtatious by-play on the side.

29 *The Ice Bridge at Longueuil* c. 1847–8
23 × 29 in / 58.4 × 73.7 cm
National Gallery of Canada, Ottawa

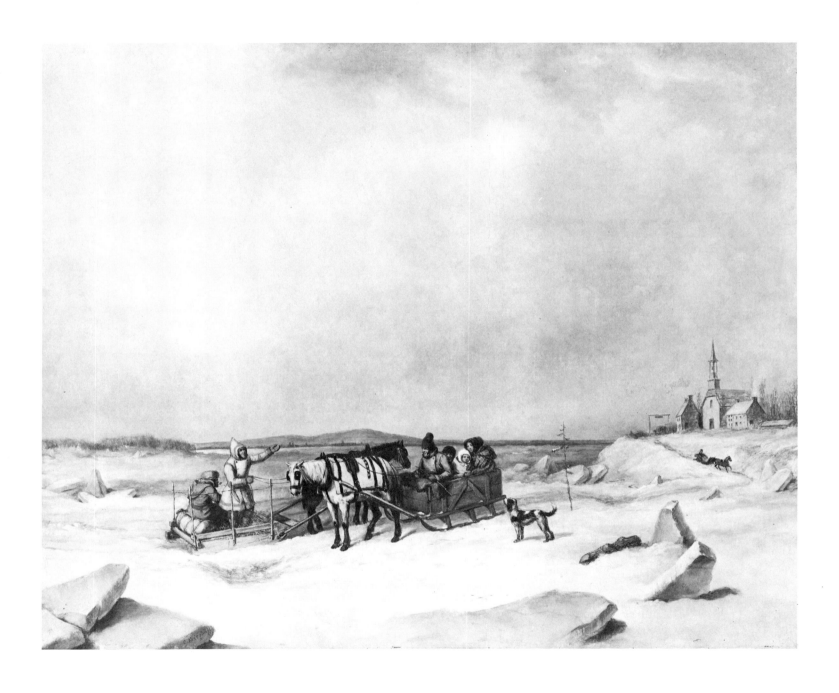

Dutch winter landscapes Krieghoff had seen in Europe had an equal influence on his outdoor depictions of Longueuil. Salomon van Ruysdael (1600–70) and Jan van de Capelle (1624–79) had painted frozen canals with peasant houses along the banks; *Winter Scene* (fig. 28) by Adriaen van de Velde (1636–72), with its emphasis on human activity, is typical of other paintings that influenced him in both its composition and its spirit. Krieghoff copied a number of seventeenth-century Dutch paintings including one by Hendrick van Avercamp (1585–1663) of men playing hockey, which is now in the National Gallery in London (he worked from a reverse print). This seventeenth-century interest was revived in the Low Countries during Krieghoff's lifetime by several artists, of whom Andreas Schelfhout (1787–1870) was one of the more prominent.

Krieghoff based his canvases of Longueuil on these earlier Dutch compositions, replacing frozen canals with the ice-bound St Lawrence River, exchanging the peasant houses for those of the habitants, and introducing the people of Longueuil. Some early treatments of the theme are timid experimental works in which sleighs and houses are so small as to be virtually lost in open spaces. But increasingly he eliminated the expansive vistas and focused on the human element. This tendency is evident in *Return from the Village* and in other canvases where sleighs pause on the road while neighbours have a friendly chat. The same leisurely note is found in a number of winter landscapes of those years such as *The Ice Bridge at Longueuil* (fig. 29), a somewhat misnamed canvas since the church in the painting is that of Laprairie. The atmosphere of good will and comfort embodied in these canvases found favour with a wide Canadian and English audience. Krieghoff was painting eye-catching pictures for a comfortable bourgeois class in a materialistic age and neither he nor his patrons were interested in beggars, the victims of the typhus epidemic of 1847, or other evidences of the realities of life at the time.

In subject and mood, many of Krieghoff's canvases are similar to contemporary American popular art, which found its widest acceptance in the popular lithographs of the firm of Currier and Ives in New York. A very few of Krieghoff's canvases were direct copies of Currier and Ives prints (a view of the Thousand Islands in the St Lawrence is one such example), but there is much duplication in subject matter. From both sides of the border come images of rural

30 I. Maurer, *Preparing for Market* 1856
lithograph published by N. Currier

farmsteads, of maple sugar harvesting, of swells with their sleds. Krieghoff's elegant sleighs glided over the frozen St Lawrence, those of wealthy New Yorkers in the Currier and Ives prints graced the ponds of Central Park, but the spirit is identical.

In many instances of parallel subject matter Krieghoff anticipated Currier and Ives by a few years. The print *Preparing for Market* (fig. 30) after a painting by the American Louis Maurer (1832–1932), issued by Currier and Ives during 1854, is strikingly similar to Krieghoff's *Habitans Going to Market* (fig. 31) painted at Longueuil in 1848. In this elaborate composition Krieghoff accented human activity. The family is loading a high two-wheeled cart. The man on top of the cart, probably the artist himself since he is dressed in smart European clothes and wears a high black hat rather than traditional habitant dress, stows away eggs and other farm produce for the trip to town. A local product of the habitant home, straw hats, are piled up ready for sale.

Many travellers commented on these hats: Charles Dickens, for instance, was fascinated by these 'great flat straw hats with most capacious brims.' In later years Krieghoff painted a woman weaving such hats from straws plucked from temporary storage in a pottery jug, all the while sparring verbally with a pipe-smoking visitor while the children play on the

31 *Habitans Going to Market* 1848
13½ × 20¼ in / 34.3 × 51.4 cm
The Hon. K.R. and Mrs Thomson

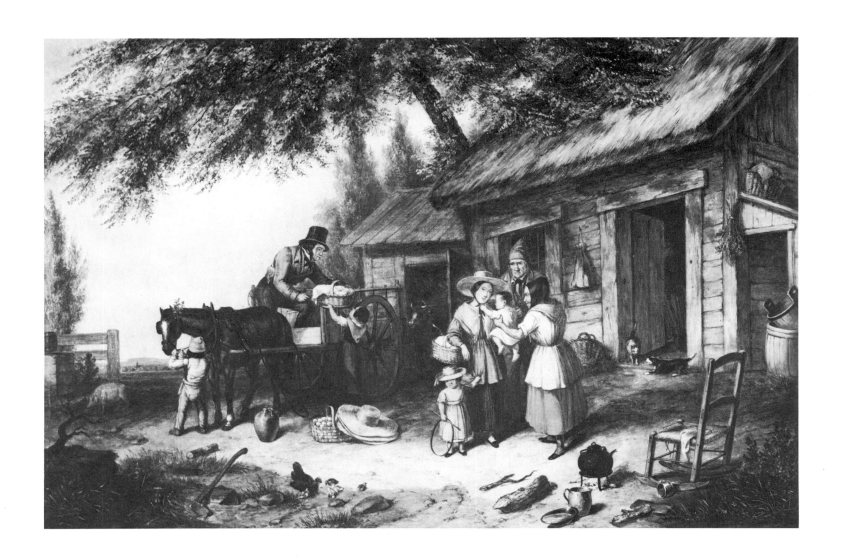

catalogne rug (fig. 32). Her house is warmed by a square St Maurice stove made from iron in the early nineteenth century, although ore had been mined commercially near Trois-Rivières since the 1600s.[25]

In large measure Krieghoff's extensive use of ordinary life as subject matter was innovative in the Canadian context. Certainly other artists had introduced similar genre notes into their paintings. They are suggested in some of the works of English topographical watercolourists such as Colonel James P. Cockburn (1779–1847) and Thomas Davies (c. 1737–1812), who painted during their Canadian tours of duty. Krieghoff's contemporary, James Duncan, filled sketchbooks with pencil and watercolour studies of Montreal market scenes and street activities. But in most of these paintings the artists seem interested primarily in landscape as such; they did not seek to exploit anecdotal qualities for their own sake, and lacked the intimacy that would justify the label 'genre painter.'

Krieghoff extended his portrayal of habitant subject matter throughout the years to include many other activities with potential public appeal. Associated with the Longueuil canvases are pictures of sleighs hauling their loads in winter to Montreal's (and later Quebec's) haymarket in the city centre: hay was essential to the dray horses, on whom much of the rhythm of city life depended, and to the coach horses stabled in the mews. In another series, habitants cut blocks of ice from the St Lawrence for sale to companies. The workers chose a level spot among the chaos of broken ice that littered the frozen river. They then sawed out slabs of ice to fill the ice-houses in the city. A traveller, William Kingston, described the process: 'They first marked a furrow on the ice with an ice-plough, which is in shape not very dissimilar to a common plough, and then with long saws they cut through the ice at right angles to the line marked by the plough. Other men with hooks dragged the slabs thus separated through the water to a spot where sleighs were in readiness to carry them off. The slabs were under two feet in thickness, and four or five in length. The charge we were told for a hundred such blocks is three dollars; but whether delivered at the ice-house or on the river, I know not. The water ran rapidly under the hole thus cut, and rose at once to the level of the ice, but did not overflow it.'[26]

The familiar views emerged only after Krieghoff had made a trial version of the subject (fig. 33). In his first experimental

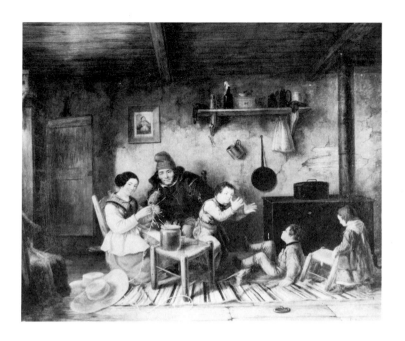

32 *Flirting While Braiding Straw Hats* (1862?)
19 × 21 in / 48.3 × 53.3 cm private collection

painting he introduced a team of highly strung horses which he seemingly copied from a print. But the drab clothing and absence of homey atmosphere in this first attempt found little favour, and the composition was not repeated. However, canvases with habitants and shaggy little *canadien* horses pulling the loads of ice blocks (fig. 34) had a very different reception. The artist gave a sense of place by painting Mount Royal on the horizon, and on occasion gave greater immediacy by introducing the distinctive towers of Notre-Dame-de-Montréal. Once he painted a habitant returning with a load of snow removed from the city streets. Years later he painted a man in Quebec who had halted with his load of ice on the Plains of Abraham road near the Martello Tower to speak to a friend hauling hay in the opposite direction.

No paintings give a better idea of the little *canadien* horse developed by the habitants than do Krieghoff's pictures of ice-cutting. One visitor, Frederic Tolfrey, described the 'stiff little ponies of the country' as the 'most serviceable hardy animals, [which] shuffle over the ground at an astonishingly quick pace; the gait, however to an English eye is an ungainly

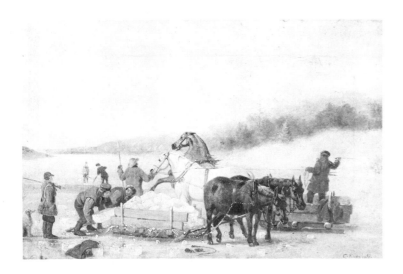

33 *Cutting and Hauling Ice* undated
$11\frac{1}{4} \times 17\frac{1}{4}$ in / 28.6 × 43.8 cm private collection

34 *Ice Harvest* c. 1847–50
$9\frac{1}{16} \times 11\frac{13}{16}$ in / 23 × 30 cm Musée du Québec, Quebec City

one – a kind of amble, between a trot and a canter. A *Habit-ant's* pony is out in all weathers, and is inured to hardships and rough usage from the day it is foaled.' Having driven to market in the morning, large parties of habitants at the day's end streamed towards 'their rudely-constructed vehicles, into which they jump, flourish their whips, and start off at full speed across the squares, round corners, and down streets to the imminent jeopardy of the limbs and lives of the pedestrians.'[27]

The maple sugar ritual occupied the habitants annually with the approach of spring. Visitors were fascinated by the procedure, learned long before by the French from the Indians, and Krieghoff was quick to provide souvenirs of all its stages (fig. 35). Sugar-making heralded the winter's end, even if snow was still so deep that when the farmers took to the woods late in March they were forced to leave horses and sleighs at home. Instead they hauled large cauldrons, hatchets, and provisions into the sugar bush on hand sleighs. There, surrounded by maples, they either built a shelter open on one side or made a hole in the snow, clearing about twenty feet of ground, and raised a little round cabin in the middle leaving an opening two feet across to let the smoke in the cabin escape.[28]

Each member of the family had a role to play. A household could tend two or three hundred trees, each of which produced a pound of sugar in five days. From a niche cut into the trunk, sap dripped into buckets or hand-made wooden troughs which were emptied each afternoon by the men on snowshoes. The liquid was poured into tanks or barrels and then boiled in a cauldron over the open fire. The mother tested its consistency repeatedly while her husband stirred the cauldron until the crucial moment was reached when the syrup would solidify into sugar. Children filled sugar moulds set out on benches. Some moulds were carved into traditional folk designs of hearts and cocks, or into model habitant houses and village churches. These whimsically shaped sugar blocks sold for twelve cents a pound in nineteenth-century markets. Scenes picturing both the maple sugar harvest and ice-cutting were so popular that Krieghoff had them lithographed for mass sale in print form.

Longueuil provided colourful sights beyond habitant life. A parade of wealthier merchants, army officers, gentlemen, and their ladies, with blood horses and flashy sleighs, passed along the streets of Montreal on weekends, delighting watching pedestrians, on pleasant winter afternoons spilling out of the city across the ice to the village. Krieghoff enlivened his panoramic Longueuil views by dotting the river ice with such sleighing 'turn-outs,' just as Dutch painters brought life

35 *Making Maple Syrup* 1853
12 × 18 in / 30.5 × 45.7 cm
private collection

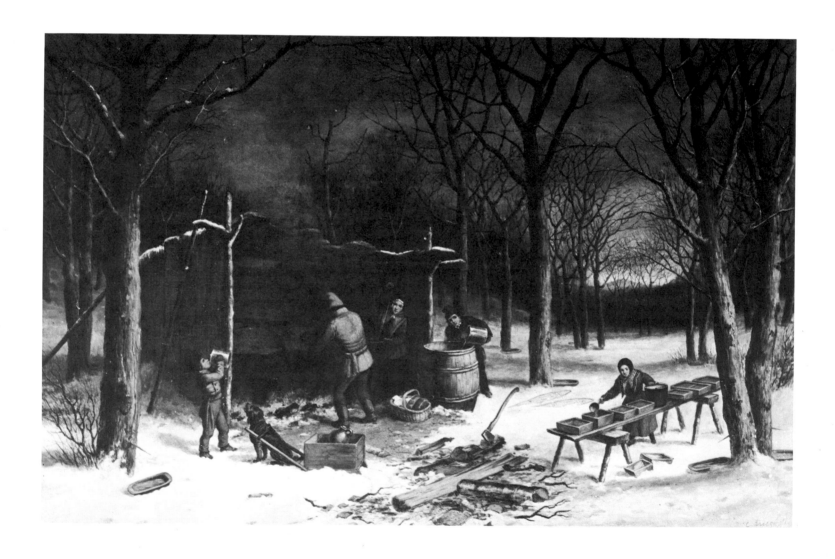

36 *Habitants in Winter* 1858
17 × 24 in / 43.2 × 61 cm
Power Corporation

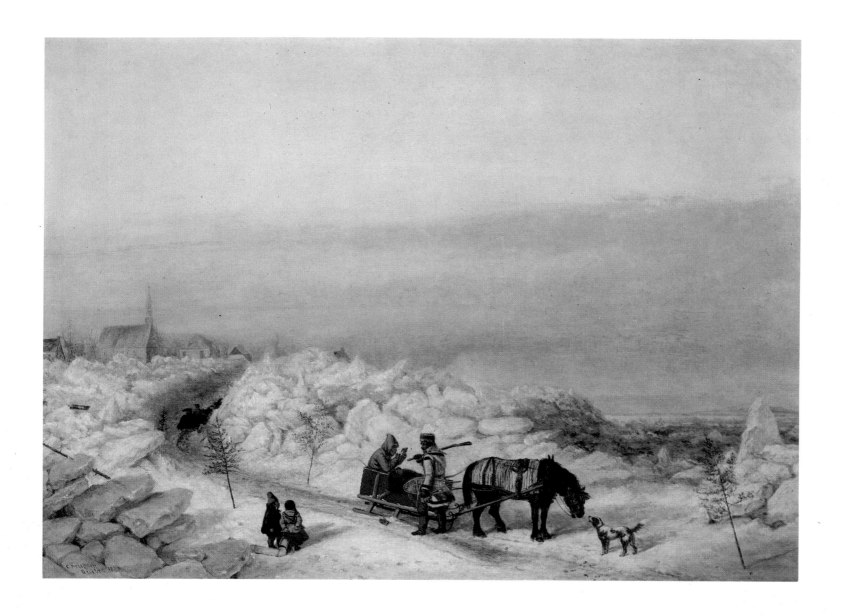

37 *Sledge Race near Montreal* 1848
coloured lithograph $13\frac{3}{16} \times 19\frac{1}{8}$ in / 33.5 × 48.6 cm
private collection

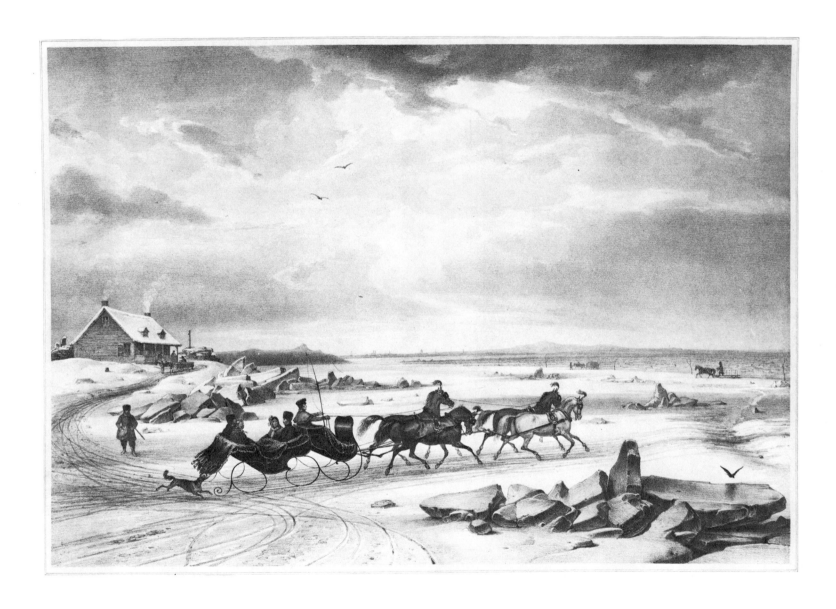

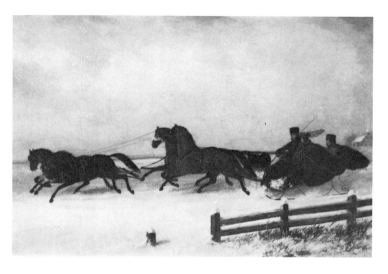

38 *The Blue Carriole* late 1840s
14⅛ × 20¾ in / 35.9 × 52.7 cm private collection

39 *Sleigh with a Team of Four* late 1840s
14 × 21 in / 35.6 × 53.3 cm private collection

to frozen canals with miscellaneous traffic. He also painted intimate studies of the horses, sleighs, and their celebrated drivers, a subject much repeated during his Quebec years. The smart 'English carrioles' contrasted with the simple habitant sleighs. Many of the holidayers are unidentified, but in one canvas Krieghoff pictured Colonel Augustus Heward, a prosperous Montreal merchant and one of the founders of the St James Club, driving with his wife on the river ice. He also painted the Honourable John Molson whose business enterprises included the south shore railway which ran along the Richelieu and terminated at nearby Laprairie. Molson drove his incredibly elegant team of a bay and chestnut horse tandem-style: red plumes on their heads provide a distinctive note as their sleigh speeded down the south shore road. A particularly fine, if anonymous, example is seen in a painting of a smart blue carriole (fig. 38).

Occasionally four-horse sleigh teams pranced along majestically (fig. 39). Gentlemen drove black, brown, or white horses according to their individual fancies. Lord Elgin, the governor-general, had the most elaborate of all vehicles and indeed it must have been a noble sight to see him approaching Longueuil. In Krieghoff's painting (fig. 37) the vice-regal sleigh resembles a landau on runners; the four horses are highly decorated, a coachman sits in front, and a costly fur

flows out behind. On one seat the governor and Lady Elgin face Colonel and Mrs Campbell on the other. Campbell's seigneury nestled below the mountain at Rouville several miles back from the St Lawrence east of the Richelieu. The governor-general visited there on many occasions and the direct route from Montreal crossed the St Lawrence on the ice and climbed the bank at Longueuil. Undoubtedly Krieghoff saw Elgin and his party passing through the village. There is a tale that Henry Jackson's diary makes reference to a day on which he introduced the artist to the governor;[29] but such a story cannot possibly be true since the diary was closed the year before Krieghoff moved to Longueuil. Krieghoff's painting of Elgin's sleigh crossing the ice was lithographed as one of his first set of four prints. This was a tactful act since the governor had given the artist permission to dedicate them to him.

Krieghoff retained fond memories of Longueuil and its people after he left there. Though he took a house in Montreal in 1849 he continued to paint themes based on the habitants across the river. He moved to Quebec City in the early 1850s, but returned briefly to Montreal in 1858 to paint pictures on commission for sale to the engineers constructing the Victoria Bridge, the first to span the St Lawrence. He seized the opportunity to record new versions of winter

sleighing scenes at Longueuil (fig. 36); as before, habitants stop to chat with neighbours and children play in the snow on the village road leading up the steep shore from the St Lawrence through a chaos of great blocks of ice.

In Krieghoff's broad range of subject matter one of his most successful themes was the native people. He began to paint Indians shortly after his return to the Montreal region, producing large canvases for the wealthy and tiny ones for those with modest incomes. Of his known paintings approximately 450 or one-third portray natives. Some document the solitary moccasin or basket sellers who wandered the streets of Montreal and Quebec City in all seasons; others are of lonely hunters, gun on shoulder, plodding over snowy plains. In the unspoiled wilderness the Indian people sit by campfires, paddle or portage canoes, and follow the trail in search of game. When introduced as casual visitors into pictures of habitant farms or as guides in sporting scenes they contribute to an aura of romance. In one painting (fig. 3) an Indian girl, popularly known as 'Marie of Montreal,' stands clutching beaded moccasins and a purse, like a 'cigar-store Indian' trade sign, in the doorway leading to Krieghoff's studio.

The Indians in Krieghoff's paintings during his Montreal years are based on the Iroquois people from the village of Caughnawaga, situated on Indian lands bordering the St Lawrence south shore just upstream from the Lachine Rapids. They were descended from Indians converted to Christianity by Jesuit priests. Their village was moved several times but was finally established at the Jesuit mission of St-François-du-Sault, which became Caughnawaga.[30] They spoke the Mohawk tongue and were commonly described as 'French Praying Indians' to distinguish them from the Iroquois who adhered to native ways. The shy, quiet individuals who wandered into the city radiated little of the wild exuberance associated with their race in the European imagination. They were the subjects of passing curiosity. A British army officer, James S. Buckingham, described them during 1843: 'In the streets of Montreal are to be seen every day, groups of female Indians, wearing moccasins of their own manufacture on their feet, English men's hats on their heads, and large blue English blankets thrown over their shoulders. They come down to the city daily, from the Indian village of Caghnawaga, to sell the articles made by themselves and their female children, in basket-work and other trifles; but it was a

pleasing feature in their character to observe that they were always sober, a rare occurrence with the Indians of either sex, who frequent the towns in the United States. This difference is occasioned by the influence of Christianity, as the Caghnawaga Indians are Catholics, and under a most rigid discipline and solemn vows of abstinence from the use of spirits, which it is said they faithfully observe.'[31]

Krieghoff's earliest known Indian canvases are from the Montreal period, since none of the Seminole group he allegedly completed in the United States seems to have survived. As early as 1846 he painted a daring Caughnawaga man guiding his fragile birchbark canoe through the hazardous rocks and waves of the Lachine Rapids, where the St Lawrence broke 'into masses of white foam, moving in a direction the reverse of that of waves produced in a troubled ocean, by the agency of storms. They curl their resplendent tops, towards the quarter from whence they are impelled. The mind of a stranger is filled with admiration, on beholding, in the calmest, and finest weather, all the noise, effect, and agitation, which the most violent conflict between the winds and waters, is capable of exhibiting.'[32] Technically this early painting is crudely executed, and was long thought to be the work of another hand; but its discovery among the group of Krieghoff's works hanging on the walls in the *Officer's Trophy Room* tends to confirm its authenticity. The rapids were not far from Longueuil and Krieghoff may even have seen such a feat performed. He painted at least three versions of the incident to satisfy demand: the public, like the artist himself, was fascinated by the excitement, imminent danger, and expectation of disaster. Big John, a celebrated river pilot from Caughnawaga, dramatically shot these rapids on New Year's Day in 1878;[33] the imagination of later generations entwined this well-publicized event inseparably, if incorrectly, with Krieghoff's painting of forty years earlier.

There is no proof that Krieghoff ever visited Caughnawaga itself. Though the Jesuits kept a book for the signature of visitors to the settlement, it does not contain the artist's name. Nor do any of his canvases portray the actual village with its two hundred or so European-style stone houses. Some stories maintain that the Indians left the village during the summer months to live in their traditional native fashion in the woods on surrounding tribal lands. In a series depicting such summer encampments, Krieghoff gave glimpses of this older style of life, staging tableaux-like family groups in front of

40 *Caughnawaga Indian Encampment* late 1840s
13½ × 20½ in / 34.3 × 52.1 cm
Sigmund Samuel Collection, Royal Ontario Museum, Toronto

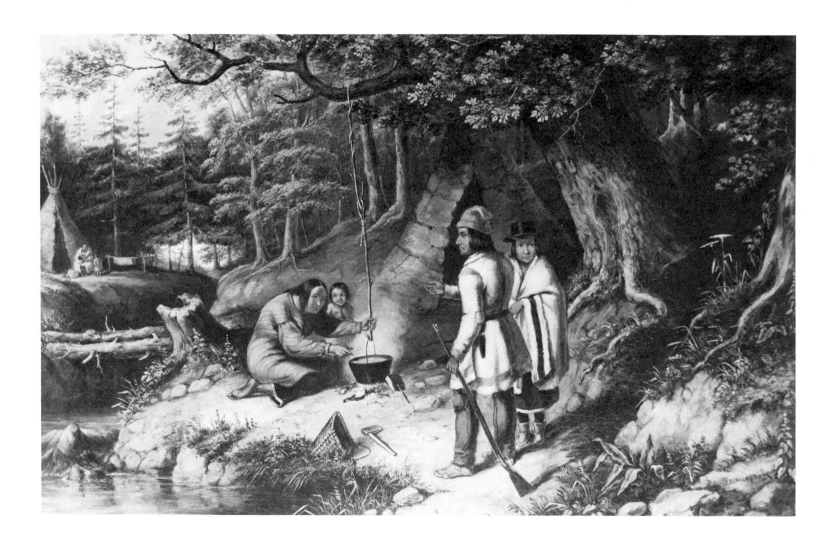

41 Detail of fig. 40

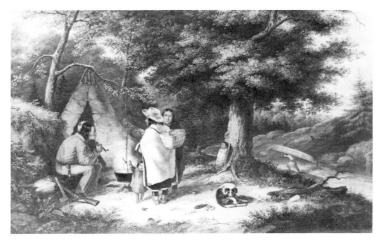

42 *Caughnawaga Indian Encampment at a Portage* 1847
14 × 21¼ in / 35.6 × 54 cm
Sigmund Samuel Collection, Royal Ontario Museum, Toronto

wigwams that look rather like plains teepees in an appropriate wilderness setting of rocks, trees, and streams. Such an image conformed more closely to the popular conception of Indians than a painting of them in stone houses.

In Krieghoff's paintings Indian families gather around campfires and cook in pots suspended on sticks or from overhanging branches (fig. 40). Cradle boards are propped against trees, baskets are filled with freshly picked raspberries. The Indians have trade guns and axes, and decorated paddles. Often canoes are pulled up on the shore or at the end of a portage trail. Women wrapped in blankets stand around the fire and children play. Dogs hunt for fleas. One picks out various plants growing in the foreground (fig. 41).

Curiously, there is such a stilted air about many of them that one wonders whether Krieghoff actually drew and painted them from life. Some resemble the composed arrangement of leaves, flowers, and stems that would seem to have been created in the mind, rather than from the eye following the lines of a living plant; in this he departed from his usual custom of literal exactitude so noticeable in his drawings of Indian baskets and similar artifacts. Indeed the 'composed' treatment of these plants makes them resemble those in contemporary German lithographs and paintings.

In some of these pictures a stolid man sits in profile on a log or stone, smoking his pipe as he gazes into the campfire (fig. 42). He is the Indian figure that appears in many paintings to symbolize the New World; though he is best known from *The Death of Wolfe* by Benjamin West (1738–1820), Krieghoff seems to have copied the figure directly from *Indians Bartering* (fig. 43) by Coke Smyth (died 1867). In one picture a little girl clutches a string which tethers her pet bluebird (fig. 45), a touch that comes from Smyth's *Zity, A Huron Indian*.[34]

These earliest Indian paintings are confined and tight in treatment. By the end of the decade Krieghoff was taking more interest in the painting of landscape for its own sake, and some of his later Indian groups are set in more expansive hilly countryside. But even in these, despite the change in

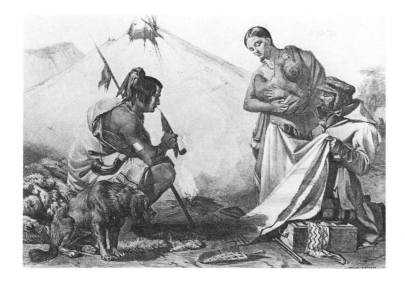

43 Coke Smyth, *Indians Bartering* c. 1840
lithograph 10½ × 14¾ in / 26.7 × 37.5 cm

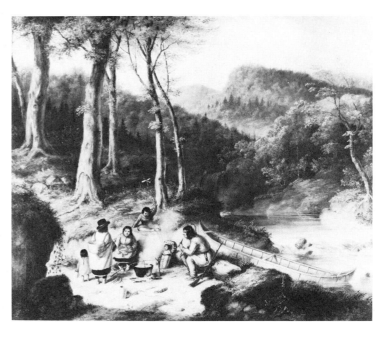

44 *Indians at a Portage* 1850
28½ × 33 in / 72.4 × 83.8 cm
Sigmund Samuel Collection, Royal Ontario Museum, Toronto

mood, he continued to introduce such whimsical and anec-dotal touches as a child playing with a whirligig held in the breeze (fig. 44).

In the summer camp scenes, native articles are delineated with great precision (fig. 46). A woman weaves a basket of coloured ash strips, each carefully outlined, as a child plays at her side. Birchbark containers, sewn together by roots instead of string, are shown in various shapes and sizes. A v-shaped rush basket for carrying on the back, and another of a com-pletely different weave made from reeds, are of sufficiently detailed draughtsmanship that they might serve as patterns for a modern reconstruction of the article. Krieghoff accen-tuated this realistic portrayal of detail over the years. There is an air of authority in his painting of baskets and bags, paddles with herring-bone pattern, and unusual cradle boards, sug-gesting they were painted from specimens on display in his studio. He may have had access to a collection similar to the one pictured in the *Officer's Trophy Room*. The same men, women, and children are rearranged and twisted like pup-pets in a variety of poses to vary the composition rather than painted from sketches based on a posed group of live models. Did the artist visit one of the Indian camps, fix in his mind a generalized idea of family activities, and then in his studio

create a series of mood canvases from a repertoire of stock props?

These same Caughnawaga people were painted by Krieghoff in a winter setting on snow-covered plains along the river's south shore (fig. 47). Several canvases of informal groups include a man and his unobtrusive wife chatting with women friends wearing black hats or blankets over their heads. The man stands with snowshoes or toboggans; the women carry baskets or a baby in a carrier. In the same way, habitants at Longueuil stopped to gossip with acquaintances. A black and white dog, apparently borrowed from Smyth's *Moose Hunter*,[35] waits beside the group. Indians haul tobog-gans along the shoreline in the background while the blue peak of Mount Royal on the horizon in many pictures gives a sense of place. Like the figures in the summer views, they have a certain puppet-like, emotionless quality. Krieghoff's merry habitants have whimsical expressions; his Indian faces say nothing.

An Indian winter house peeks from the edge of the spruce

45 Detail of fig. 42, *Caughnawaga Indian Encampment at a Portage*

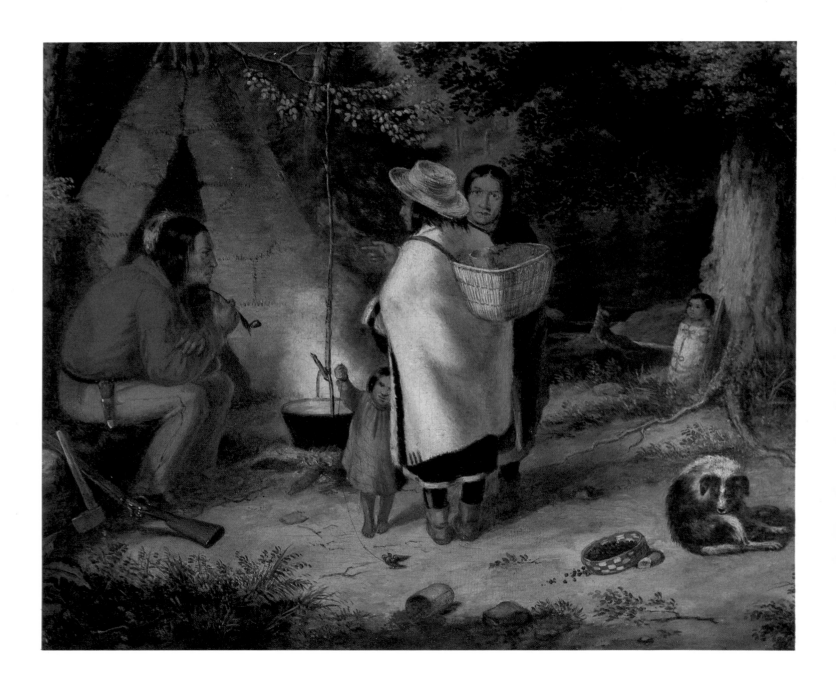

46 Details of Indian baskets from Caughnawaga canvases

woods in several snowy scenes (fig. 48). Were such structures built in the region or did Krieghoff borrow them from prints to add romance and 'Indianness'? The house has a two-pitched roof with a vertical log façade, behind which there is a semi-subterranean room cut into the hillside for warmth. The doorway is covered with a blanket, which is ineffectual to stop draughts and the bitter cold. Such houses were used by Iroquoian people throughout a broad geographical area but are not mentioned by visitors to Caughnawaga. Krieghoff introduced them into his paintings of the Quebec City hills after 1853 where the local people were Huron or Algonquin. His tendency to collect ideas and props from varied sources for use in his picture-making poses certain ethnological problems.

On her way into Montreal in 1792 Elizabeth Simcoe, wife of Upper Canada's first lieutenant-governor and herself an amateur painter, described passing 'a group of Indians sitting around a fire near the river, which in this dark night afforded a good subject for a picture.'[36] Half a century later Krieghoff was inspired by similar nocturnal scenes to paint a successful series of Indians spearing fish in the St Lawrence at night (fig. 49). The practice was widespread and drew frequent comments. Richard H. Bonnycastle, a traveller along the river in 1841, described an occasion when the 'night was somewhat dark, and we saw the interesting spectacle, at a distance, of fishermen pursuing their avocation by torchlight, spearing salmon with other large fish, near the dangerous rapids of the

Cedars, where there is a small canal, and a tiny village, thirty-two miles from Montreal.'[37] A youthful Paul Kane, who had seen the Mississaugas spearing fish along the Toronto waterfront, was inspired to paint the Menominees of Lake Michigan doing the same.[38] The subject may have recalled to Krieghoff some seventeenth-century Dutch canvases, such as one painted by Jan Asselijn (1610–52) of men holding torches while fishing for crabs in a canal. In this painting the flame's glow added mystery to the enveloping darkness, just as Indians with smoking torches, reflections in the water, a rising moon, and the velvet darkness of the surrounding woods intrigued a romantically inclined nineteenth-century audience. Krieghoff painted night views based on themes other than spear-fishing. In one variation, hunters rest beside campfires in winter woods while their families dance, after a successful day's hunt, beside a recently killed caribou.

In his Indian paintings Krieghoff relied heavily on three sources, from which he borrowed ideas or even made outright copies. A favourite source was Coke Smyth's *Sketches in the Canadas*, a book of prints based on Smyth's impressions of what he felt to be characteristic Canadian subjects during a tour of the country with the Earl of Durham in 1838. Krieghoff made a direct copy of *Indians of Lorette*,[39] and two of the other canvases that picture Indians bartering with a trader originated in another Smyth print (fig. 43); in one of these he reversed the figures to provide variety. Secondly, he consulted engravings in a widely circulated book entitled

47 *Caughnawaga Indians in Snowy Landscape* c. 1848
$13\frac{1}{2} \times 20\frac{1}{2}$ in / 34.3 × 52.1 cm
Estate of Robert Lindsay

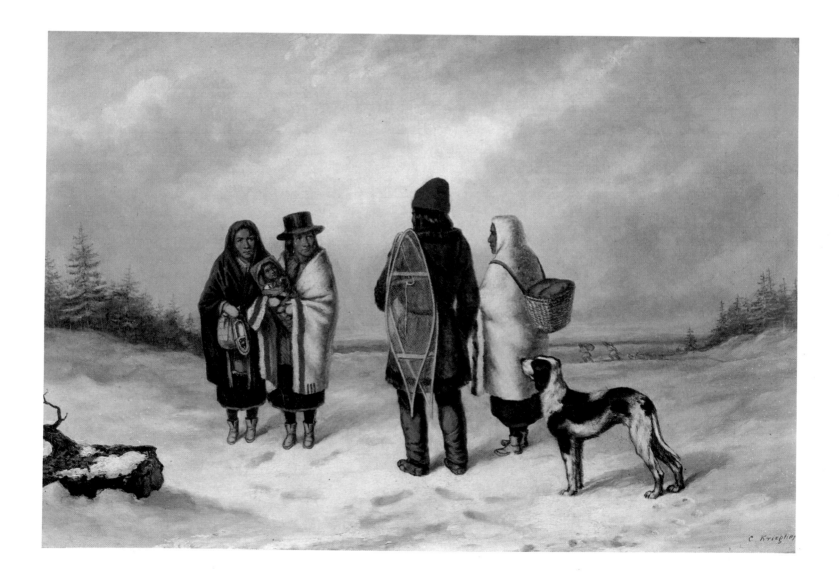

48 *At Camp* undated
12 × 18 in / 30.5 × 45.7 cm
private collection

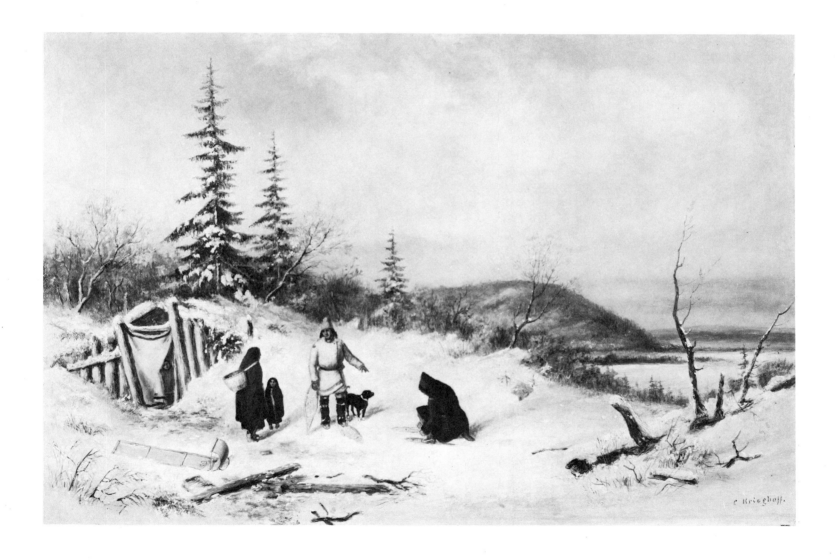

Canadian Scenery, based on the sketches of W.H. Bartlett (1809–54). One engraving provided the details of birchbark teepee construction. Krieghoff's *The Squaw's Grave*,[40] an early Indian subject, is a direct copy from another Bartlett print. The title's sentimental note was attuned to current tastes, just as the cross silhouetted against the moonlight on the water and the glow from the campfire strike romantic notes paralleling those in the fish-spearing canvases. Finally, a Currier and Ives print supplied the subject matter for several versions of an Indian encampment on the islands in the St Lawrence.

Normally Krieghoff had little interest in painting Indian portraits as character studies of individuals with distinct feelings. For him the Indian was primarily a symbol of 'the native' whether it be a girl in the streets of Montreal or the hunters of Lorette. One exception to the mask-like face, however, is his portrait labelled as being of the Seneca chieftain, Red Jacket (fig. 50). It seems obvious that the painting was done from life because the piercing eyes, the long carefully groomed hair, and other distinctive touches reflect the man's character. Yet it is a portrait that poses problems since Red Jacket had died years before the canvas was completed. It bears no similarity to the famous chieftain whose features are well known from Charles Bird King's portrait of 1828. Krieghoff's portrait seems to have been painted as a commission for the actor Colonel Steele MacKaye of Buffalo in the late 1840s.[41] Presumably it was a case of expediency through using some deception; the artist must have engaged a model to sit for him whom he thought looked like Red Jacket. The deception went even further, for in painting the pendant portrait of Red Jacket's wife, whose age seems more appropriate to a mother than to a spouse, he reverted to a stock face. Her features, framed in a blanket drawn over her head, are those Krieghoff first introduced into the Caughnawaga group, then reproduced as a lithograph, and repeated later in isolated figures of Indian women.

Krieghoff sought for the expression of individualism on another occasion when he painted three Chippewa chieftains from life in a studio in Montreal. The three men visited Lord Elgin in the city during 1849. They came seeking compensation for the loss of hunting rights in the region of the St Mary's River near Sault Ste Marie from which game was fast disappearing through an influx of copper and silver miners. Their leader was Little Pine Chief or Chinowackonna, the most important sachem or great chief of the entire tribe, a

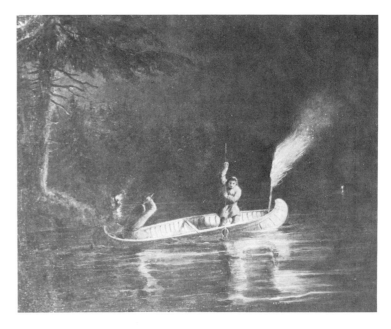

49 *Fishing by Torchlight* late 1840s
8 × 10 in / 20.3 × 25.4 cm private collection

venerable and respected elder of seventy-eight years. He wore a medal received from Sir Isaac Brock at the outbreak of the war between Canada and the United States, and had fought at the Battle of Queenston Heights in which Brock was killed. The wampum around his neck was his badge of authority, and he could be singled out in any group by his striking head-dress of black and white American eagle feathers tipped with ermine skins and red feathers. His ear ornaments were of wire and feathers with attached deer hooves that rattled as he moved. Another man, son of a chief who had died at the same battle at Queenston, was known as the Great Warrior or Manissinowenninne. He was an elegant six-foot-four giant and such a dandy that even his companions joked about his immaculate toilet; with contemptuous bravado he had attached a skunk's skin to his right heel as a warning against molestation. Thirteen scalps were nailed to his war club, a few of them blond souvenirs of battles south of the border. The third chieftain was a man known as the Eclipse or Wabumagoging. An imposing red crane totem had been painted on this young man's chest; he carried a silver amulet around his neck and flaunted a fan made from the tail feath-

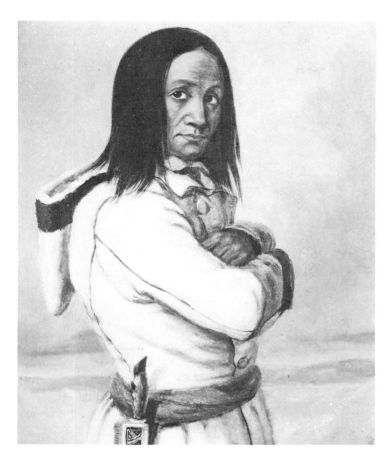

50 *Chief Red Jacket* undated
$10\frac{7}{8} \times 9$ in / 27.6 × 22.9 cm private collection

ers of a large brown hawk as a sign of chieftainship. His clothes were scarlet with blue edging and decorated with white bead patterns, while on his head was a bark band of embroidered quill work with alternating figures of men and animals.

Both Krieghoff and Martin Somerville sketched the three chiefs in a studio. Krieghoff's watercolour of Little Pine Chief (fig. 51), in which the old man is sitting on the floor, has an air of immediacy lacking in his oil paintings of the Eclipse (fig. 52). Nevertheless, the Eclipse is an impressive figure, particularly when backed by an appropriate wilderness setting. Krieghoff painted a second, smaller version of the latter; indeed, a third oil bears a 'C. Krieghoff' signature but has

been so repainted that it is impossible to determine whether it was originally from the brush of Krieghoff or Somerville. The original painting of the Great Warrior has been lost and is known only from a rough woodcut in which he stands holding his war club. Somerville made precise pencil studies of the Indians at the same time, one of which survives in the Royal Ontario Museum,[42] and a woodcut picturing the three men in *The Illustrated London News* is based on his sketches.[43] The extraordinary clothing worn in Krieghoff's canvases is in marked contrast to the more drab European blankets, jackets, and tuques of the Caughnawaga and Lorette people who had been robbed of their native colour through contact with Europeans. In his approach to these three chieftains, Krieghoff allied himself to George Catlin, Paul Kane, and Charles Bird King who documented the 'vanishing' American Indian in the mood of historians rather than as picture-makers.

An element of mystery surrounds many aspects of Krieghoff's personal life. His wife, Emilie, is mentioned in no documents between the births of her children in 1840 and 1841 until a reference at the time of her husband's death some thirty years later. There is no record at all of the human incidents which would make her come alive as a person. Second-hand accounts, however, describe her in a variety of situations. One says that she cautioned her husband against moving to Quebec, another describes her effusive greeting of an old Boucherville friend in some German city, and a third tells of her being replaced in her husband's affection by some German 'frau' in Quebec City.[44] All this amounts to nothing more than imaginative guesses about possible conversations and situations. The way in which she seemingly remained in the background suggests that she preferred to live in seclusion with her daughter rather than mix with her husband's exuberant friends. Certainly it is a shy, retiring, and somewhat wistful woman who has been identified as Emilie in Krieghoff's paintings.

With his taste for city living and his obvious ambitions, Krieghoff ultimately would have found Longueuil a limiting and inconvenient base for operations. Many nights must have been spent in his Montreal studio on Great St James Street rather than returning home across the St Lawrence. The trip took a certain amount of time at any season and at this point when there were no bridges was virtually impossible during

51 *Little Pine Chief* c. 1848
watercolour
private collection

52 *The Eclipse (Chief Tanaghte)* c. 1848
13 × 9½ in / 33 × 24.1 cm
The Hon. K.R. and Mrs Thomson

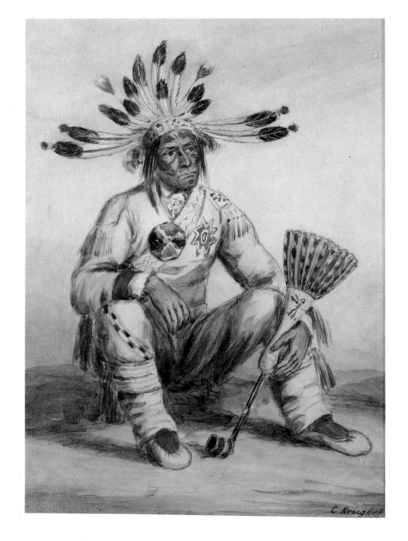

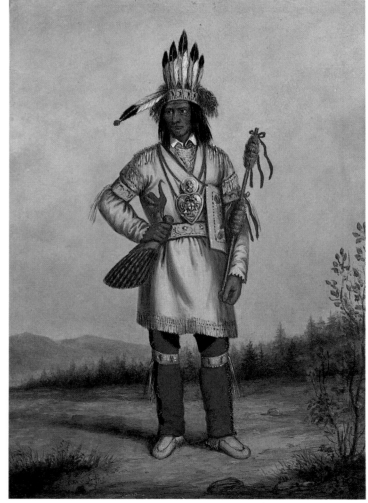

the autumn freeze-up and spring thaw. He rented a residence on Courant Ste Marie in the crowded Montreal waterfront district in 1849. A short time later he took quarters further out of the city near Beaver Hall Hill, first living on Belmont Street in 1850–1, and then in Barclay Place during 1852. His brother Ernst had visited Germany in 1849 in search of a bride and married eighteen-year-old Susannah Müller in Frankfurt. On his return to Canada Ernst took a house on La Gauchetière Street, just a few blocks from Cornelius, and there his wife gave birth to four children between 1849 and 1853.[45]

There was a gathering together of the Krieghoff family when the parents arrived in Montreal during 1850. Johann Ernst and his wife left Schweinfurt during May, went first to Nürnberg, and then on to Canada for a visit that lasted for two years. By making the trip they were escaping a family scandal that was provoking much gossip at home. It revolved around the younger daughter, Charlotta Sophia, who had married Wilhelm Sattler, Jr, and lived in the castle at Mainberg. Charlotta's husband was an intellectual who wrote philosophical treatises and advocated liberal ideas. The young couple had been promoting a local religious sect dedicated to the union of the Protestant and Catholic faiths. Wilhelm was jailed as a dangerous radical during 1848 at the time when Europe erupted in social revolt; shortly after her husband's arrest the impetuous Charlotta eloped with the minister of the new sect. Charlotta and her lover went to Switzerland where she produced the first Wagnerian operas presented on the Swiss stage. Her abashed husband, when ultimately released from prison, took his two sons on a long tour which ended up in Richmond, Virginia, far removed from Schweinfurt's wagging tongues. There he sold artists' colours and supplies. The elder Krieghoffs remained in Montreal until May 1852 when they returned home by way of New York and Bremen. All apparently had been forgotten and forgiven by the time they arrived back in Schweinfurt. They received a cordial welcome from their old friend Wilhelm Sattler and even lived briefly in his house before moving to their own residence on the Kornmarkt as 'people of independent means.'[46] The house still stands. Charlotta Sophia never returned home; she was abandoned by her preacher lover and eventually died in Dresden, though her memorial stands in the little cemetery in the shadow of Schloss Mainberg.

The Krieghoff brothers remained in close contact even after the artist had moved to Quebec. They collaborated during the later 1850s in producing a handsome tilt-top table of typical mid-Victorian style (fig. 53). Ernst, a cabinet maker, fashioned the article; Cornelius painted a colourful canvas of Indians at the Grand'Mère Falls on the St Maurice River, which was inserted under the glass table top and surrounded with a ring of waxed maple leaves. Ernst's wife died at Zurich in 1860: probably she had contracted tuberculosis and had gone to Switzerland for treatment in one of its noted sanatoriums. Her widower moved from Montreal to Toronto where he worked as an upholsterer and became a naturalized Canadian citizen in 1862. His family remained in Toronto for many years. One resident recalls that when attending Jarvis Collegiate in the 1920s or 1930s he played on the same football team as Ernst's grandson and visited the Krieghoff home. Quebec views lined the living room, but the youth did not realize that they were painted by a celebrated ancestor.[47]

Montreal as an artistic centre began to sour for Krieghoff about 1849, at the precise moment when he seems to have propelled himself into a most advantageous position for further participation in the city's life. Economic difficulties had been plaguing the capital, but the troubles went deeper. There was a building up of serious political unrest which exploded when conservative elements were affronted at passage of a government bill compensating those who had lost property during the 1837 rebellion. On 25 April 1849 the Earl of Elgin, the governor-general, drove to Youville Square to sign the controversial act into law. Few incidents in Canadian history have stirred deeper emotions. A howling mob pelted the governor's carriage with stones and rotten eggs, and his personal safety was endangered. When a demonstrator set fire to the Parliament Buildings, few volunteered to help quench the flames. Krieghoff's friend, Martin Somerville, sketched the burning building and sold the drawings to *The Illustrated London News*. The ringleaders and some of the rioters were arrested and thrown into prison. The irrepressible Dolly, indignant and uncowed and convinced there had been a gross miscarriage of justice, carried the finest of foods from his chop house to the dreary jail where he served a banquet to the prisoners at his personal expense.[48] A staunch supporter of Elgin was the Colonel Campbell whom Krieghoff had pictured in the governor's sleigh crossing the St Lawrence.[49] Krieghoff himself painted Elgin's portrait,

53 *Portage at Grand'Mère Falls* c. 1859
oil canvas set in top of table made by Ernst Krieghoff
Mr and Mrs Jules Loeb

based on a lithograph after a canvas by Théophile Hamel.

Montreal's prestige was damaged and its fate as Canada's capital sealed. Politicians decided on the cumbersome compromise plan of having the government function alternately in Toronto and Quebec City. A great pilgrimage moved back and forth between the two cities, resembling the baggage trains of medieval nobles as they travelled between their castles and their capitals. One by one, civil servants and officials trickled out of Montreal.[50] Many were Krieghoff's friends. Government business no longer attracted the steady stream of officialdom that had come by stage, boat, and railway. A lively social scene pulsated less vigorously, and the pendulum of cosmopolitan life slowed to a virtual halt. Montreal's sparkle had dimmed, and so had its potential as a market for art.

The fire had destroyed all but one of the paintings on the Assembly walls. A gallant gentleman, reputedly Sir Allan MacNab whose ample waist must have made the feat a remarkable one, rushed into the burning chamber and rescued an enormous portrait of Queen Victoria in her coronation robes allegedly painted by John Partridge (1790–1872).[51] This same canvas was removed from the blazing Houses of Parliament in Quebec City a decade later. It was rescued a third time in a dramatic fire on a sub-zero night in February 1916 in Ottawa which burned the central block of the Houses of Parliament. Krieghoff's portrait of the Queen, which had been presented to the government by the Honourable P. McGill, was slightly damaged in the 1849 blaze; it had hung for less than a year in the Montreal building.

The *Montreal Gazette* reported that money was being set aside for a new portrait of the monarch. Krieghoff felt that he had a first claim on any commission and thus sent a request to the Honourable John S. Pinhey on 26 October 1849,[52] citing McGill's name. But the Krieghoff magic failed to generate action and the matter dragged. He even resorted to the expedient of painting for the committee's inspection a trial canvas copied from a newly issued engraving of Her Majesty. She sits on a cream-coloured charger presiding over the Trooping of the Colour ceremony on London's Horse Guards' Parade. This chic woman, fashionably dressed in blue, wearing the Order of the Garter, and with ostrich plumes waving in her hat, is a startling contrast to the usual stuffy official portraits of the Queen. The painter of the original was the Comte d'Orsay, whose likenesses of the 'immortal' Duke of Wel-

lington and other noble ladies and gentlemen were then scoring sensational triumphs in the heart of empire. D'Orsay's daring and sprightly original still hangs in British government offices along Whitehall. Krieghoff's copy so bewitched one government official that the man bought either the trial version or commissioned a second version for himself. But Pinhey, the politician to whom Krieghoff addressed his appeal, preferred to 'play it safe,' bypassing the unorthodox pose and deciding on 20 March 1850 that George Theodore Berthon should paint the Queen's portrait. Had Berthon's prestigious but unimaginative provincial clientele in Upper Canada's largest city exerted some influence? It is not clear either whether Berthon painted an entirely new portrait or merely repaired and restored the damaged Partridge painting.

There is some controversy as to the state of Krieghoff's financial affairs during the early 1850s. Persistent stories describe him as being reduced on this and other occasions to a state of poverty, forced to peddle paintings from door to door. It has even been said that he worked for a time for a sign painter.[53] But it seems he was still living a full life, travelling much, and associating with the affluent. At the same time it is quite evident that he was prepared to grasp at any potential for increased income.

One possibility that crossed his mind seems to have been triggered by the new painted panorama craze that was sweeping America in the late 1840s. A forerunner had been a gigantic panorama of Quebec and Montmorency Falls exhibited by Robert Burford (1792–1861) at Leicester Square, London, in 1830.[54] But panoramas really came into their own in North America when the American artist William Burr (1810–75/6) painted views of the Canada-United States border about 1848. Burr and three artist companions sketched the Niagara River, Lake Ontario, the Long Sault Rapids, and the shores of the St Lawrence from Montreal to the mouth of the Saguenay, and from these sketches they painted a great moving canvas fifteen feet high and ballyhooed as seven miles in length (in reality only about half a mile). Burr spent $30,000 and two years on the undertaking. It was tremendously successful when shown in New York during 1849, and when it was moved to Boston a promoter arranged special railway excursions to visit the city. Several hundred Montrealers made the train trip to Boston in September 1850: other excursions followed with 'package tours' that included

railway fares, accommodation, and incidental expenses. A million visitors had seen the marvel in Boston by 1851 and another million in New York.[55] Washington Friend (c. 1820-following 1886) painted his own version of the same scenery and added a singer, who stood on the platform performing appropriate Canadian folksongs as various regions came into view.[56]

Krieghoff must have been dazzled by tales of the profits, but realized that to paint a similar work was quite beyond a single artist's capabilities and finances. He consulted with James Duncan and the two men decided to collaborate in the duplication of something resembling Burr's panoramic painting and featuring the 'most picturesque views' on several Canadian rivers.[57] Announcements about the project were made on 17 July 1851 and again two weeks later. Then there was silence, although a large canvas of Montreal seen from the mountain, now in the McCord Museum, may be an experimental work relating to the scheme. It would have been remarkable if the two artists had completed the task since the quixotic Krieghoff and the methodical Duncan were temperamentally so different that they scarcely could have preserved an amicable friendship through such a long and tedious endeavour. Yet Krieghoff did not entirely drop the idea, which was to reappear in a different form a few years later in Quebec.

Krieghoff was searching out a wider geographical radius in which to sell his paintings, and began to make more frequent trips away from Montreal. Certainly he went to Quebec City. He also visited New York, where the Düsseldorf Gallery was exerting a tremendous influence on American painting with its canvases imported from Germany reflecting the tastes of mercantile northern Europe. While en route to or from Quebec, Krieghoff seems to have ascended the St Maurice River from Trois-Rivières to see the falls at Shawinigan. A painting of Indians near the brink of a waterfall dates from about 1850, and this could well be one of the subjects he later envisioned for his projected series of 'picturesque river views.' He would exploit other St Maurice River themes with more success and vigour in later years. The artist's name is still listed in the Montreal Directory of 1853–4, on Aylmer Street, though Emilie may have lived there alone. Quite evidently Krieghoff himself was living in Quebec from some time in 1853. His interests were shifting from Montreal at the same time as Quebec City was beginning to assume its role as the new government centre, with the attendant concentration of business and social life.

Fulfilment, Quebec City, 1853-63

KRIEGHOFF'S HAPPIEST and most productive years were spent in Quebec City. In the decade following 1853, when he first settled there at the age of thirty-eight, he achieved his greatest success as an artist. Despite the many light-hearted hours he spent with close friends, his output was enormous. Canvases sold quickly, and at relatively high prices, to many admirers. His art, reflecting the lively and agreeable scene around him, was transformed beyond any suggestion of dull mediocrity. His keen wit and buoyantly infectious spirit, his understanding of his audience's tastes, and his versatility in themes combined to give his paintings of this period a popular appeal unrivalled by any other Canadian artist of the century.

Quebec City and the surrounding countryside provided an abundance of subjects for his canvases. The city was overlooked by the great Citadel crowning the precipitous front of Cape Diamond; below, the majestic St Lawrence flowed by on its way to the sea. Habitant villages, reminiscent of Longueuil, were strung along the banks of the river and on the nearby Ile d'Orléans. Northwest of the city was the village of Lorette, where the Hurons had lived since they sought refuge near their French allies two centuries earlier. Unparalleled natural scenery stretched in every direction. A succession of waterfalls cascaded over noble cliffs; Krieghoff must have thought of the wild alpine views beloved by many contemporary German artists. And as summer gave way to the glories of autumn foliage and the blinding whiteness of winter ice and snow, one season vied with the next for the attention of his brush. He continued to paint the everyday life of the habitants, in the centuries-old villages and farms around Quebec and in the pioneer regions of the St Maurice valley. Stylistically he developed new romantic overtones in his portrayal of the Indians. Equally he injected high romanticism into his landscapes by the use of brilliant sunshine or violent storms. He extended the range of his subject matter to include the waterfalls, lakes, and valleys of the region, sportsmen hunting and fishing, holiday-makers, and scenes of lumbering and newly built railways. He was excited by the world around him, and his enthusiasm for living radiates from his creations.

In the early 1850s Quebec was a city of about forty thousand people of whom just over half were French-speaking. Its social structure was diverse and fairly rigid. A visitor from Toronto, Samuel Thompson, marvelled at length about the many cliques.[1] First there were the high Roman Catholic churchmen and the seigneurial gentry, the French-speaking upper class, considered somewhat aloof and isolated by those who did not belong. Equally exalted was a prosperous and powerful English-speaking class of merchants, bankers, lesser officials, shipbuilders, and agents for Liverpool lumber importers, mostly of the Anglican faith, whose numbers were augmented by the garrison officers serving their tours of overseas duty in this rather leisurely outpost of empire. At the other end of the social scale were the Irish immigrants, a sizeable minority, and an expanding population of habitants who were seeking a new life in the city. They did the hard work and fraternized in neighbour's homes. The poorest among them lived in the squalid slums of St Roch on the eastern edge of the city. There were also a great many sailors in town, off the hundreds of ships that annually called at Quebec from ports all over the world.

For an artist like Krieghoff there was little competition in Quebec. The upper strata of the French community patronized established French-speaking artists such as Antoine Plamondon and Théophile Hamel, who specialized in religious works and portraiture. They were not interested in Krieghoff's popular and light touches. But the well-to-do English residents proved to be generous patrons. With the zest and easy rapport of the extrovert, Krieghoff shared many of their activities, fishing in the lakes and rivers, hunting in the woods, carousing in inns during long nights of

merrymaking. The gay and fashionable officers, representative of some of Britain's best-known families, were also eager patrons, taking home the paintings as souvenirs of army life in Quebec. The only likely rival, and the sole resident English artist, Robert C. Todd (1809–66), departed for Toronto about the time of Krieghoff's arrival.[2] Todd painted both landscapes and genre works but his subject matter was so limited that he posed no real threat artistically to the ambitious, versatile, and ebullient newcomer.

Before moving to Quebec, Krieghoff evidently made several trips to the city, no doubt to visit friends and to explore the possibilities of eventually settling there. A few canvases based on Quebec subjects were painted prior to his arrival, as if to test reaction to his work. An Indian encampment, for example, similar to his Caughnawaga material but clearly from the Quebec area, is dated 1851. The next year he painted habitants hurtling along the river ice below the Citadel, one group driving a red sleigh like those used at Longueuil, alongside them a trio of carefree young men on a low sled, whipping their horses in an impromptu race (fig. 55). Another canvas painted in 1852 shows weekend crowds on an outing to nearby Montmorency Falls (fig. 61). One of his most surprising and delightful early Quebec canvases is a painting, meticulous in detail but imbued with 'atmosphere,' of the noble ship *Quebec*, steaming up the St Lawrence past the great fortress (fig. 2). It was painted sometime in 1853 for the ship's master, Captain A.M. Raddall.

Christopher O'Connor, one of Krieghoff's closest friends in Quebec, maintained that the artist had visited the city as early as 1849, bringing with him a large collection of canvases which he offered for sale. But O'Connor's reminiscences were set down half a century afterwards; memory is fickle and this visit may have occurred a year or two later. At any rate, O'Connor has left a description of this first meeting 'about the middle of August 1849':

I had seen in a shop window (I think it was near where Lee the tailor is now) a number of oil paintings of Canadian scenery, all new ideas to me and mostly very interesting and nicely painted, I asked the boy where they came from – he said a gentleman had brought them from Montreal two or three days previously to my seeing them, there was quite a number hanging round the shop. Whilst I was looking at them the boy said to me, 'Oh! here's the gentleman coming up to the door.' I turned round and saw a tall thoughtful looking person, rather young than middle aged, dressed neatly but with a certain disregard of the 'fashion,' the boy told him that I had enquired as to the prices of some of the pictures. We then entered into conversation on the subject but the prices were altogether above my means. One of the pictures was large (rather over the general size) representing a scene in the woods, in the middle distance and well down to the foreground was a circle of Indians holding a council, an orator declaiming in the centre altogether a fine subject and well treated (fig. 120). I was much taken with it, but had to leave it alone. In the course of our conversation the gentleman told me that his name was *Krieghoff* and *Cornelius* also ... I wanted some of the pictures badly – as I was then daubing some 'flats and wings' for the infant 'Dramatic Club,' and wanted to get some ideas of 'red and yellow' foliage – but I had to wait a long time.[3]

It seems likely that the man who finally persuaded Krieghoff to move to Quebec in 1853 was John Budden,[4] whose portrait he had painted several years earlier in Montreal. With Budden's help the artist made friends, established himself as a painter in the city, and resumed a gay bachelor's life: presumably Emilie joined him in Quebec but no document states that she did. He 'put up' first in an upstairs room at Mr Philip's boarding house on Angel Street, in the old quarter near the Ursuline Convent, where Budden also had rooms. According to O'Connor, Budden took an early opportunity to introduce the artist to some acquaintances at a 'convivial spread – oysters and things.' Friendships established in those early days lasted for the rest of Krieghoff's life.

One man who became a close friend as well as a good patron was James Gibb, a banker, lumber merchant, and prominent businessman. Also close were the O'Connors, who, like Budden, on occasion gave intimate little dinner parties. Krieghoff painted a small canvas in 1860 as a souvenir of one of these dinners and gave it to his friends as a Christmas memento (fig. 56). The table top with its linen cloth, bottles, drinking glasses, and dishes is in the disarray left as the company rose from feasting and drinking. A copy of *Punch* warns against solemnity, and two spaniels trespass dangerously among the cutlery threatening to create imminent disaster. On the wall hangs a superb embroidered moose-hoof pouch, with a letter inside; such Indian souvenirs were purchased on outings to Lorette.[5] Krieghoff inscribed these words on the reverse: 'The pets & the materials. Presented to his friends, Anny, Christr. & Robt. O'Connor in

54 Quebec Curling Club, early 1860s, Krieghoff is on the right
photograph by Jules Livernois, Quebec

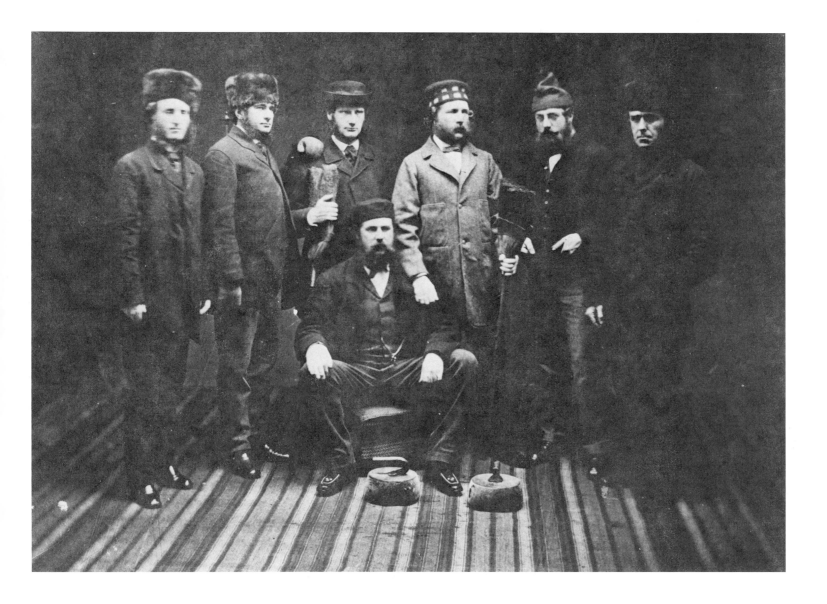

55 *Sleighs Racing in Front of Quebec* 1852
$17\frac{1}{4} \times 24\frac{1}{4}$ in / 43.8 × 61.6 cm
The Hon. K.R. and Mrs Thomson

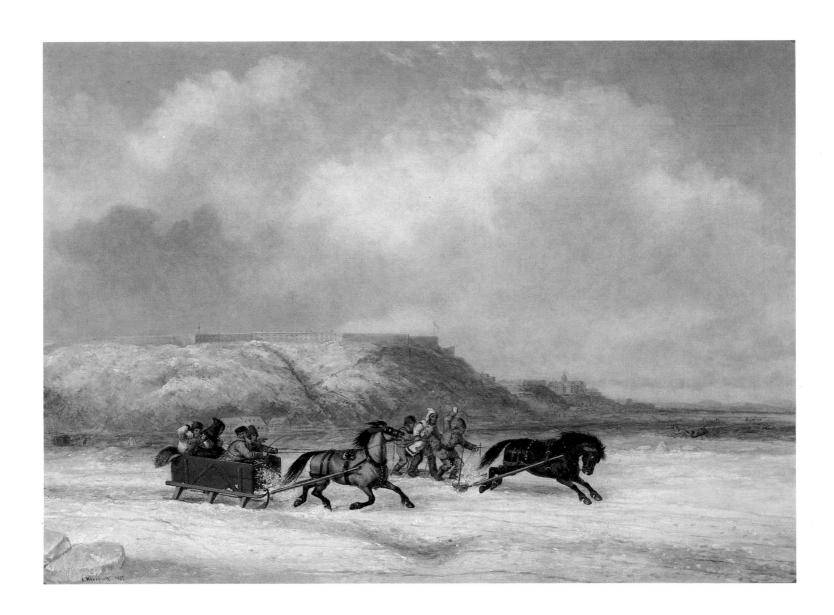

56 *Still Life* 1860
9 × 11½ in / 22.9 × 29.2 cm
private collection

token of regard & friendship by their sincere wellwisher. C. Krieghoff, Quebec, Dec. 1860.'

Superficially this little painting is a modest still life. In reality the artist has produced a narrative description conceived in the seventeenth-century Dutch anecdotal tradition. The general concept can be compared to a painting dated 1634 in which Willem Claesz Heda (1594–1670) introduced a broken glass, an overturned tazza, oyster shells, a partially peeled lemon, to capture a jolly dinner from which a fashionable party has just departed (fig. 57). The approach to recording a merry occasion remained unchanged, despite the more than two hundred years that separated the paintings.

Budden, Krieghoff, and their companions belonged to the Histrionic and Dramatic Club of Quebec.[6] A little is known of some of the other members. Christopher O'Connor painted the scenery. Mr Clerihue, one of Budden's close friends, lived near the old Laval University buildings and was at one time briefly Krieghoff's landlord. Edward Sanderson was a clever actor; his daughter, Florence Valencia, who was said to have made a tragic marriage, was a fine player and musician. Other members were Louis-Flavian Dufresne, William Home, and Mr Enright, a relative of the dramatist Sheridan. A photograph found in Budden's album of a man in fancy dress speaking from a podium may be a souvenir of a club meeting. This amateur group of players usually put on plays merely for their own amusement, but occasionally they gave public performances. They may be the actors referred to as the 'Young Canadians' who produced M.J. Bonchardy's *Le Secret des Cavaliers* in six acts at the St Louis Music Hall in 1860; the 17th regimental band played during intermission.[7]

Music also rated highly in the Quebec winter social scene, and Krieghoff's interests vacillated between the dramatic club and a local orchestra. Stewards for the promenade concert in 1860 were Colonel John Irvine, for whom Krieghoff painted a canvas of a hunting trip, and John Ross, who eventually married the widow of James Gibb. Eight dollars was the subscription price for six concerts, including refreshments, and again the regimental band performed.

The orchestra rehearsals apparently had social spin-offs, involving the burning of midnight oil, the consuming of copious quantities of Canadian wine, and much grumbling by neglected wives.[8] Some practices were in winter, and afterwards the members often adjourned to the slopes surrounding the Citadel. There Krieghoff painted a little sketch of a

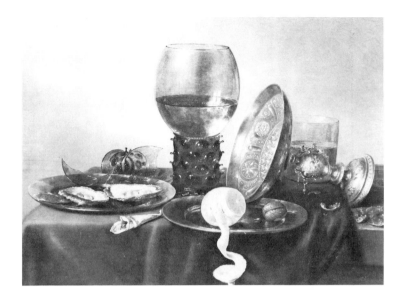

57 Willem Claesz Heda, *Still-life* 1634
oil on panel 17 × 22½ in / 43 × 57 cm
Museum Boymans-van Beuningen, Rotterdam

fellow member and his wife tobogganing down the hill followed by their excited dog Spot (fig. 58). He donated the picture to his friend and then painted several versions of it for sale. It is one of those more intimate paintings, autobiographical in nature like O'Connor's dinner table, on which one must rely to reconstruct Krieghoff's life in Quebec in the absence of letters and other written records.

Winter sports were popular in Quebec. Irvine, Gibb, and Krieghoff curled and had themselves photographed with some friends and their rocks (fig. 54). Either this same group or some daring army officers were pictured by Krieghoff as they streaked down the frozen St Lawrence in an ice boat flying the Union Jack, with the city in the background (fig. 59). Ice boats were still a novelty in Canada; they had been introduced from northern Europe only shortly before and were used principally in transporting freight.[9] Sportsmen, however, were soon enthralled by their speed.

The Quebec social season was thus a succession of sporting events, plays, musical concerts, and socializing; the perpetual whirl of winter activities induced an infectious lightness of spirit and an air of 'absolute restlessness.' The English tourist

58 *Sliding on Toboggan from Quebec Citadel* 1863
8½ × 13 in / 21.6 × 33 cm
private collection

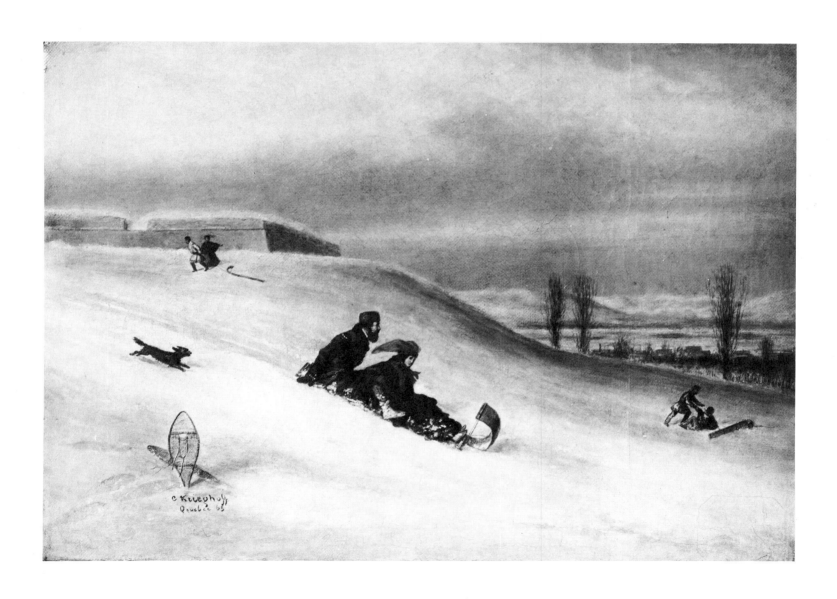

59 *The Ice Boat* undated
9 × 13 in / 22.9 × 33 cm
Musée du Québec, Quebec City

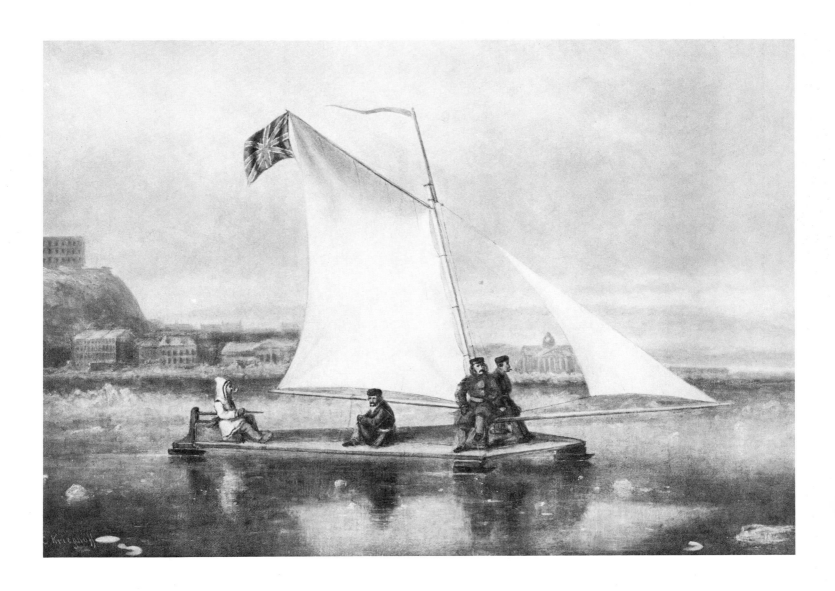

60 *Racing on the Ice Road, Quebec* late 1850s
11½ × 20 in / 29.2 × 50.8 cm private collection

Isabella Lucy Bird expressed her astonishment at the balls, moose hunting, sleigh driving, and 'tarboggining,' and, last but not least, the 'muffins.' She commented on one gentleman, just arrived from England, who declared that 'Quebec was a horrid place, not fit to live in,' but a few days later confided that the city was 'the most delightful place in the whole world; for, do you know, I have a got a muffin.'[10] Muffins were the young ladies who dared to accompany the gentlemen on lively outings without a chaperone; their unconventional behaviour resulted in much clacking of tongues among society matrons.

A 'tarboggining' outing and winter picnic was the subject of the most successful of Krieghoff's early Quebec paintings (fig. 61). The canvas portrayed a lively crowd gathered at the foot of Montmorency Falls, about ten miles from the city beside the St Lawrence on the road to Sainte-Anne-de-Beaupré. Montmorency was a favourite spot for weekend romps. Two ice cones gradually built up from the freezing spray of the high waterfall. Small boys cut steps in these, and it was one of the visitors' chief amusements to climb up and coast down the icy slopes on little sleds.[11] Frances Monck, the sister of the governor-general, visited Montmorency on a fine Sunday morning in the 1860s and put down in words what Krieghoff had set down in paint. She described the scene on the ice below the falls: the governor-general's four-horse sleigh, the garrison officers' elegant tandem teams (fig. 62), single animals hitched to smart carrioles, the shaggy habitant horses with low sleds. It was all 'too wonderful':

As we turned into the sort of amphitheatre of rocks and fir trees, in the middle of which are the grand Falls, we saw all the 25th in their red coats, and all the R[oyal] A[rtillery] in dark-blue overcoats, grouped about on the ice, and on the cone. There was a large collection of sleighs and harness in one spot, and a little further on were all the ladies of the party sitting at lunch on the frozen river at a table, with forms all round it. The officers were in undress uniform with fur caps, and were attending on the ladies ... The big cone is about eighty feet high. There is also a 'Ladies' Cone,' a much smaller one. You go down these cones on '*sleds,*' or little flat forms of wood on runners ... A fire was lighted on the ice ... and we had hot soup. The sun was so hot that we did not feel the least chilled eating our food on the river! ... After lunch we walked off to look at the sliding down the cone. How we laughed! About twelve soldiers all held on one behind the other, and came down the cone, not sitting on sleds, but just bumping or slipping down on nothing ... We went to see the beautiful ice-house cut in the cone, and the ice curiosities there. There is an ice-sofa and table, an ice-horse, a bird, a dog, and *two mummies*, they are marvellously cut out of blocks of ice ... Soon the band of the 25th struck up, and a quadrille was proposed ... The novelty of dancing on the river was not to be resisted ... A ring of soldiers was made round the dancers; it looked altogether curious and novel.[12]

Then came light-hearted races back to Quebec (fig. 60) when, as they approached the city, the great Citadel was silhouetted against the sunset, the colours of the sky matched only by the bright red and shining gold of the smart young officers as they emerged on arrival home from shaggy bearskin coats. They were noisy, rowdy afternoons which annoyed the local curé, Father Grégoire Tremblay; he attempted, apparently with some success, to stop the levity at the ice cones on the sabbath.

Krieghoff's paintings of the falls in winter were designed for popular sale, for the glittering Quebec social set they pictured would buy his work. The canvases would have had particular appeal to those 'scarlet coats' who found 'no quarters in the world ... so delightful as those at Quebec,' to quote again Miss Bird. Gentlemen of the officers' mess, in regarding such a purchase, could recall how the young ladies of Canada conferred favours on budding moustaches in preference to more elderly waxed handlebars.

The first of these Montmorency Falls paintings, completed

61 *Montmorency Falls in Winter, Quebec* 1852
26 × 37½ in / 66 × 95.3 cm
The Hon. K.R. and Mrs Thomson

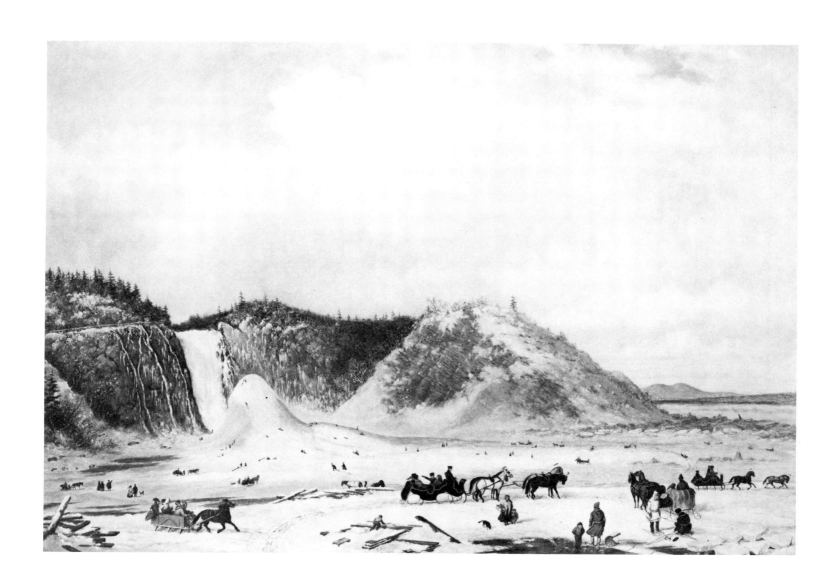

62 *Tandem Driving, Quebec* 1858
13½ × 17½ in / 34.3 × 44.5 cm
The Hon. K.R. and Mrs Thomson

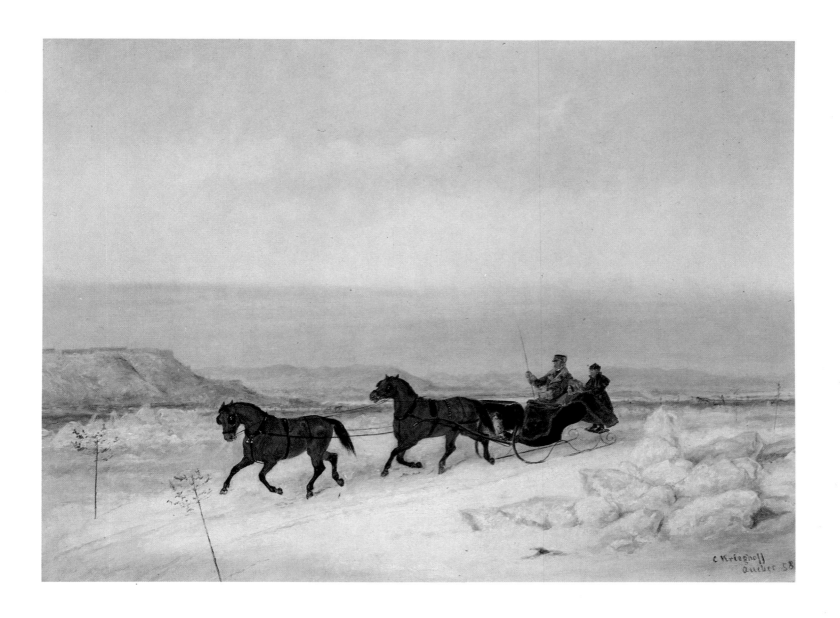

in 1852 before he had moved to Quebec, did much to establish his reputation as an artist in that city. At least five other versions of the subject were completed, the last in 1859. His popularity was spread, too, by the publication of a print entitled *The Ice Cone at the Falls of Montmorency near Quebec, Lower Canada, in 1853* (fig. 159). Published by the prestigious London firm of Ackermann & Company in December 1853, the print is similar but not identical to any of his known paintings. The print maker was William Simpson (1823–99), recently arrived in London from Glasgow and working for Day & Son, lithographers to the Queen. In later years he depicted other parts of her empire, travelling to India, Abyssinia, and Afghanistan, and also recorded the visit of the Prince of Wales to the Czar of Russia. The Montmorency Falls print reached homes that would have spurned the cheaper Currier and Ives works; Sir John Beverley Robinson, chief justice of Upper Canada, hung one beside his fireplace in Beverley House, one of Toronto's grandest residences.[13]

The rowdier side of Quebec social life is illustrated in several canvases of 'night-hawks' cavorting at country inns outside Quebec. No written accounts of specific occasions when Krieghoff and his friends visited inns have come to light, although we do know that on one occasion he painted draperies for the doorway of an inn on the Lorette road, and may guess it was to settle a drinking bill. But his paintings of nights spent drinking, dancing, and singing are more eloquent than words. That Krieghoff fully exploited pictorially the behaviour of uninhibited extroverts at such resorts did much to enhance his own reputation as a drinker. Such revelries were not a new subject, for he had painted the *White Horse Inn by Moonlight* in 1851 before leaving Montreal. In 1856 he painted a favourite haunt, the hostelry of 'A. Jolifou,' with departing drinkers climbing into a sleigh by the light of the new moon. It is likely that the reeling violinist staggering across the snow is a self-portrait.

During the next year he painted a splendid canvas of revellers spilling out of an inn, *The Morning after Merrymaking in Lower Canada* (fig. 1). A better-known version, entitled simply *Merrymaking* and based on the slightly smaller and less elaborate 1857 version, was completed in 1860. The scene is set outside a large stone building, which Krieghoff dubbed the inn of 'J. Bste. Jolifou' to remove personal reflections, though everyone knew that it was actually the inn of Ambroise Gendron on the Rue Royale about a mile and a half from Mont-

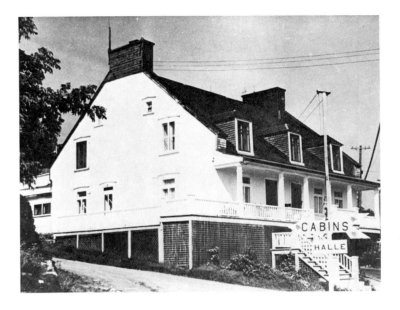

63 Gendron Inn (Chez Jolifou) in the 1930s

morency Falls.[14] By day it was an agreeable if somewhat sleepy hotel in which refreshments were served to sightseers visiting the ice cones. Isabella Lucy Bird described it as 'a small *cabaret*, where some women were diligently engaged in spinning, and some men were superintending with intense interest the preparation of some *soupe maigre*. Their *patois* was scarcely intelligible, and a boy whom we took as our guide spoke no English.'[15] The Englishman William Kingston and his bride, on a sightseeing tour in the mid-1850s, stopped at the inn to shake snow from their clothes, dry their coats around a fire, and sit down in a large room to 'a splendid cold collation [accompanied by] hot soups, hot pies, and hot potatoes, and champagne [which] gladdened our eager eyes and hungry mouths. A very sociable, pleasant, merry dinner had we; and, as the re-cloaking and re-booting took some time, it had long been dark before we were ready to start [back to Quebec].'[16]

At night the same large room was set aside for card-playing, drinking, and dancing. Gendron, the genial host, had hired a boy to wax the floor. Two cousins, Marcoux by name, played the violin and clarinet. When they could not be there, the landlord would engage three Indians from Lorette to play the violin, clarinet, and tambourine.[17] Merrymakers from

64 *Merrymaking* 1860
$34\frac{1}{2} \times 48$ in / 87.6×121.9 cm
Beaverbrook Art Gallery, Fredericton

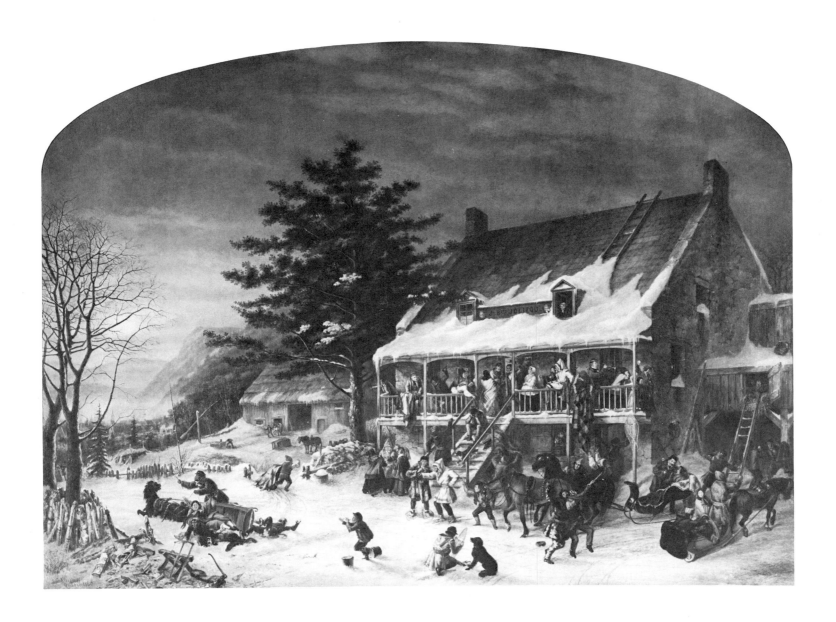

65 *The Upset Sleigh* late 1850s
13 × 21¼ in / 33 × 54 cm
The Hon. K.R. and Mrs Thomson

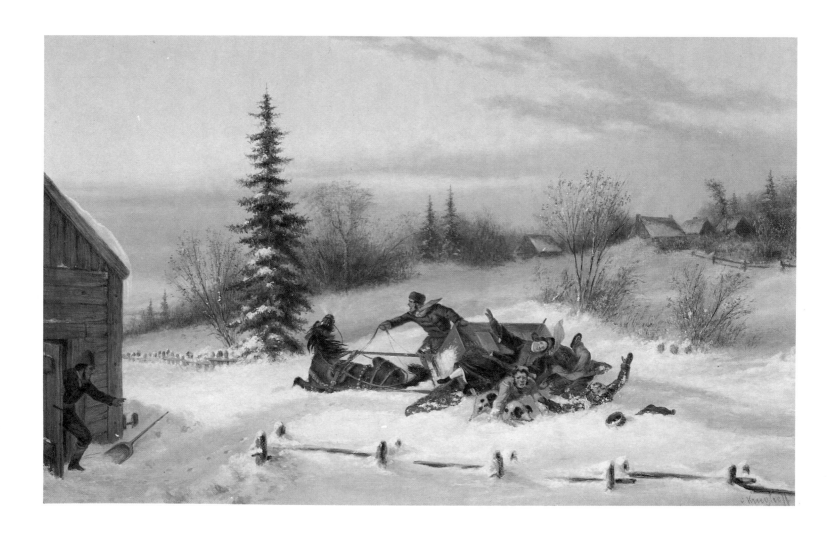

66 *No Money, No Water* early 1850s
9 × 11½ in / 22.9 × 29.2 cm
The Hon. K.R. and Mrs Thomson

Quebec transformed the place into a bedlam of dancing, whooping, horse-play, and buffoonery. In time, the clientele deteriorated, the building was sold to a man named Bureau, and the inn acquired an unsavoury reputation. The fine old structure still stands (fig. 63) but recently has suffered the indignity of losing its steps, and it is now crowded in on all sides by buildings on land where once the barn and stable stood.

Krieghoff's *Merrymaking* (fig. 64) is conceived in the best genre tradition of the inn scenes and studies of peasant life of Pieter Brueghel (1528–69) and Jan Steen (1626–79). With half a hundred revellers within its frame, it tells a story to be read slowly with each detail fully savoured. Breaking day reveals a motley scene. Men hitch horses to sleighs for the homeward journey; women wait on the porch where a tippling musician toots his horn in their ears; a man who has imbibed too much sits on the steps holding his aching head; the relieved innkeeper's wife watches the departing guests from an upstairs window. A secondary theme is introduced, like a sub-plot in a story. An unfortunate habitant attempts to drive past the mêlée on his way to the morning market. His horse is alarmed by the drunken confusion. Frantically the poor man tries to control the terrified animal, who upsets the sleigh, dumping the farmer's scrambling family unceremoniously into the snow. One practical passenger is restraining the pig intended for sale in town. Krieghoff had used the subject earlier in a canvas of a habitant group with an escaping spotted pig overturned in a snowy country road (fig. 65).

As early as April 1862 a Quebec newspaper referred to *Merrymaking* as a 'celebrated' work, 'conspicuous by its variety of figures and fidelity of detail, colouring and attitude.'[18] One feels, however, that Krieghoff failed to catch all the sparkle and full richness that lit up his first interpretation of the theme in 1857. Whether this is justified or not, it was the second canvas, now in the Beaverbrook Art Gallery in Fredericton, that enhanced his fame, chiefly because it became so well known, while the earlier version remained hidden away from the time it was painted until recent years. *Merrymaking* was widely reproduced over the years and became a 'nine-day wonder' when newspapers announced its sale in 1957 to Lord Beaverbrook for $25,000, reputedly the highest price paid for any Canadian painting up to that time. In his lifetime Krieghoff capitalized on its popularity and painted further scenes of merriment at inns in 1868 and again in 1871. The

1868 version was probably painted in Chicago but eventually went to Philadelphia where it hangs in a club. These inn pictures suggest Krieghoff's lighter moments in Quebec; they say even more about his clever ability to amuse a bourgeois public.

The habitants continued to be favourite subjects in Quebec, as at Longueuil. In one canvas, painted either in his late years in Montreal or shortly after he arrived in Quebec, a water vendor with a barrel mounted on a sleigh stops at a house on the village street (fig. 66). The stolid housewife has no pennies to pay for her jug of water. His laconic remark, 'no money, no water,' provokes a colourful flow of language much like a viper's venom – choice gossip indeed for the neighbours! Krieghoff then painted a series of canvases of a baker. In one (fig. 67), he is driving briskly along, his fresh loaves lined up in a neat row on top of the van, which is mounted on sleigh runners. In another picture the baker has pulled up beside a house on a country road, and is about to deliver his bread when a mishap occurs (fig. 68). A lively and pretty young woman stands on the verandah. The baker is so bewitched by her sparkling eyes that he forgets to watch his step. A patch of ice brings disaster. His feet fly into the air, the horse bolts, the bread falls to the ground before the horrified housewife. The mishap might have been even more serious if it had happened anywhere but beside the wayside cross.

About 1856 Krieghoff conceived the composition for what would prove to be his most successful habitant genre subject, 'bilking the toll.' He painted it repeatedly throughout the years for an audience delighted by such saucy escapades. Tales were legion of audacious country people galloping through the gate without paying the much resented fee. Krieghoff had heard them from his earliest days on the south shore and had pictured a tollgate in the distance in *The Ice Bridge at Longueuil* (fig. 29). Now he focused his attention on a well-known gate on the road outside Quebec, which was described by Samuel Thompson: 'The toll-gate on the St. Foy Road was quite an important institution to the simple *habitans*, who paid their shilling toll for the privilege of bringing to market a bunch or two of carrots and as many turnips, with a basket of eggs, or some cabbages and onions, in a little cart drawn by a little pony, with which surprising equipage they would stand patiently all morning in St. Anne's market, under the shadow of the old ruined Jesuits' barracks, and

67 *Baker's Cart* early 1850s
7 × 10½ in / 17.8 × 26.7 cm
private collection

68 *The Baker's Mishap* early 1850s
9 × 11½ in / 22.9 × 29.2 cm
The Hon. K.R. and Mrs Thomson

69 *Bilking the Toll* 1859
$16\frac{1}{2} \times 24\frac{1}{2}$ in / 41.9 × 62.2 cm
The Hon. K.R. and Mrs Thomson

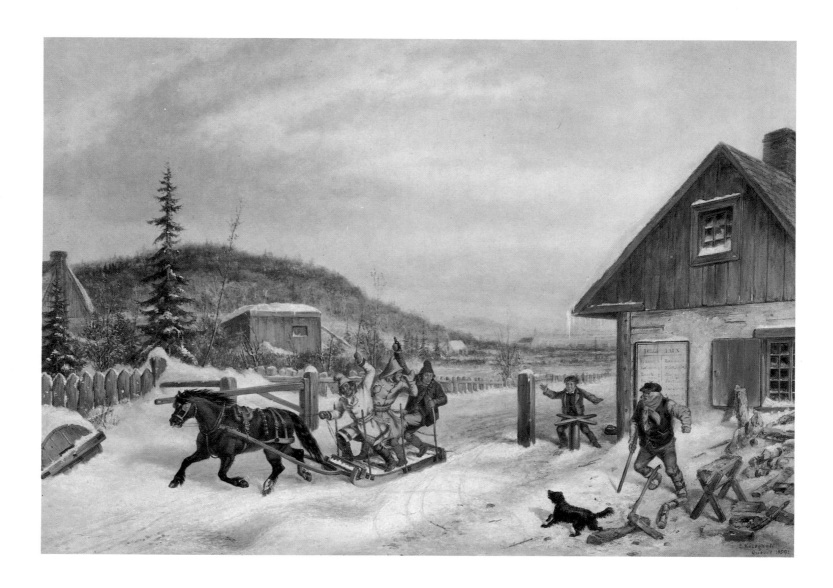

70 *The Blizzard* early 1860s
13 × 18 in / 33 × 45.7 cm
McCord Museum, McGill University, Montreal

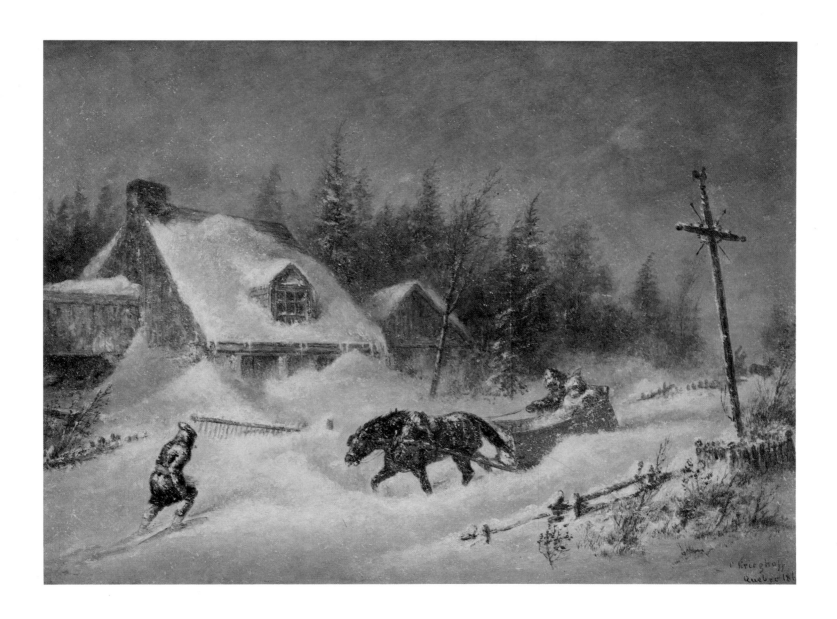

return home contented with the three or four shillings realized from their day's traffic.'[19]

In most of Krieghoff's numerous 'bilking the toll' canvases three young blades stand on a low sled behind a horse racing through the gate (fig. 69). One of the law-breakers thumbs his nose in derision at the old and helpless peg-legged gatekeeper, who lives in the little house by the gate. His indignant wife (in some pictures), a boy helper, and a barking dog can do nothing to stop the young scoundrels. In a few canvases the villains ride in more elaborate carrioles (fig. 71). The fine for breaching the regulations was considerable but the toll was bilked over and over again, and as if to match the frequency Krieghoff painted at least twenty-three versions with adventurers going to town, and another four with them returning home to the country after a day of leisure and carousal.

Tollgates were not the only obstructions on the roads of Lower Canada in mid-nineteenth-century winter. Travellers jolted over innumerable holes in the track. William Kingston described the problem in the 1850s: 'The cariole ... is placed on low runners of wood, so that the front part of the body almost touches the ground; and when it meets with any slight impediment in the shape of a heap of snow, it drives it onward till a ridge is formed, over which it has to mount; when coming down on the other side it forms a corresponding hollow. Thus it progresses, covering the whole road with ridges and hollows like the waves of the sea, which gradually increase in size as other carioles pass over them. These hollows are called "cahots," and they and their cause are justly held in abhorrence by all Canadian travellers in winter.'[20] The country roads, not to speak of the streets of Quebec, thus made rough by habitant vehicles, were cursed by English officers in their fancy high-runner turn-outs.

A more serious hazard for winter travellers were the blizzards. In several of Krieghoff's canvases a habitant and his wife ride bundled up behind a horse in a sleigh in a blinding snowstorm, on the way to mass or to visit a neighbour (fig. 70). Wayside crosses, rail fences, and evergreens mark the way. In one painting a man drives his sleigh through the St Jean Gate into Quebec; the howling blizzard is so bad that the soldier on sentry duty does not bother to challenge him. Another blizzard painting is punctuated with oaths: the driver has been upset by a brash fellow in a hurry who forced him off the track into the ditch (fig. 72).

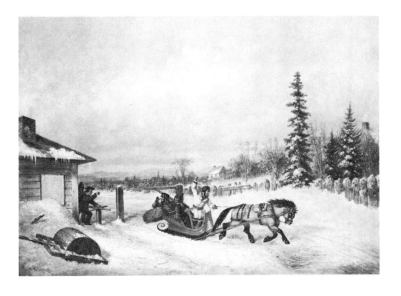

71 *The Toll Gate* 1861
13 × 18 in / 33 × 45.7 cm
National Gallery of Canada, Ottawa

Other road scenes picture habitants in little red sleds driving over the hills on clear sunny days. Sometimes a man is simply on an outing, at times he takes an officer and his lady for a ride. In one painting private bets are laid as two parties race on the river ice.

Immediately upon his arrival in Quebec City, Krieghoff began a series of canvases depicting habitant houses with a village and church in the background. He painted a view of a farmstead on the heights overlooking the city itself, and then a second large canvas of a log farmhouse on the Beauport shore (fig. 73). In the latter, the father is preparing the sleigh to set out for town. A woman gives instructions from the verandah; these were features of log houses frequently referred to in accounts of the Quebec City region. Children play around the door, there is a dog and chickens, and in the background a village and a large church with twin steeples. The painting has all the ingredients of his successful Longueuil canvases. In another fine painting a habitant stops outside a house to give instructions to a hunter with his dog (fig. 74). Krieghoff painted other farm buildings as well. In one canvas a farmer works outside a picturesque old barn with decaying boards (fig. 75). One child feeds or waters the

72 *Run Off the Road in a Blizzard* undated
12 × 18 in / 30.5 × 45.7 cm
private collection

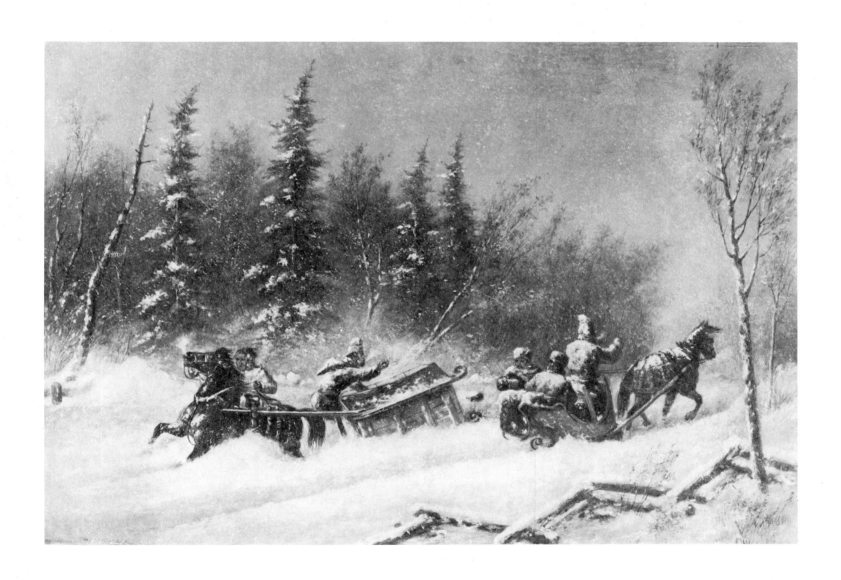

75 *Log Cabin, Winter Scene, Lake St. Charles* early 1860s
$17\frac{1}{2} \times 23\frac{1}{2}$ in / 44.5 × 59.7 cm
The Hon. K.R. and Mrs Thomson

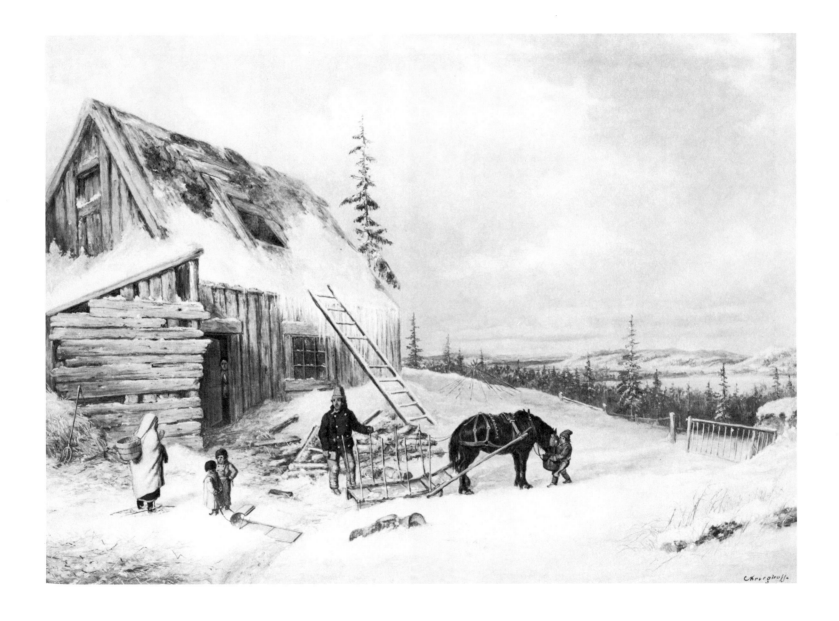

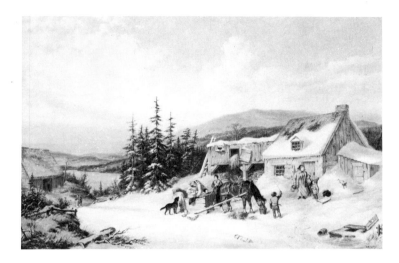

76 *The Habitant Farm* 1856
24 × 36 in / 60.9 × 91.4 cm
National Gallery of Canada, Ottawa

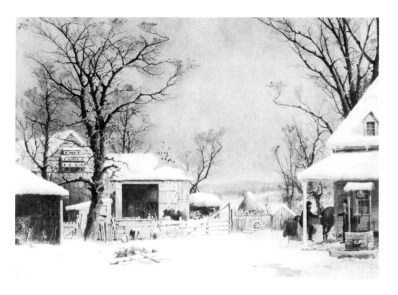

77 George Henry Durrie, *Farmyard, Winter* 1862
26 × 36 in / 66 × 91.4 cm
New York Historical Society, New York City

horse while others play with a toboggan. As the farmer talks to a visiting Indian woman his wife peeks out cautiously from the barn doorway.

The habitant houses around Quebec fascinated English visitors. Lieutenant Francis Hall early in the century described a continuous line of whitewashed farmhouses with attached log barns and stables stretching along the shoreline of the St Lawrence all the way from Montreal to Quebec. He remarked as well on the many church spires in the villages.[21] The little white houses were also one of the first features of the Canadian landscape to catch Lady Durham's eye, when she arrived in the late 1830s with her husband on his mission to investigate discontent in the colonies. By Krieghoff's day, there are references to painted as well as to whitewashed houses. Travellers, and Krieghoff's patrons, were still delighted by what impressed them as a quaintness in the life of the country people and by the remarkable cleanliness of their homes. One officer, James Buckingham, made special mention of the 'peculiar neatness' of the habitants. He noted that the glass windows of the cottages were cleaner than any he had seen in the United States, but that was only to be expected since each week the sashes were removed, 'the glass washed with water, while the frames were scrubbed with brushes and soap, and the whole wiped perfectly dry before the sashes are

replaced. Fresh flowers are usually placed in the windows after this; and every part of the interior is throughly cleaned.' He found the well-dressed, respectful, and courteous French-speaking peasantry in Canada to be a marked contrast to the dirty, ill-clad, rude, and disorderly appearance and conduct of the pioneering Irish and other immigrant settlers south of the border. He rationalized that 'the Canadian peasant lives in the home of his fathers, and intends that it shall be the home of his children; he accordingly takes the same kind of pride, in improving, adorning, and preserving his patrimonial dwelling, that an English landowner does in preserving the family mansion.' The American settler's first wilderness homestead, however, had 'no patrimonial charm or association connected with it, and he continues to occupy it only until he can move further on, or build a better house near the same spot.' Buckingham continued to rationalize that whereas the Canadian found time to enjoy himself in his home, the newly settled American was so busily involved in schemes to better himself or in arguing about politics and religion that he had little time to admire his surroundings.[22]

Squalor did exist in Canada of course. In order to reach the agreeable rural domesticity of the Beauport and Montmo-

rency countryside, travellers rode through the narrow alleys of St Roch where windows were stuffed with rags and pigs rooted through heaps of cabbage stalks and accumulated garbage. One saw 'women with tangled hair standing in the streets, and men with pallid countenances and bloodshot eyes ... you breathe the poisoned air, laden with everything noxious to health, and have the physical and moral senses alike met with everything that can disgust and offend.'[23] But to paint this district did not enter into Krieghoff's artistic interests or his philosophy of life. Unlike Dickens through his novels, Krieghoff was no social reformer or propagandist exposing the evils of society through his paintings. Nor would his patrons along the fashionable Chemin St Louis have bought such distasteful subjects.

In 1856, about the time he began to explore the more remote countryside back from the St Lawrence front, Krieghoff painted one of his best pictures of a farmstead set in a winter landscape. In *The Habitant Farm* (fig. 76)[24] he went far beyond recording the architectural features – the old squared-log house with attached outbuildings, the shed for hay and wood and a loft for pigeons, and the thatch-roofed barn. The buildings, like the landscape itself, are background for an intimate study of habitant life. The farmer returns home with his mother, a welcome winter visitor. In her finest clothes, she is already inspecting the grandchildren who have grown since last she saw them. The farmer's demure wife stands by the sleigh, inspecting the supplies from town. An old fellow creaks rheumatically up the hill with the aid of a stick; a bag thrown over his shoulder no doubt contains a rabbit caught in a snare, his contribution to the table.

Farmsteads in winter settings were equally popular with bourgeois art lovers in the United States. George Henry Durrie (1820–63) painted canvases identical in subject matter to Krieghoff's but with an essentially different effect. His *Farmyard, Winter* of 1862 (fig. 77) is materialistic in tone; Krieghoff's *The Habitant Farm*, painted six years earlier, is anecdotal and picturesque, as were David Wilkie's paintings of European country life. Durrie's farm houses are those of immigrants or settlers who have 'made it.' They have left behind the initial squalor and the harsh struggles of pioneer settlement and have reached a stage of comfort and well-being. The veneer of prosperity has been achieved by hard work. In Durrie's painting neat fences run everywhere, no doors on the barn are askew, the pigeon loft is an elegant affair. It is a scene to delight any prosperous farmer. Whereas people and human reactions play a major role in Krieghoff's work, in Durrie's painting the greeting of the visitor shrinks to a mere incident, and personal relationships take a secondary role to the portrayal of material success.

A fishing trip with friends up the St Maurice River in 1858 inspired Krieghoff to paint a successful series of canvases of the pioneer habitant homesteads in that region, which architecturally and in their ungroomed setting contrasted vividly with the old farms around Quebec City. The rural people began to move into these still forested and less accessible interior lands when the farms along the St Lawrence, divided and redivided among so many generations of sons and grandsons, became too small to allow further subdivision. Many new parishes were created along the St Maurice in the 1850s. St Narcisse, to the east, received its name in 1851 and opened its register in 1854.[25] To the west of the river St-Boniface-de-Shawinigan was established in 1859. Valmont was made a mission post in the previous year, though the first mass had been said there in 1854.

Krieghoff had painted habitants clearing the forest closer to Quebec in earlier years, but these first canvases are dull in comparison to his realistic and sophisticated portrayal of pioneer life in the Shawinigan area. He was entranced by the bustle of activity as sturdy young men chopped down trees and wives and children worked busily around the squat new houses, which were erected hastily without squaring the logs (fig. 79). Stoves and circular metal stovepipes replaced old-style fireplaces and massive stone chimneys. The inevitable cow and flocks of chickens wander around the yard. The haze of Indian summer hangs in the air and mingles with the smoke of burning underbrush and tree toppings as the settlers work frantically to clear the land.

Krieghoff's winter views of the St Maurice farmsteads proved to be a favourite subject; indeed one was his last known painting. Some were set in the less rugged landscape downstream; others pictured the more mountainous terrain as one penetrated further into the interior. He documented sleighs arriving in the farmyards with firewood or a recently killed deer or moose (fig. 78), young women baking bread in outdoor ovens or spilling milk on the way in from the barn, the hauling of water from the icy stream and the chopping of wood for the stove (fig. 80). Tree stumps jutting through the blanket of snow and the towering Laurentian hills in the

78 *Bringing in the Deer* c. 1860
20½ × 23 in / 52.1 × 58.4 cm
The Hon. K.R. and Mrs Thomson

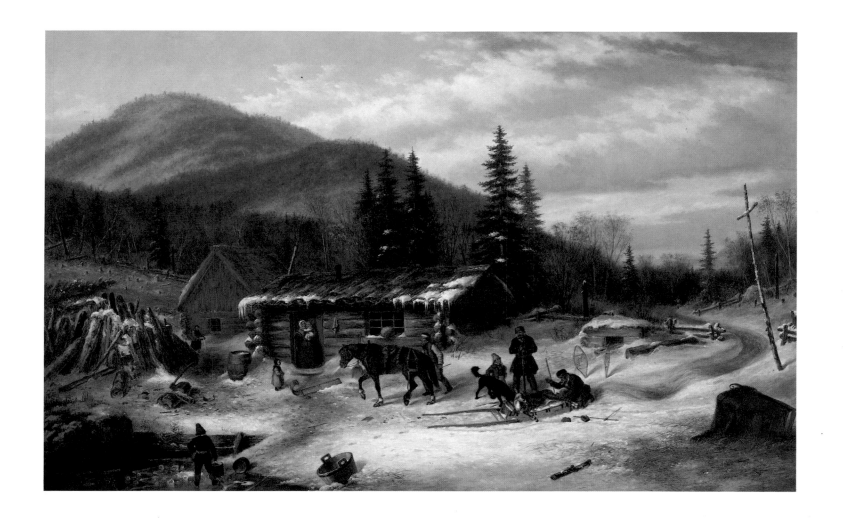

79 *Log Farm House in the Forest* 1867
18 × 27½ in / 45.7 × 69.9 cm
Power Corporation

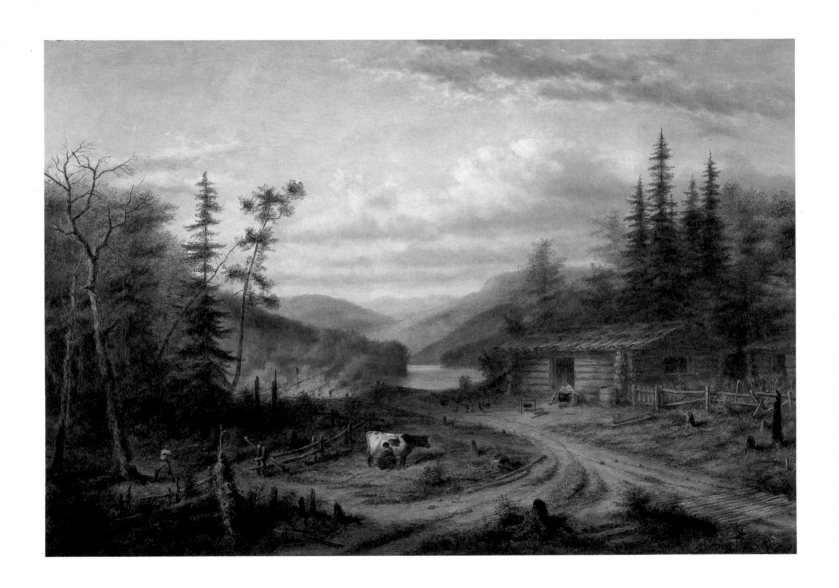

80 *The First Snow*
22 × 34½ in / 55.9 × 87.6 cm
private collection

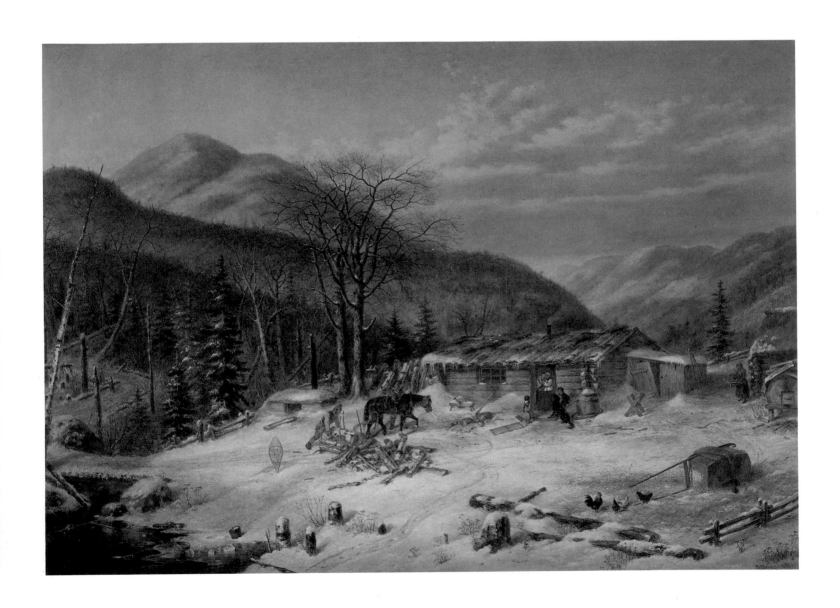

background of the scenes add to the atmosphere.

Although never particularly interested in fashionable portraiture, Krieghoff did paint in Quebec a number of studies of habitant heads. They could be more properly described as genre than as portrait studies, however, and are an extension of his interest in the people in his farm scenes. Bronzed faces reflect years of exposure to summer heat and winter storms (fig. 81); red or blue tuques, knotted scarves, and clay pipes accentuate the fact that these are people who are 'different.'

The growing demand for paintings necessitated an extension of subject matter in general. So Krieghoff isolated the aged man in patched trousers returning from checking his snares, first introduced in *The Habitant Farm*, and painted a series of small canvases exclusively devoted to him. He wears as the badge of his people the *ceinture flechée*, which some say were woven by the betrothed in youth and worn proudly through the years. His sharp quizzical glance has prompted him to be labelled erroneously in some paintings as 'the poacher' (fig. 82): in fact there is no suggestion he is doing anything illegal in the English sense of 'poaching.' In one painting the old man crawls along across the slippery ice of the St Lawrence. A similar study pictures a man setting out for market weighted down with his load of berries for sale (fig. 83).

Although innumerable studies exist of the heads of habitant men, there are none of women. But women are always important in the group studies, and often it is a domineering and aggressive housewife of mature years, admired or feared by those around her, who demands central stage. The 'grandmother' is the prominent figure in *The Habitant Farm*. A similar woman, stouter and less serene, leaps from the canvas in a painting of a pioneer homestead where she loudly scolds a girl for spilling the milk she is carrying from the barn to the house (fig. 84). In other paintings she curses the water vendor (fig. 66) or bargains shrewdly with the horse dealer as her approving family looks on (fig. 145). One senses it is she who runs the household.

This commanding matron received special treatment in four canvases painted between 1860 and 1862 (fig. 85). Against a mountainous background she walks primly down a snowy road, a basket on her arm, on the way home from the store; there is a smile on her face at the gossip she has heard from her friends. For her trip to the village she is dressed in her finest clothes, 'to see and be seen.' She is a woman with

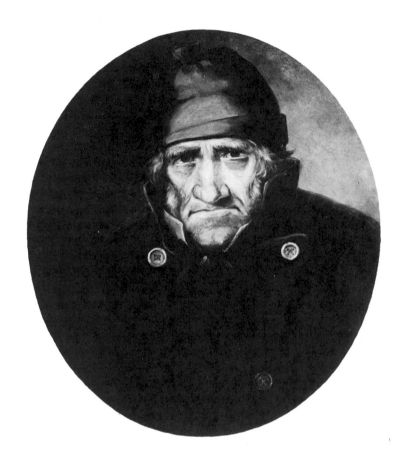

81 *Habitant Head* 1850s private collection

character. Perhaps Krieghoff's mother-in-law was such a matriarch.

Some habitant men lived a venturesome life in contrast to the placid farm people portrayed in most of Krieghoff's canvases. Passengers between Quebec and Lévis on the other side of the St Lawrence travelled during the winter months aboard special Royal Mail canoes. The boatmen or *canotiers* who operated these were a hardy breed who jumped out on the ice floes which impeded their progress and hauled the wooden canoes over the obstacles. Some passengers who gave them a hand received a reduction in their passage money.[26] It was an adventurous trip for the uninitiated, and one of the experiences remembered by visitors to Quebec in the winter

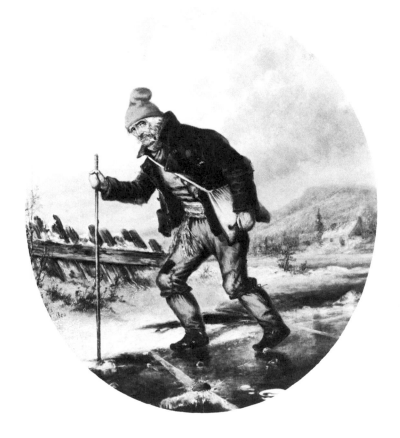

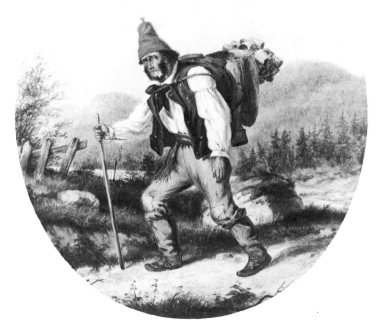

82 *Habitant with Red Toque and Pipe* 1860
feigned oval 11⅛ × 9⅟₁₆ in / 28.3 × 23 cm
The Robert McLaughlin Gallery, Oshawa

83 *Canadian Berry Seller* 1859
11⅛ × 9⅛ in / 28.3 × 23.2 cm
Dominion Gallery, Montreal

months. Krieghoff painted numerous versions of these boats crossing the icy river. Mostly the boats are set in a wide panoramic view; but in 1858 and 1859 he completed a series of larger canvases in which he focused in on a canoe where a man and a woman seated amongst the baggage are clearly pictured (fig. 5). The woman holds a small lap dog. In some versions there are red spots on her face, and it has been said that she had contracted smallpox and was being ferried across the river because of her illness.

Krieghoff apparently visited Montreal about this time and sold most of these rather elaborate canvases to the well-paid engineers who were constructing the Victoria Bridge. When a book was issued on the new bridge, the publishers wanted to include illustrations demonstrating how inadequate the old ice boats were as opposed to the convenience of the bridge. They took one of Krieghoff's views, simply cut out the horizon line with the Quebec Citadel, and declared the boats to be operating in Montreal.

Krieghoff's interest in the Montreal area was seemingly revived by this visit to his old haunts. He painted some fresh views of Longueuil in winter, and apparently drew some of the figures in published lithographs of the new bridge, which

84 *Spill My Milk!* 1865
$14\frac{1}{2} \times 21\frac{3}{4}$ in / 36.8×55.2 cm
The Hon. K.R. and Mrs Thomson

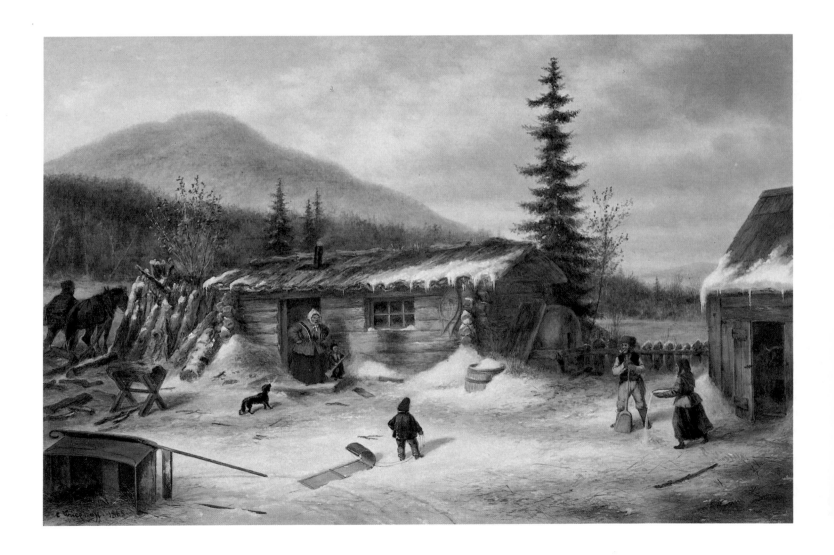

with proposals by which the Canadian treasury could be of financial assistance. Some of his money-making schemes were practical and some were ingenious. Three years after moving to Quebec he conceived the idea of painting 250 views of various subjects to be used in print form in an illustrated volume on Canada. This was only the first step. On 23 February 1856 he petitioned aid from the governor-general, Sir Edmund Walker Head, describing his project as a 'Series of Tableaux in oil descriptive of Canada, and containing views of the principal cities, and picturesque spots along the St. Lawrence, Ottawa and tributaries Richelieu, St. Maurice, St. Francis, Saguenay and the Lakes.'[27] Some were subjects he had already painted, but it is doubtful that he ever did paint along the Richelieu and Saguenay rivers or on the Great Lakes. A large painting which he described as a view of Lake St Clair, in an inscription on the reverse, seems rather to have been suggested by some of the lakes and rocks to the north of Quebec City, and painted in his studio there.

In addition to using his paintings as illustrations for a book he proposed to take them on a tour of Europe. In his petition he argued that this would strengthen his claim for government aid, stressing the benefits that would 'accrue to Canada from the exhibition in England, France, Germany, and other European States of Paintings of this nature, shewing as they will the various public works of this Province, large lumbering establishments, the various branches of industry of its inhabitants, and thus calling the attention of a better class of Emigrants to a country so rich in resources, and yet so little known to the Foreigner.' In support of his plan, Krieghoff declared that he had been a naturalized subject of Her Majesty for many years.

The proposal parallels similar projects of the era. For example, George Catlin had toured Europe with six hundred paintings of Indians and had shown them to King Louis-Philippe of France in the Louvre during the very year Krieghoff copied paintings there. Catlin also published volumes with illustrations based on his paintings. But the Canadian government was *not* interested in any schemes to hand money to artists. After waiting years for delivery it had just straightened out a deal with Paul Kane under which money had been advanced to buy twelve of his series of Indian paintings. An artist in British Columbia proposed and began to paint a series of paintings of that colony during the early 1860s, designed for an English tour to promote immigration,

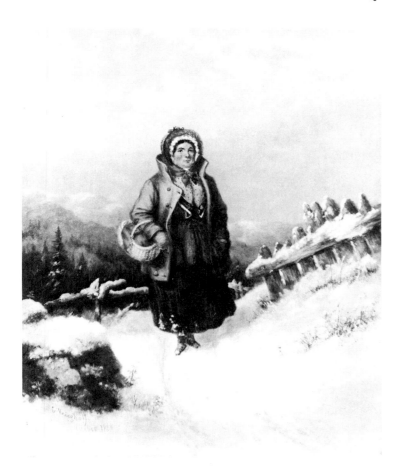

85 *Coming from Market* 1860
11 × 9½ in / 27.9 × 24.1 cm
private collection

was officially opened in 1860 by the Prince of Wales. As part of the celebrations, the Board of Arts and Manufactures built a Crystal Palace on Sherbrooke Street to house the annual provincial fair exhibits, including a new art gallery for the exhibition of the province's best art. Naturally there were a number of Krieghoff's paintings on display.

Krieghoff had been particularly insistent when he unsuccessfully sought government money in Montreal in 1849 to paint the portrait of the Queen. It was not the last time he came up

but this project too came to naught.[28]

Krieghoff continued to publish occasional popular prints for local sale. In this connection, too, he thought a little government understanding and co-operation could be of some help. His first prints had been printed by a Munich firm but he later gave publishing commissions to lithographers in New York, Buffalo, and London, and was annoyed because he had to pay duty when they came into Canada. Accordingly, on 6 March 1859 he wrote to Sir Alexander Tilloch Galt, the minister of finance, asking him to remove the duty.[29] His approach was more subtle than a direct suggestion that he might personally benefit financially. Rather he questioned the logic of charging duty on prints when there was none on books, emphasizing that it took 'another class of common sense' than his own to understand the distinction. Prints, he argued, were even more important for Canadians than books since 'in many portions of Canada ignorance is so rife, that by the eye only some little education is obtained; as to better class of prints, dear already from copyrights &c, the more duty is charged the less good can come of it, both to public & treasury. A good print has not been offered for sale here – a city like Quebec, since 3 years.' He is probably referring to a stock of imported prints offered by John Smith, a Quebec print seller, during 1856. His advertisement for 'First Class Engravings' after paintings by Landseer, Herring, and other European artists first appeared in May of that year.[30] These were the very artists whose paintings were being copied by Krieghoff in oil for a local clientele.

The letter to Galt continued with a scathing denunciation of Canadian neglect of the arts: 'Something ought to be done to further art in the province. Our very normal schools, high schools, &c are without able drawing masters, without casts, or collections of prints & ornaments. No wonder that our young men will be drunkards & our young girls flirts ... This is a matter of importance & we should not follow in the low wake of United States, indifference to the fine arts. To our leading men we must look for proper measures, as it is the duty of artists to bring the matter before their eyes.'

Krieghoff seemed unaware of the fact that Dr Egerton Ryerson of Toronto, then roaming England, France, and Italy with his two daughters, had similar thoughts about art education. While the young ladies were benefiting from the 'Grand Tour,' their conscientious father was purchasing antique casts and commissioning copies of Old Master paintings to promote the arts in Canada. Like Krieghoff, he knew that every European art school had its quota of casts, all duly camouflaged with fig leaves in a 'moral' age. He brought back his treasures as a nucleus for a Canadian art museum where they could be used by student copyists for the improvement of artistic taste and appreciation, and begged for even more money when his allocated funds were exhausted.[31] The casts were drawn by life students when an organized art school was established in Toronto during the 1870s. Ryerson's collection remained in the city's Normal School for generations.

Almost certainly Krieghoff was justified in complaining about the public indifference to art at the time. Canada's most prominent artists boycotted the provincial exhibition held in Montreal in 1857 on the grounds that the prizes were insufficient to justify the costs of packing and shipping. Complaining that the drop in the general artistic level was such that the Fine Arts department at the exhibition was 'below contempt,' an outraged critic in the Quebec *Morning Chronicle* of 19 September declared: 'we have a hideous piece of Amateur Sculpture, marked $20, and dear at as many coppers, some drawings and paintings in what is known as the *Ten-Try* style of Art, and resembling nothing so much as pictures on the pelt side of Buffalo skins.'

Krieghoff finally had some success in his dealings with the government. Since 1849, when the Parliament Buildings had been burned in Montreal, the capital of the united Canadas had moved back and forth between Toronto and Quebec City. Quebec had some difficulty providing suitable accommodations. The first session held there, in 1852, sat in the old grey stone legislative buildings of Lower Canada, but these buildings were destroyed by fire in 1854 and the politicians, who continued to argue vigorously about the permanent seat of government, moved temporarily to the Music Hall. When the government returned to Quebec the next time, it moved into a new structure built hastily during 1859 on the site of the old legislative buildings on the Côte de la Montagne. The plans had called for an austere building, but it was to be dressed up with an elaborate reredos behind the Speaker's chair. Krieghoff received a commission for paintings to enliven the ornamental screen.

The wealth of many Quebeckers originated in the surrounding forests,[32] and so the lumber trade was deemed a suitable subject. Lumbering then was Canada's major industry. Somewhat more than half her total exports in 1851 were

86 *Log Rafts in Sillery Cove* 1862
private collection

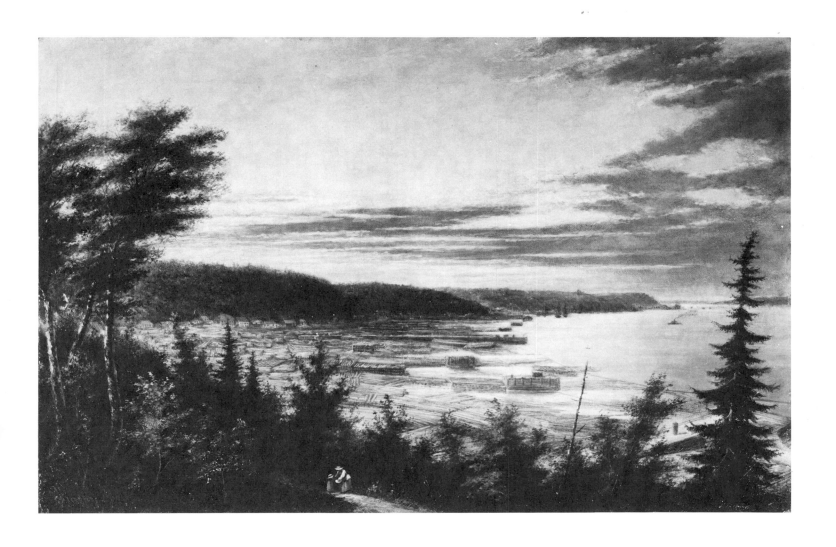

forest products, totalling over one and a half million pounds, and the bulk of the trade was funnelled through Quebec City. Timber merchants' offices lined the wharves; loading facilities were located in nearby Wolfe's Cove and Sillery beyond Cape Diamond. Quebec drew a steady stream of raftsmen from the interior and of foreign sailors from the great sailing ships that fanned out to distant ports all over the world.

A photograph was taken of the new Assembly after its completion. Canon H.A. Scott saw a copy of it in 1919 and described the chamber in a book. Although the photograph has subsequently been lost, Scott's description of the reredos is so precise that it is possible to tell the subjects of Krieghoff's paintings and even how they were mounted on the wood-work.[33] He identified nine paintings in all; since Krieghoff normally made several versions of each of his subjects, one can reconstruct the group from surviving canvases that are replicas of those painted for the Assembly. The originals were all presumably destroyed when the building was burned in 1883.

Two replicas are known of the central painting behind the Speaker's chair, a large canvas of Sillery Cove (fig. 86) – wharves jutting out into the river, piles of timber on the shore, sailing ships, the Quebec skyline in the distance. The noble vista is framed on either side by trees, as it had been in an engraving after Bartlett a few years earlier; indeed the Bartlett engraving seems to have inspired the composition.[34]

Several of the canvases originated in the St Maurice region north of Trois-Rivières, where there were still large stands of timber. In one of them a log shanty stands at the edge of a frozen river (fig. 87). The barrels stacked against the building's outer wall hold salt pork to feed the hard-working lumberjacks. Bags of flour and other provisions arrive by sleigh. Logs lie on the expanse of ice, awaiting spring break-up and the long journey to Quebec: an encircling log boom has already been put in place as insurance against loss in a freshet. In another winter scene of the region, oxen pull firewood. Two of the paintings display the forest in sparkling autumn colours, demonstrating the glories of the Canadian woods: in one there is a log jam where Krieghoff and his friends went fishing (fig. 106); the other depicts Indians portaging around the Grand'Mère Falls, down which the logs shot (fig. 118). Krieghoff also caught lighter moments in the lumber camps; one circular medallion canvas shows a fiddler sitting on a table

in the mess room and playing by candlelight as the hardened shantymen dance.

The lumberjacks in the woods led a hard life, but the men who brought the logs down the rivers to the ports were even more adventurous. Huge rafts of pine, oak, and maple trunks were floated down the St Maurice, St Lawrence, and Ottawa rivers in spring flood. Indians from Caughnawaga and French from the Montreal area annually went to the woods around Kingston for the task,[35] and equally robust Irishmen and Glengarry Scots manned rafts on the Ottawa River. Where they joined company above Montreal, the river was a floating mass of logs, all eventually converging on Quebec. The raftsmen were a special breed, and their occupation gave rise to many legends.

The rafts were made up of several cribs joined together. Generally a cook and his helper took over one crib and on it constructed a rough pine cabin where they lived with the raft foreman on the long journey to Quebec. Sand sometimes a foot deep was dumped on the raft surface on which an out-door fire was lit to boil the salt pork and potatoes in an iron pot. Crewmen lived in a second cabin and manned the thirty-foot-long oars or 'sweeps' that kept the rafts in the channels (fig. 90). Many rafts flew their firm's flag. Sails were erected to catch the wind and hasten the clumsy craft. Sometimes several rafts were linked together in a huge slow-moving mass of logs. Charles Dickens, travelling from Montreal to Quebec by steamer, went on deck after breakfast and was amazed at 'a most gigantic raft, with some thirty or forty wooden houses upon it, and at least as many flag-masts, so that it looked like a nautical street.'[36]

Most of the lumbermen were Catholic and offered prayers for a safe journey as they passed Ste Anne's shrine below the junction of the Ottawa and the St Lawrence rivers. They were also traditionally a rough lot: there were many private wars between rival gangs, and much drinking and fighting on the journey. In the Ottawa Valley facial scars from boot caulks were known as shantymen's smallpox.[37] The Ottawa men rioted in Quebec during 1858 when they were preparing to return home on board the steamer *Quebec*,[38] which Krieghoff had painted (fig. 2).

Several of Krieghoff's canvases pictured rafts on the river, but one suspects that he never made the trip himself to make sketches and had no intention of doing so in the interests of art. It was easier to copy Bartlett's engravings. A Krieghoff

87 *Lumberer's Shantee* 1867
13½ × 21¼ in / 34.3 × 54 cm
The Hon. K.R. and Mrs Thomson

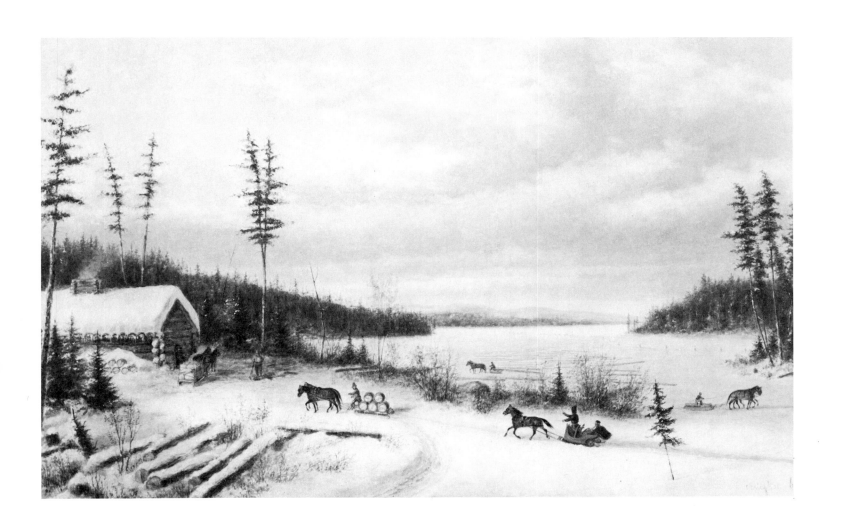

painting in the Assembly group of log rafts at the junction of the Ottawa and the St Lawrence (fig. 89) is indeed a revisualization of a Bartlett print of the same view (fig. 88).[39] A comparison of the two versions reveals Krieghoff's developing 'photographic realism,' as he became increasingly aware of competition from the camera. The trees in Bartlett's engraving, for example, consist of swags and swaying lines which had their origins in the second half of the eighteenth century and the aesthetics of Edmund Burke and Thomas Gilpin: they are symbolic 'picturesque' trees made up of decorative foliage masses. Krieghoff's pine, on the other hand, is an anatomically correct skeleton with a trunk and limbs that branch progressively from it as nature dictated, providing support for tufts of needles. His attitude is attuned to the new scientific and materialistic age of Darwinian scrutiny. Yet he retained a 'composed' approach rather than giving way to a purely photographic view, for he framed the vista carefully with masses on each side. At the same time, this 'composed' picture incorporates highly detailed units. The word 'realism' has many different meanings: Krieghoff's exactness is conceptually very different from the contemporary sombre scenes of French peasant life as interpreted by Courbet, to which art historians give the name 'realism.' The Quebec audience who admired Krieghoff's detail would have had little understanding of Courbet's philosophy of 'realism,' even if they had had an opportunity to see his works.

A more colourful and romantic canvas in Krieghoff's House of Assembly series is a painting of a wild storm on Lake St Peter below Montreal where the St Lawrence widens out to become a shallow lake, seven miles wide and twenty-three miles long. Even in a moderate wind the lake would 'run a sea,' and many rafts were wrecked or damaged in its high waves. The storm in the painting resembles those painted by Jacob van Ruisdael (1628–82), whose canvases Krieghoff had copied. But here again he was apparently quite content to make a literal transcription of one of Bartlett's engravings of rafts being tossed by a storm on the lake.[40]

In addition to painting replicas of the Assembly paintings for private sale, Krieghoff produced other lumbering canvases with related themes. One painted in the summer of 1862, for example, shows a lumberer's ferry taking oxen to an island (fig. 91). In another a habitant is welcomed by his family as he arrives home from the camp with two great logs on his sleigh (fig. 92).

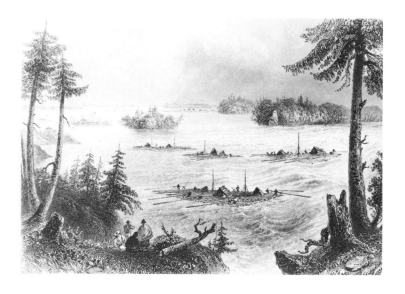

88 W.H. Bartlett, *Junction of the Ottawa and St. Lawrence* 1842 engraving

While most of the lumber from the camps was squared into timber for export, a certain amount was cut into stove lengths for local consumption. The forests around Quebec were already depleted of larger trees, though some of smaller diameter were still cut along the Montmorency River and on hills to the rear of the city. Krieghoff painted small canvases of men chopping and sawing wood. A striking composition shows lines of horses and sleighs carrying the cordwood to town; it seems inspired by Coke Smyth's print, *Posting on the St. Lawrence during Winter*,[41] but Krieghoff added a colourful sunset in an apparent bid to catch the public imagination. One other canvas shows a habitant haggling over the price of a load of wood for sawing into stove lengths (fig. 93). The well-fed, well-dressed customer looks as if he could afford to pay the extra money. But in any case the habitant may have his revenge: one labour-saving trick of wood suppliers was to leave a few uncut logs at the bottom of piles of sawn lengths delivered to Quebec homes.

John Budden introduced the artist to the wealthier Quebec sporting crowd, and these contacts allowed him to expand into a whole new range of subject matter. A few months after his arrival Krieghoff was commissioned to paint a famous

89 *Junction of the St. Lawrence and the Ottawa* c. 1858
$6\frac{3}{4} \times 6\frac{3}{4}$ in / 17.1 × 17.1 cm
private collection

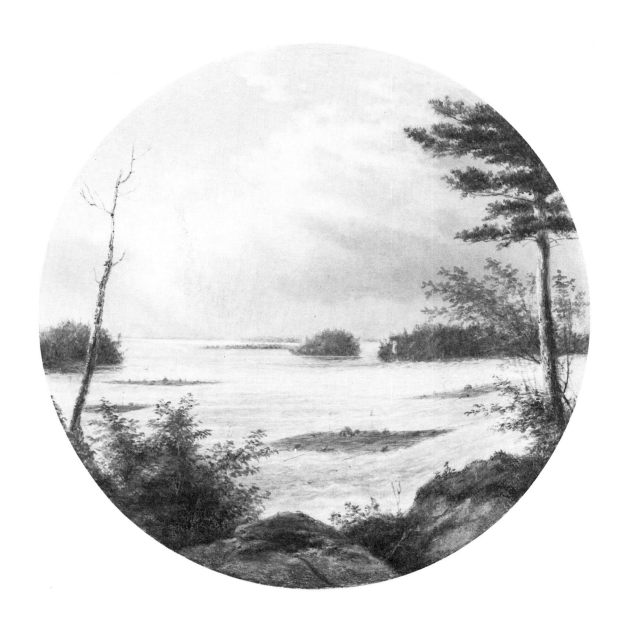

90 *Raft of Logs* c. 1858
private collection

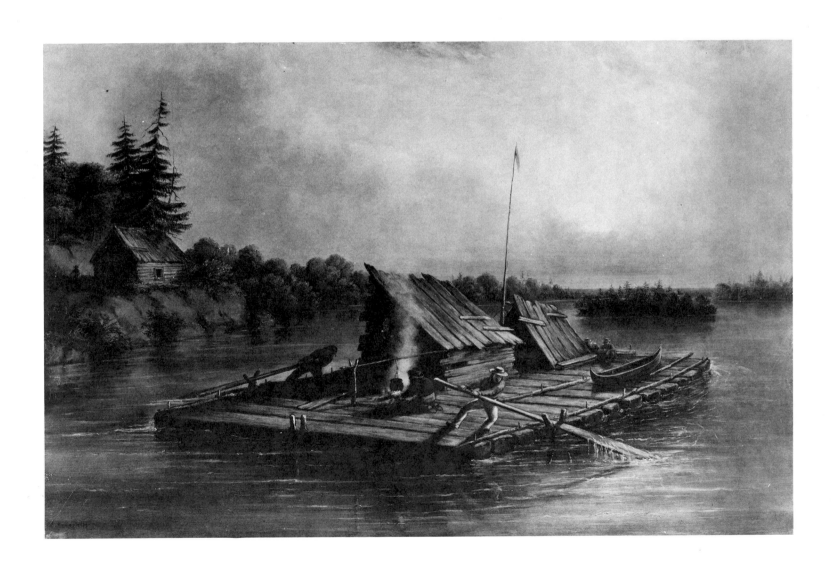

91 *Lumbermen's Ferry* 1862
11 × 18 in / 27.9 × 45.7 cm
McCord Museum, McGill University, Montreal

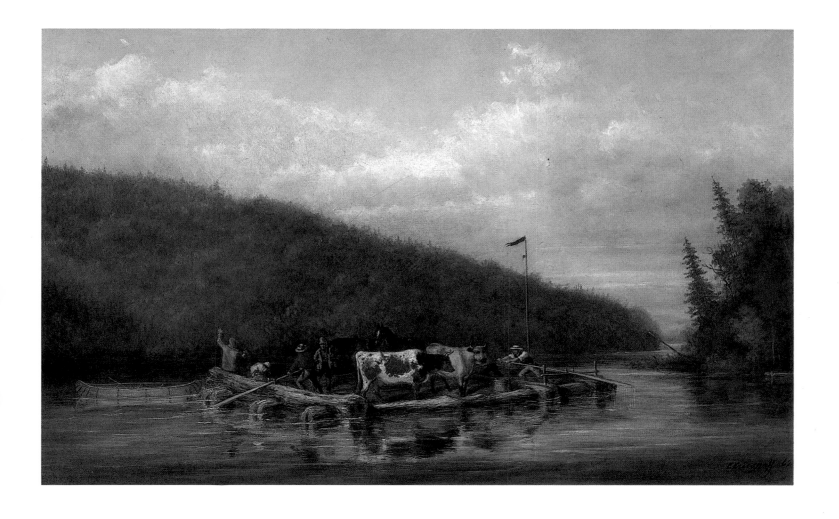

92 *Home from the Lumbering Camp* undated
17 × 24 in / 43.2 × 61 cm
Sigmund Samuel Collection, Royal Ontario Museum, Toronto

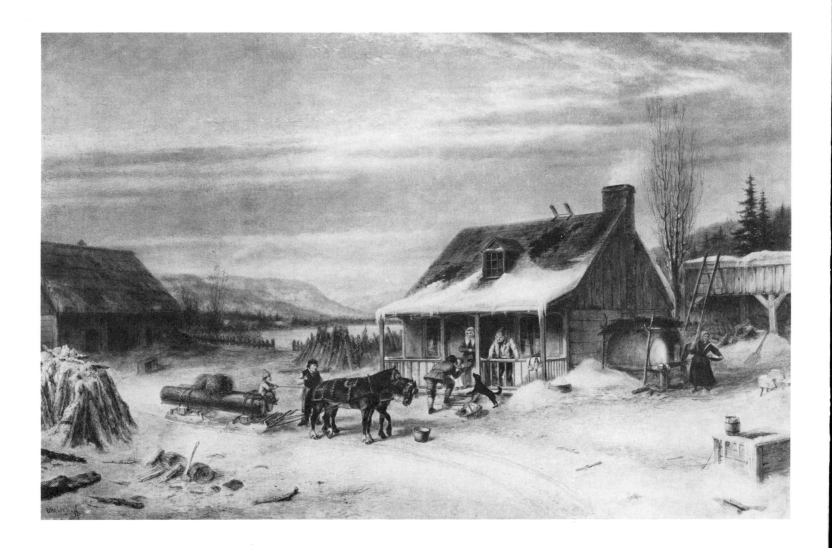

93 *Argument about a Load of Wood* 1863
$11\frac{3}{4} \times 17\frac{3}{4}$ in / 29.8 × 45.1 cm
The Hon. K.R. and Mrs Thomson

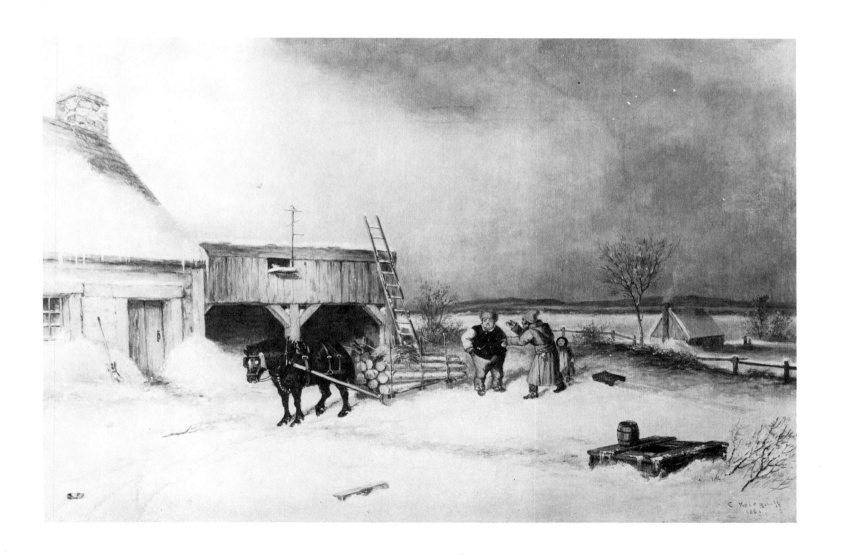

94 *Death of the Moose, South of Quebec* 1859
18 × 24 in / 45.7 × 61 cm
private collection

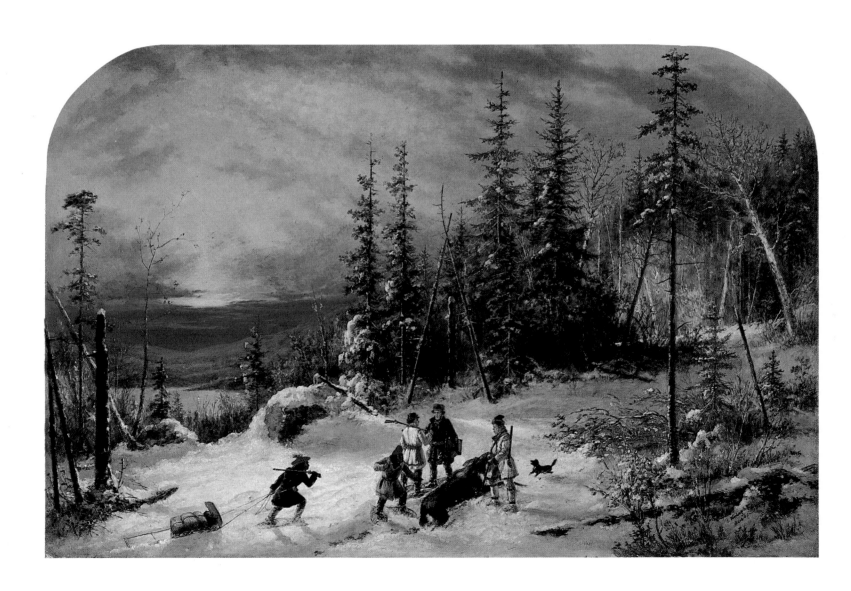

95 *Tracking the Moose on Lake Famine South of Quebec* 1863
14 × 21 in / 35.6 × 53.3 cm
McCord Museum, McGill University, Montreal

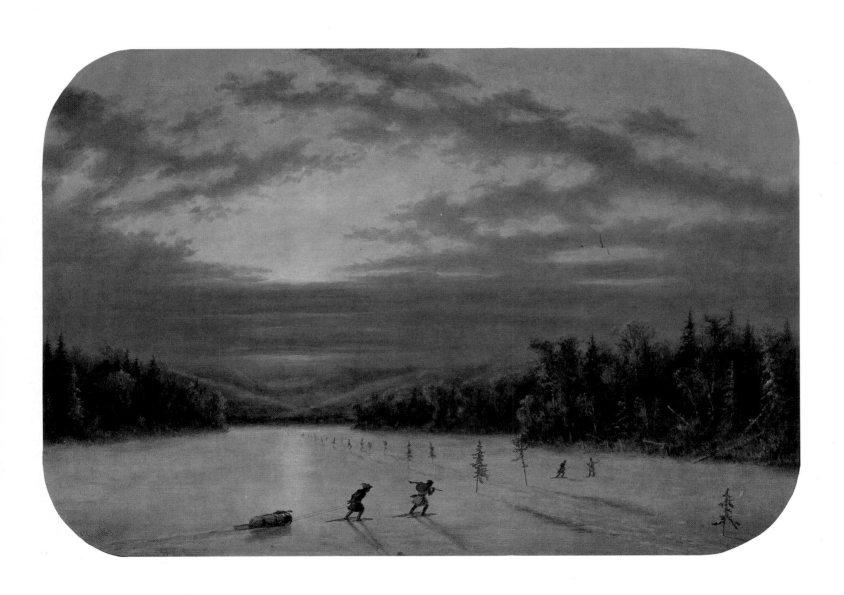

horse, Fraser, who had created a sensation at the Quebec Races held on the Plains of Abraham in August 1854. As the season's major sporting occasion, attended by wealthy horsemen, much fine blood stock, and heavy betting, the event had attracted a great crowd (though ladies are said to have shunned the field because of rowdiness). The seven-year-old chestnut gelding had failed in his first two races. But on the third day, pitted in the hurdle race against Lady Franklin, owned by the Honourable R. Harbord of the 71st Regiment, Fraser had taken the lead, had stumbled and lost ground, but then had recovered to win a thrilling see-saw battle.[42] Robert Todd, who had been painting horses for Quebec breeders, had already moved to Toronto, so Krieghoff was asked by Mr Kirwan, the owner, to paint the winner.

In Krieghoff's painting the jockey, Mr Miller, dressed in the owner's red and black racing colours, poses on the Plains of Abraham on the back of the prize-winner (fig. 96). The artist astutely emulated the numerous fine prints of racehorses then popular. Many of these, published as wood-cuts in *The Illustrated London News*, were based on the canvases of the fashionable English painters Benjamin Herring (died 1871) and his father, John Frederick Herring (1795–1865). Kirwan may have gazed at his painting and imagined himself with a winner in England at the Derby or the St Leger Stakes. But, on the basis of some evident retouching, there must have been a problem. Probably Krieghoff's draughtsmanship followed a Herring prototype so closely that Kirwan asked him to repaint the head to make the horse look more like Fraser. If the canvas is examined closely, one can detect overpainting on the head to make it smaller.

The hardier Quebec sportsmen took to the woods. Krieghoff himself enjoyed hunting, and is said to have been a fine marksman with an exceptionally keen eye. His first winter in Quebec he went to the woods near Lorette with two politicians who were also prominent businessmen: the Hon. John Irvine and Colonel William Rhodes. Some other friends were also in the party. In the painting of the occasion (fig. 98), commissioned by Irvine, the hunters warm themselves by a recently built shelter. Rhodes kneels outside to buckle his snowshoes while John Budden discusses strategy with James Gibb and a guide from the Indian village. A boy cuts firewood. There is an iron pan ready to fry freshly killed meat for supper, to go along with the salt pork, mutton, sea biscuit,

96 *'Fraser' with Mr. Miller, Up* 1854
$25\frac{1}{2} \times 32\frac{1}{4}$ in / 64.8×81.9 cm National Gallery of Canada, Ottawa

coffee, and liquor which experts advised for such outings in the many contemporary books on the subject.[43] Light-weight boxes are filled with straw packing to prevent breakage of the many black bottles and fine glass goblets; already some empty flasks have been discarded. Krieghoff's record was so detailed that even the faces are miniature portraits. A delighted Irvine reminisced about the painting for years, and Krieghoff established a reputation as a painter of the hunt.

That outing was typical of hunting parties organized throughout the winter, and many good stories were told of such adventures. William Kingston, during an extended wedding trip to Canada, described dining with the 71st Regiment in the Quebec Citadel on 22 December 1854, just before the Crimean War necessitated the unit's recall to England. The colonel and some of his officers were in high spirits after hunting caribou and moose some sixty miles down the St Lawrence and thirty miles inland: they had travelled on snowshoes, camped out for eight nights, and returned towing the haunches of five caribou on a toboggan. Krieghoff painted such hunters returning with their kill (fig. 99). Some years earlier twenty-three officers had reportedly killed

97 *The Dead Stag* undated
$8\frac{7}{8} \times 10\frac{5}{8}$ in / 22.4 × 27 cm
Art Gallery of Ontario, Toronto

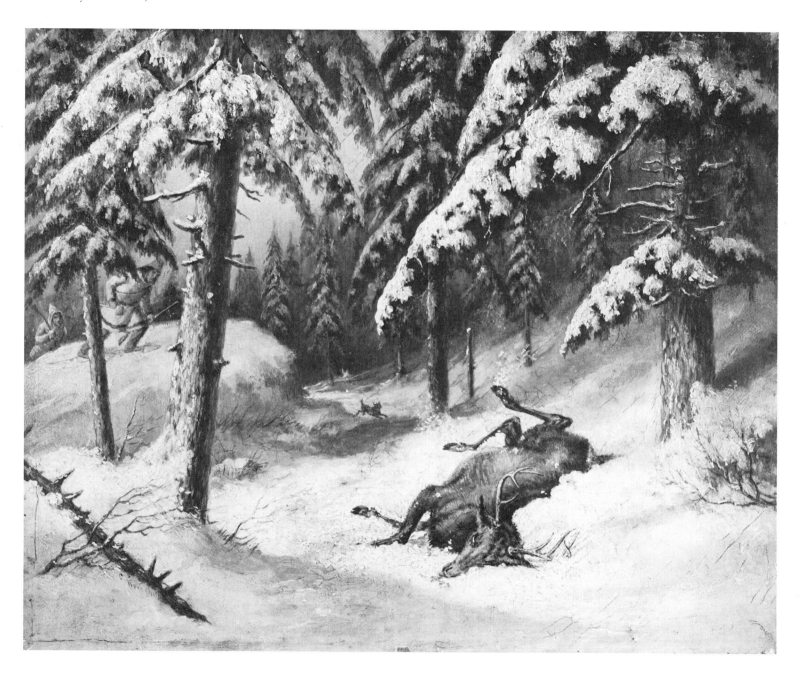

98 *Sportsmen in Winter Camp* 1853
18 × 27 in / 45.7 × 68.6 cm
private collection

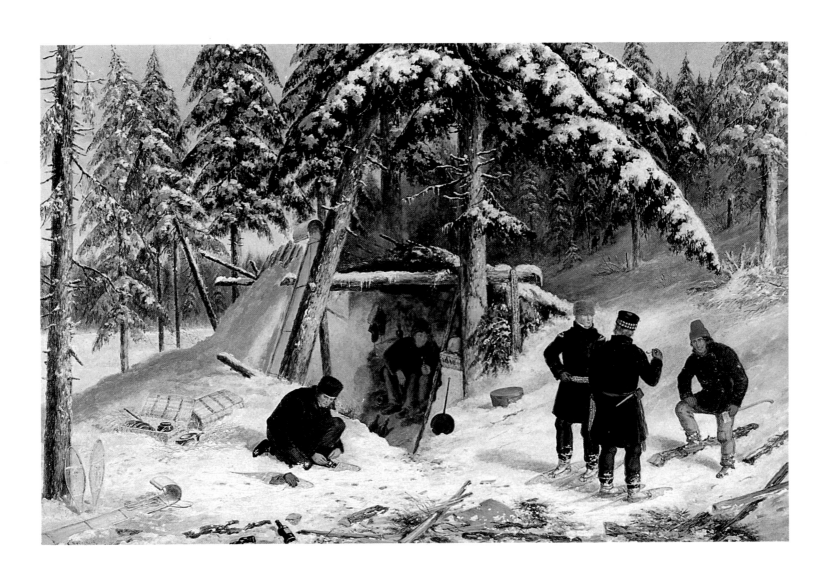

99 *Returning from the Hunt* undated
13 × 18½ in / 33 × 47 cm
private collection

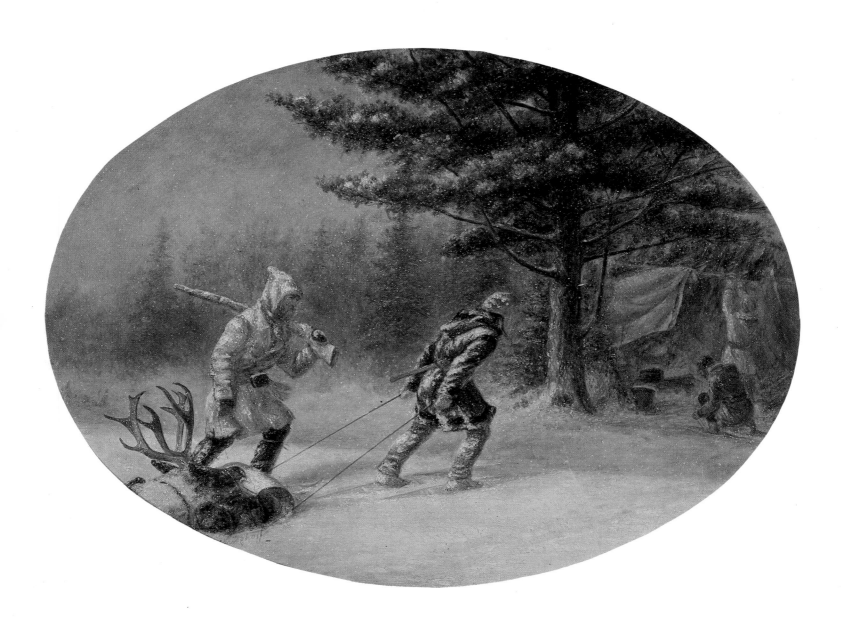

forty-three moose on a brief hunting trip. Kingston did not care for moose, which he described as the 'ugliest-faced member of the species,' like a 'demon deer,' and such mean customers that they would carry on after a ball shot had passed right through their flesh.[44]

The most famous of Quebec marksmen was Colonel Rhodes, president of the Quebec Game Club, who was known as the 'mighty hunter.' In 1865 he allegedly killed four caribou with a single shot. An equally tall tale was told by a bystander who described seeing a habitant driving a sleigh topped with antlers along a Quebec street: there followed a second sleigh, and a third, until twelve passed by, loaded with caribou. Two more sleighs in the bloody procession were piled high with hare, grouse, and ptarmigan. The final sleigh contained a wolverine and 'le colonel Rhodes' himself, who seemed determined to kill every animal in the country.[45]

Despite Kingston's low opinion of the great beast, moose hunting was the most princely of all game sports in eastern Canada, and Krieghoff depicted it in several elaborate canvases. In one, hunters fire a volley at a bull moose and its mate struggling through the deep snow of the Montmorency River valley. In another, an Indian guide is about to butcher an animal as two moose hunters gaze at their prize (fig. 101); the errand boy hunts out a bottle for a victory toast, while an old habitant admires the great span of the animal's antlers, a suitable trophy for some wall. Krieghoff was moved sufficiently by the old man's gaunt, wrinkled face and grey hair to paint a little portrait study of him in which he has the bearing of an ancient patriarch (fig. 100).

One painting, *Death of the Moose, South of Quebec*, is autobiographical (fig. 94). Krieghoff and his friends, Budden and Gibb, admire a recently downed moose against a backdrop of a splendid setting sun. The dog barks excitedly and a guide comes forward with a toboggan to carry the animal away. The locale is supposed to be Lake Famine near the Maine border,[46] but the topography is curiously similar to that in several canvases of hunting parties on the shore of Lake St Charles, north of the city (other scenes attributed to Lake Famine share this confusion). This painting provides one of the best self-portraits of Krieghoff himself.

Lake St Charles was a favourite game area. In some paintings caribou hunters are strung out on the ice of the lake against a sky illuminated by a flaming red sunset (fig. 95) – brilliance that matches the autumn colours in Krieghoff's

100 *The Habitant* mid-1850s
11¼ × 9⅜ in / 28.6 × 23.8 cm
Sigmund Samuel Collection, Royal Ontario Museum, Toronto

landscapes of the same period. Other hunting scenes picture sportsmen tracking wounded caribou in blinding blizzards and hunters running excitedly through the woods to catch up with a buck deer that has just been felled (fig. 97). In one painting a guide stands with toboggan and snowshoes waiting to set out across Lake St Charles from a hunting lodge owned by Thomas Sewell, the descendant of a former chief justice (fig. 102). Krieghoff also painted more humble hunters: habitants and Indians, rifle on shoulder, often with a pair of rabbits slung over the barrel.

101 *Moose Hunters* late 1850s
$13\frac{5}{8} \times 18\frac{1}{2}$ in / 34.6 × 47 cm
private collection

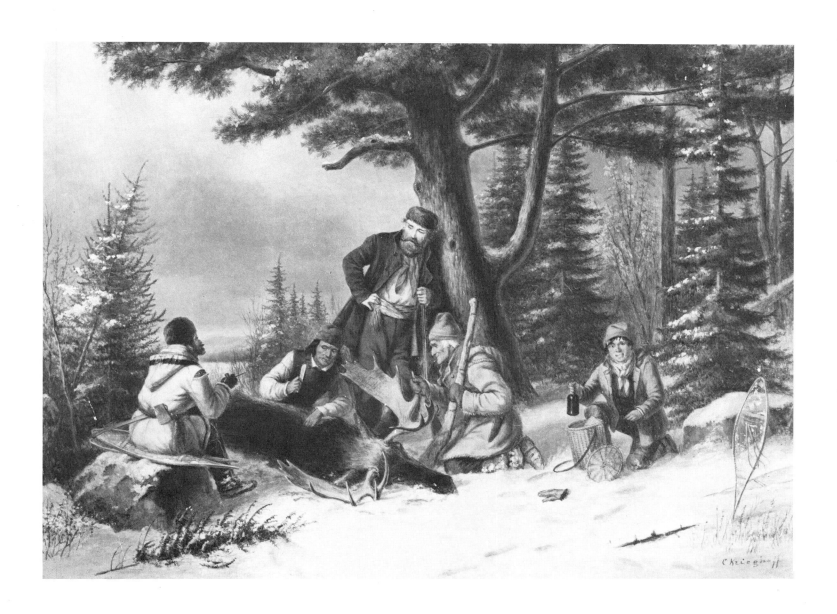

102 *Indian Hunter Guide* 1863 private collection

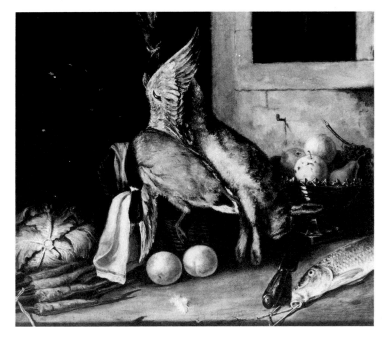

103 *Still Life (from Nature)* undated
$15\frac{1}{4} \times 17\frac{1}{4}$ in / 38.7 × 43.8 cm The Hon. K.R. and Mrs Thomson

No Krieghoff paintings are known of sportsmen actually hunting game birds, although it was a popular and productive pastime. Frederic Tolfrey, an English visitor, and some friends once took a boat down the St Lawrence fifteen miles to Château Richer after birds: Tolfrey bagged thirty-one pair of snipe while another man got twenty-four. Krieghoff did paint still life groups that included snipe and ducks as well as other bounty of the hunt. His most successful such still life included a duck, a fish, and various vegetables, the items providing a range of colours, tones, and textures that enhanced the whole (fig. 103).

The sportsmen who took to the woods with their guns in winter were often the same men who fished in summer and autumn. The anglers set out with rods, nets, and creel after the trout and salmon in Quebec's lakes and forest streams. Favourite spots were Lakes Magog and Memphremagog, south of Sherbrooke in the Eastern Townships. To reach the latter lake, the fishermen took the morning train to Sherbrooke, thence a stage to Magog Outlet, where they boarded the little steamer *Mountain Maid*. Gaily decorated with evergreens and flags, the boat steamed slowly through Lake Memphremagog while passengers leaning against the rail took shots at birds; the captain would obligingly stop the craft to retrieve the hunter's take. Eventually the little ship reached a large summer hotel called Mountain House at the foot of towering Owl's Head Mountain, where the sportsmen found lodging. From there they set out to catch pickerel and muskelunge in the large lake or trout in adjoining smaller bodies of water.[47] Krieghoff painted fishermen on the shores of these lakes (fig. 104), but the romantic majesty of the Owl's Head itself, with autumn foliage at the base and clouds swirling around its peak, proved a more popular subject (fig. 105). On several canvases he emphasized the height of the moun-

104 *Sunshine and Showers, Lake Memphremagog* 1861
14 × 24¼ in / 35.6 × 61.6 cm
private collection

105 *Owl's Head, Memphremagog* 1859
$17\frac{1}{4} \times 24$ in / 43.8×61.1 cm
National Gallery of Canada, Ottawa

tain by inscribing the elevation of 2800 feet on the reverse.

During the autumn of 1858 Krieghoff went on a fishing trip with two intimate friends to the St Maurice River and the Shawinigan country. It was one of those all-male sporting trips so beloved by the more affluent Quebeckers. An Indian guide was secured at Cap-de-la-Madeleine to take Budden, Gibb, and Krieghoff to the deep pools twenty miles upstream from Trois-Rivières. In a painting of the spot James Gibb thrashes the deep brown water as he sits on a giant tree trunk, part of a log jam clogging the river; the guide watches over the canoe, the food, and the faithful brown jug (fig. 106). Krieghoff has obligingly identified the fisherman by painting the initials 'J.G.' on his creel.

As his friends fished, the artist wandered over the log jams with his sketching portfolio: in some versions of the scene he painted himself crawling over the logs. The trip brought more pictorial dividends than did any other outing with his Quebec friends. As well as discovering fresh and exciting subject matter, he experimented in the use of brilliant colour and achieved results that far surpassed his earlier work. In his painting of Gibb fishing, the surrounding autumn woods glow in riotous reds, oranges, and yellows, which sparkle against the dark green pines and tawny waters. Krieghoff painted eight canvases picturing these lower rapids; in some there are glimpses of the great upper shoot down which the river spilled before disappearing beneath the log jam. Then the party went further afield to the waterfall named after the legendary Grand'Mère rock that jutted spectacularly from the brink (the whole has now been obliterated by hydroelectric power developments). Numerous pictures of Indians portaging were painted in this beautiful setting. And it was on this same fishing trip that Krieghoff began to paint the newly built homes of the habitants who were pioneering settlement in the region.

Much closer to Quebec City were the placid waters of Lake St Charles. Krieghoff painted many canvases of sports fishermen there, including Major F. Robinson of the Scots Guards in 1860. His particular friends preferred fishing at a place on the lake called The Narrows: the Indian guide, Gabriel, selected choice spots near Campbell's Point, so named after a notary, W.D. Campbell, who had a summer house there. In one canvas his friends are fishing from canoes while the artist sketches (fig. 137). In another the anglers are near the famous 'Big Rock' on the shoreline (fig. 107); two

men prepare the gear while a third is already poised on a raft with his rod.

As the moose were to the hunters, so were the salmon to the fishermen. Jacques Cartier River salmon were so celebrated that any particularly large specimen caught in the St Lawrence was presumed to have spawned in that river. The road to Montreal crossed the Jacques Cartier at Dery's Bridge near Donnacona where was located the best of all salmon pools. Some anglers stayed nearby at a little inn with a whitewashed parlour 'adorned with stuffed birds, fishing tackle, records of large fish caught, and such sporting trophies.' A sportsman could have his catch 'cooked for supper and sleep in the lull of the torrent neath his chamber window.' Frederic Tolfrey left Quebec at 4:30 in the morning, drove to Dery's Bridge, hooked a sixteen-pound salmon, and consumed cold joints, poultry, tongues, ham, Madeira, bottled stout, Hodgson's pale ale, and excellent brandy in the inn. His fish were roasted on a spit: 'No fish dinner at Blackwall or Greenwich ever produced such appetizing samples of piscatorial elegance as did these juicy pieces of Jacques Cartier salmon, cooked by the hands of the rude Indians in the North American woods.'[48] John Budden reminisced about a day's fishing trip there, with fond memories of a bottle gurgling like a baby wrapped up at his side. Krieghoff's earliest picture of the fishing pool at Dery's Bridge is dated 1863. By then the inn had disappeared and the salmon stock had been reduced to dangerously low levels by upstream spearing and netting; but a certain aura lingered over the spot where the stream plunged between narrow rock walls, and hopeful fishermen still lurked along the shores.

There is an air of gentility in scenes of pleasant summer and autumn outings when ladies were present. Picnics and sightseeing expeditions were a favourite diversion for leisured Quebeckers and army officers with much free time in a peaceful garrison. Krieghoff often went along and no doubt enlivened the occasion with his wit and conversation. Many of his landscape subjects originated on visits to well-known beauty spots along the St Lawrence, on Lakes St Charles and Beauport, and in the Laurentian hills.

James Buckingham described a typical trip to Lake St Charles, with 'a most agreeable party of ladies and gentlemen, whose acquaintance we had the good fortune to form in Quebec, and whose intelligence and lively spirits added much to the delight of our journey.' Some rode on horseback,

106 *The Falls of the Little Shawinigan* c. 1858–9
19½ × 23¾ in / 49.5 × 60.3 cm
The Hon. K.R. and Mrs Thomson

107 *Fishermen on Lake St. Charles* late 1850s
private collection

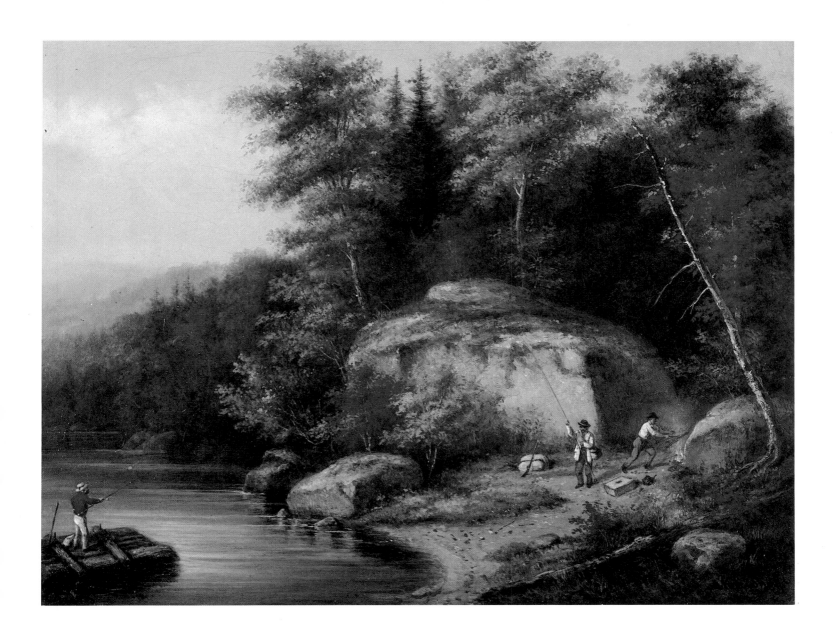

108 *Falls of Lorette, near Quebec* 1854
$12\frac{1}{4} \times 15\frac{3}{16}$ in / 31.1 × 38.6 cm
Musée du Québec, Quebec City

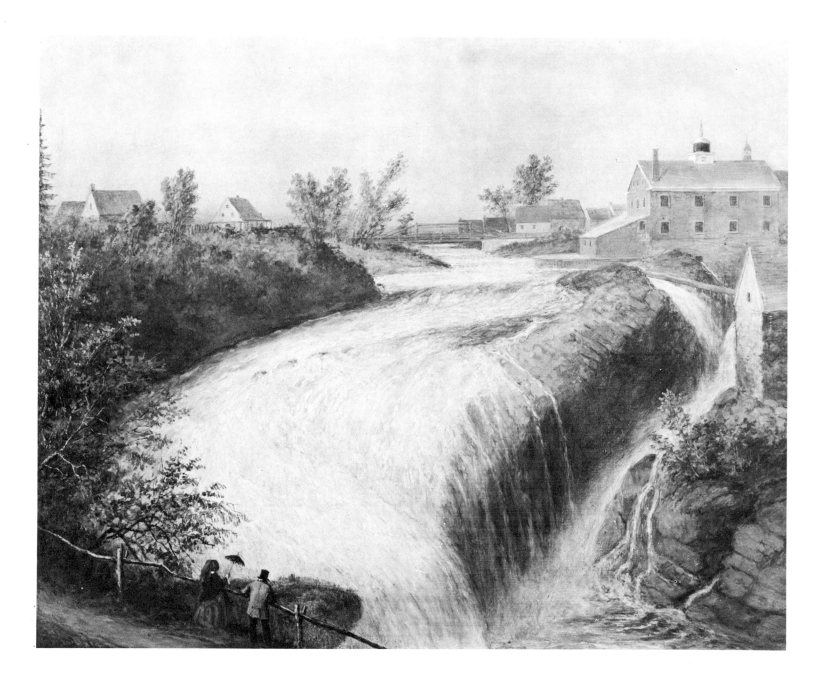

others in carriages, as they followed the St Charles River past 'deep, woody, and romantic ravines' and over mountainous stretches. At the lake they halted to admire the sunlit autumn foliage backed by snow-capped hills in a region peopled with only a few Indians and an occasional trapper. On the return trip they spent two or three hours at Lorette, where their interest centred on the Indians, although even at that time they had intermarried much with the French; nearby was the village of 'Canadien' or 'French' Lorette. At the chief's house in the Indian area near the waterfall they purchased souvenir quill work: mainly articles of Indian dress and ornaments in leather worked with porcupine quills and richly coloured moose hair as well as birch and basket work of fanciful forms and devices. An old Indian guided the visitors through the little chapel with its carved 'House of the Virgin,' and he told them how the house had once been swept hundreds of miles through the air by Satan before good spirits had wrested it from him and returned it. The party descended the slope to see the Lorette waterfall from the best vantage point.[49]

It was a 'romantic and pretty torrent.' Even Isabella Lucy Bird, who visited the falls within weeks of the time Krieghoff painted it, had to grope to find adequate words to express her reaction. It was Indian summer, she wrote, and the air was soft like the breath of May: 'Beautiful Lorette! I *must* not describe, for I *cannot*, how its river escapes from under the romantic bridge in a broad sheet of milk-white foam, and then, contracted between sullen barriers of rock, seeks the deep shade of the pine-clad precipices, and hastens to lose itself there. It is perfection, and beauty, and peace; and the rocky walks upon its forest-covered crags might be in Switzerland.'[50] The travellers brought hampers of food in their carriages and ate heartily in the 'neat and clean dwelling of one of the inhabitants of the village before the three hour drive back to Quebec.'

Krieghoff painted Lorette shortly after moving to Quebec, and completed a second version a year later. Both pictures show the village from the tourist lookout; they differ only in the onlookers. In one an Indian gazes at the waterfall, in the other a fashionably dressed European couple, the lady protecting her complexion with a parasol, stand in the same spot (fig. 108). The composition resembles Bartlett's view of Lorette, but with sufficient variation to make it uncertain whether Krieghoff relied on Bartlett's as a prototype. Later he painted two canvases of the part of the village further

upstream called 'Canadien Lorette,' where lived some five hundred people of pure French descent (fig. 109). Habitant houses border the stream, the villagers go about their business, and children dash towards the school operated by the Christian Brothers.[51]

The most indefatigable of the sightseers was Lady Frances Monck, sister-in-law of the governor-general, who stayed in Quebec for several months while on a visit to Canada during 1864 and 1865. She visited 'Picnic Rock' at Lake Beauport where Krieghoff and his friends went for picnics. The rock, the focal point of these trips, was an enormous flat boulder overlooking the lake onto which the more venturesome gentlemen climbed despite top hats, dark coats, and clean grey trousers; their timid lady companions in voluminous skirts and wide-brimmed hats watched safely from the ground. Krieghoff first painted the spot during the green midsummer of 1854. The many people with happy memories of the place prompted him to paint at least six versions by 1860. Increasingly he added more brilliance by introducing autumn colours. Sometimes he wandered down the road through the autumn woods to paint a more distant vista: in one canvas a man walks along the road (fig. 110), while in another painting of the same scene the man is replaced by a carriage carrying holiday-makers to the picnic site.[52]

In his petition to Sir Edmund Walker Head in 1856 seeking aid for his proposed series of Canadian views, Krieghoff had specifically mentioned a group of waterfalls. Though Coke Smyth's print of Montmorency Falls may have suggested this,[53] Krieghoff strove for variety of treatment – and since waterfalls were one of the favourite rendezvous of sightseeing parties, it was natural enough that he should choose to paint them. Visitors to the little hamlet of Château Richer, for example, went on to admire the ruins of the old seigneury house and the falls of La Puce, nicknamed in English the 'Jumping Flea.' In Krieghoff's painting of them a lacy network of water winds back and forth across a hillside (fig. 111).

The Chaudière Falls, on the south side of the St Lawrence near the present-day Quebec Bridge, were also popular. James Buckingham hesitated to visit there because he had received lack-lustre reports of them from friends, but when he did go he was amazed to find the rising mists and gorgeous colouring comparable in some respects to Niagara. Frances Monck and some friends crossed on the ferry to Lévis and reached the same falls by a hired wagon. She was ecstatic: 'No

109 *Lorette in Winter* 1857
24 × 36 in / 61 × 91.4 cm
Power Corporation

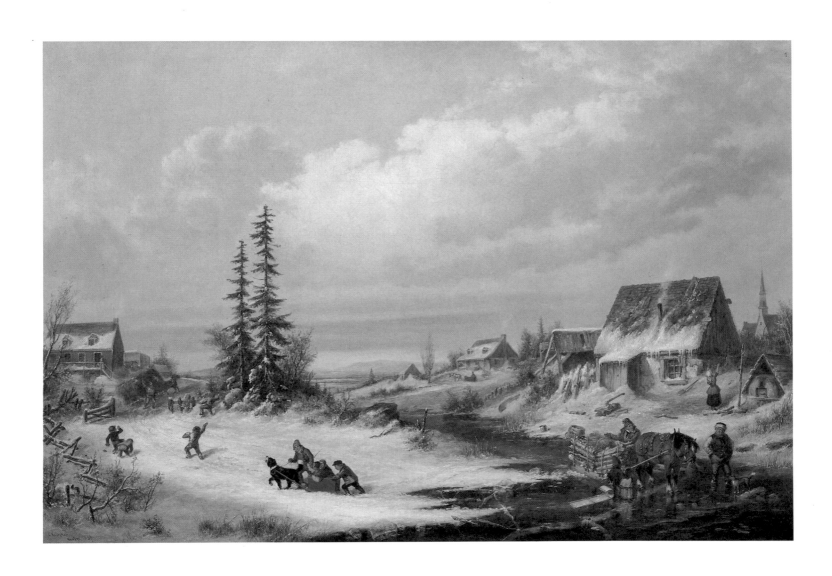

110 *Lake St. Charles, Quebec* 1862
13½ × 20½ in / 34.3 × 52.1 cm
The Hon. K.R. and Mrs Thomson

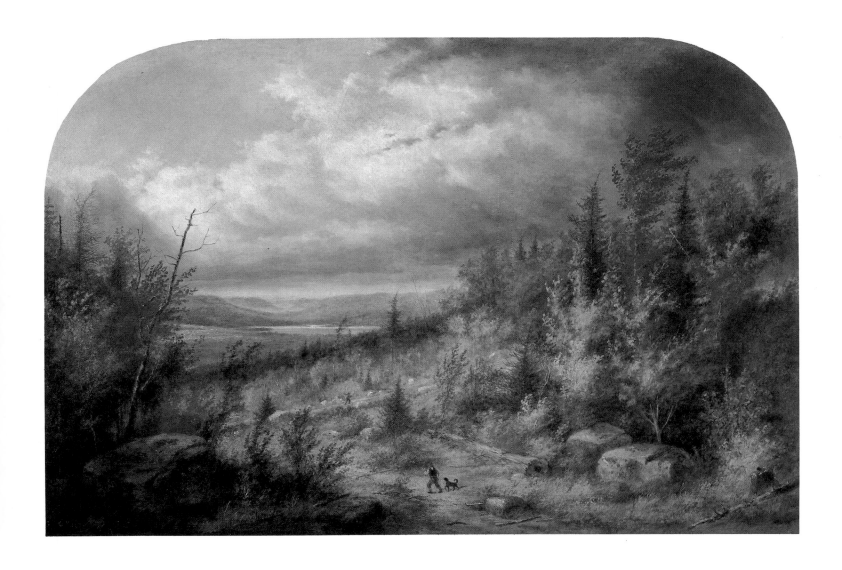

sky so blue as the Canadian sky, and no leaves like the Canadian autumn leaves! Such rich red tints everywhere ... The Chaudière Falls ... are most beautiful. We had to clamber over gates, and were much sprinkled by the spray from the Falls. Lunch was laid on the green grass, and we lit a fire with sticks, and were soon warm and dry.'[54] Krieghoff painted the Chaudière in 1855 and returned to paint it a second time with the new Quebec and Richmond Railway bridge in the background. Like so many other Quebec beauty spots, the Chaudière has been destroyed by a hydroelectric plant.

These views of waterfalls have a romantic beauty, but they lack the elemental fury that transforms into turbulence Krieghoff's interpretations of two waterfalls on the Ste Anne River beyond Ste-Anne-de-Beaupré. In a frankly disturbing canvas of a passing storm at the St Fériole Falls (fig. 112), Krieghoff achieved a wild romanticism. The river lashes against the rocks in an uncontrolled and furious descent, resenting any attempt at restraint by rocky barriers. Trees are whipped by gale-force winds, and bursts of slanting light create a sparkling mosaic of brilliance interspersed with turgid shadows. Broken trees enhance the wild effect as they have in paintings since the days of Salvator Rosa (1615–73). The turbulence of natural forces so permeates every part of the canvas that there is no spot on which the eye can rest. The canvas was painted for Christopher O'Connor when the two men were camping at the spot. Its disturbing effect would have offended some, who would have been more comfortable with a quieter romantic scene of the falls that Krieghoff painted several years later (fig. 113).

The wild views of St Fériole Falls must have disturbed many who sought quiet, cool spaces and the calms that come from the stability of horizontal lines, whether in a pictorial composition or in the soothing elegance of a Georgian drawing room. The cluttered turbulence of these paintings has much in common with the new style of Victorian living rooms of the 1860s, where one is subjected to a mighty clutter of bric-a-brac, velour drapes, tables, chairs, albums, and vases of every shape, size, and colour. They overpower until one can hardly breathe. It is a mood that is reflected in many ways.

These storm scenes, in their subject matter, have themes that were of interest to John Ruskin, the most influential of Victorian English art critics. Ruskin moulded the attitudes of his generation to a new appreciation of the landscape. During 1842 he vigorously defended a painting by J.M.W. Turner

(1775–1851) of a ponderous storm, which wreathed and moaned as it passed. He described Turner's forest wailing and weaving in the evening wind, the steep river flashing and leaping along the valley. In Turner's work he found a deeply religious manifestation of the deity.[55] In Krieghoff's, one may surmise, he might have sensed a 'pagan' overtone, a feeling that seems to emanate from the fact that Krieghoff was dealing with an enclosed space, from which there is no visible escape, a setting suited to an aboriginal man of nature. Turner, despite the ferocity of his storm, showed a glimpse of the open heavens, echoing a visible order of nature and a divine pattern in the whole.

Krieghoff painted the falls of Ste Anne's from above, with the stream flowing towards the precipice; deep cracks split the bare rocky outcropping before the impending leap (fig. 114). The foreground is bathed in bright sunshine, but beyond the forest has turned sombre as an approaching thunderstorm lashes the trees and plunges the whole into darkness. Such cataclysmic manifestations of nature's force and destructive power have Wagnerian overtones: they echo the violence of the pagan gods expressed in the themes and sounds of his operas. The brilliant focuses of light shining through mountain storms were popular with Munich painters at the time, and C.J. Way (1835–1919) also drew on such elemental forces in a canvas of a storm over the Saguenay River, which was exhibited at the Art Association of Montreal in 1865.[56] Ste Anne could be admired as well from another vantage point, by scrambling into the great gorge where gloomy cavernous depths were screened by tree trunks and brilliant autumn foliage. German painters were delighted by such views in the Alps, and in 1865 Otto Jacobi (1812–1901), who had himself studied at Düsseldorf about 1833 under the artist J.W. Schirmer (1807–63), painted Ste Anne's from this perspective. The powerful rock masses in his picture anticipate in colour the 'Brown Decades,' in which the more academic painters preferred sombre colours. Jacobi's detailed reportorial rendition and overpowering sense of solidity are in great contrast to the sparkling romanticism and breath-taking excitement of his countryman's more fanciful version.

In what may be considered the first Canadian novel, *The History of Emily Montague* (1769), Frances Brooke had written about the succession of social activities in Quebec in the 1760s and of the unrivalled scenery. She described a life that closely

111 *Falls of La Puce* 1854
$19\frac{1}{2} \times 15$ in / 49.5×38.1 cm
private collection

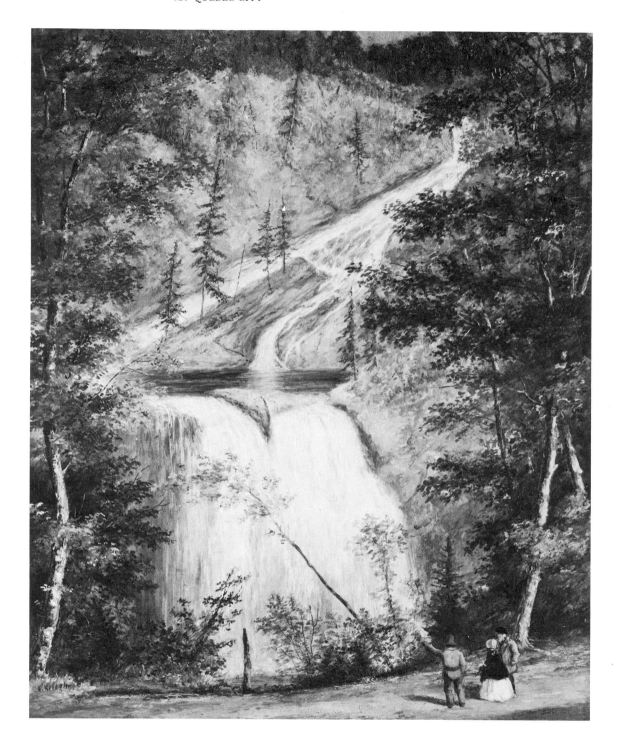

112 *The Passing Storm, St. Féréol* 1854
$15\frac{1}{2} \times 19\frac{3}{4}$ in / 39.4 × 50.2 cm
National Gallery of Canada, Ottawa

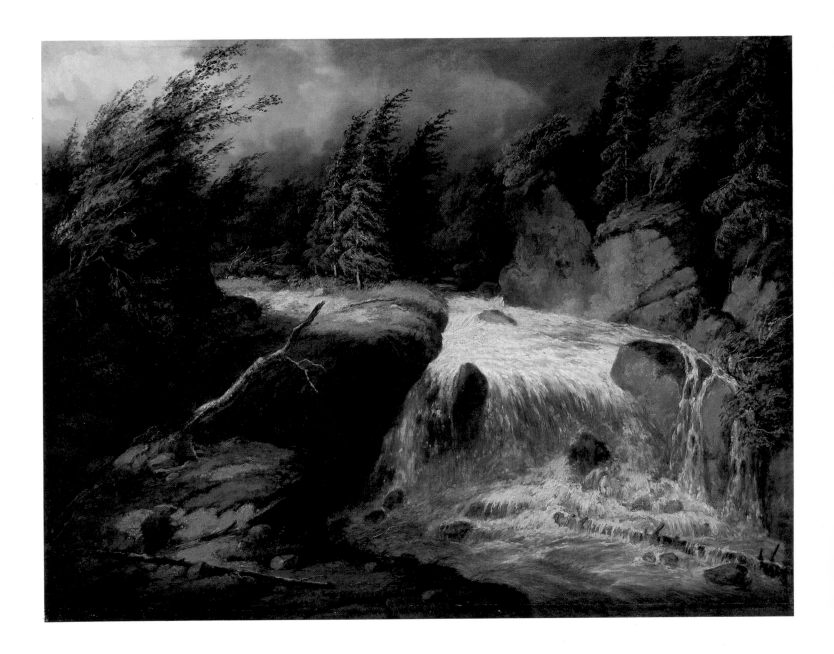

113 *St. Feriole, St. Ann's River,*
below Quebec 1861
22 ×18 in / 55.9 × 45.7 cm
J.C. Barron Collection

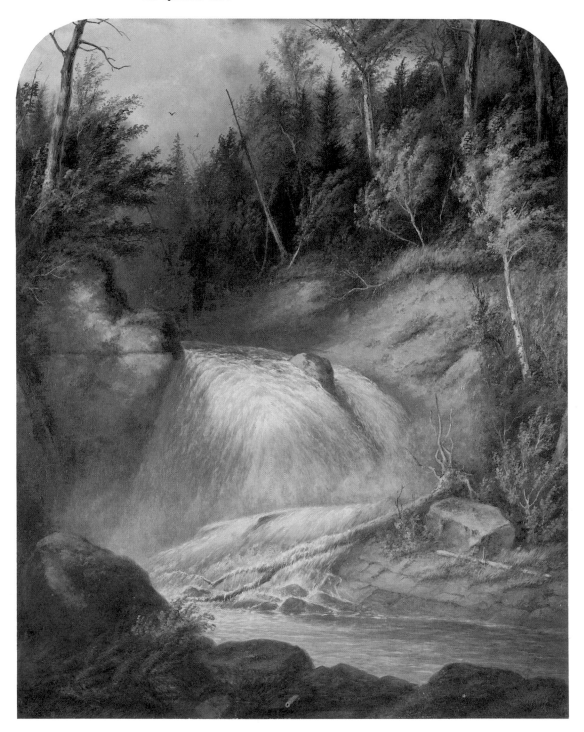

114 *St. Ann's Falls, Looking Downstream from the Grand Rocks* undated
private collection

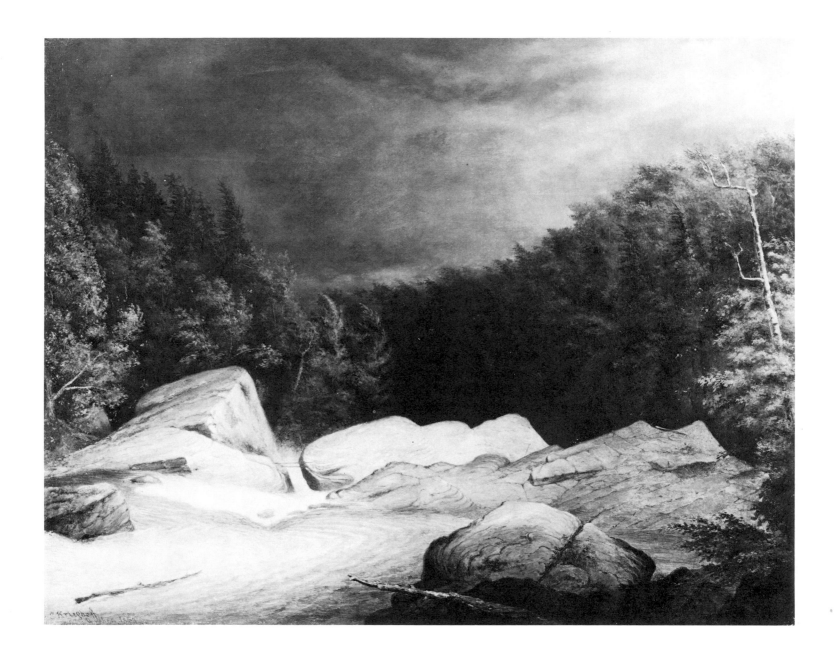

115 *The Coming Storm* c. 1860
$12\frac{1}{8} \times 18\frac{1}{8}$ in / 30.8 × 46 cm
Art Gallery of Hamilton

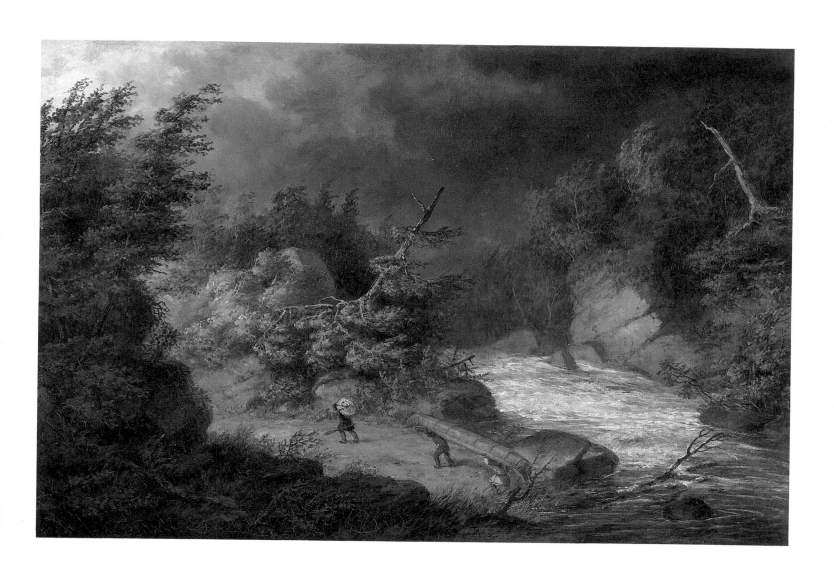

116 *The Indian Woman*
Basket Seller 1850s
$10\frac{1}{2} \times 8\frac{3}{4}$ in / 26.7 × 22.2 cm
private collection

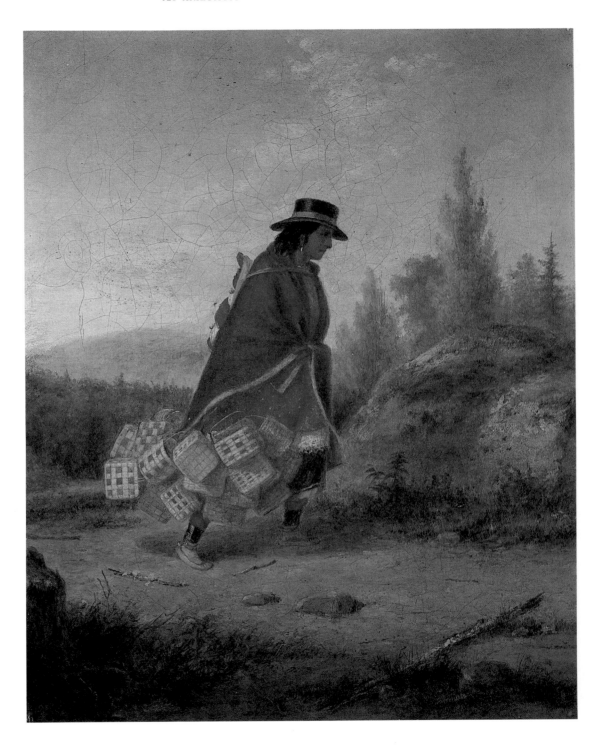

117 *Indian Hunter* 1850s
11 × 9 in / 27.9 × 22.9 cm
private collection

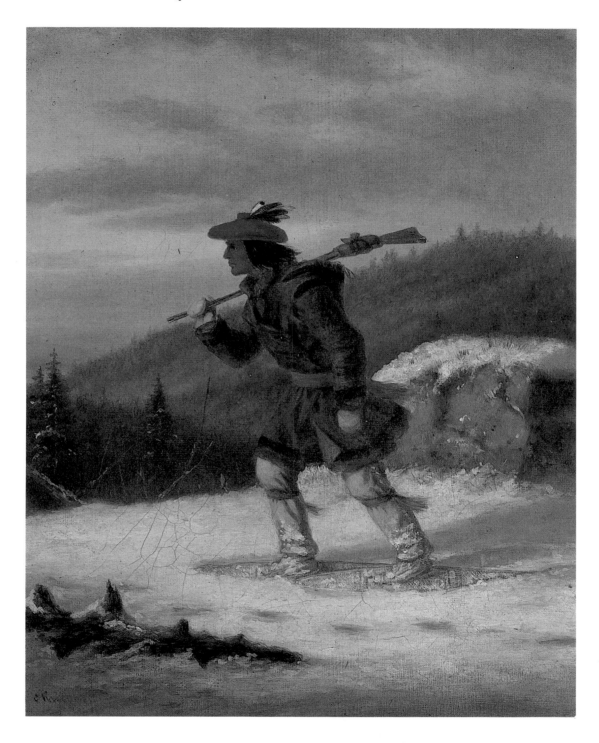

118 *Portage at the Grand'Mère Falls* 1858
13 × 17¾ in / 33 × 45.1 cm
The Hon. K.R. and Mrs Thomson

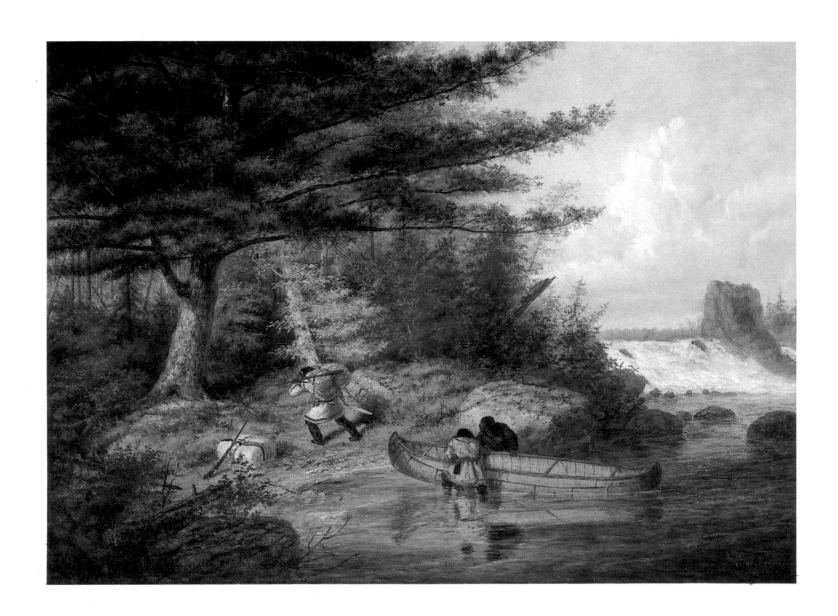

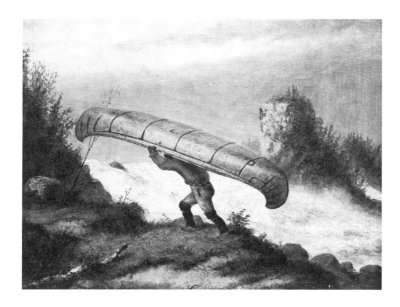

119 *Portaging a Canoe* c. 1858
8 × 9½ in / 20.3 × 24.1 cm private collection

paralleled the society Krieghoff painted almost a century later. But the prevailing concepts of landscape had changed. Mrs Brooke, in her vivid impressions of waterfalls and cliffs and great natural expanses at all seasons, wrote of the 'great sublime' of scenery, using the term as had Edmund Burke and William Gilpin: the massive works of a supreme being overpowering fragile man. Krieghoff's was a nineteenth-century interpretation; he overlaid his canvases less with awe than with high romance, consistent with the artistic mood of his generation.

During his years in Quebec City Krieghoff continued to paint Indians. Increasingly he viewed them romantically and at the same time he shrunk them into larger landscapes. In his habitant canvases the people and their activities are brought forward and form the central theme of the painting; but the Indians are portrayed as part of nature. In one scene Indians scurry up a portage trail with a canoe as a furious storm envelops the forest (fig. 115): one senses that this began as a painting of a waterfall and a thunderstorm, and that the people are an afterthought.

Nevertheless, he continued to paint small canvases of single Indian figures. Women in black hats and blankets wander up hills laden with great festoons of baskets (fig. 116), or carry cradle boards as they pick their way through craggy mounds of ice cakes crossing the St Lawrence in front of the city. They are reminiscent of the women in the Montreal streets, but are infinitely more appealing as a result of increased detail and unsurpassed craftsmanship. There are also lone hunters in a snowy wilderness, wearing tams decorated with bright ribbons (fig. 117). These small canvases were often dashed off with incredible rapidity when finances were low, but on other occasions the artist threw his heart into the work, painting single figures with care, pride of workmanship, and a more acute artistic sensibility (see also fig. 139).

Inspired by his fishing trip to the Shawinigan country with Budden and Gibb in 1858, Krieghoff painted a spectacular series of canvases depicting Indians portaging around the Grand'Mère Falls (fig. 118). Krieghoff had visited the spot years before and at that earlier date he painted Indians at the edge of the falls itself, but the early rendition was dull compared to the new work. Eventually he painted at least sixteen versions of the Indians landing their birchbark canoes at the beginning of the portage trails along the St Maurice River. One group he labelled 'Hudson Bay Co. Voyageurs,' possibly to attract potential buyers among the wealthy fur traders. In a quite different mood, after several canvases filled with spectacular opulence and virtual arrogance of colour, he made a little study of an Indian portaging a canoe on his head along the edge of the rapids (fig. 119); its subtle harmony, with a balance of warm and cool colours, creates a mood that Krieghoff seldom achieved.

More and more Krieghoff's Indians became symbols of noble man in nature. In one canvas, which is stylistically early (fig. 120), a group of Indians sits in a circle in the foreground of a landscape as an orator holds forth, telling a story or imparting ancient wisdom. In later pictures families meet on the ice of Lake St Charles and chat in an idyllic winter setting as the sunset tinges the whole scene with warmth; the sky is echoed in accents of vivid red, yellow, and blue trim on their blankets. Canoes are drawn up on the shores of peaceful lakes at the head of portage trails, and hunters on Lake Magog stealthily stalk their prey in an idealized autumn wilderness (fig. 121). A family is grouped around a cooking pot in front of a bark tent, in an opening in the forest at the edge of a gentle stream (fig. 122) – a scene of domestic contentment.

120 *Indian Council* 1856
24 × 30 in / 61 × 76.2 cm
The Hon. K.R. and Mrs Thomson

121 *Indians Stalking Deer* 1867
14½ × 14½ in / 36.8 × 36.8 cm
National Gallery of Canada, Ottawa
Krieghoff's inscription on spandrel

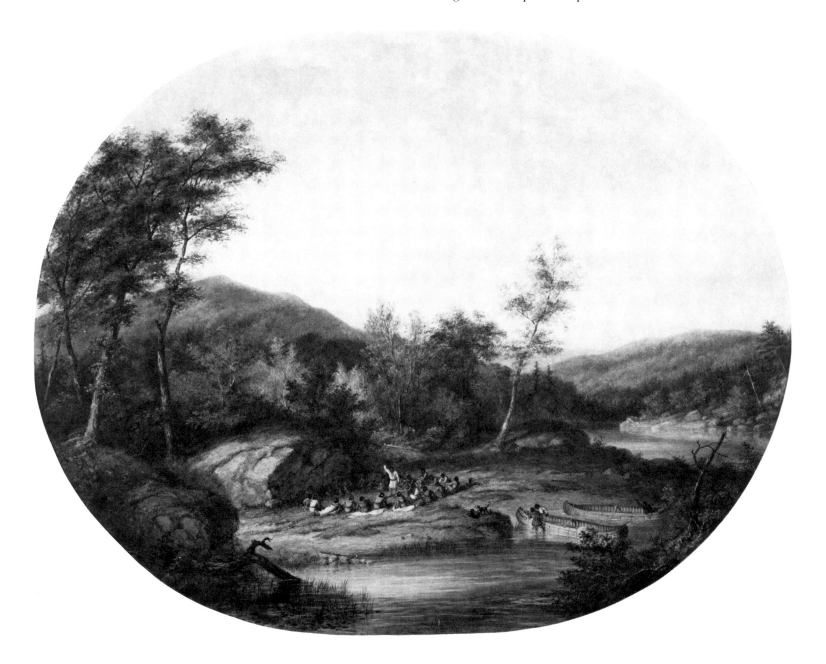

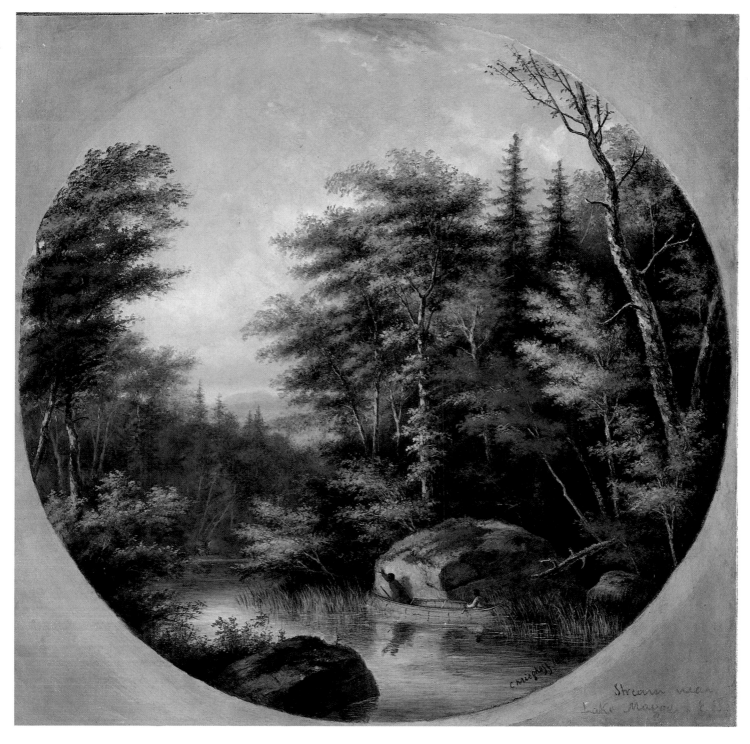

122 *Indian Camp* undated
$17\frac{3}{4} \times 26\frac{3}{4}$ in / 45.1 × 67.9 cm
private collection

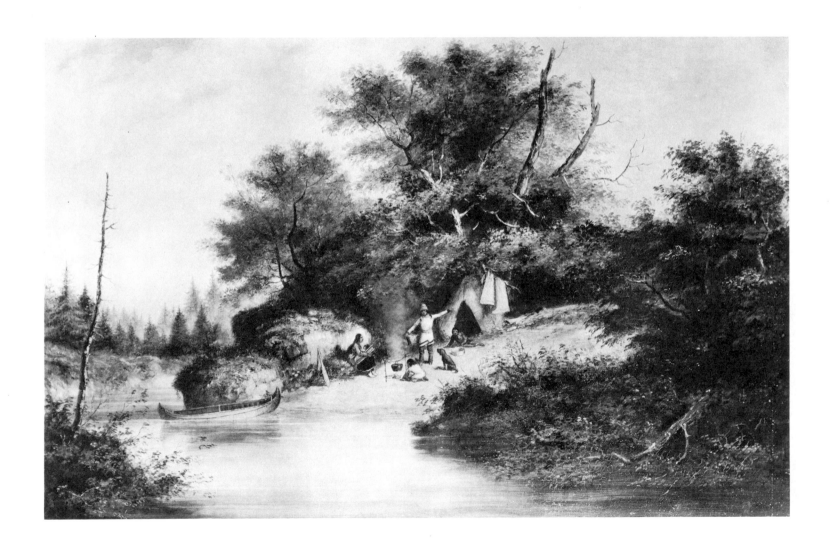

123 *Indians Running a Rapid* late 1850s
9 × 13 in / 22.9 × 33 cm
private collection

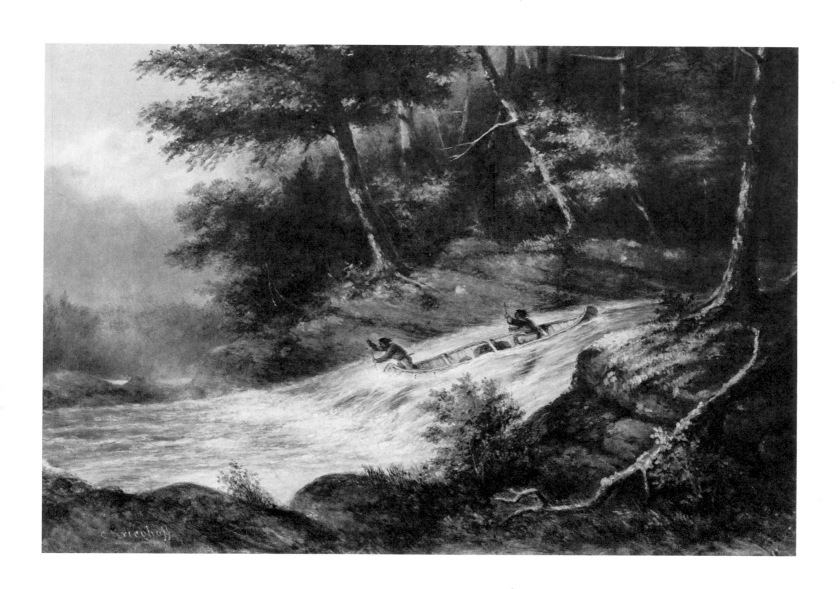

124 *Midday Rest or Indians Camping at Foot of Big Rock* 1864
$25\frac{1}{2} \times 35\frac{1}{2}$ in / 64.8 × 90.2 cm
Power Corporation

125 *Hunting Scene on the St. Maurice* 1860
$17\frac{3}{4} \times 16\frac{1}{2}$ in / 45.1 × 41.9 cm
Power Corporation

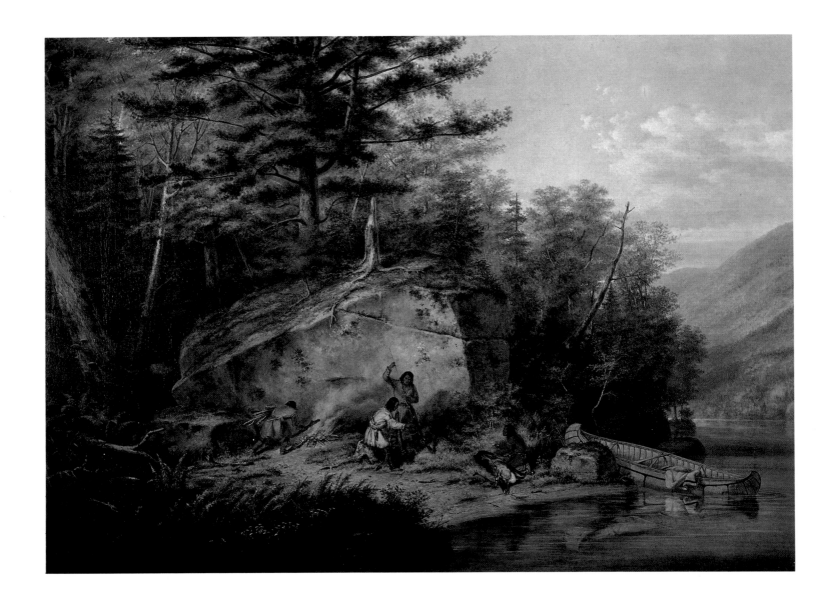

125

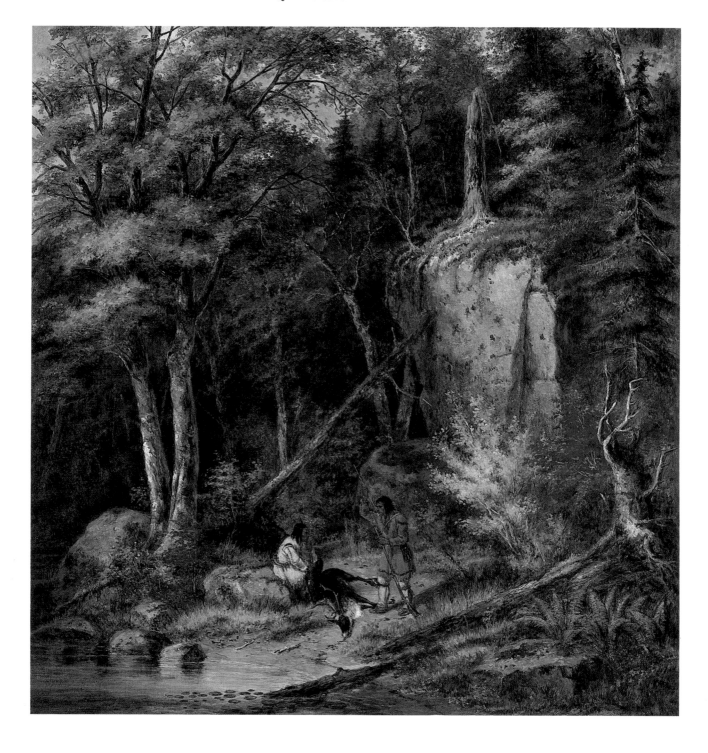

126 *Indians in Canoe on St. Lawrence* undated
14 × 21 in / 35.6 × 53.3 cm
private collection

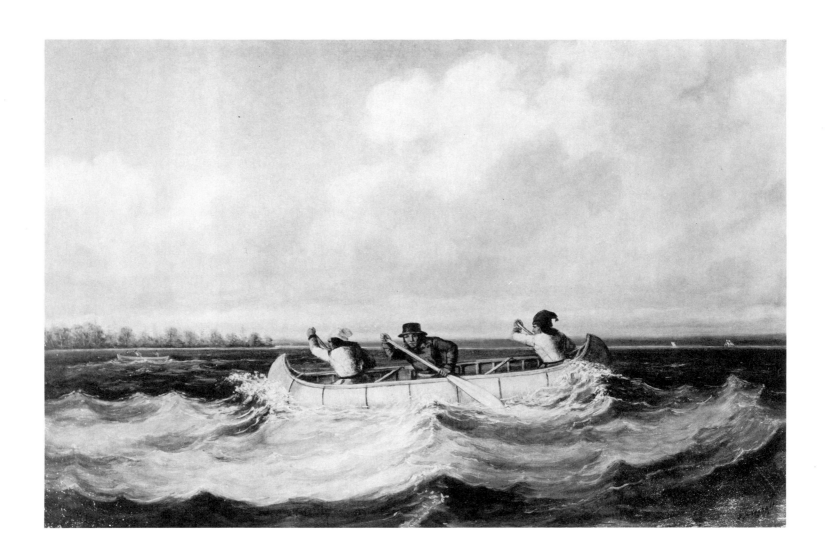

In other paintings of Indians, brave men hurtle down the Montmorency River rapids (fig. 123) or paddle their canoe in the windy, open St Lawrence (fig. 126), carefree men of nature exulting in the simple life of the wild.

One of Krieghoff's greatest series of paintings, large in format, brilliantly coloured, and highly romantic, pictures Indians beside a huge boulder popularly known as the 'Big Rock' (fig. 124). Antiquarians insist they have identified the original stone at several points along various lakes and rivers north of Quebec City, but there is no real consensus. Krieghoff likely moulded the rock from the rough Laurentian shield to suit his compositional needs, perching it near the edge of a cliff or at the water's edge, as an appropriate stage prop for various Indian tableaux. Here again the Indians are perfectly attuned to nature. In one painting they chat around campfires flanked by a caribou freshly killed in a successful hunt. The sunshine warms the scene, as it does in another painting of men reclining in front of a rock wall on a hunting expedition surrounded by autumn splendour (fig. 125). The setting can only be described as a sylvan paradise.

Not even Jean-Jacques Rousseau could have imagined a more idealistic relationship between man and nature. The best of the simplest of worlds bestows her most beneficent bounty on her children, man unspoiled by the complexities of artificial and unnatural civilization. Krieghoff obviously had deep-seated feelings that sympathized with this life. At the same time it suited his purposes to incorporate this view into his paintings, for scenes of the harsh side of Indian life would have been as unacceptable to his patrons as pictures of the Quebec slums. He deliberately excluded all that was uncomfortable: the shivering cold and the howling winds, the huddling in inadequate shelters, the arthritis and sickness from winter exposure, the shortness of lives. Even the Indian in a blizzard on a winter hunt, about to overtake and kill the wounded caribou just ahead, is not puny man struggling for survival against the elements, but triumphant man, the 'noble savage.'

There was a shrewdly practical side to Krieghoff's nature, perhaps born of early association with the businessmen of Schweinfurt. He was a welcome guest at dinner parties, social gatherings, and sporting expeditions; he hoped also to be a man of means. Since he realized that public taste could be fickle when it came to the buying of paintings, he sought a regular income in Quebec by teaching art to young ladies, as he had done at the Misses Plimsoll's school in Montreal. Thomas Brown operated a 'classical academy for young Quebec gentlemen at 2 Ursula St.'[57] His wife ran a complementary girls' school in a separate part of the building: the mixing of the sexes was considered a flagrant invitation to immorality and youthful integrity was a matter of great concern in the middle of the nineteenth century. Greek, Latin, and practical mathematics were appropriate subjects for a young man's curriculum, but the age saw no logical reason for their inclusion in a woman's world. Her education rested on the 'polite' talents thought desirable for a Victorian chatelaine: she learned to sing sweet ballads, to entertain guests, to dance dainty waltzes, to embroider pious mottoes, to paint 'clever' pictures.

Krieghoff was engaged to teach at Mrs Brown's school. As was the custom at the time, he taught by instructing his students to copy attractive paintings. On occasion he placed his own paintings before the class for this purpose. The results were acceptable both to the young ladies and to their fond parents, for the copies more agreeably resembled nature than did the students' fumbling original compositions. A Miss Carter made an impressive copy of the Montmorency Valley in winter, even including Krieghoff's signature. One of the youthful students, Charlotte Victoria Houghton, attended the school in 1854; she worked in pastels and received special instruction from Krieghoff on weekends at Lake Carron near Lake St Charles.

For art to be profitable as a vocation it is essential to have publicity. In order to build himself a clientele in Quebec Krieghoff placed his canvases where they could be seen by the public. The Lower Canada exhibition, held annually in either Quebec City or Montreal, was a popular and well-attended event. Though primarily directed to agricultural products, it gave prizes as well for art work and crafts. Krieghoff had sent canvases to the exhibition held in Montreal during 1853, but on that occasion the judges had preferred Antoine Plamondon's masterpiece, *La Chasse aux tourtes*: its impressive size, academic overtones, precise draughtsmanship, suave finish, and subdued colours appealed to men schooled in earlier styles.[58] Krieghoff's popular and saucy vignettes of everyday life were viewed in a more favourable light at the Quebec exhibition in September 1854 when he won £3.10 in prizes in the animal category for *Canadian Winter Scene* and *Cart*

Horse.[59] Joseph Legaré, the most prominent French-speaking exhibitor, won an equal number of prizes but received £4 since his pictures were entered in categories considered slightly more important. But what really mattered was that the thousands who filed by had had the opportunity to see Krieghoff's work and admire his skills.

Krieghoff had found in Montreal that his canvases based on prints of English and continental paintings sold well. There was much demand in Canada for works with the sentimental narrative subject matter that aped Royal Academy exhibitions. In this aspect, as in others, the English community in Montreal and Quebec followed faithfully the tastes of wealthy English bourgeois families. Even the most prestigious English social leader, the Duke of Wellington, furnished Apsley House, London's most famous residence, with paintings by Landseer, Wilkie, and seventeenth-century Dutch genre artists; they hung among canvases that recorded aspects of the Napoleonic War, in which the duke had a very personal interest. The Gibbs and other Canadian families who purchased Krieghoff's copies of these paintings were creating an artistic milieu in their homes that reflected current English tastes.

Several of his most ambitious copies in Quebec were of works by Sir Edward Landseer (1802–73), the most popular artist in England at the time. Part of his popularity stemmed from Queen Victoria's fascination with his work; eventually Landseer's paintings of dogs and game would line the walls of Balmoral Castle. Royal approbation had an influence in the nineteenth century that can scarcely be appreciated today. However, the prices demanded by the more fashionable London artists far exceeded the budgets of most Quebeckers. Thus Krieghoff painted a particularly delightful copy of Landseer's *Return of the Scottish Hunter* for Mrs Gibb in 1855. At a fraction of the price of the original, she was able to enjoy the old Highlander's aged and expressive face, his brightly coloured kilt, the sheen of his dog's coat, and the textures of the many pots and pans with which his cottage was furnished. Krieghoff copied at least three other Landseer subjects. In his library was a set of books, *The Vernon Gallery of British Art*.[60] The comments in the text about the paintings reproduced are banal in the extreme to the contemporary reader: Landseer's *High Life, Low Life*, for example, is described as significant, not for the artist's enviable technical ability, but because of the subject of the painting, a genteel dog and a battle-scarred

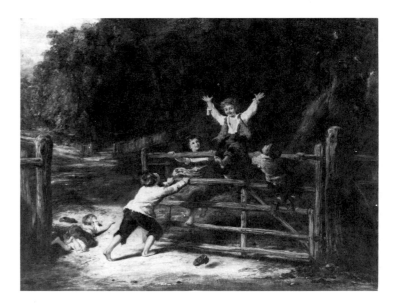

127 William Collins, *As Happy as a King*
Tate Gallery, London

mastiff. What was really at stake – as the Vernon Gallery exposed and Krieghoff recognized – in a successful painting was the ability to please the sentimental tastes of a public which had little interest in art for its own sake.

Another example of a painting with a trivial narrative subject that Krieghoff copied, presumably from an illustration in the same work, was *As Happy as a King*, or *The Swinging Gate*, engraved from a canvas by William Collins (fig. 127). A copy of the picture painted by William Sawyer was exhibited at the Montreal Society of Artists in 1849. The painting had a popularity in the nineteenth century that is astonishing today; it was even published in Germany as a chromolithograph to be used as an early jigsaw puzzle. The subject had a light, breezy, narrative touch: a country lad swings on a gate, recalling a story about King George III. 'Farmer George,' as he was popularly known, stopped to speak to some children on his daily stroll; unrecognized, he asked a boy what most he desired, and the lad replied that if he were king he would swing on the gate and eat fat bacon all day and would then be 'as happy as George.' Krieghoff painted other subjects that appealed to current tastes: in one nostalgic painting, after a canvas by William Clarkson Stansfield (1793–1867), the great

128 *The Last of the Mohicans* 1857
15 × 20 in / 38.1 × 50.8 cm
Sigmund Samuel Collection, Royal Ontario Museum, Toronto

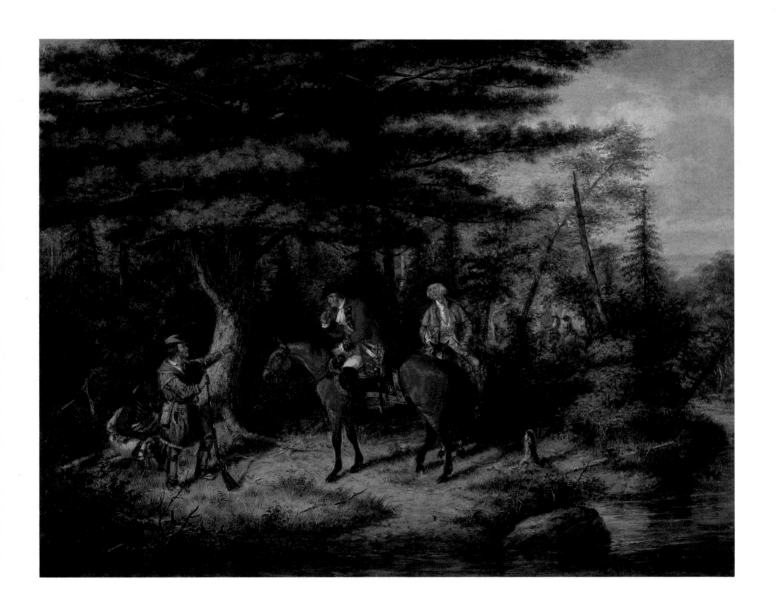

129 Thomas Faed, *Evangeline*
detail of hands from lithograph after painting by Faed

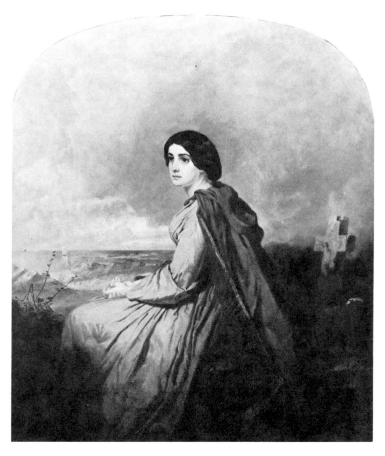

130 Krieghoff, after Thomas Faed, *Evangeline* 1857
23 × 19⅛ in / 58.4 × 48.6 cm Beaverbrook Art Gallery, Fredericton

warship *Le Vengeur* is on its way at sunset to be broken up.

Victorian artists often drew inspiration for subject matter from contemporary literature. Krieghoff had painted a series of copies of illustrations in the mid-1840s based on the life of Mary Queen of Scots, the details of which were drawn from Sir Walter Scott's historical novel *The Abbot*. It was an ideal subject for Canada with its many sentimental Scottish connections. His familiarity with popular literature continued in the 1850s when on another occasion he painted an illustration for *The Last of the Mohicans* by James Fenimore Cooper (fig. 128). The book had mesmerized Americans and fascinated Krieghoff who found an excuse to introduce the wild forest, Indians, and soldiers he had so often painted before.

Another popular nineteenth-century literary subject was Evangeline, the Acadian girl immortalized by Longfellow's poem. The pathos of the lonely maiden left behind as her lover sails away to exile in Louisiana appealed to Victorian sentiment. A painting by the English artist, Thomas Faed (1826–1900), pictured the girl pining on a Nova Scotian shore as the ship disappears on the horizon; a lithograph made from it was used to illustrate the first collected edition of Longfellow's poetry. Appropriately, because of his familiarity with contemporary literature and his understanding of the popular tastes of the time, Krieghoff made a copy in oil (fig. 130). The oddly clasped hands are puzzling, to say the least: it is disconcerting to find three fingers apparently belonging to the right hand rising above the left, and another three digits encircling the left hand below. Krieghoff was accurate in making his copy: the fingers all appear in the original lithograph (fig. 129).

Krieghoff's subject matter was influenced by paintings being sold in the United States as well as in Britain. He had undoubtedly visited the Düsseldorf Gallery in New York,

131 *Quebec from Lévis* undated
view painted on porcelain plate

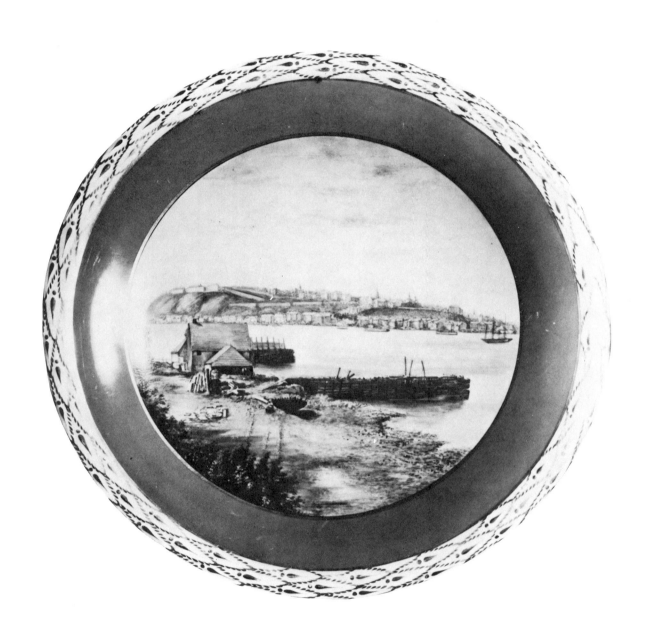

132 *Tubular Bridge at St. Henry's Falls* 1858
14½ × 20¼ in / 36.8 × 51.4 cm
McCord Museum, McGill University, Montreal

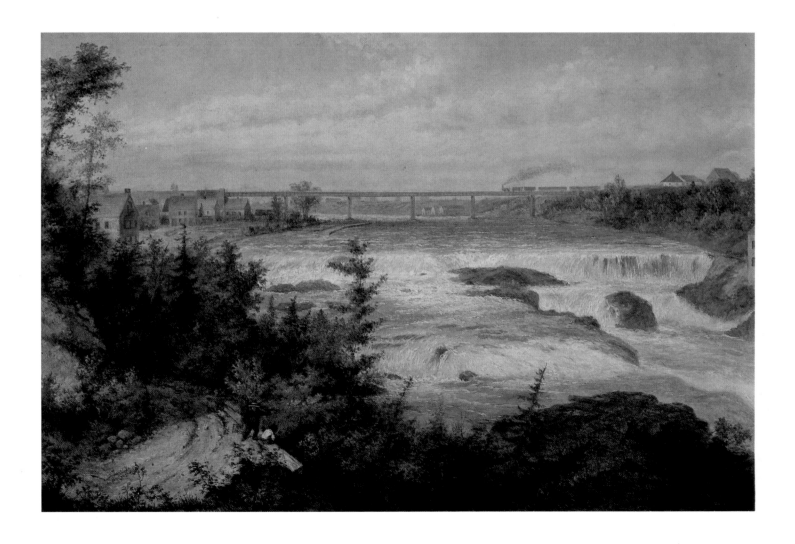

133 *View of Quebec, Canada, from the Railway Station Opposite Quebec,*
the City 1856
$16\frac{1}{4} \times 24\frac{1}{2}$ in / 41.3 × 61.6 cm
private collection

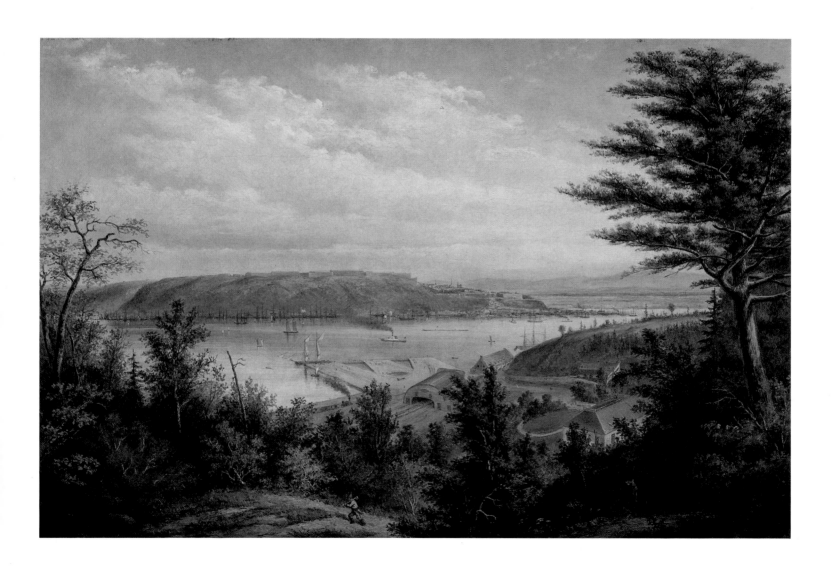

which had been founded in the 1840s to promote and sell the works of the Düsseldorf School. In the 1850s the gallery was expanded to become the Cosmopolitan Association, with outlets in New York and Sandusky, Ohio. A sampling of the paintings offered for sale, both imported and American, closely parallels Krieghoff's range of subject matter. In 1858 the gallery listed copies of *Portrait of a Terrier* after Landseer, *Cleopatra Applying the Asp*, and *Alchemist in Studio*, all subjects Krieghoff had painted. His pictures of Quebec outings resemble *The Picnic Party* by A.F. Tait (1819–1905) and *Night Scene, Hunters in Woods*; his pre-Cambrian shield landscapes are similar to contemporary landscapes of the rugged eastern American terrain such as *Catskill Cascades, Landscape – White Mountain Scenery, Falls of the Catskill*, and *Morning on Lake George*. Cosmopolitan's *Fruit and Flowers* and *The Dead Woodcock* are akin to his still life compositions. Its literature describes *Winter Sunset* as 'A very highly colored canvas, with landscape and skaters,' and mentions *The Smoker*; both might well be Canadian themes. One of its explanatory notes lauds a canvas as a stylistic example in which the 'artist has *daguerreotyped* the Alpenhorn and Sturzbach':[61] this suggests the photographic realism of units that Krieghoff stressed more and more. Not only did he parallel many American subjects; on occasion some of his ideas as to what would be appealing themes pioneered the way on this continent. Repeatedly one is struck by Krieghoff's range of interests, so diverse they befog the mind. Perhaps no other man of his time even attempted to duplicate his versatile performance.

Krieghoff was never a snob when it was a question of making money. He once swept aside all artistic pretensions to accommodate the whim of a Dr Douglas in Quebec who wanted a dinner set decorated with local subjects. Krieghoff undertook the arduous task of painting views on twenty china plates,[62] some based on his own canvases of waterfalls such as Montmorency and St Fériole, others copied from engravings of local monuments. One plate had a view of Quebec as seen from Lévis (fig. 131). The painting of the Beauport Asylum was of personal interest to the patron, for Douglas had founded the first asylum there at the old Giffard seigneury, which was near the 'Jolifou Inn.' This collection of painted china must have been a unique conversation piece at dinner parties.

The 1850s were the first important era of railway building in Canada and it is fitting that Krieghoff expanded his subject matter to include these harbingers of a new age. In a canvas romantically entitled *The Invasion of the Happy Hunting Ground*, Krieghoff portrayed Indians on top of a hill watching a train crossing their land. He also painted a train traversing the new railway bridge over the St Henri Falls on the Etchemin River south of the St Lawrence (fig. 132); there is a hint of nostalgia since the two children in the foreground are engaged in the ancient game of 'chardonnerie,' holding a cage containing a female goldfinch as a ruse to catch a curious male. Krieghoff's panoramic view of Quebec City from Lévis with its new railway station is another reminder of progress (fig. 133). The mighty Citadel on Cape Diamond still dominates the city, and the great fleet of sailing ships, which carried the bulk of the freight, continues to overshadow the steamships that would eventually take over. The old world was not yet ready to be passed by.

The Final Years, 1863-72

BY THE EARLY 1860s Cornelius Krieghoff was a familiar figure on the streets of Quebec and a well-established artist in the city. More than twelve hundred paintings identified as his in recent years provide eloquent testimony to his labours and his success over a lifetime. A photograph taken about 1862 shows the artist at work in a studio setting, holding palette, brushes, and maulstick in front of a canvas set on an easel; beneath a nearby table lies a guitar (fig. 134). Tales of the time describe him working surrounded by a group of congenial friends, discussing philosophy, literature, travel, music, and art. When released from the concentration of his painting, he would snatch up the guitar and play a rollicking tune. One can imagine the sense of occasion in the studio as he finished a particularly arresting canvas while friends watched him apply the final touches of paint and praised the work for its vivid effects and sharp characterizations. Such an event would have paralleled the more sensational London spectacles when crowds flocked to the studio parties arranged by Sir John Everett Millais (1829–96), by William Powell Frith (1819–1909), and other celebrated academicians to view the completion of their latest masterpieces.

The photograph gives us some idea of how Krieghoff worked. The maulstick was designed to steady the hand and was commonly used by professional artists who sought the precise detail so much admired at the time. His somewhat utilitarian paint box, sitting on the floor filled with tubes of paint, is in marked contrast to the elegant mahogany cases, fitted with drawers to separate the colours, used by Paul Kane. Marius Barbeau stated that Krieghoff's pigments, particularly the blues and vermilions, were based on information received from an old Indian chieftain, Gabriel Teoriolen, and that these colours were not like the average commercial products.[1] Certainly there is great brilliance in his paintings and the colours are of a high quality, but the statement by Barbeau that they were chemically different has not been verified by modern laboratory testing.

Some insight into Krieghoff's method of working can also be gained from his canvases, for the artist introduced himself into several of his own paintings during his Quebec years. Though he painted a full-face portrait of himself in 1855 (fig. 4), perhaps the finest self-portrait in artistic quality is in a painting of an incident during a hunting trip in 1859 (fig. 135). Krieghoff, his friends Budden and Gibb, and an Indian guide surround the dying moose they have just shot. The artist is dressed in a blue, blanket cloth coat trimmed with red, leggings, and high boots. He wears a brightly coloured *ceinture flechée* sash, which was said to have won much admiration from the ladies for its fine weaving.[2] There is a jaunty air about him as he grasps under his arm a neat little sketching portfolio, possibly twelve by sixteen inches, with protective leather corners and spinal reinforcements. The same portfolio is carried in an earlier painting of himself at Montmorency Falls, and in another canvas he has it in his hands as he clambers over a log jam at the falls at Shawinigan. In a painting of a brilliant autumn woods, the portfolio is open on his knees as he sits alone on a rock sketching a derelict settler's cabin (fig. 136).

A canvas dated 1859 demonstrates very clearly his field working methods. The painting shows Krieghoff, Budden, and some other men on an autumn fishing expedition at The Narrows on Lake St Charles (fig. 137). While his friends cast, the artist spends his time sitting on a board supported by the canoe gunwales, sketching on a sheet of paper backed firmly by the portfolio on his knees. He is in the last stages of completing a monochrome pencil or charcoal study.

No oil or watercolour sketch box is to be seen in this or any other of his outdoor paintings. Budden is supposed to have said that Krieghoff would paint an oil outdoors in a day or two, but the evidence suggests that he normally drew quick

134 Cornelius Krieghoff c. 1862
photograph by Jules Livernois, Quebec
McCord Museum, McGill University, Montreal

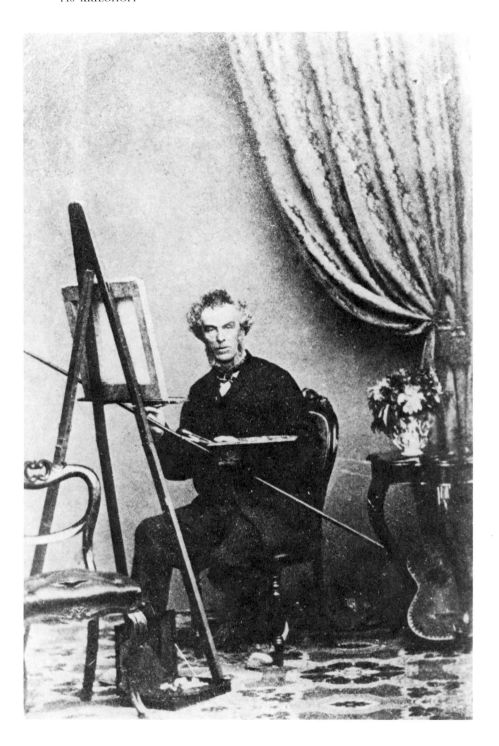

135 Detail of fig. 94, *Death of the Moose, South of Quebec*, showing
James Gibb, Krieghoff, John Budden, and Indian guide

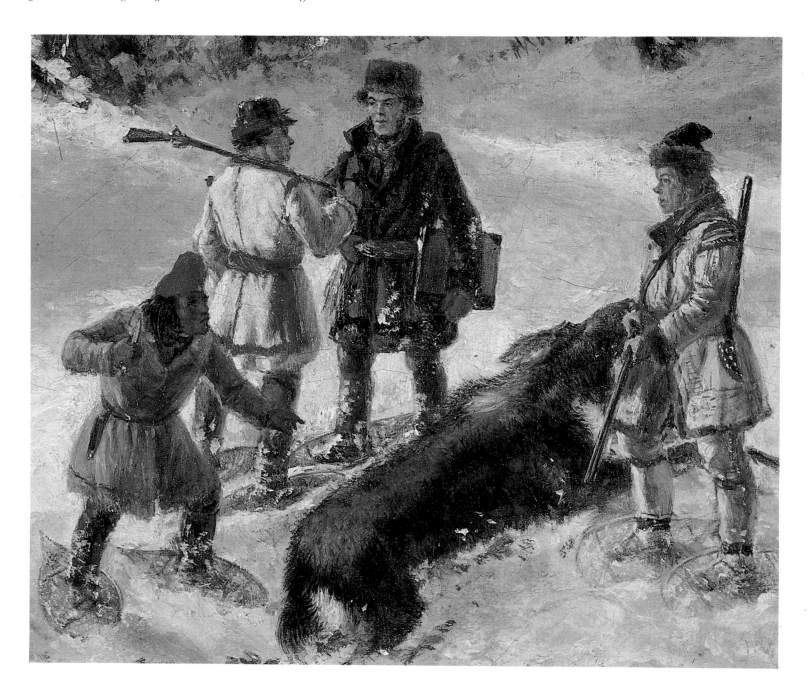

136 *Untitled (Artist Sketching)* undated
9 × 13 in / 22.9 × 33 cm
The Hon. K.R. and Mrs Thomson

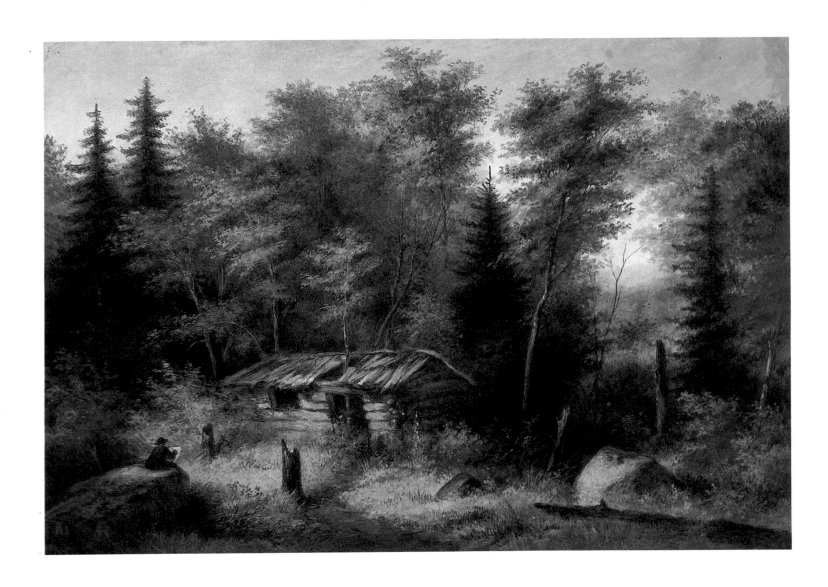

137 *Lake St. Charles or The Narrows on Lake St. Charles* 1859
15 × 20 in / 38.1 × 50.8 cm
private collection

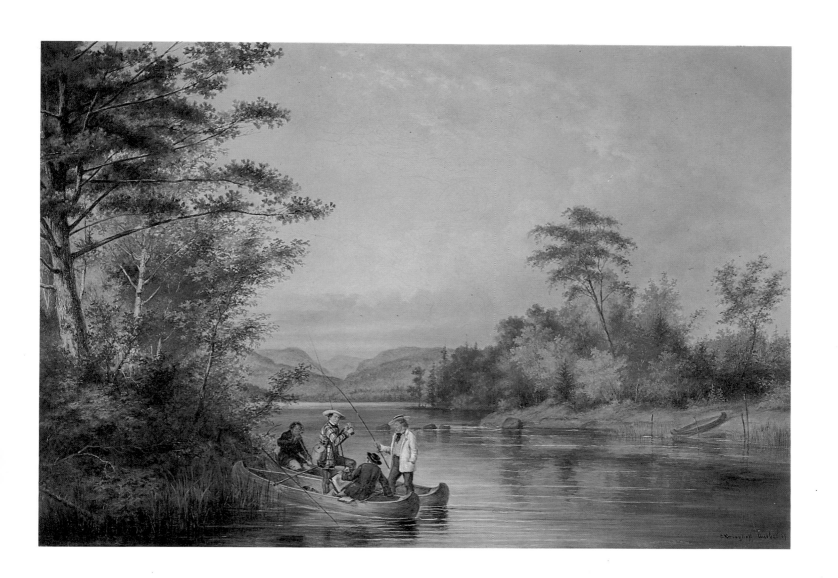

studies in black and white of the type shown in the fishing picture and used them as aids for painting oils in the studio. In fact, there is no first-hand evidence that Krieghoff ever painted in oil from nature in the open air; rather he seems to have simply made monochrome studies in pencil. To paint canvases in a studio from such field sketches, and improvising the colour indoors, presumably would have presented no great difficulty to a man who worked repeatedly from black and white engravings. One suspects that after completing a couple of versions of a subject such as 'bilking the toll' he was able to extemporize the whole painting without needing to refer to any sketches whatsoever.

James Geggie of Quebec once bought a box filled with Krieghoff drawings on brown paper which presumably had been made on such outings. He identified the subject of one of them as the Beauport manor house, but Krieghoff is not known to have painted the old seigneury in any canvas, though he did paint it on one of the plates he decorated for Dr Douglas. One wonders if the sketch was not the basis for the inn in the *Merrymaking* pictures. Geggie apparently destroyed the lot, which he described as little 'scratchings,' because he considered them too rough to be of interest.[3] Other Krieghoff drawings, then in Budden's possession, are supposed to have been burned in a fire in 1881.

A mood of restlessness seems to have come over Krieghoff in the early 1860s. References to travel, and even to leaving Quebec, began to appear in various newspaper items advertising the sale of his works. Certainly he had always enjoyed, and been stimulated by, the excitement of novel experiences and new surroundings; and he had already spent more years in Quebec than in any other city. There is evidence of an increasingly apparent attempt to wind down his affairs there. On 6 August 1861 he offered for sale much of his print collection.[4] These prints, which he used in making oil canvases on commission, included chromolithographs from original paintings as well as antique and modern engravings after Landseer, Herring, Frith, Sir Augustus W. Callcott (1779–1844), Henry Lemon (active 1855–66), Sir William Allan (1782–1850), and Richard Ansdell (1815–85). His disposal of these working tools suggests that he felt no further personal need for them.

In September 1861 he announced that he proposed to make a trip to New York,[5] supposedly to import paintings for local sale. Then on 21 December he held an auction in Quebec offering for sale both his own canvases and some European paintings,[6] some of which may have been purchased in New York. The advertisement for the December sale stated that he planned to visit Europe. During 1862 he held further auctions. Was he involved in some commercial venture that involved periodic visits to New York, or even to Europe on the fast new steam packets, to buy paintings for resale locally? Or was he simply reiterating his intention to move from Quebec while postponing the final break from month to month? The impending marriage of his daughter, in March 1862, may have altered his plans.

At a spectacular sale held on 8 April 1862 at a new auction house on the rue St-Jean, John Budden auctioned a hundred of Krieghoff's most important canvases.[7] The sale was probably the commercial peak of Krieghoff's artistic career, and it created a sensation. At a time when Canadian art criticism was mundane in the extreme, a critic in the *Quebec Telegraph* commented perceptively on the colourful array of canvases:

The exhibition of Mr. Krieghoff's collection of paintings, at Ross' buildings, St. John Street, yesterday, attracted all the art connoisseurs of the city and vicinity and an immense number of visitors generally including many ladies. The pictures on exhibition comprise all, or nearly all, this popular artist's favourite subjects, and form a rare collection of Canadian landscape pieces, and incidents of rural life. Among the latter, the celebrated *Merrymaking* (fig. 64) – generally considered the finest canvas of the collection – is conspicuous by its variety of figures and fidelity of detail, colouring and attitude. We may here remark that the fidelity to nature is the great merit of Mr. Krieghoff's paintings. We have seen Canadian subjects treated by celebrated foreign artists, but they always lack the native brilliancy of sky and forest which is the leading characteristic of Mr. Krieghoff's pictures. All his autumnal pieces – as indeed as much may be said of his winter scenes – are remarkable for fidelity which rivals the photograph and can not be surpassed. Some of the forests reflected in the calm lakes and lonely streams, are worthy to rank with the best works of modern landscape painters. In fact, the only difficulty a man of taste, desirous of adding to his collection, can experience is an 'embarras de Richesses' – the difficulty of selecting a few among the many fine paintings by which he finds himself surrounded.

The aspect of Krieghoff's paintings most singled out for comment, and perhaps the most significant quality of his

work admired by Quebeckers, was his 'photographic realism.' He seems to have become aware of the camera's exacting eye first when his studio adjoined that of a daguerreotypist in Montreal, but he was in contact with other photographers thereafter. His new brand of 'realism' in Canadian painting was continued in the works of painters such as William G.R. Hind (1833–89).

A second painting in the April sale, *The Alchemist*, seems to have been almost equally celebrated as *Merrymaking*. Undoubtedly it was copied from one of numerous alchemist engravings: the subject had been repeated in a host of canvases since the Flemish painter David Teniers (1610–90) painted an early version. There is a story that Krieghoff gathered the props for this painting from his Quebec friends, but it seems improbable. He did, however, infuse a personal magic into the canvas through weird blue lighting and atmospheric overtones that transform the laboratory into a mystical place, perhaps reminiscent of Schule's workshop in Schloss Mainberg. Carte-de-visite photographs of the canvas were sold commercially. Here again Krieghoff gauged popular Victorian tastes: Daphne du Maurier described a nineteenth-century drawing room of her youth where hung another alchemist engraving whose awesome details had been etched vividly and permanently on her mind.[8]

Both *Merrymaking* and *The Alchemist* were purchased at the sale by James Gibb, who took them to Sillery where he had a 'tiny and unostentatious cottage' named Rosewood. The approach to this summer retreat was by a network of walks and spruce hedges in ornamental gardens complete with trout pools, flower gardens, bowers, and Classical marble sculptures. Inside, Gibb's collection of Krieghoff canvases hung about a large aquarium filled with goldfish. Rosewood's atmosphere, it was said, breathed the spirit of nature.[9]

In addition to works sold privately, Krieghoff painted about thirty more canvases between the sale in April and another held on 23 December 1862.[10] The date for the auction was chosen deliberately since, as the artist wrote to his patron John Young, pictures sell better at Christmas.[11] The advertisement listed the paintings, providing a survey of Krieghoff's subject matter at the time:

Autumn, Lake Magog, 9 × 11.
Squaw, Winter, 9 × 11.
Indian, Winter, 9 × 11.

Autumn, Stream on the St. Maurice, Caribou, 13 × 18.
Sled, 13 × 18.
Derry's Bridge, Jacques Cartier, 9 × 13.
Winter Piece – Log House, Going to Market, 14 × 21.
Winter Piece, Returning from Market, 21 × 28.
Autumn, 9 × 13.
Lake Memphremagog, – Startled Caribous, 27 × 36.
Sledge, Montmorenci, 13 × 18.
Squaw, Autumn, 9 × 11.
Interior – Group of Canadians, Girl making Straw Hats, etc., 23 × 19.
Salmon Spearing, 12 × 16.
Lumberers' Ferry, 11 × 8.
Game – Duck, Woodcock, etc., 20 × 25.
Red Sleigh, 9 × 13.
Winter, Mountains on the North Shore, below Quebec, 15 × 17.
Autumn, 15 × 17.
Sleigh, Montmorenci, 9 × 13.
Autumn, Indians, Canoe, Caribou, 27 × 34.
Autumn – Storm, 15 × 18.
Sunset – Winter, Indian File, 14 × 21.
Autumn – Indian with Caribou, 16 × 18.
Marine, 13 × 18.
Old Beggar, 9 × 11.
Canadian Woman, 9 × 11.
Canoe crossing through the ice, Quebec, 13 × 18.
Indian, 9 × 11.
Lake Laurent – Autumn, 14 × 21.
Falls of Ste. Anne, Autumn, 18 × 27.

The advertisement for the sale in December 1862 warned potential buyers that this would be their final opportunity to purchase Krieghoff's paintings and further mentioned that, at the preview, notice would be given of the time of sale of his furniture and other effects, including such items as a collection of stuffed birds, coins, and Chinese curiosities. Also coming up for sale would be a library of twelve hundred volumes, comprising a fine choice of historical, scientific, and classical works.[12] A few books once in this library have been traced; they are inscribed with the artist's name and deal exclusively with art subjects, principally British painters. One of the volumes is illustrated with a print of a William Collins painting that Krieghoff copied. The books from the collection that have been found are:

138 *Winter Scene in the Laurentians* 1867
$26\frac{1}{4} \times 35\frac{3}{4}$ in / 66.7 × 90.8 cm
The Hon. K.R. and Mrs Thomson

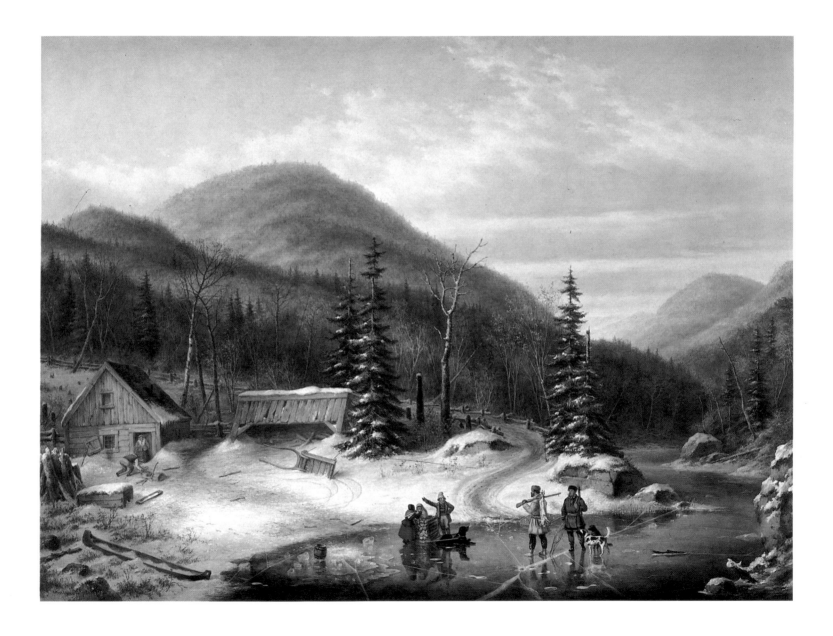

Allan Cunningham, *The Lives of the Most Eminent British Painters, Sculptors and Architects*, London, John Murray, n.d., vols. 1–7

George Stanley, *Painters of the Dutch and Flemish Schools ...* London, 1855

Ralph N. Wornum, *Lectures on Painting by the Royal Academicians, Barry, Opie and Fuseli*, London, 1848

S. C. Hall, ed., *The Vernon Gallery of British Art*, Third Series, London, 1853

Henry William Beechey, *The Literary Works of Sir Joshua Reynolds*, London, Bohn, 1846, 2 vols.

In that same year, 1862, Krieghoff had painted the first of many versions of a winter scene, in which the Laval River, northeast of Quebec City, emerges from a deep Laurentian valley. It is an isolated spot. In some versions he has introduced a habitant farmhouse, outside of which the family cuts firewood or chats to hunters or Indians. One of the large canvases, *Winter Landscape, Laval*, is now in the National Gallery of Canada, while a second painted the same year ended up in the Gibb collection. A third impressive version, painted during 1867 (fig. 138), was eventually purchased by Lord Strathcona, the railway magnate who drove the last spike in the Canadian Pacific at Craigellachie, British Columbia, in 1885.

Krieghoff was developing a second source of income at this time. He began to receive royalty payments from William Notman in Montreal and G.W. Ellison in Quebec from the sale of photographs of his paintings. Photographers in those days referred to themselves constantly as 'artists' and coloured photographs were held in high esteem as works of art. The earliest documented photographs made from Krieghoff paintings date from 1862. They were prepared in the popular carte-de-visite form – photographic prints measuring $2\frac{1}{4}$ by $3\frac{1}{4}$ inches and mounted on cardboard. Hundreds of thousands of similar prints were being sold commercially by numerous American and European firms; they recorded a vast range of subjects from Queen Victoria to Tom Thumb, from the buildings of antiquity to current events. The public bought them avidly, and interspersed them among the grim-faced relatives in the albums that lay on parlour tables. Both Notman and Ellison carried the commercial sale further by preparing photographic prints measuring six by eight inches, mounted on cardboard and ready to frame. J. Henry Sandham (1842–1910), who worked for Notman, Joseph Dynes

(1825–97), and many other Quebec and Montreal artists tinted the photographs.

On 28 April 1864 Krieghoff took the unusual step of registering a copyright of thirteen paintings with the Author's Rights Division for Canada;[13] with two exceptions, coloured carte-de-visite photographs have been located of all the works listed. Logically one must conclude that he took this action to assure himself of a continuing income by way of royalty from both the Notman and Ellison firms or from anyone else selling photographs of his paintings. Engravers frequently copyrighted their prints in this manner; but there seems no other Canadian precedent for artists registering their paintings against commercial use by photographers at this period.

Photos were also used commercially as illustrations in books, in the place of engravings which were more difficult to prepare and lacked the detail admired by the public of the day. Printed on thin photographic paper, they could be readily glued into bound folios, a practice first recorded at the Manchester Exhibition in 1858. Five years later Notman produced a volume illustrated with photographs of paintings entitled *Photographic Selections by William Notman*;[14] a second book appeared in 1865. These are the most famous examples of such volumes and included paintings by both C.J. Way and Krieghoff.

One group of carte-de-visite photographs was even over-painted in watercolours by Krieghoff himself. He mounted them in a little red morocco album with gilt clasps and presented the book to Mrs Gibb. In it is a photograph of himself, followed by nineteen others picturing his better-known prints and paintings (fig. 139). The collection has never been exposed to light, shows no evidence of fading, and seems as fresh as the day that Krieghoff applied the transparent watercolour touches of cobalt blue, scarlet, and yellow. He signed his name on several in a script so minute that it can be read only with the aid of a magnifying glass. It was a gracious gesture to the wife of a patron, and one he did not extend to his friend, John Budden, who possessed a similar album of little photographs of his paintings.

Krieghoff had painted some of his best canvases in the closing years of the 1850s. Public demand had been great, and the hundreds of canvases were completed with remarkable speed. The hard work must have left little enough time for quiet relaxation and he was tiring. There are rumours that he

was drinking a great deal and that his health was not always the best: a story associated with a painting of Niagara Falls describes how it was presented to a Dr Sutherland in payment for medical attention during a serious illness. He seems not to have slackened his output during the early 1860s, but most of his new paintings, churned out in a steady stream, were simply variations on earlier themes. After 1861 he created few fresh compositions; those subjects that are completely new seem to have originated as personal whims. Otto Jacobi, his countryman, claimed that Krieghoff made excuses for giving in to the pressures of commercial needs in later life: he felt his earlier pictures were the best, later 'the cares of his family forced him to turn out all sorts of careless daubs ... but when he painted for himself, that is as an artist, he always aimed at doing something worth while, arranging and composing as well as ever he could.'[15]

It is difficult to reconcile the frequent tales of his penurious state with the considerable income he must have been making from the sale of his paintings. His income should have provided a sense of freedom, permitted a certain amount of travel, and made possible breaks from his rigid Quebec routine. In any case, he had sufficient money during 1861 to buy shares in the Colonial Mining Company,[16] a speculative investment probably made at the urging of his friend Denis Gale, who was a mining promoter as well as a painter, picture dealer, amateur natural history student, and man about town.

Krieghoff was also able to rent a pleasant two-storey house with attic and basement and take possession on 1 March 1861, possibly in anticipation of his daughter's wedding which occurred just two weeks later. The house stood at 42 Grand-Allée, an extension of the attractive Chemin St Louis outside the city walls;[17] just beyond was the old tollgate he had painted many times. It had some pretensions: there was an entrance hall, dining room, bedroom, and lounge, presumably the room where he entertained friends while painting. There was a carriage yard at the rear, and a well had been dug for convenience in the basement. A privy stood outside, since watermains and sewers had not been yet installed on the Grand-Allée.

A year later Krieghoff vacated the house. In the list of contents for sale, we find that he had owned a piano. Silver dishes, porcelain, and plated silverware (in contrast to the sterling found in wealthier homes) suggest a genteel but unpretentious atmosphere. Parian marble statues and

139 Gibb photographic album c. 1864
carte-de-visite photographs overpainted by Krieghoff of Indian moccasin seller and hunter private collection

Chinese curios are typical of the miscellaneous bric-a-brac that created the well-known clutter in Victorian homes. Framed chromolithographs and other pictures would have covered the walls. Cases of stuffed birds added to the confusion; Krieghoff apparently had a passion for collecting natural history specimens and when moving sold boxes of bird skins.

There are various tales about the artist's personal life at this time, but as always they seem to be based chiefly on gossip rather than on documented fact. One concerns a liaison with a stout German woman.[18] Some say that he was separated from his wife, Emilie, but there is no way of checking if they were living at the same address since the 1861 census records for that part of Quebec have been destroyed. It would be easy to believe that Emilie died, as another inaccurate tale has it, since she kept in the background so much that one never hears of her; but in fact she did not die until 1906.[19] An elderly Quebec woman, recalling the artist a half century later, said that he and his daughter spent the summer of 1864 (or could it have been 1863?) on Lake Larron.[20] A former owner of the Russell Hotel in Quebec recalled that the artist lived there for several weeks and paid for his lodging with a painting.

Obviously some crisis erupted during the summer of 1863, for Krieghoff assigned all of his property to A.J. Maxham on 21 August, empowering the firm to settle his debts and finan-

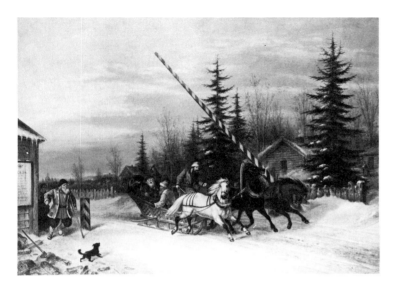

140 *Bilking the Toll in Russia* late 1860s
18 × 24 in / 45.7 × 61 cm private collection

cial affairs.[21] Had some simmering family troubled boiled over and precipitated the abrupt action? Was there a connection with the resignation, on the very next day, of Krieghoff's son-in-law from the army?[22]

Krieghoff's daughter Emily had married Lieutenant Hamilton Burnett of the 17th Regiment of Foot (Leicestershire) on 18 March 1862.[23] Burnett's background is mysterious, though we know from his army records that he was born in 1840. He may have been the son of Sir Frederick Burnett, a well-known Bournemouth and London barrister. The documents suggest he was illegitimate and that his father had not married until his son was well launched on his army career. Burnett had entered the British army as an ensign in 1858, and in 1860 Sir Frederick seems to have purchased for him a lieutenant's commission. He had joined his regiment in Quebec during June 1861.[24] The Quebec regimental chaplain performed the marriage, which was witnessed by Krieghoff, John Budden, and Lieutenant Ravenshall, a friend of the bridegroom.

In 1863 Burnett had been living in a house on the Grand-Allée, rented from the Ladies' Protestant Home on 21 February; he then sub-leased another property from a M. de Courtenais.[25] After leaving the army in August, he disappears. It was reported that he died, but no obituary has been found. The Krieghoff genealogical tree in Germany records the divorce of Burnett and Emily, but there was no provision for divorce in the Quebec provincial statutes of the time. Another story has it that Emily remarried a certain Count de Wendt, who had financial interests in Chicago and took his bride there, her father following at his urging.[26] But no such name is mentioned in the Chicago directories, and there is nothing to confirm that the man ever existed. An 'E. Burnett' is listed in the 1865 Chicago directory, but there is no way of knowing if this is Emily; she did use the name Burnett, and not de Wendt, in her later life.

In any case, sometime late in 1863 or early in 1864 Krieghoff left Quebec and seems to have gone to Europe. John Budden, while not always accurate in recalling small details, wrote Robert Harris to this effect in the 1890s, and repeated it to G.M. Fairchild in 1907.[27] Budden added that Krieghoff disposed of his collection of bird's eggs, skins, and coins in Paris. Marius Barbeau believed that he also sold his insect collection to the Jardin des Plantes in Paris, but there is no record of such an accession. That Krieghoff visited Paris seems confirmed by an album of nineteen carte-de-visite photographs of his paintings and prints bearing the stamp of Moulin, a Parisian photographer who operated at 25 rue Richer near the site of the Folies-Bergère. Krieghoff must have taken the negatives to Paris since there is no evidence that Moulin ever had a Canadian branch; and it is unlikely that some of these paintings left Quebec to be photographed since at least one remains in the family for which it was painted. The Moulin firm, one of the world's largest suppliers of carte-de-visite photographs, had been founded in 1853 and by 1861 specialized in portraiture and in photographic views of the Crimea, Venice, Syria, Egypt, and other exotic places. To ally himself with Moulin was typical of Krieghoff's business sense.

That the Krieghoffs lived for a time in Europe is consistent with a tale told by Philéas Roy of Boucherville.[28] Roy liked to travel. During a visit to Stuttgart, while walking along a broad street exploring the shops he saw in a window a canvas of a Canadian Indian encampment. Curious about its origins, he entered the store. There he discovered Krieghoff's wife, who identified herself as the daughter of Roy's elderly friend in Boucherville, 'Old Pocane.' The artist himself, returning a few minutes later, is said to have found his wife and the

stranger embracing in nostalgic memory of their faraway home.

Certainly Krieghoff did not stop painting after he left Quebec. A few canvases of Canadian subjects, several of them Indians in the forest, are dated 1864, 1865, and 1866, and his works turn up periodically in continental Europe. His mother died at Schweinfurt in 1866 and his father in 1867; one can envision him visiting them in their last years, since a sense of 'family' continues strong among Krieghoff descendants.

Auction notices in Quebec give further clues to Krieghoff's wanderings. Maxham sold some of his paintings on 20 October 1870, and advertised them as having been painted in Munich and Paris. Other Krieghoff canvases in the sale were of Canadian, English, and Russian subjects.[29] Presumably one of the 'Russian' works was a canvas in which three horses hitched to a troika rush through a tollgate (fig. 140). The theme is familiar, but the artist has replaced the little Quebec church in the distance of some of his 'bilking the toll' canvases with a Greek Orthodox church. In another Russian painting, wolves pursue travellers in the forest. The use of this foreign subject matter brought the authenticity of these canvases into question in 1954,[30] but both the advertisement and a close scrutiny of the technique seem to justify completely their attribution to Krieghoff.

Even when Krieghoff was in Europe, an active trade continued in his paintings. Indeed, their popularity spread both east and west of his old home. As a step towards his ambition to become a picture dealer, another Quebec artist, and friend, Denis Gale, began to sell Krieghoff's paintings after he left Quebec. In 1864 he took some of his own watercolours and some Krieghoff canvases and coloured photographs of paintings to sell in Halifax. He visited the east coast again in August 1865,[31] taking with him what were described as particularly fine Krieghoff autumn and winter landscapes and 'artistic photographs.' Seemingly he stopped to make sales in Saint John, for some of Gale's own paintings were burned in the great fire there in 1877,[32] and some scattered Krieghoff canvases were still owned in the city in 1960. Gale probably sold Krieghoff canvases in other Canadian cities; so many once were owned in Kingston that they gave rise to a story that the artist's wife had retired there.

A man named Colonel A. Booker supervised a large exhibition of paintings in Hamilton about 1864, in which were included 'well-known' Krieghoffs and a few canvases by Gale;

the latter seems to have sent them to Booker on consignment. The handbill for the sale heaped praise on the works 'from the Studio of Mr. Krieghoff, whose truthful rendition of Canadian character has justly gained for him popularity and distinction.'[33] Krieghoff's canvases were not inexpensive: they brought from $16 to $80 at this sale. By comparison, eggs were then selling in the Hamilton market at 10 cents a dozen, cheese at 10 cents a pound, and a commodious house in town could be purchased for $2000. The handbill listed a number of the paintings and the prices asked for them:

27.	Indian Woman	$16
28.	Winter Sunset	18
29.	Drawing Ice	18

Three Pictures, by this deservedly popular Canadian artist.

47.	Crossing to Quebec	35
48.	Canadians in Sleigh	35

Two works of marked Canadian character.

49.	Indian Hunter	16
50.	Indian Woman	16
67.	Group of Indians	20
68.	Hunter in Storm	16
69.	Bilking the Toll	80

A splendid picture of Canadian subject, full of life and character.

70.	Autumnal	80

A group of Indian Hunters, with slain Cariboo. A beautiful companion to the preceding one. They form two important works of much interest.

The mysterious Colonel Booker, whose military rank seems to have been adopted in much the same way as those of latter-day Kentucky colonels, left Hamilton hastily during the Fenian Raids in 1866, following some local scandal. No one has been able to pinpoint exactly what he had done. But two years later he was operating an auction house in Montreal and selling Krieghoff paintings, some of which he described as examples of the artist's well-known scenes of Canadian life.[34] Two were labelled as 'passage du chagrin au bonheur,' and may have been the originals for a pair of popular prints of a

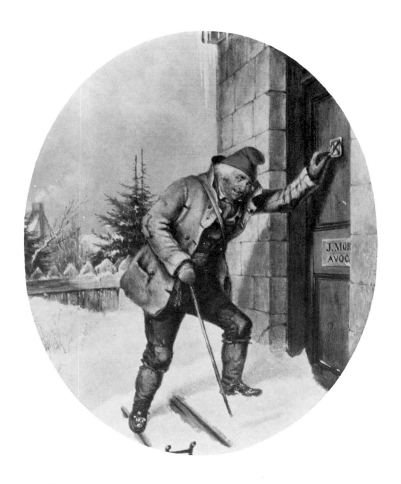

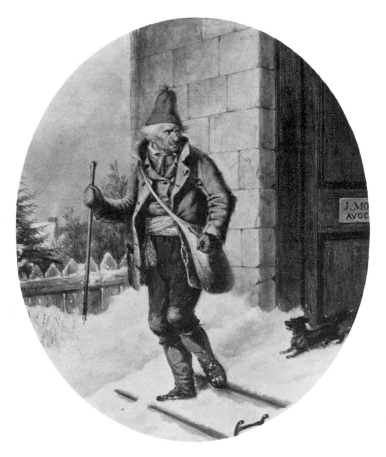

141 *Pour l'amour du bon Dieu* 1859
private collection

142 *Va au Diable* 1859
private collection

penniless habitant going to an unfeeling notary for a loan. 'For the love of God,' he pleads in the first print; turned away in the second, he snarls: 'Go to the Devil.' Krieghoff painted another pair of little canvases which are variations on this theme (figs. 141 and 142). The originals, from which chromolithographs were made, had overtones of subject matter found in popular German lithographs – vines at the door, bright red cheeks, stubble on an unshaved face. But in the second pair the Germanic style was replaced by a much more Canadian character: the notary's office is located on a snowy Quebec street and the money lender's barking dog speeds the would-be borrower on his way. Tactfully

Krieghoff has altered to some unknown name that of the Scrooge-like notary with heart as cold as flint, but everyone in town knew at whom he was pointing his finger.

Other Montreal dealers promoted Krieghoff canvases locally, both during his lifetime and after his death. Dawson Brothers, with whom he had done business ever since they sold his prints early in his Montreal years, acted as his agent on occasion. They sent a painting of the falls of St Fériole (fig. 113) and two other canvases, paintings that would attract much favourable attention, to the Art Association of Montreal exhibition during 1864. Charles J. Way and Robert S. Duncanson (1817–72) were both loudly praised for work in

143 *Bilke Rock, Lake St. Charles* 1867
private collection

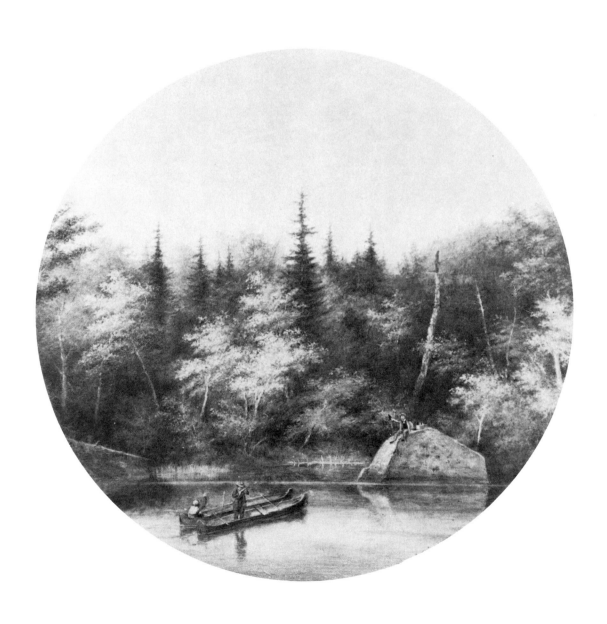

144 *New Year's Day Parade* 1871
25 × 42 in / 63.5 × 106.7 cm
Power Corporation

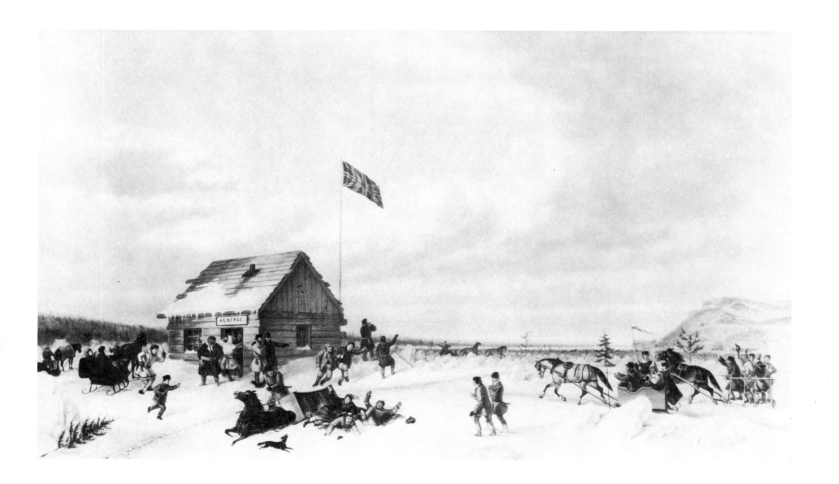

145 *The Horse Trader* 1871
14 × 20 in / 35.6 × 50.8 cm
J. Blair MacAulay

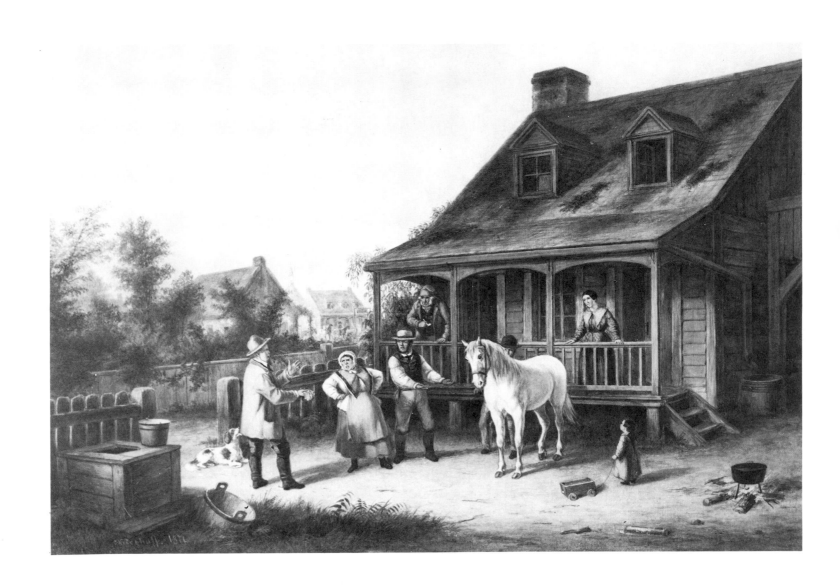

146 *The Blacksmith's Shop* 1871
$22\frac{1}{4} \times 36\frac{1}{4}$ in / 56.5×92.1 cm
Art Gallery of Ontario, Toronto

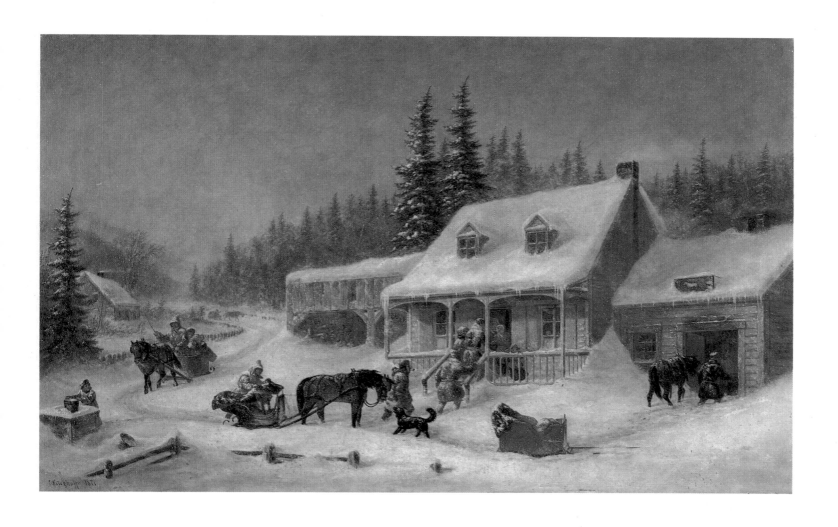

the next year's exhibition; their landscapes and genre had qualities in common with those of Kreighoff. Three Krieghoff paintings were in the 1867 exhibition, but on this occasion they were sent by the dealer William Scott:[35] *Chippewa Indians* sold for $150 and *Crossing the Mail at Quebec* (fig. 5) for $160, while a third, *Spill My Milk!* (fig. 84), had been sold already and was lent privately for the occasion. Other Kreighoff canvases were exhibited in Montreal Art Association shows from 1879 to 1886. Three more were on the walls at the opening of the first Royal Canadian Academy exhibition in Ottawa during 1880. It is possible that no one had an opportunity to see them on the opening evening, however, for it was a crowded vice-regal occasion; the band played, the Marquis of Lorne, Queen Victoria's son-in-law, made a speech, the place was full of politicians, and there was such confusion in the cloakroom that many were said to have gone home wearing the top hats of their deadliest political foes.

The extravaganza known as the Great Exhibition held in London's Hyde Park in 1851 had started a fashion for exhibitions. Most made provision for an art section, and it became the ultimate goal of many Canadian artists to achieve the honour of exhibiting in these 'world fairs.' The Canadian government neglected to allocate money until the very last minute for participation in the 1865 Dublin Exhibition; the display had to be thrown together in a matter of a few days. A dozen larger and thirty-one carte-de-visite size photographs of Krieghoff paintings, all overpainted, seem to have been the best examples of his art that could be secured on such short notice. The only original paintings sent to Dublin were by William Armstrong (1822–1914) and Robert Duncanson.[36] Two years later one Krieghoff canvas and several photographic enlargements were sent to the Universal Exposition in Paris; newspapers in the province did not bother to note the subject of his painting, but they were most ecstatic about the fine frame supplied by William Scott.[37] According to one tale, a canvas dominated by brilliant red autumn foliage was sent to Paris for exhibition but the French authorities refused to hang it as a work of art because they found the colour so exaggerated as to be unacceptable. The canvas in question is possibly that of a deer at the edge of a lake in the Eastern Townships. Krieghoff's *Winter in Lower Canada* was borrowed from a Montreal patron, Mrs Frothingham, for inclusion with the Canadian art sent to the highly publicized 1876 Philadelphia Exhibition honouring the American centennial. Three Krieghoff paintings were sent to the Colonial and Indian Exhibition held in London during 1886.

Krieghoff had forged emotional links with the New World, attuned himself to its spirit of enterprise, and grown accustomed to its freedom of action and carefree attitudes. He returned to Canada during 1867, the year of Confederation, unable to stay away in Europe indefinitely. Alert to business, he took the opportunity afforded by the visit to send some canvases to a sale of engravings, watercolours, and canvases held in Montreal.[38] Old Quebec friendships were renewed. The artist painted John Budden and himself on a happy outing (fig. 143): Budden sits on top of Bilke Rock with a picnic basket and a bottle of wine, while Krieghoff stands with his sketching portfolio in one of two dugout canoes. The canvas breathes a very personal air, and on it the artist inscribed both Budden's and his own initials, 'C.K.' and 'J.B.' Then his name vanishes from the records until 1870.

It may have been at this time that Krieghoff joined his daughter in Chicago.[39] Few dated paintings are known for the years 1868, 1869, and 1870; perhaps the raw western American city did not suit his artistic temperament. The Quebec directory of 1870–1 lists his name in such a way that by then he had apparently moved back and intended to stay permanently. He signed a lease for the upper floors of a Richelieu Street house on 30 August 1870,[40] and began to try and pick up the threads of his life from earlier days. Only four days later there was praise for his oil paintings offered for sale at the Robert Morgan music store.[41] He revisited old friends and patrons, ostensibly to examine their newly acquired 'Krieghoffs' and sort out forgeries painted during his absence. Probably he also wanted to remind them that he was back in town and available for business. Actually the forgeries were a measure of tribute to his success, for local artists had capitalized on his popularity by painting their own variations of his more popular themes. Quickly he quarrelled with his landlady, as artists have done through the ages, and rented another house at 6¾ Prevost Street on 30 April 1871.[42] His canvases were hung at that year's Quebec exhibition; crowds lionized him, and many stopped to admire the 'Canadian scenes which had a life like quality and by Mr. Krieghoff who returned to Canada a little while ago.'[43]

Seven known canvases are dated 1871, the largest number for a single year since 1863. Some seem to have been commis-

sioned by patrons who wanted their own versions of much admired subjects. There was a new *Merrymaking* and a new *Bilking the Toll*. A horse-racing scene of Quebeckers celebrating the New Year on the city outskirts is one of the largest canvases (fig. 144). All the young blades and older sportsmen converge on the city; they have overturned a sleigh just as a habitant sleigh had been upset one morning years before following that all-night carousal at the Jolifou Inn. There is a new canvas of horses racing on the ice. A new treatment of an earlier painting in which a rural matriarch tongue-lashes a horse trader (fig. 145) incorporates the satirical wit of former days. To these were added *The Blacksmith's Shop* (fig. 146), a pretentious canvas with habitant sleighs converging on a local smithy and inn in search of shelter from a wintry blizzard; it was reproduced on a Canadian postage stamp to commemorate the centennial of the artist's death.

One of the few personal impressions we have of Krieghoff comes from about this point in his life. Otto Jacobi visited Montreal during the late 1860s or early 1870s and met Krieghoff who was then living in Quebec. He seems to have expected to meet an older individual, for he commented on Krieghoff's youthful appearance, saying that he looked not more than fifty (his fiftieth birthday was in 1865). Jacobi described him as a tall and gentlemanly looking man, dressed in a grey suit, with hair that was turning grey. He had a 'very good presence' and 'did not talk much but all he said was to the purpose.'[44] By contrast, we know that Krieghoff was a lively conversationalist when he was with his close friends.

There were those who were jealous of Krieghoff's popular success. A jarring note was published in the *Journal de Québec* of 30 March 1872: 'Up to a late date those who had a wish to encourage Native Arts had to fall back upon the multiplied crudities of Krieghoff.' One can never be certain as to what prompted such an outburst. Possibly it was the frustration of a disgruntled artist, or it may have been a genuine feeling that there was a lack of real talent in Canada in those years.

Krieghoff left Quebec City for the last time late in 1871 – the exact date is unknown. The city itself was changing, for the British garrisons were withdrawn from Canada that year.[45] On 11 November the troops marched from the Citadel on Cape Diamond as the military band played *Goodbye, Sweetheart, Good-bye* and *Auld Lang Syne*. They wound down the cobbled streets to the troopships waiting at the St Andrew's Dock, where a large and sorrowful crowd saw them on their way. The Union Jack flew at half-mast. A miniscule Canadian force replaced them, and Quebec's social life changed its complexion forever.

The artist moved to 721 West Jackson Street in Chicago.[46] The city must have been in a chaotic state for the great fire, started when Mrs O'Grady's cow kicked over a lantern, had swept through the streets not long before, leaving incredible devastation in its wake. He would scarcely have moved there at that moment unless his daughter had quarters ready to receive him. There he painted a settler's log cabin in the snow, a subject he had repeated so often that he could have done it entirely from memory. This last known painting was completed, signed, and dated sometime during the first weeks of 1872; after much wandering in the United States it recently found a home in Ontario.

A few months after leaving Quebec, Krieghoff died. John Budden wrote: 'I have not the date of his death but it was so sudden that I have a letter of his addressed to me about Eleven o'clock at Night, and within ten minutes his wife found him on his bed dead.'[47] At the end, then, he was in touch with the two people he seems to have loved most during his lifetime. He died on 8 March 1872 at the age of fifty-six and was buried in Graceland Cemetery in Chicago. There were no long eulogies in the newspapers, nor was there any official tribute to his accomplishments. But his memory lingered on in the country he had adopted as his home during his most fruitful years. His paintings continued to be included as symbolic of the highest Canadian artistic achievements at national and international exhibitions. There they served as belated tributes to the man and his work.

Misattributions, Deceptions, and Forgeries

IT IS A MEASURE of Krieghoff's artistic prowess that he has been so frequently imitated. Even before his death in 1872 it was becoming increasingly difficult to be certain that a 'Krieghoff' painting was actually done by his own hand. Anyone studying his work must recognize that there are three different kinds of imitations. There are, first of all, the many artists of his own time who copied him in both style and subject matter; many knew him and some may have even worked closely with him. As well, there are the amateur copyists, including his own students, who created art that may be mistaken for Krieghoff's; it was an age when the copying of the paintings of others was common practice and widely accepted. Finally, there has been a steady production of outright forgeries intended for sale to a gullible public – a fraud that began during his lifetime, and still flourishes today. Although there has been confusion enough concerning his works in oil, the problem of distinguishing imitations and forgeries from authentic works is particularly complex when it comes to watercolours.

Krieghoff influenced many artists of his own generation, who capitalized honestly on his success by following his lead in subject matter. Regrettably, their work is sometimes sold today as Krieghoff's. The increasing cost of his paintings, which now sell for astronomical figures, is eloquent proof of his success, but this popularity has had undesirable results. The value of his paintings has prompted the alteration of many signatures on works of others even when the resemblance is only vague. Fortunately there are ways to distinguish Krieghoff from his disciples.

Martin Somerville's paintings closely resembled those of his friend. Although he frequently signed them in ink on the reverse, this ink can be easily bleached and a 'C. Krieghoff' signature painted on the face of the work to upgrade its value. The two men, who for a period had adjoining studios in Montreal, knew each other's work well, collaborated on pro-

jects, and possibly even copied one another's paintings. Both painted gentlemen driving horses on the frozen St Lawrence River, for instance. Somerville's versions are distinguished readily by his linear draughtsmanship and duller colours in contrast to Krieghoff's sense of volume and his more vibrant tones. Both also painted solitary Indian women in a winter setting. Somerville's women (fig. 147) wear moccasins with lacing around their ankles (fig. 148), while Krieghoff painted women wearing moccasins with unlaced tops (fig. 149). Somerville introduced awkward and disagreeable lines around the eye sockets in contrast to Krieghoff's more naturalistic effect. Somerville's background sunset colours introduce an orange tone which is different from Krieghoff's pinks at the time they shared adjoining studios. Both artists painted men with packs on their backs and wearing snowshoes; the less imaginative Somerville painted the cross-lacing of the snowshoes in a precise diamond effect (fig. 150), whereas the more literal Krieghoff added bits of snow as it oozed up through the lacing (fig. 151).

George H. Hughes (active 1861–78) was a Montreal painter about whom little is known. He lived at 73 St Patrick Street from 1870 to 1878, is referred to earlier as an engineer, and is said to have studied under Krieghoff although no documents are known to prove the fact. Many of his original oils depict habitants driving sleighs in winter, rural houses, and views of the Quebec countryside. Fascinated by Krieghoff's pairs of little paintings, one showing an Indian hunter on the trail, its companion showing a woman with moccasins in hand and blanket over her head, he copied them repeatedly. One Hughes pair was given to B.H. LeBlanc of Montreal in 1872 as a wedding present. Hughes had no intention of deceiving anyone into thinking that they were Krieghoff originals and was careful to sign these copies with the inscription: 'G.H. Hughes/After/C. Krieghoff' (fig.152). Unfortunately, picture sellers have removed the first part of

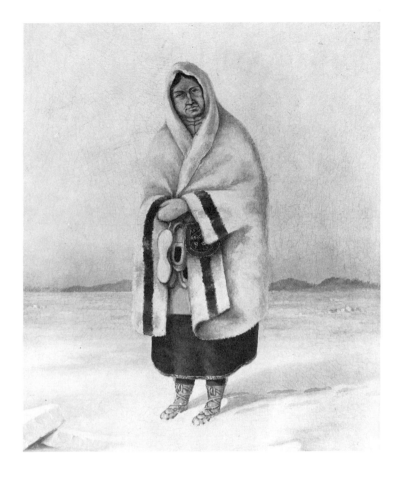

147 Martin Somerville, *Indian Woman* late 1840s
oil on panel 11 × 10 in / 27.9 × 25.4 cm private collection

148 Somerville, moccasins,
detail of fig. 147

149 Krieghoff, moccasins,
detail of fig. 3

150 Somerville, snowshoes,
detail

151 Krieghoff, snowshoes,
detail of fig. 117

this signature from many examples, leaving only the 'C. Krieghoff'; when tested, the paintings are found to be genuinely old.

There are variations between a Hughes version and a genuine Krieghoff. Hughes added short vertical strokes to indicate the thongs wrapped around the snowshoe frame (fig. 153). Krieghoff omitted this refinement. Hughes used a blue pigment that tends to be a cobalt shade in contrast to Krieghoff's ultramarine, and his curious raw yellow for jackets is quite unlike Krieghoff's paler pigment. Sometimes Hughes introduced a clear 'baby pink' streak into his sky just above the horizon; Krieghoff sometimes used pinks but diffused his tones. Hughes, like Somerville, painted variations on the hunter theme, treated the altered versions as original works, and on these variations signed his own name without giving any credit to Krieghoff. In many of these he painted a little emerald green spruce seedling growing out of a crack in a jagged boulder, and a disagreeable curving stump to the rear of the hunter. These features are never found in a Krieghoff oil.

A large group of imitative painters can be included in this 'School of Krieghoff.' One of the most unusual of his followers was Zacharie Vincent (1812–86), the Huron chieftain at Lorette who copied his landscapes and Indians. S.S. Macaulay (d. 1869), who was a member of Parliament for Trois-Rivières, copied the Indian trapper but in doing so elongated the figure to the point of absurdity; he also made a copy of a Krieghoff autumn landscape which, while naïve in treatment, has real charm as a 'primitive.' Robert S. Duncanson and

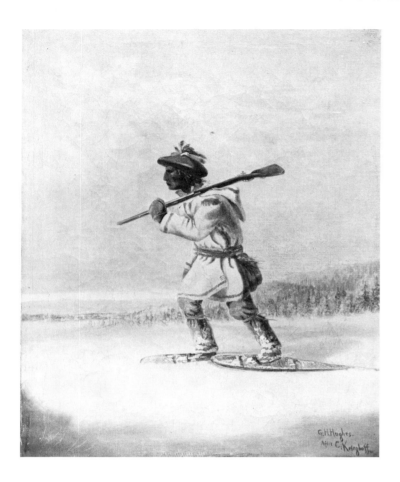

152 G.H. Hughes, after Krieghoff, *Indian Trapper*
9 × 11 in / 22.9 × 27.9 cm private collection

153 Hughes, snowshoes, detail

Alexandre-S. Giffard (active 1865–78) painted Quebec winter views with sleighs on country roads which were possibly suggested by Krieghoff paintings. Works of Samuel C. Hawksett (active 1856–1903), who painted pastels of autumn landscapes, and John B. Wilkinson (active 1865–1907), who painted similar scenes in oil, are similar enough to have had signatures changed to that of Krieghoff. A 'Robert C. Todd' signature on another canvas, a race horse in front of the frozen Montmorency Falls, has been removed and 'C. Krieghoff' substituted for it. John Howard (1803–90) of Toronto owned a Krieghoff landscape which is now in the Art Gallery of Ontario,[1] and he made watercolour copies of it. Charles J. Way was an artist who prided himself on the original nature of his subject matter; but he too in 1864 produced a series of four prints of the Quebec City region symbolizing the Canadian seasons (in one an ice boat crosses the St Lawrence, in another the coloured autumn forest surrounds a lake in which drifts a birchbark canoe) which were seemingly inspired by Krieghoff themes, and at least one of which was bought as a Krieghoff watercolour.

Krieghoff found that friends had bought fresh forgeries in his absence when he returned to Quebec in 1870 and 1871. It seems they were painted by lesser professionals who were capitalizing on the brisk market he had created for his subjects. One artist was a certain 'Rowand,' who made two copies from a Krieghoff original picturing habitants racing in front of the Citadel in winter. One is signed 'C. Krieghoff' and the other has two signatures, 'C. Krieghoff' and 'Rowand 1870.' The technique is identical in both, and interesting comparisons can be made with the original. Krieghoff prided himself on painting piles of ice at the river's edge, using firm brush strokes and achieving a cubistic effect in setting down the ice cakes with sharp planes and angles; Rowand's ice cakes are really huge snowballs. Krieghoff used a dark viridian green pigment in painting bare river ice; Rowand painted the same areas in black.

Joseph Dynes was another artist who probably copied Krieghoff's works during his lifetime. He became very familiar with them when overpainting photographs of Krieghoff's works in the Ellison studio in Quebec. The Quebec Museum has a handsome version by Dynes of Krieghoff's *The Boys Go to Town*, in which three habitant lads merrily drive their sled on the back road towards the city. One wonders if other similar examples have been converted to

'Krieghoff' by removing the Dynes name and substituting that of his better-known contemporary. There exist at least two most attractive paintings of the ice cone at Montmorency which imitate the Krieghoff lithograph but are by another hand; the firmness of stroke in them makes it possible that they were painted by Dynes.

Charles Huot (1855–1930) made a reputation for himself late in life by painting the murals in the Quebec Legislative Assembly. As a young man he painted his own version of Indians in a canoe shooting the rapids of the Montmorency River. It was completed in 1874 when he was only nineteen years of age, and is based directly on the Krieghoff series.

The vast number of Krieghoff-like paintings should not perhaps cause surprise for Krieghoff belonged to an age when amateurs copied avidly and gained notoriety as 'artists' on the basis of copies. Krieghoff was himself responsible for some of these amateur replicas; he placed his own canvases as copy pieces before his young women students. One early copy that seems to be an amateur work, probably by some student, is a circular painting of an Indian stalking a deer from a canoe (type of fig. 121). It is so crude that one can scarcely believe that it would be accepted as authentic by anyone, yet it surfaced in California where a speculator bought it for several thousand dollars. But Krieghoff originals, at the time, were virtually unknown in California.

Copies of Krieghoff prints can be charming and intended as flattering imitations rather than frauds. Such is the case with a pair of paintings on velvet, which are attractive in their own right by virtue of their crispness of execution, bright colours, and primitive quality. One of these (fig. 154) is based on a lithograph of *Indian Wigwams of Lower Canada*, a particular favourite with copyists. Another copy of this same lithograph, but done in oil on canvas, is intriguing because it seems to have been painted by Princess Louise, the daughter of Queen Victoria. As wife of the governor-general, she was bored with life in Ottawa; her only genuine interest in this country seemingly was in painting. Other amateurs specialized in making copies for their friends.

There exists also a copy of one of Krieghoff's *Indian Trapper* canvases. This was a subject he himself painted in many variations, one of which was sold as a carte-de-visite photograph (fig. 139). On the frame is an inscription reading: 'This painting by/C.V.M. Temple/in 1859/ was the ninth one ever did/C.V.M. Temple/No. 9.' Temple was Krieghoff's

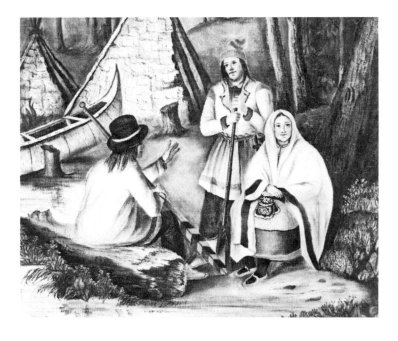

154 Student of Krieghoff, *Indian Camp Scene*
painted velvet, based on Krieghoff painting private collection

neighbour and one of the Quebec sporting crowd. He made copies of other Krieghoff works: a habitant head and a habitant approaching a notary for a loan are two of them. The very fact that he painted at least nine versions of the trapper demonstrates how common was the practice; fortunately they are scarcely sufficiently proficient to be mistaken for genuine Krieghoff paintings.

More sinister are the many canvases painted by picture forgers with deliberate intent to deceive. Krieghoff 'fakes' command sensational headlines; the 1976 'award of the year' for the most newsworthy story in English journalism related in part to Krieghoff forgeries in the United Kingdom. The racket flourishes where individuals buy paintings for profit rather than for aesthetic content. Forgeries offered at a smaller sum than the regular market price are snatched up by speculators who hope to make an inordinate profit, or who believe those dealers who sell inferior canvases as quality items. A much damaged Krieghoff canvas can be repainted by a clever restorer to a point where it will pass as a quality

work by the artist; in fact, what is sold is primarily the *restorer's* painting and virtually of no value. Shady dealers extract thousands of dollars from the public each year.

Two case histories of fraudulent paintings that follow warn of the dangers inherent in purchasing expensive paintings. In the first, word began circulating in art circles in 1975 that an important Krieghoff canvas was for sale in a downtown shopping plaza. This was an unlikely place for such an item because of the constant danger of theft and damage; on the other hand, the shopping mall was lined with expensive shops and frequented by the affluent. The newly offered work was inspected. The large canvas appeared to be a Krieghoff from a distance because of its typical subject matter: a habitant home in winter, habitant figures grouped around a sleigh, and homey touches of Quebec farm life. Much of the composition was based on *The Habitant Farm* (fig. 76), a National Gallery of Canada painting that has been frequently reproduced. No forger or his agent would risk offering for sale an exact copy of such a well-known work, so the painter introduced variations – an extra horse and sled in the foreground, possibly copied from a tiny canvas, *The Habitant*, which had been reproduced when it belonged to R.S. McLaughlin. But the technical execution was so bad that on that ground alone the forgery could fool only the naïve. When the dealer offering it for sale was accused bluntly of his fraudulent intent he restrained himself, but barely, from physical assault.

A genuine painting of this size and with so popular a subject would have commanded at that time a price of possibly $35,000. The dealer was asking $20,000, apparently a tantalizing bargain; the figure was sufficiently low to prompt an impulse purchase, but not low enough to arouse real suspicion. Yet purchasers who are about to spend such a sum and who know nothing about art should seek advice; they would insist on being allowed to have a lawyer check the title if they were buying a piece of land.

The deception in this painting was obvious to anyone knowledgeable about Krieghoff canvases, for the pigment had been applied with a palette knife which the artist himself seems never to have used. The dealer tried to prove that it was old by momentarily showing the reverse of the canvas. But the canvas was not new; it was possibly fifty years old and probably obtained by scraping the pigment from some worthless work. Raw canvas on the reverse of any oil painting turns brown during the course of a century; the reverse of this one was brown from accidental stains and not from the ageing that characterizes true Krieghoff works. Furthermore each of the four stretcher frames had angled ends, fitted together, and with wooden stretcher pegs – a refinement introduced after the artist's death. The dealer insisted that he had a certificate of authenticity signed on behalf of the National Gallery of Canada but declined to produce the document; National Gallery employees are forbidden to give such certificates. Subsequently, two prospective purchasers enquired about the painting. One man, after some bargaining, was offered the canvas for $14,000; two weeks later a woman could have had it for $8000. The ultimate fate of the painting is not known.

The second example was a more clever forgery, of Indians portaging their canoe through autumn woods at the Grand'-Mère Falls. The painting had probably been sold by one of a group of individuals implicated in what became Canada's most famous forgery trial, held in Toronto in the early 1960s. Possibly one hundred paintings were produced in court, purportedly by Emily Carr, A.Y. Jackson, Tom Thomson, Arthur Lismer, J.E.H. MacDonald, and other prestigious Canadian artists. Reputedly the records of the ring listed sales of fraudulent paintings to a total of $800,000. These sales had been made both privately and through art auctions. The fraudulent paintings had been produced in a number of ways. Some had been painted by Rita Mount (1887–1967), a competent but little-known Montreal landscape artist; dealers bought a large number of her sketches, erased her signatures and replaced them with those of Lismer, MacDonald, and other painters whose work resembled the subject matter, and upgraded the price accordingly. Other sketches and canvases were completely new works. Some had been painted by an elderly destitute painter: an agent for the dealers would deliver a colour print and paints to him in the morning, he would make a replica in oil during the day, and the fresh painting and the print would be picked up that evening and the painter given a token sum. In due course, the new work of art would be offered for sale as genuine.

A careful examination of the Grand'Mère Falls 'Krieghoff' (fig. 155) uncovered a fabrication of such skill that it warrants a detailed description to lay bare some of the forger's many ingenious techniques. The subject is colourful and attractive and so bewitched Krieghoff patrons that the artist himself painted at least sixteen slightly varying rectangular and oval

variations during his lifetime (see fig. 118 for an example). In view of the many originals, discovery of yet another would not be expected to arouse much surprise or comment. It was a 'safe' subject. The forger had had access to an original during the 1950s. He made a direct copy, but altered the rectangular to an oval format; superficially this made it appear to be quite a different work. The forger, moreover, must have had an intimate knowledge of other Krieghoff originals, realized the appeal of their colours and realism, and understood the technical expertise involved. Yet his colours did not match precisely those used by Krieghoff in the 1850s; manufacturers had changed their formula slightly in a hundred years. The forger added more oil medium than Krieghoff used: the result was an almost imperceptible blending of one stroke into the next because of the paint's fluid consistency; by contrast Krieghoff's brush strokes stand out in three-dimensional relief, mirroring every bristle because of the drier consistency, while the forger's more liquid pigment caused the strokes to flatten out in the copy. In the area where the surging flood strikes the rock in the waterfall, Krieghoff had attacked the pigment with a vigorous manipulation, matching the strength of the rushing water; the forger's brush work is timid by comparison, a result of *following* the model. The forger made no obvious mistakes but achieved a crawling effect rather than the spontaneous freshness so evident in the original; the situation parallels signatures by cheque forgers whose lines crawl in imitation rather than plunging forward with an uninhibited flourish. Indeed the forgery lacked those precise crisp touches that highlight form and give life to an authentic Krieghoff.

Curiously, the forger was careless in execution of one portion of the canvas. He concentrated his skill on the eye-catching aspects such as the colourful Indian figures, and relaxed in the 'space-filler' areas. The brilliant red and yellow autumn foliage is painted carefully, but the dull green pine branches and characterless shrubbery overshadowing the portage path are summary and meaningless. He did not appreciate the fact that Krieghoff's quest for realism extended even to those portions of the canvas that did not attract attention. In his pines, Krieghoff isolated and set down a basic skeletal framework of branches with accurately attached clusters of needles. If a corresponding detail from the forgery is isolated and enlarged, one finds a series of daubs and unconnected lines.

Other unusual techniques were used in the attempt to perfect this deception. Newly applied paint retains a superficially 'new' appearance for years. Indeed the pristine bloom may disappear only after the paint has become crazed through a lengthy drying process and dust has settled into the crevices. To telescope years of ageing, the forger mixed a little darkening pigment into his varnish and overpainted the forgery once it had dried sufficiently to lose its tacky surface; then he baked it in an oven to produce premature cracks.

The forger had to solve one other difficult problem. The obverse of the new canvas support was hidden completely by fresh paint, but the reverse remained completely new in appearance. Normally forgers overpaint the back of the canvas with a wash of burnt umber in turpentine to simulate age discolouration. Here an ingenious but simple method was used to hide the fresh reverse. Many original Krieghoff paintings have been re-lined – to strengthen the old and fragile canvases, a new canvas is glued to the reverse of the painting. So the forger glued a re-liner's canvas on the back of the newly painted forgery. This had a double result: it completely hid the fresh canvas on which the forgery had been painted, and at the same time created an illusion of age by suggesting that the original canvas was in such a precarious state because of age deterioration as to require a restorer's first-aid treatment. Then a final touch completed the 'masterpiece.' Some well-known restorers affix a monogram on valuable paintings on which they have worked to serve as their mark of authentication. This forger, in a unique refinement, added such a restorer's monogram before enshrining the 'old-new' painting in a discarded period frame to await a purchaser's inspection.

Many paintings of European origin bear forged 'C. Krieghoff' signatures. The majority are of German, Dutch, and Flemish origin. Their subject matter may be ice, snow, or peasant houses, all associated in the public mind with Krieghoff paintings. They are works of no merit and, lacking aesthetic value, have no significant sale value; the adding of a fraudulent signature merely makes them seem of importance.

A few worthless historical paintings – illustrations of celebrated events of the past – bear similar added signatures. Such subjects were popular in the nineteenth century, but with the change of fashion few are now valuable unless they are contemporary records of interest. Most could be dismis-

155 *Portage*, after a Krieghoff canvas
14 × 16⅞ in / 35.6 × 42.7 cm

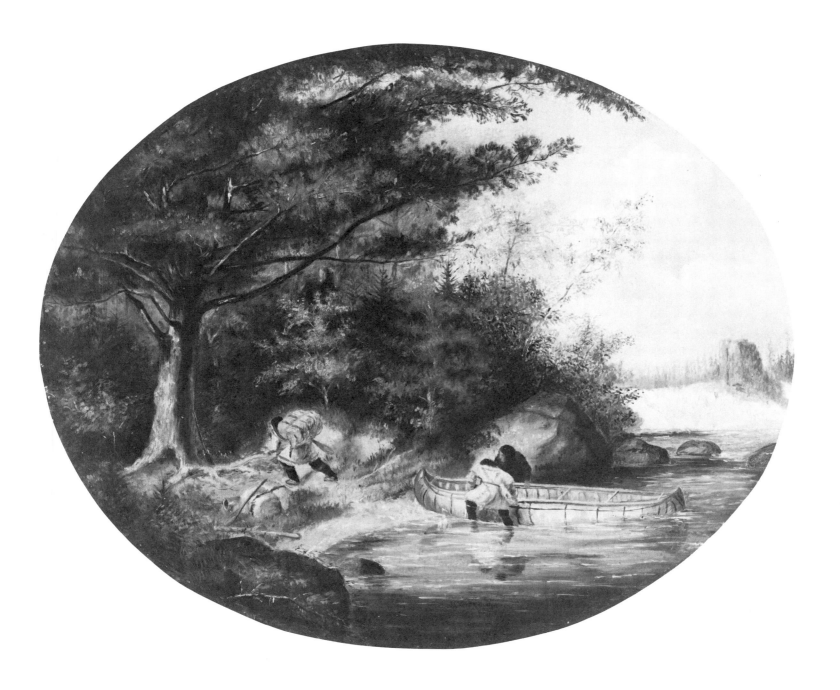

sed immediately as not painted by Krieghoff if it were not for the fact that he did copy a few historical canvases relating to the life of Mary Queen of Scots and similar subjects. Consequently signatures must be checked carefully in case the work might be an obscure copy, despite the apparent dissimilarity to Krieghoff's other work.

Krieghoff's various practices as a painter are worth knowing for those who wish to avoid forgeries. While he preferred canvas to composition panels as a support for his oil paintings, he did use panels on occasion in the earlier stages of his career. Only two unquestionably authentic paintings on panel post-date 1850; a few others are possibly authentic. An early example of his use of a panel is a copy of a David Wilkie painting of card players (fig. 10), presumably done in Rochester. The panel came from Edward Declaux, who sold artists' supplies at 306 Broadway, New York, between 1841 and 1853. During the 1840s Krieghoff also used a small panel supplied by the firm of Ackermann & Company, London. His version of a soldier courting a habitant girl in the Quebec Museum, painted in the 1845–8 period, is on a grey composition panel bearing the stencil of 'Reeves & Sons, Cheapside, London.' Several other paintings of approximately the same date are on similar panels but without a supplier's mark. The manner in which their edges have been cut suggests that panels were sold in large sheets and cut to the desired size by the artist.

All canvases Krieghoff used were commercially prepared, evidently purchased in bulk and cut up to be mounted locally on soft wood stretchers. Canvas stretchers used in the earlier years of his career are square or rectangular, with the ends of each stretcher frame cut at right angles, and the corners fastened rigidly. Later he used stretchers that were not nailed at the corner; tension was obtained by inserting triangular pins of wood at each of the corners. While not unique to his work, it should be noted that dark concentric rings are visible on the reverse of Krieghoff canvases. This is the result of a circular cracking of the paint which has permitted the oil to penetrate through the canvas support; one suspects this occurred because the artist bought rather cheap canvases with a poor priming coat.

Unfortunately, the reverse of only a small percentage of the paintings in this study could be examined to determine whether there was a supplier's name. But an 1858 painting of

156 Inscription by Krieghoff on stretcher of fig. 91

Indians portaging a canoe at the Grand'Mère rocks bears on the reverse the stencil of 'Reeves, 113 Cheapside,' and other similar stencils have been noted. A *Bilking the Toll* stamped 'Colin, Place du Louvre, Paris' is undated, but was presumably painted during the post-1863 period. Barbeau declared that all Krieghoff canvases were manufactured by the Rowney firm of London,[2] but I have found no Rowney stencils on any paintings examined.

Krieghoff signed all but a very very few of his oil works, and even these may have once had a signature. They demonstrate a multiplicity of scripts and a rainbow-like range of colours over the years. Earlier paintings generally bear a small, carefully executed signature in black, burnt umber, or white, and sometimes have a date added. Greater freedom and more florid signatures appeared in the later 1840s; paintings of gentlemen driving sleighs in winter and of ice cutters on the St Lawrence are often signed in a greenish grey that blends with the prevailing colour of winter paintings. Two undated canvases of this period have a blue 'CK' monogram. The painted signatures tend to be brighter in colour after Krieghoff's move to Quebec. In 1856 there are examples of a bright vermilion, of white lettering standing out against dark tones, and of burnt umber against light areas. The vermilion was repeated frequently during the next few years, particularly on paintings of autumn views or on canvases with brilliant winter sunsets; one might imagine that the gay colour reflects an exuberant mood. Other signatures are in deep green, blue, neutral grey, and ochre. The word 'Quebec' frequently precedes the date and he even added the month in an 1858 canvas. After his divorce from the jolly Quebec atmosphere during his later years, he reverted to more frequent use of sombre burnt umber and other dull colours.

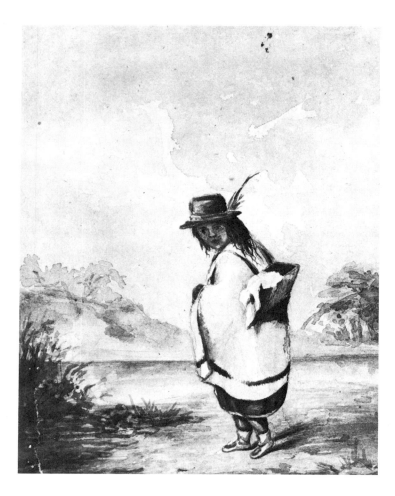

157 *Indian Woman* early 1860s watercolour
$4\frac{1}{2} \times 6$ in / 11.4 × 15.2 cm Public Archives of Canada, Ottawa

Many late signatures are applied in a script style.[3]

Krieghoff inscribed titles, dates, and details of the subject on occasional works. Pictures to be framed in an oval or circular format he painted on rectangular canvases, with the corner spandrels painted in ochre; frequently details of the painting were inscribed on one of these spandrels or on the reverse of the canvas. In one such example, the spandrel reads: 'Stream near/Lake Magog, E.T.' (fig. 121). Details on the reverse may be either on the canvas or on the stretcher itself, and are normally in black. A typical example on a stretcher reads: 'Crossing Cattle for Lumbering Purposes'

(fig. 156). The script is precise and distinctive. In one exception, a painting of caribou hunters crossing the ice on Lake St Charles at sunset, the inscription is in vermilion.

A number of watercolour studies were painted by Krieghoff during his years in Quebec, and much controversy has arisen about his works in this medium. Indeed, his forged signature on watercolours occurs so often, and so little documentary proof exists about any examples, that it has seemed prudent to question whether any authentic Krieghoff watercolours actually exist. Yet he was certainly familiar with the medium, for he taught watercolour at the Misses Plimsoll's school in Montreal during the late 1840s. Despite lack of documentation, a few paintings located in the course of writing this book have characteristics indicating that they are authentic. There may be no more than twelve genuine watercolours among the many examined; on the other hand, a great many fraudulent 'Krieghoff' watercolours have been found.

An important early example of a genuine Krieghoff watercolour is *Little Pine Chief* (fig. 51), painted probably in 1848 during the visit of the Chippewa chieftain to Montreal. Its execution has the freshness of an experienced artist working directly from the model. Documentary and stylistic grounds as well connect it to Krieghoff. It also has qualities that relate it to such later works as a watercolour sketch of an Indian girl (fig. 157) which dates from 1860 or slightly later. This modest little work, which has good documentation, is of a figure wearing a hat with a feather on her head, a blanket over her shoulders, and a basket on her back. Originally the sketch was mounted in an album belonging to Charles S. Ogden, the American consul in Quebec City in the early 1860s. The album, now in the Public Archives of Canada, contains autographs by Sir John A. Macdonald and other noted public figures. Photographs of the writers of the autographs are mounted on the facing pages, with one exception: this small painting faces Krieghoff's photograph. This is circumstantial evidence that the watercolour is genuine, but it seems fully confirmed when the sketch is compared to Krieghoff's oils. It has the same quality of crisp precision and sharp accents found in his oil studies of Indian figures, and indeed in the watercolour of Little Pine Chief. The pencil drawing is unobtrusive. The watercolour has been built up by first applying a series of transparent flat washes, which are strengthened and enhanced by dark crisp strokes to achieve

solidity and volume. It is this crispness and a three-dimensional effect, paralleling the brush work of his oil subjects, that gives Krieghoff's finished watercolours their distinctive character.

A group of five watercolour sketches of Quebec subjects evidently date from the later 1850s. They are certainly by Krieghoff's hand, despite the fact that the signatures when tested under ultraviolet light gave inconclusive results (unfortunately, ultraviolet light is not a satisfactory process for testing ink signatures on watercolours). In one of these pictures a milk seller makes his rounds through the village with a sled drawn by a dog (fig. 158). This sketch and another in the set, of a team pulling an enclosed box sled inscribed 'Royal Mail' over the frozen St Lawrence against a Quebec background, are unique subjects in Krieghoff's repertoire. The other three sketches are of subjects known in his oil paintings. In one, a man wearing a round fur hat, accompanied by a lady in a heavy coat, long dress, and blowing scarf, walks in a snowy landscape. Another, the ice road to Longueuil, is similar to canvases of the late 1850s (type of fig. 36). In the last, a tandem team pulls a gentleman's sled on the ice in front of Quebec City (type of fig. 62). The sharp accents, a sense of conviction, and a directness in each example match that in the two Indian watercolours.

A watercolour entitled *Sleigh Riders in a Snowstorm* shows habitants on a country road in a blizzard passing a wayside cross, a favourite Krieghoff theme (type of fig. 70). It was formerly in the collection of Princess Louise and was presumably acquired when she was in Canada. The documentation does not go back to the actual date of execution; however, one assumes that the wife of a governor-general would not have been offered a forgery. As well, it is so fresh and bold in execution that it must be considered authentic.

Another watercolour, of a man holding a bunch of grapes, evidently dates from Krieghoff's student days in Europe. A couple of early watercolour portraits were presumably painted in Montreal; there is nothing about them that is inconsistent with his work in general, but one would have difficulty in pointing to characteristics that definitely link them to his hand.

Of recent discovery is a magnificent *Bilking the Toll* watercolour, far exceeding in size (19¾ × 24 inches) any previously known Krieghoff watercolour. It is unsigned, but its execution, the powerful, dynamic strokes and expressive

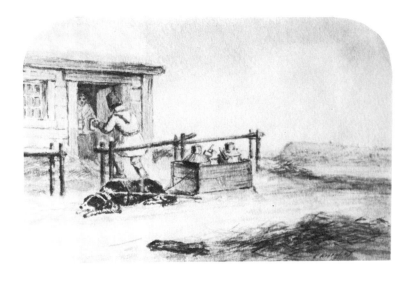

158 *Milk Seller with Dog Hitched to Sled* undated watercolour
5¼ × 7¾ in / 13.3 × 19.7 cm private collection

faces, and every other detail are such that it seems impossible it could be the work of any other artist. It opens a whole new range in the appreciation of his output in this medium.

While these apparently authentic examples do exist, there are many more watercolour paintings that are purportedly the work of Krieghoff but are in fact merely copies or bear forged signatures. The proportion of fake watercolours to true ones is far higher than is the case with oils. Many were painted by nineteenth-century amateurs and copyists and are based on lithographs or on original oils. Their spurious origin is more difficult to detect than that of forged oils, primarily because Krieghoff watercolours have as yet received little scholarly study.

The Public Archives of Canada possesses a watercolour of the falls at Montmorency (fig. 160), signed 'C. Krieghoff 1853.' In fact, this work is a forgery, although it has been exhibited and published as authentic.[4] It has been said to be the original on which a well-known lithograph (fig. 159) was based. Detailed examination of both works have disclosed irrefutable evidence that the watercolour was copied from the print rather than the other way around. The watercolourist, in following the print model, set down each brush stroke with one stilted detail after another, rather than working in the

159 *The Ice Cone at the Falls of Montmorency near Quebec, Lower Canada,*
in 1853 1853 lithograph
$15\frac{13}{16} \times 23\frac{1}{8}$ in / 40.2 × 58.7 cm private collection

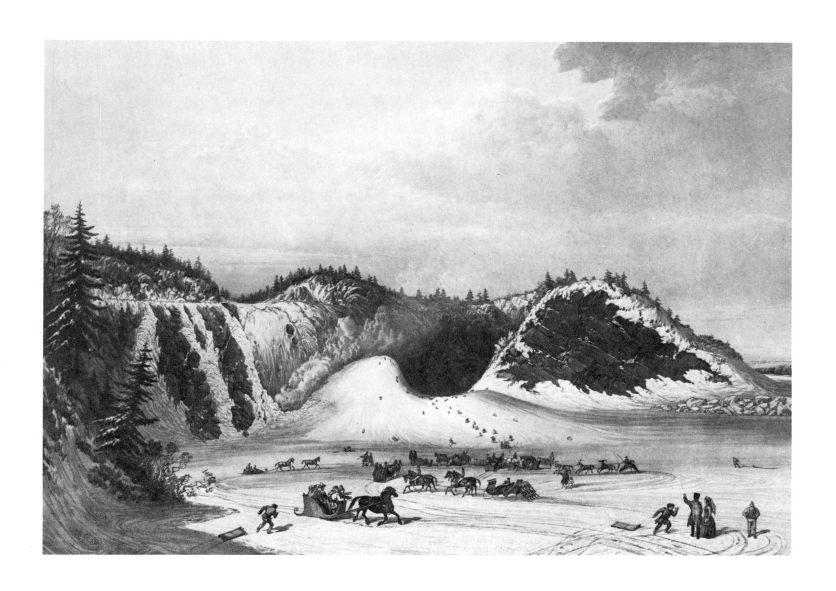

160 Follower of Krieghoff, *Falls of Montmorency in Winter*
watercolour
$15\frac{3}{4} \times 23\frac{1}{2}$ in / 40×59.7 cm
forged signature
Public Archives of Canada, Ottawa

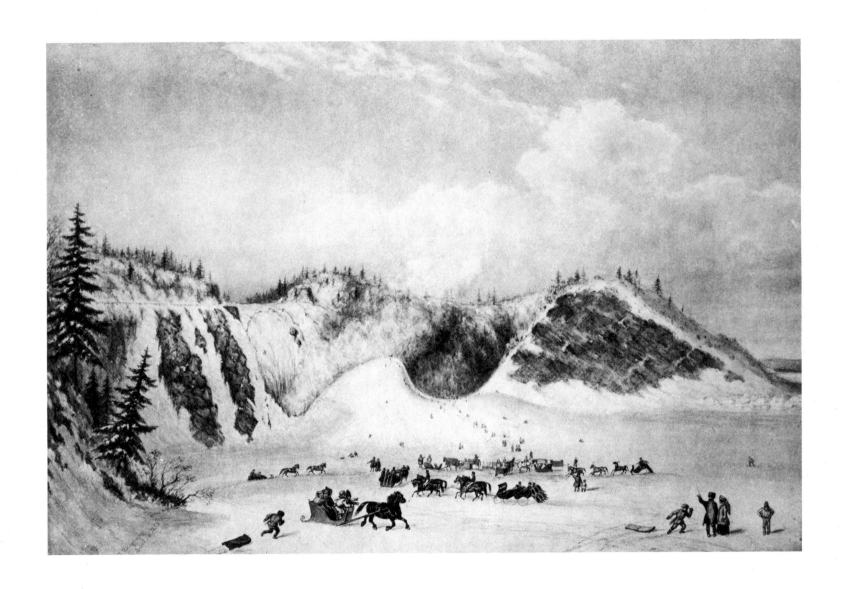

161 Detail of fig. 159

162 Detail of fig. 160

163 Denis Gale, *Tobogganing at Quebec Citadel*
watercolour $5\frac{7}{8} \times 8\frac{5}{8}$ in / 14.9 × 21.9 cm
forged Krieghoff signature Public Archives of Canada, Ottawa

bold sweeps of a painter striking out to create a new work. The watercolour was checked against the print to determine whether the lithographic artist – if he *was* copying onto the printing stone – had made the minute alterations in transcribing the original painting that such men normally were allowed. This detailed cross-checking revealed a curious detail. In the print, a scratch line extends diagonally from the raised hand of the man standing beside a lady in the lower right foreground (fig. 161). The watercolourist – who must in fact have been working from the lithograph – failed to realize that this line was *accidental*; he misinterpreted it as a walking stick the man is brandishing to point out some landscape feature (fig. 162). It is eloquent testimony to the time sequence in which the two versions were executed.

Probably more of Denis Gale's watercolours have been transformed into 'Krieghoffs' than those of any other single artist. The reason lies in the similarity of their work. The two men probably sketched together, and Gale may even have copied Krieghoff's paintings. There is a complete volume of Gale sketches that parallel such Krieghoff subjects as sleighs on river ice and an artist gazing at Montmorency Falls.

One group of Gale's watercolours have been exhibited as the work of Krieghoff (again they are in the Public Archives of Canada),[5] the subjects paralleling various authentic Krieghoff paintings: Indians shoot the rapids in a canoe, a mail boat crosses the frozen St Lawrence, parties toboggan on

the Quebec Citadel slopes (fig. 163), and Indians gather in varied groups. One characteristic of Gale's work is an extensive use of Chinese white to achieve highlight effects, in preference to leaving areas of unpainted paper. Gale used this same Chinese white in other signed examples. No known authentic Krieghoff watercolour employs this pigment.

The Archives group is signed with Krieghoff's name but in a precise script quite unlike his hand. Their background, too, is revealing. A famous collector, W.H. Coverdale, amassed a superb collection of Canadiana nearly half a century ago which included a group of watercolours identical in type of subject, technique, execution, format, and materials to the so-called 'Krieghoffs' in the Public Archives; but they are signed by Denis Gale. The entire Coverdale Collection was purchased by the government in recent years, and the Gale paintings were placed beside those with the forged Krieghoff signatures purchased many years earlier. It was obvious that originally both the Coverdale works and the Archives group had formed a single collection. Some dealer had split them into two units, sold the half signed 'Gale' to Coverdale, erased the signature from the other half, and substituted 'C. Krieghoff.' The forgery must have been made at a time when the research and publications of Marius Barbeau, as well as

exhibitions at the National Gallery, the Montreal Museum of Fine Arts, and the Art Gallery of Ontario, had aroused great interest in Krieghoff. The dealer would have faced slight danger of exposure since little or nothing was then known about Krieghoff's watercolours.

Many spurious Krieghoff watercolours have been painted by artists whose identity is completely unknown. The materials used and the painting techniques are many. Some have been painted on nineteenth-century paper, evidently intended as stationery for letters. A number on such paper seem to be by the same hand. The draughtsmanship is imprecise. In faces and heads such features as chins are literally 'cut off,' there is little indication of eye sockets, no attempt is made to give a three-dimensional modelling, or to treat the head in terms of planes. This same carelessness in detail extends to the rendering of shrubbery, which lacks any attempt at 'anatomical' correctness. The Krieghoff signatures are consistently forged.

Confusion may also arise around the work of James Duncan who painted many Montreal subjects with genre groupings reminiscent of Krieghoff's. Other Duncan watercolours picture autumn and winter hunting scenes. A Duncan sketchbook was transformed into a 'Krieghoff' during the 1940s by the audacious and adroit introduction of various Krieghoff signatures. The paintings document life in Montreal: habitants and shoppers congregate in the market, along the streets, and at the docks. Sigmund Samuel purchased the sketchbook on the advice of F. St George Spendlove, who was then the Canadiana expert at the Royal Ontario Museum in Toronto. Spendlove realized its importance as a historical document; Dr Samuel donated it to the museum; and in 1952, at Spendlove's suggestion, the author of this study published an article on the so-called Krieghoffs.[6] The discovery of the fraud came much later. In 1967 the National Gallery of Canada exhibited an unsigned Duncan watercolour as the work of Krieghoff on the basis that the style related to the sketchbook.[7] But there had been a lurking suspicion from the first that the Krieghoff attribution in the book was incorrect, and it was confirmed when a companion Duncan sketchbook was auctioned in 1968.[8]

The techniques of Duncan and Krieghoff vary. Perhaps the most obvious characteristic of the Duncan sketchbook is the bold pencil drawing that virtually transforms the watercolours into tinted drawings. Yet Duncan also painted

164 James Duncan, *Tobogganing* watercolour
7 × 9½ in / 17.8 × 24.1 cm
forged Krieghoff signature
private collection

watercolour paintings with full colour and no sign of the pencil drawing. Several of these circulate with forged Krieghoff signatures. One example is a painting of a couple tobogganing in winter (fig. 164). Some show brilliant autumn woods. Others picture a man in a blue, blanket cloth coat pulling his toboggan uphill in a blizzard; in these Duncan strove for an effect of blowing snow by scratching through the layers of dried watercolour with a pin to create irregular white lines on the paper.

Some collectors own Krieghoff items which they insist are original watercolour paintings; in fact they are photographs of his paintings overpainted in watercolours for commercial sale in the 1860s. The misconception first arose because photographic emulsion fades through the years, and after a century this layer can scarcely be detected beneath the overlying pigment. Barbeau, in writing about Krieghoff's paintings, lists a little watercolour measuring 2½ by 3½ inches of horses racing on the ice of the St Lawrence.[9] It is undoubtedly an overpainted carte-de-visite photograph. Misinterpretations arise more frequently with the larger photographs measuring approximately 6 by 8 inches, overpainted by ar-

tists working for Notman and Ellison. Many of these studio artists mixed opaque Chinese white with their colour pigment and as a result the underlying photographic emulsion layer is effectively hidden. But the colour pigment fades out after exposure to many years of light in homes, and the whole takes on a curious ghost-like appearance. It should be remembered that Krieghoff signatures on paintings may legitimately appear in the photographs; these are quite different from the freshly overpainted signatures on the Gibb set of carte-de-visite photographs (fig. 139) discussed in an earlier chapter.

There is no infallible test to determine the authenticity of Krieghoff watercolours. Each painting demands careful, individual scrutiny. Many spurious works can be rejected immediately because they bear no relationship to his work. Others pose real difficulties, particularly if they are painted by a skilled artist, and even more so if painted by Krieghoff himself in a little-known stage of his career. A safe rule is to assume that a few of the watercolours offered for sale *may* be originals. This possibility is what makes collecting and research so interesting, just as the fresh colours and vigorous subjects maintain Krieghoff himself as the most popular of Canada's early painters.

Notes

CHAPTER 1: The formative years, 1815–46

1 Information here on the Krieghoff family comes from the following sources: the Register of Births, Amsterdam, 1815, vol. 3, folio 202; the Krieghoff family genealogy in the archives of Langensalza, Thuringia (a copy was examined in the possession of Dr Charlotta Sattler, Schweinfurt); and the records in the Church of St Johannis in Schweinfurt. Krieghoff's father was born on 30 April 1786 and died on 28 May 1868: his death certificate in the Church of St Johannis states that he was born at Mollsdorf, Thuringia, but the marriage documents in Amsterdam say that he was born in Ufhoven. His first name is variously spelled Johann and Johan in different sources; Krieghoff's own first name is spelled 'Cornelis' in the record of his birth in Amsterdam. The family genealogical records state that Krieghoff's grandfather was a minor court official, though Paul Ultsch, in 'Die Eintracht baut ein Haus,' *Schweinfurter Heimatblätter*, 12 Nov. 1966, p. 48, says he was a miller.

2 The Register of Marriages, Amsterdam, 12 May 1811. Johann Ernst was twenty-five, his bride three years older. Curiously, Krieghoff's mother's given name is set down as 'Charlotte' in the records of the Church of St Johannis, Schweinfurt, at the time of her death on 9 February 1867 when she was said to be eighty-three years old. At the time of the wedding Isabella's widowed mother was living in Bruges. See also Vézina, *Krieghoff*, 23 and 24.

3 The German words that identify his profession are vague, and he has been described at different times as a maker of tapestry wallpaper and as a carpet weaver. In view of his later vocation, it is probable that he was making wallpaper.

4 Wilhelm Sattler, *Das alte Schloss Mainberg bei Schweinfurt und seine frühern Bewohner* (1836), 47

5 Interview with Paul Ultsch, Schweinfurt. The Krieghoffs moved out of the castle about 1848.

6 Information on the wallpaper factory comes from the Sattler family archives in the possession of Dr Sattler. The story about 'Schule's Green' is also told in an undated letter from Christopher O'Connor to Robert Harris, Harris Papers, Confederation Centre, Charlottetown, Prince Edward Island.

7 A scrapbook survives in the collection of Dr Sattler.

8 The castle was sold in the 1920s to a wealthy manufacturer named Sachs who turned it into an unbelievable playboy's estate: in this hideaway he installed marble bars, a pipe organ in one of the ballrooms, pseudo-medieval and Renaissance decorations, and an electric elevator to reach the upper floors. One of Sachs' sons, who was later married for a time to French actress Brigitte Bardot, was the last resident of the rooms where the Krieghoff family had lived a century before.

9 A great-nephew of Cornelius, W.G. Krieghoff of Philadelphia, wrote that Krieghoff had studied music and painting in Düsseldorf when aged about eighteen – that is, about 1833.

10 Fairchild, *Gleanings from Quebec*, 68; Jouvancourt, *Krieghoff*, 20–2; Vézina, *Krieghoff*, 31

11 Jouvancourt, *ibid.*, 21–2

12 Fairchild, *From My Quebec Scrap-Book*, 122. If Krieghoff studied in Rotterdam it could not have been at an advanced institution of learning, since that city had no university until recent years. One curious study, Guttenberg, 'Krieghoff,' goes so far as to detail the various countries Krieghoff visited; yet nothing is documented, and since the author states that the artist's father died when Cornelius was eighteen while in fact he died many years later, the whole becomes somewhat suspect.

13 Budden to Harris, O'Connor to Harris, both undated, Harris Papers

14 Fairchild, *Gleanings from Quebec*, 68. The exact date of their arrival is not known, but their great-nephew stated that they landed just before the outbreak of hostilities with the Seminoles.

15 Herman Viola, *The Indian Legacy of Charles Bird King* (New York: Doubleday 1976), 61, 142

16 War Records, National Archives, Washington; Fairchild, *From My Quebec Scrap-Book*, 68

17 John C. Ewers, *Artists of the Old West* (New York: Doubleday 1965), 95; *Braves and Buffalo: Plains Indian Life in 1837*, intro-

duction by Michael Bell (Toronto: University of Toronto Press 1973), 6; George Catlin, *Letters and Notes on the Manners, Customs, and Condition of the North American Indians*, 2 vols. (London 1841)

18 *Rochester Daily Advertiser*, 30 May 1843

19 War Records, National Archives, Washington, Adjutant General's Office, Enlistment Papers, Record Group 94

20 Barbeau, *Krieghoff* (1934), 3; quoting from Roy, *Les petites choses de notre histoire*, IV, 168–71. Barbeau said the information came from an old newspaper article of Louis Fréchette.

21 Vézina, *Krieghoff*, 30, quoting death certificate, 4 Sept. 1906, Denver, Colorado

22 Ste Famille parish records, Boucherville, 18 June 1840. In his death certificate the child is called 'Ernest Gauthier,' perhaps renamed in honour of his grandfather and uncle.

23 Notre-Dame parish records, Montreal, 13 June 1841

24 Barbeau, *Krieghoff*, 97

25 J. Russell Harper, *Paul Kane's Frontier* (Toronto: University of Toronto Press 1971), 10–11

26 Budden to Harris, n.d., Harris Papers

27 For example, Barbeau, *Krieghoff* (1962), fig. 6 and others

28 Barbeau, *Krieghoff* (1934), 34

29 Louvre Archives, Paris, Registre des cartes d'études délivrées aux élèves, 1840–5, no 2590

30 Prints of Robert's paintings were being sold for use by copyists at mid-century. See *Cotton's Catalogue of Drawing Materials, Stationery ... To which is prefixed Instruction in Water Color Painting by T. & T.L. Rowbotham, Jr.* (Boston: N.D. Cotton, n.d.), 96 (the volume would appear to date from after 1850).

31 Barbeau, *Krieghoff*, 101

32 *Ibid.*, 97. Ernst's name has not been found in the city records.

33 Jameson, *Winter Studies and Summer Rambles*

34 Harper, *Paul Kane's Frontier*, 14f.

35 Toronto Society of Arts, *First Exhibition* (Toronto 1847)

36 Barbeau, *Krieghoff*, 33, 130; *Country Life* (London), 22 Sept. 1960

37 Reproduced in G.H. Marius, *Dutch Painters of the 19th Century*, ed. Geraldine Norman (Antique Collectors' Club 1973), 63

CHAPTER 2: Maturity, Montreal and Longueuil, 1846–53

1 Dickens, *American Notes*, 221

2 Harper, *Paul Kane's Frontier*, 141, pl. XXVI

3 Raymonde Gauthier, *Les manoirs du Québec* (Montreal: Fides 1976), 100–2

4 The *Montreal Gazette*, 15 January, singled out the painting for particular attention: 'Mr. Krieghoff shows very good taste in colouring and perspective and drawing generally correct, and signs of originality which, under favourable auspices, would develop themselves. There is a great deal of merit in his interiors, particularly one of "an officer's apartment," (we think it is called,) in which there is much skilful and characteristic grouping of inanimate objects, and great soundness and transparency of colouring, which, indeed, seems to be his leading characteristic.'

5 Staunton's arrival in Montreal is listed in the British Army List, 1846. The painting, when sold in London earlier in this century, allegedly belonged to Macdonnell, who did serve in Montreal at the time and subsequently rose to the rank of major-general. Staunton's initials on the gauntlet and his paintings hanging on the wall, however, suggest that it was originally painted for him. Macdonnell may have acquired it in Montreal after Staunton's death.

6 Elinor Senior, 'An Imperial Garrison in Its Colonial Setting: British Regulars in Montreal, 1832–54,' unpublished PH D thesis, McGill University, 1976

7 The painting of Montreal hanging on the wall is based on a canvas reproduced in R.H. Hubbard, *Painters of Quebec, Maurice and Andrée Corbeil Collection* (Ottawa: National Gallery of Canada 1973), no 27, *View of Montreal*. The original signature of Krieghoff has been removed and replaced by that of James Duncan.

8 The Krieghoff files, Montreal Museum of Fine Arts, list three copies of Staunton sketches made by Krieghoff.

9 Shakspeare [*sic*] Club Papers, Rare Book Room, McLennan Library, McGill University, Montreal

10 Louis Carrier, *Catalogue of the Château de Ramezay* (Montreal: Antiquarian and Numismatic Society of Montreal 1957), no 133

11 Day, *English America*, II, 225

12 Edgar A. Collard, 'The Glory That Was Dolly's,' *Gazette*, 24 Nov. 1973

13 *Gazette*, 10 Oct. 1845

14 *Atlantic Advocate*, Fredericton, Jan. 1963, letter from W.A. Craick

15 [Winkworth], *Scenes in Canada*

16 Harry T. Peters, *Currier and Ives: Print Maker to a Nation* (New York: Doubleday 1942)

17 *Gazette*, 18 Jan. 1847

18 *Ibid.*, 29 May 1852

19 Barbeau, *Krieghoff* (1934), 4, maintains that Krieghoff lived in Longueuil. It seems possible that Emilie's family had Longueuil connections since it had early residents named 'Gauthier dit Saguingoira,' evidently a variant of the name 'Saintaguta.'

20 Barbeau, *ibid.*, 5

21 For a discussion of habitant clothing, see Robert-Lionel Séguin, *La civilisation traditionnelle de l' 'habitant' aux 17e et 18e siècles* (Montreal: Fides 1973).

22 Bird, *Englishwoman in America*, 283–4

23 C.P.T. Chiniquy, *Forty Years in the Church of Christ* (Chicago: F.H. Revell 1900), 41–2

24 Robert Rumilly, *Histoire de Longueuil* (Ottawa: Societé d'histoire de Longueuil 1974), 138, 283

25 Séguin, *La civilisation traditionnelle*, 377

26 Kingston, *Western Wanderings*, II, 261–2. *The Illustrated London News*, 16 April 1850, p. 381, also describes the process of ice-cutting in Canada.

27 Tolfrey, *The Sportsman in Canada*, I, 266–7

28 Robert-Lionel Séguin, *Les Moules du Québec* (Ottawa: National Museum of Canada 1963), 21, quoting Nicolas-Gaspard Boisseau

29 Jouvancourt, *Krieghoff*, 55

30 Frederick Webb Hodge, *Handbook of Indians of Canada* (Ottawa: King's Printer 1913), 81–2

31 Buckingham, *Canada, Nova Scotia, New Brunswick*, 150–1

32 Heriot, *Travels through the Canadas*, 119–20

33 Edgar A. Collard, *Montreal Yesterdays* (Toronto: Longmans 1962), 104–13

34 Smyth, *Sketches in the Canadas*, nos XVIII and IX

35 *Ibid.*, no XXIX

36 *Diary of Mrs. John Graves Simcoe*, 94

37 Bonnycastle, *The Canadas in 1841*, I, 88

38 Harper, *Paul Kane's Frontier*, 58

39 Smyth, *Sketches*, no III

40 Willis, *Canadian Scenery*, I, 36

41 Percy MacKaye, *Epoch: The Life of Steele MacKaye*, 2 vols. (New York 1927) I, 45, pl. 3

42 Mary Allodi, *Canadian Watercolours and Drawings in the Royal Ontario Museum*, 2 vols. (Toronto: ROM 1974), II, no 1584

43 The general account here of the visit of the three men to Montreal and the woodcut picturing them is in *The Illustrated London News*, 15 Sept. 1849, p. 180; the rough woodcut of the Great Warrior is in *ibid.*, July 1855, p. 28.

44 All three tales are from Barbeau, *Krieghoff*, 9–10, 26, 78

45 The information on the Krieghoff residences comes from the Montreal Directories; on Ernst's trip to Germany from family documents in the possession of Mrs Elizabeth A. Taylor, Cincinnati. Ernst's first child, named Ernest, died on 27 April 1850, shortly after his birth, St George's Church Records, Montreal.

The other children were Ernest Philip, b. 14 April 1851, William Lewis, b. 22 April 1853, and Charlotte Caroline, b. 29 June 1855, Christ Church Cathedral Records, Montreal.

46 Schweinfurt Directory, 1865

47 Ernst had descendants who were painters, one of whom is remembered as a well-known Philadelphia artist. Barbeau, *Krieghoff*, 97–9

48 Collard, 'The Glory That Was Dolly's'

49 In appreciation of Campbell's backing, Elgin commissioned a tie pin from a jeweller as a gift for him. On the pin a pearl shaped like a hen's egg was held firmly by the claws of a golden hen's foot.

50 Even Sir George Augustus Wetherall, deputy adjutant-general of Canada, who had been in the colony since 1837, was posted home from Montreal in 1851. He had engendered much personal affection with the local people, and Krieghoff and others signed a testimonial of regret at his departure.

51 Edgar A. Collard, *Canadian Yesterdays* (Toronto: Longmans 1955), 290–7

52 Krieghoff to Pinhey, 26 Oct. 1849, private collection

53 Barbeau, *Krieghoff*, 9

54 Burford produced a second Canadian panorama in 1834 of the Boothia Peninsula in the Arctic, after drawings by Captain Ross.

55 J.E. Arrington, 'William Burr's Moving Panorama of the Great Lakes, the Niagara, St. Lawrence and Saguenay Rivers,' *Ontario History*, LI (1959), 141–62.

56 Harper, *Early Painters and Engravers*, 121–2

57 *La Minerve*, Montreal, 17 and 31 July 1851

CHAPTER 3: Fulfilment, Quebec City, 1853–63

1 Thompson, *Reminiscences of a Canadian Pioneer*, 225–6; he was in Quebec in 1859–60.

2 Todd later regretted his abrupt move, bemoaning the fact in the 1861 census return that Toronto was 'too new and too poor to support an ornamental artist.' Canada Census, Toronto, 1861

3 O'Connor to Harris, n.d., Harris Papers, Charlottetown. The painting described seems to be one of an Indian council dated 1855 or a similar subject dated 1856; either O'Connor was incorrect about the year or Krieghoff completed a version of this subject at an earlier date that has now been lost.

4 Budden is said to have visited Montreal to press the point that Krieghoff should move to Quebec, but there is no proof of this. Barbeau, *Krieghoff* (1934), 8–9. Krieghoff had painted Budden's portrait in 1847, so they had met by then, presumably in Mont-

real. While Emilie would have joined her husband in Quebec in the normal course of events, there is no actual document mentioning her presence in that city.

5 Margaret Swain, 'Moose-hair Embroidery on Birch Bark,' *Antiques*, New York (April 1975), 726–9, fig. 6

6 Barbeau, *Krieghoff*, 92

7 *Morning Chronicle*, Quebec, 17 Jan. 1860. The photograph album, inscribed 'John Budden, 1862,' is in a private collection. According to O'Connor, the club suspended operation for a time because an early manager, Mr Leslie, had died during one of Quebec's recurrent cholera epidemics.

8 Barbeau, *Krieghoff*, 93

9 C.H.C., *It Blows, It Snows*, 58

10 Bird, *Englishwoman in America*, 264

11 Kingston, *Western Wanderings*, II, 212

12 Monck, *My Canadian Leaves*, 298–301

13 Lucy Booth Martyn, *Toronto, 100 Years of Grandeur* (Toronto: Pagurian Press Ltd. 1978), 50

14 Barbeau, *Krieghoff*, 102

15 Bird, *Englishwoman in America*, 286

16 Kingston, *Western Wanderings*, II, 214–15

17 Barbeau, *Krieghoff*, 102

18 *Quebec Telegraph*, 9 April 1912, repeats the earlier news item; the original is missing.

19 Thompson, *Reminiscences of a Canadian Pioneer*, 221

20 Kingston, *Western Wanderings*, II, 163

21 Hall, *Travels in Canada*, 96–7

22 Buckingham, *Canada, Nova Scotia, New Brunswick*, 267–9

23 Bird, *Englishwoman in America*, 266–8

24 A more elaborate account of this painting is given in Harper, *Cornelius Krieghoff: The Habitant Farm*.

25 Hormisdas Magnan, *Dictionnaire historique et géographique des paroisses, missions et municipalités de la province de Québec* (Arthabaska 1925)

26 Edgar A. Collard, *Canadian Yesterdays*, 285–9, gives an account of the 'canotiers' crossing the river ice.

27 Public Archives of Canada, Legislative Council Papers, 1856, Petition no 193

28 J. Russell Harper, *William G.R. Hind* (Ottawa: National Gallery of Canada 1976), 22

29 Krieghoff to Galt, 6 March 1859, Galt Papers, Public Archives of Canada, RG19, E1(a), vol. 4

30 *Morning Chronicle*, Quebec, 15 Aug. 1857 (advertisement dated 29 May 1856)

31 F. Henry Johnson, 'A Colonial Canadian in Search of a

Museum,' *Queen's Quarterly*, Kingston, LXXVII, 2 (Summer 1970), 217

32 Prominent among the timber traders in Quebec were the Ross, Dobell, Rhodes, Fraser, and other English-speaking families. Thomas Fraser, the son of a Quebec lumber merchant, expanded his collection of paintings to picture every phase of the timber trade. Barbeau, *Krieghoff*, 100. John Young was a prominent Quebec lumberer who bought several of Krieghoff's lumber canvases about the time he did the Parliament paintings. By the time of his death he had collected forty of Krieghoff's works and left ten to each of his four heirs, one of whom stayed in Canada, the others ending up in England, Australia, and New Zealand. One of the latter, of an ice boat crossing the St Lawrence, recently returned to Canada from New Zealand.

33 H.A. Scott, *Grands anniversaires* (Quebec City 1919), 297–9. The paintings were arranged on the reredos as in the diagram:

1 / voyageurs going into the forest (evidently canoeists landing at the end of a portage trail; type of fig. 118); 2 / oxen working in winter (normally hauling wood); 3 / woodsman's cabin covered with snow (type of fig. 87); 4 / hauling of a load of wood in winter; 5 / timber cove at Sillery (type of fig. 86), the central painting behind the Speaker's chair; 6 / raft in danger in a storm on the St Lawrence; 7 / river obstructed by log jam (type of fig. 106); 8 / Ottawa River emptying into the St Lawrence (type of fig. 89); 9 / interior of a log house at night (evidently related to a known painting of a log shanty interior with fiddler playing as lumbermen dance).

34 Willis, *Canadian Scenery*, II, 12, 'Timber Depôt near Quebec'

35 D.D. Calvin, *A Saga of the St. Lawrence* (Toronto: Ryerson 1945), describes the timber trade from the Kingston district in about 1840. Wages paid to St Lawrence raftsmen rose from $9 to $15 a month between 1840 and the 1860s.

36 Dickens, *American Notes*, 220

37 Charlotte Whitton, *A Hundred Years A-Fellin', 1842–1942* (Ottawa: Gillies Bros. 1942), 120

38 Collard, *Canadian Yesterdays*, 224–7

39 Willis, *Canadian Scenery*, II, 5, 'Junction of the Ottawa and St.

Lawrence'

40 *Ibid.*, I, 116, 'Raft in a Squall on Lake St. Peter'

41 Smyth, *Sketches in the Canadas*, no XVII

42 *Morning Chronicle*, 19 Aug. 1854

43 Herbert, *Frank Forester's Field Sports*, II, 223

44 Kingston, *Western Wanderings*, II, 181. The slaughter of the forty-three moose is described in Herbert, *ibid.*, II, 222.

45 LeMoine, *Picturesque Quebec*, 364

46 The painting is illustrated in *Notman's Photographic Selections, Second Series* (Montreal 1865); although the caption says it is Lake Famine, it looks like Lake St Charles.

47 The *Morning Chronicle*, 26 Aug. 1856, provided the details of such a trip.

48 Tolfrey, *The Sportsman in Canada*, I, 184

49 Buckingham, *Canada, Nova Scotia, New Brunswick*, 282, 287

50 Bird, *Englishwoman in America*, 287

51 Willis, *Canadian Scenery*, I, 112, 'Village of Lorette, near Quebec'; for information on the village, see Barbeau, *Krieghoff*, 106–7, and Buckingham, *Canada*, 288

52 This painting was taken to England by a titled family, later purchased by Sir Harry Oakes, who discovered many millions of dollars worth of gold in northern Ontario in the early twentieth century, and it has now returned to Canada.

53 Smyth, *Sketches in the Canadas*, no XII

54 Monck, *My Canadian Leaves*, 120–1

55 Ruskin, *The Argument of the Eye* (London: Thames and Hudson 1976), 31

56 *Montreal Herald*, 28 Feb. 1865

57 *Morning Chronicle*, 11 Aug. 1856

58 *Anglo-American Magazine*, Toronto (Oct. 1853), 535

59 *Quebec Gazette*, 14 Sept. 1854

60 Edited by S.C. Hall (London c. 1853)

61 *Cosmopolitan Art Journal*, New York, III, 1858–9

62 Barbeau, *Krieghoff*, 151 (see p. 197 for a list of the paintings on china)

CHAPTER 4: The final years, 1863–72

1 Barbeau, *Krieghoff* (1934), 71

2 Krieghoff's *ceinture flechée* was later given to a friend in Quebec, who long regarded it as a prized possession. Fairchild, *Gleanings from Quebec*, 105

3 *Ibid.*, 92

4 *Journal de Québec*, 1 Aug. 1861

5 Barbeau, *Krieghoff*, 88

6 *Journal de Québec*, 21 Dec. 1861

7 *Ibid.*, 27 March 1862

8 Du Maurier, *The House on the Strand* (London: V. Gollancz 1969), 31

9 LeMoine, *Picturesque Quebec*, 382

10 Fairchild, *Gleanings from Quebec*, 72–3

11 Barbeau, *Krieghoff*, 89

12 *Journal de Québec*, 13 Dec. 1862

13 'Series of registrations dated 28th April, 1864, by C. Krieghoff, artist, of photographic pictures, the rights to which he claims as author:

 363. Drawing Blocks of Ice: Winter Scene.

 364. Lake St. Charles: Summer Scene.

 365. Conveying in a canoe opposite Quebec: Winter Scene.

 366. Lake Beauport: Summer Scene.

 367. Tandem upon the Ice: Winter Scene.

 368. Cheating the Toll-Man: Winter Scene.

 369. Canadians in Sleigh: Winter Scene.

 370. Indian Woman: Winter Scene.

 371. Indian Woman: Summer Scene.

 372. Indian Hunter: Winter Scene.

 373. Old French Canadian: Winter Scene.

 374. Spearing Fish by Torchlight: Summer Scene.

 374. Lady and Gentleman Tobogganing: Winter Scene.'

Province of Canada, Author's Rights Division, Department of Consumer and Corporate Affairs, Ottawa

14 J. Russell Harper and Stanley Triggs, eds., *Portrait of a Period: A Collection of Notman Photographs, 1856 to 1915* (Montreal: McGill University Press 1967)

15 Jacobi, notes in the hand of Robert Harris, Harris Papers, Charlottetown

16 Vézina, *Krieghoff*, 206

17 *Ibid.*, 206–7. Barbeau, *Krieghoff*, 103, noted a painting described as 'The Artist's House, Quebec 1857,' said to be inscribed on the reverse: 'My house at 512 (or 506?) St. John St., To my friend J.S. Budden, C. Krieghoff.'

18 Barbeau, *Krieghoff*, 78

19 Vézina, *Krieghoff*, 30

20 Barbeau, *Krieghoff*, 90

21 Vézina, *Krieghoff*, 207

22 War Records Office, Public Records Office, London

23 Vézina, *Krieghoff*, 34

24 War Records Office, London

25 The Ladies Protestant Home and Hamilton Burnett, 21 Feb. 1863, Greffe du notaire Noel Hill Bowen, no 2360; Burnett and

De Courtenay, 2 May 1863, Greffe du notaire Edward Cannon, no 4962, Quebec

26 Barbeau, *Krieghoff*, 86, and Fairchild, *Gleanings from Quebec*, 74

27 Budden to Harris, n.d., Harris Papers; Fairchild, *From My Quebec Scrap-Book*, 121

28 Roy, *Les petites choses de notre histoire*, 169–71

29 *Journal de Québec*, 17 Sept., 18 Oct. 1870

30 *Maclean's Magazine*, Toronto, 24 Dec. 1954

31 *Halifax Citizen*, 29 Aug. 1865

32 George Stewart, *The Story of the Great Fire in Saint John, N.B., June 20th, 1877* (Toronto 1877), 265–8

33 *Sale of Valuable Oil Paintings, by Auction, on Friday Next, twenty-first inst. ... at A. Booker's Sale Rooms* (Hamilton, n.d.)

34 *La Minerve*, Montreal, 23 April 1868

35 Art Association of Montreal, *Fourth Exhibition* (Montreal 1867), nos 69, 81, 82

36 *Catalogue of the Canadian Contributions to the Dublin Exhibition*, n.d. [1865]

37 *Journal de Québec*, 21 May 1867

38 *Montreal Herald*, 7 Dec. 1867

39 Fairchild, *Gleanings from Quebec*, 74, gives the date as 1864, evidently in error.

40 Bail between Mme Germain Saint-Pierre and Cornelius Krieghoff, 30 Aug. 1870, Greffe du notaire Cyrille Tessier, no 3542, Archive judiciaire de Québec

41 *Quebec Daily Mirror*, 2 Sept. 1870

42 Bail between Bertha Martin and C. Krieghoff, 14 Feb. 1871, Greffe du notaire Cyrille Tessier, no 3226

43 *Journal de Québec*, 15 Sept. 1871

44 Jacobi, Harris Papers

45 C.P. Stacey, *Canada and the British Army, 1846–71* (Toronto: Longman 1936, 253)

46 Jouvancourt, *Krieghoff*, 144. Another break with the past came when Denis Gale also moved from Quebec by 1872 to become a picture dealer in the United States. He went first to Albany, and then lived for sixteen years in Philadelphia. City of Philadelphia Directories, 1872–87. Krieghoff's paintings had been known to art people in that city at least since 1861 when he was sending canvases there for framing. Barbeau, *Krieghoff*, 88–9. Gale received canvases on consignment for sale, probably at first from the artist himself, later perhaps from his widow. Numerous Krieghoff paintings have been found in the Philadelphia area, including a *Merrymaking* dated 1868.

47 Budden to Harris, Harris Papers. According to the records in Chicago, Krieghoff died of a heart attack. Budden lived on in Quebec until early in the present century. Emilie lived with her daughter in Chicago until they left and travelled further west; they were living in Denver, Colorado, by 1886. Denis Gale also moved to Denver in 1892; he spent his later years making natural history collections which he donated to the University of Colorado. City of Denver Directories, 1886–1906, and Junius Henderson, 'An Early Colorado Naturalist – Denis Gale,' *University of Colorado Studies*, Boulder, v (1907–8), 25. Gale commented that he had learned to love the birds in the Quebec logging camps of his boyhood where he was surrounded by forest solitude attuned to his artistic temperament. He might well have added that his sketching companion in the Canadian woods had been Cornelius Krieghoff. Gale died in 1905. Emilie died in Denver of heart disease on 4 September 1906; her death certificate names her father as 'Louie Saintaguta,' not Gauthier. Emily, Krieghoff's daughter, died on 29 December 1929 in an old peoples' home in Denver, when her name was given as 'Burnett.' Vézina, *Krieghoff*, 30, 35. She had no family. Those living in America who bear the Krieghoff name are descendants of the artist's brother Ernst.

CHAPTER 5: Misattributions, deceptions, and forgeries

1 Art Gallery of Ontario, *The Canadian Collection* (Toronto: McGraw-Hill 1970), 233

2 Barbeau, *Krieghoff* (1934), 23

3 Barbeau, *ibid.*, 84, reproduced various signatures but without indicating dates.

4 Vézina, *Krieghoff*, 175; Jouvancourt, *Krieghoff*, 41; Musée du Québec, *Cornelius Krieghoff* (1971), no 120

5 Barbeau, *Krieghoff*, 150–1, listed the entire group as the work of Krieghoff. The Musée du Québec Krieghoff exhibition (*ibid.*) exhibited and reproduced seven of them: nos 59, 64, 67, 70, 83, 108, 111

6 J. Russell Harper, 'A Sketch-Book of Cornelius Krieghoff,' *Canadian Art*, Ottawa, IX, 4 (1952), 163–4

7 National Gallery of Canada, *Three Centuries of Canadian Art* (Ottawa 1967), no 110

8 Sotheby (Toronto), 27–9 May 1968, no 142

9 Barbeau, *Krieghoff*, 110

Selected Bibliography

Barbeau, Marius. *Cornelius Krieghoff: Pioneer Painter of North America*. Toronto: Macmillan 1934

– *Cornelius Krieghoff*. Toronto: Ryerson Press 1948

– *J'ai vu Québec*. Quebec City: Garneau 1957

– *Cornelius Krieghoff: The Gallery of Canadian Art*, 1. Toronto: Society for Art Publications/McClelland and Stewart 1962

– 'Krieghoff découvre le Canada.' Royal Society of Canada, *Transactions*, 3rd series, XXVIII (1934), sec. I, 111–18

– 'Krieghoff Discovers Canada,' *Canadian Geographical Journal*, Ottawa, VIII (March 1934), 100–13

– *Quebec Where Ancient France Lingers*. Toronto: Macmillan 1934

Buchanan, Donald W. *Canadian Painters, from Paul Kane to the Group of Seven*, Oxford and London: Phaidon 1945, 5–8

Fairchild, Jr., G.M. *From My Quebec Scrap-Book*. Quebec City: Frank Carrel 1907, 121–7

– *Gleanings from Quebec*. Quebec City: Frank Carrel 1908, 66–74

Guttenberg, A. Ch. de. 'Cornelius Krieghoff,' *Revue de l'Université d'Ottawa*, XXIV (1954), 90–108

Harper, J. Russell. *Cornelius Krieghoff: The Habitant Farm*. Masterpieces in the National Gallery of Canada no 9. Ottawa: National Gallery 1977

– *Early Painters and Engravers in Canada*. Toronto: University of Toronto Press 1970, 184–5

– *Painting in Canada: A History*, 2nd ed. Toronto: University of Toronto Press 1977

Harris, Robert, 'Art in Quebec and the Maritime Provinces,' in J.C. Hopkins, *Canada: An Encyclopedia of the Country*. Toronto 1898, IV, 349, 353–9

Hubbard, R.H. *The Development of Canadian Art*. Ottawa: Queen's Printer 1963

Jefferys, Charles W. Review of Barbeau, *Cornelius Krieghoff*, in *Canadian Historical Review*, XVI, 3 (Sept. 1935), 329–30

Jouvancourt, Hugues de. *Cornelius Krieghoff*. Montreal: Editions la Frégate 1971

Lesage, Jules S. *Notes et esquisses québecoises*. Quebec City: Ernest Tremblay 1925, 42–57

MacDonald, Colin S. *A Dictionary of Canadian Artists*. Ottawa 1971, III, 679–85

MacTavish, Newton. *The Fine Arts in Canada*. Toronto: Macmillan 1925

Morris, Edmund. 'Art in Canada: The Early Painters,' *Saturday Night*, Toronto, 21 Jan. 1911

Morriset, Gérard, 'La peinture traditionnelle au Canada français,' *L'encyclopédie du Canada français*. Ottawa: Cercle du livre de France 1960, II, 136, 141–7

– Peintres et tableaux. Quebec City: du Chevalet 1936, I, 209–20

Reid, Dennis, *A Concise History of Canadian Painting*. Toronto: Oxford University Press 1973, 62–8

Robson, Albert H. *Canadian Landscape Painters*. Toronto: Ryerson Press 1932

– *Cornelius Krieghoff*. Toronto: Ryerson 1937

Rombout, Louis, 'Cornelius Krieghoff,' *Atlantic Advocate*, Fredericton, Dec. 1962, 42–8

Roy, Pierre-Georges, *Les petites choses de notre histoire*, quatrième série. Lévis 1922, 168–71

Schoolman, Regina Lenore, 'Cornelius Krieghoff,' *Canadian Forum*, Toronto, Nov. 1934, 66–8

Sotheby & Co. *Catalogue of Fine Eighteenth and Nineteenth Century Drawings and Paintings*, London, 29 May 1963, nos 1–24

Spendlove, F. St George. *The Face of Early Canada*. Toronto: Ryerson 1958

Vézina, Raymond. 'Cornelius Krieghoff,' *Dictionary of Canadian Biography*, Toronto: University of Toronto Press 1972, X, 408–14

– *Cornelius Krieghoff: Peintre de mœurs*. Ottawa: Editions du Pélican 1972

– 'Attitude esthetique de Cornelius Krieghoff,' *Racar*, Saskatoon, I, 1 (1974), 47–69

[Winkworth, Peter]. *Scenes in Canada, C. Krieghoff: Lithograph Drawings after His Paintings of Canadian Scenery, 1848–1862*. Montreal: McCord Museum 1972

NINETEENTH-CENTURY WORKS CITED IN THE TEXT

Bird, Isabella Lucy. *The Englishwoman in America* (1856). Toronto: University of Toronto Press 1966

Bonnycastle, Richard H. *The Canadas in 1841*, 2 vols. London: Henry Colburn 1842

Buckingham, James S. *Canada, Nova Scotia, New Brunswick and the Other British Provinces in North America*. London: Fisher, Son & Co. 1843

C.H.C. *It Blows, It Snows: A Winter's Ramble through Canada*. Dublin 1846

Day, Samuel Phillips. *English America: or Pictures of Canadian Places and People*, 2 vols. London: T. Cautley Newby 1864

The Diary of Mrs. John Graves Simcoe, with notes and a bibliography by J. Ross Robertson. Toronto: Ontario Publishing Co. 1934

Dickens, Charles. *American Notes*. London: Thomas Nelson, n.d. [c. 1912]

Hall, Francis. *Travels in Canada, and the United States, in 1816 and 1817*. 2nd ed. London: Longman, Hurst, etc. 1819

Herbert, Henry William. *Frank Forester's Field Sports of the United States, and British Provinces, of North America*, 2 vols. New York: Stringer & Townsend 1849

Heriot, George. *Travels through the Canadas* (1807). Edmonton: Hurtig 1971

Jameson, Anna Brownell. *Winter Studies and Summer Rambles in Canada*, 3 vols. London: Saunders and Ottley 1838

Kingston, William H.G. *Western Wanderings, or A Pleasure Tour in the Canadas*, 2 vols. London: Chapman and Hall 1856

LeMoine, J.M. *Picturesque Quebec: A Sequel to Quebec Past and Present*. Montreal: Dawson Brothers 1882

Monck, Frances E.O. *My Canadian Leaves, An Account of a Visit to Canada in 1864–1865*. London: Bentley 1891

Smyth, Coke. *Sketches in the Canadas*. London: Thomas McLean, n.d.

Thompson, Samuel. *Reminiscences of a Canadian Pioneer for the Last Fifty Years* (1833–83). Toronto: McClelland and Stewart 1968

Tolfrey, Frederic. *The Sportsman in Canada*, 2 vols. London: T. Cautley Newby 1845

Willis, Nathaniel Parker. *Canadian Scenery Illustrated: From Drawings by W.H. Bartlett*, 2 vols. London: Virtue 1842

CATALOGUES OF PRINCIPAL EXHIBITIONS

Art Gallery of Toronto, *Catalogue of Toronto Centennial Historical Exhibition, Paintings by Cornelius Krieghoff ...* (foreword by Marius Barbeau), Toronto 1934

Beaverbrook Art Gallery, *Cornelius Krieghoff ca. 1815–1872* (foreword by Edwy Cooke), Fredericton 1961

Canadian National Exhibition, *The Arts, Catalogue and Guide*, Toronto 1955

Dublin Exhibition, *Catalogue of the Canadian Contribution to the Dublin Exhibition*, n.d. [1865]

Laing Galleries, *Cornelius Krieghoff, Paintings*, Toronto 1966

McCord Museum, *Exhibition of Prints in Honour of C. Krieghoff 1815–1872* (text by P. Winkworth, foreword by J. Russell Harper), Montreal 1972

Musée du Québec, *Cornelius Krieghoff 1815–1872* (introduction by Jean Soucy and André Juneau), Quebec City 1971

National Gallery of Canada, *Exhibition of Paintings by Cornelius Krieghoff 1815–1872*, Ottawa 1934

CATALOGUES OF PRINCIPAL COLLECTIONS

Art Gallery of Ontario, The Canadian Collection. Toronto: McGraw-Hill 1970

Beaverbrook Art Gallery: Paintings. Fredericton 1959

Godenrath, Percy F. *Catalogue of the Manoir Richelieu Collection of Canadiana*. Montreal: Canada Steamship Lines 1930

Supplementary Catalogue and an Abridged Index of the Manoir Richelieu Historical Collection of Canadiana. Montreal: Canada Steamship Lines 1939

Hubbard, R.H. *The National Gallery of Canada: Catalogue of Paintings and Sculpture*, III: *Canadian School*, Ottawa and Toronto: National Gallery/University of Toronto Press 1960

Krieghoff's Work: A Summary

This summary of Krieghoff's artistic output is extracted from notes gathered for the compilation of a *catalogue raisonné*; it is designed to demonstrate the range of his subject matter and the frequency of use of various themes. The numbers in parentheses after the titles indicate the number of examples that have been located for each theme. The dates given are those actually appended to the artist's signature; many canvases are of course undated. Many examples of these themes are reproduced in this book, and they are referred to within the descriptions.

A / PAINTINGS IN OIL

Miscellaneous Subjects – Early Works

Montreal and Rochester

1 Figure Studies and Portraits (9 examples) 1841–4
Head and figure studies [figs. 9, 11]
2 Copies (5) 1843
Portrait after J. Bowman, unidentified landscape, genre after D. Wilkie [fig. 10]

Paris – visit of 1844–5

3 Copies (7)
Miscellaneous subjects after F.-A. Biard, C.-E. de Champmartin, C. Grolig, L.-L. Robert, J. van Ruysdael, and unlocated sources

Habitant Subjects

Longueuil and Montreal Region

4 Living Room – Card Players (9) 1845–50
Habitant family gatherings, three to fifteen figures, some playing cards, usually by candlelight [figs. 26, 27]

5 Living Room – Family Groups (3) 1848–9
Family groups with fiddler, playing dominoes, etc.
6 Living Room – Breaking Lent (3) 1848
Family eating meat and interrupted by priest entering unannounced [fig. 23]
7 Living Room – Flirtations (3)
Girl teasing sleeping suitor, woman making straw hats [fig. 32]
8 Living Room – Print Seller (1) 1846
Interior during summer day, print seller pressing wares on family [fig. 22]
9 Living Room – Soldier Flirting (5) 1846–8
Interior with soldier of Highland regiment flirting with girl and surprised by habitant [fig. 24]
10 House – Exterior – Flirtation (2)
Soldier wearing pillbox hat flirting with girl in moonlight, mother watching [fig. 25]
11 House – Exterior – Summer (4) 1848
Log house – family outside door loading cart for market [fig. 31]
12 Stopped Sleigh in Winter (25) 1845–52
Habitants in sleigh with horse halted in

winter landscape, outside farm house, in open with distant view of habitant home, or village; sometimes chatting with friends along road [figs. 20, 29]
13 Driving in Sleigh in Winter (5) 1848–9
Habitants in sleigh with horse trotting on winter road through woods, village, and with hunters
14 Children – Outside Home (1)
Children playing outside habitant house in winter
15 Habitants on Ice Road at Longueuil (7) 1858–60
Horse pulling sled with standing habitants or hitched to box sled with passengers, stopped, village on river bank, revival of earlier setting [fig. 36]
16 Cutting Ice – Rearing Team (1)
Men cutting ice on pond [fig. 33]
17 Ice Harvest – Montreal (9)
Habitants with single horse, cutting or hauling ice blocks from St Lawrence River [fig. 34]
18 Hauling Snow, Montreal (1)
Habitant with horse hauling snow,

similar setting to no 17

19 Making Maple Sugar (3) 1849–57
Habitant in spring woods gathering
sap and boiling maple syrup in shanty
[fig. 35]

20 Hauling Load of Hay (2)
Habitant with horse pulling two-
wheeled cart in summer or sled in
winter

21 Baker Delivering Bread (4)
Baker with red van on sleigh on country
road [figs. 67, 68]

22 Water Vendor (2)
Habitant with barrel on sleigh deliver-
ing water in village [fig. 66]

Quebec City and St Maurice Valley Regions

23 Pioneer Homestead – Autumn – Clear-
ing Forest (7) 1853–67
Unsquared log pioneer house, habitant
cutting trees, wife, child, rail fence, ear-
lier paintings by Lake Carron, later in St
Maurice River valley [fig. 79]

24 Pioneer Homestead – Winter – St
Maurice River (22) 1859–72
Unsquared log pioneer house, low roof,
family activity, introducing firewood,
overturned sleigh, bake oven, chickens,
outbuildings; background of low to
rugged hills [figs. 78, 80, 84]

25 Pioneer Homestead – Winter – Pitched
Roof (4) 1856–63
Unsquared log pioneer house, pitched
roof, domestic activity with ox, horse,
dog; low hills

26 Homestead – Squared Logs – Autumn
(2) 1854
House of squared logs in forest; man
chopping trees, woman and child,
domestic activity, two-wheeled cart in
one example

27 Homestead – Old Quebec Settlements –
Winter (13) 1853–65
Homestead of squared logs, sometimes

plastered; Quebec City region
farmsteads; domestic activity as families
arrive and depart [figs. 73, 74, 76]

28 Homestead – Miscellaneous – Winter
(7) 1854–63
Harnessing team by barn; habitant ar-
riving home from logging camp; bar-
gaining for wood at farmstead; derelict
log house [figs. 75, 92, 93]

29 Bargaining with Horse Buyer (2) 1871
Habitant family outside farmhouse;
woman bargaining for horse, autumn
[fig. 145]

30 Bilking the Toll – Winter – to Town (26)
1857–71
Three habitants standing on sled or
travellers in cutter going through St
Louis Road tollgate to Quebec; one in
Russian troika [figs. 71, 140]

31 Bilking the Toll – Winter – Returning
Home (4) 1856–60
Three habitants standing on sled going
through St Louis Road tollgate, re-
turning from Quebec City [fig. 69]

32 Travelling in Blizzard (29) 1853–71
Habitants driving sled or cutter on
country road; one going through St
John's Gate, Quebec; driven off road;
assembling at blacksmith's shop; bliz-
zards [figs. 70, 72, 146]

33 Walking in Blizzard (4)
Man walking on country road in
blizzard

34 Overturned Sleigh in Winter (4)
Habitant sleigh upset going to market
with pig, or load of firewood upset in
passing [fig. 65]

35 Ice Harvest, Quebec City (4)
Habitant with ice on sleigh before
silhouette of Quebec or meeting load of
straw by Martello Tower

36 Moving Sled on Shoreline (13) 1855
Two to four habitants standing on sled
driving along shoreline of St Lawrence

or on plain; habitant house in
background; 'boys go to town'

37 Moving Sled on Shoreline (4)
Two to three habitants standing on sled
as in no 36, but with woods in
background and no house; 'boys go to
town'

38 Moving Sled, Quebec City (13) 1856–62
Two to four habitants standing on sled
on ice of St Lawrence River with
silhouette of Quebec Citadel or Mont-
morency Falls; 'boys go to town'

39 Moving Sled on Country Road (9)
1860–1
Three habitants standing on sled drawn
by horse on road in rolling Laurentian
countryside; 'boys go to town'

40 Box Sled with Passengers on Country
Road (10) 1857–61
Habitant in box sled with up to three
passengers driving on country roads in
Laurentian Region or along St Law-
rence River near Quebec

41 Moving Sleigh with Bourgeois Passen-
gers (9) 1856–63
Habitant with bourgeois passengers in
cutter or box sled driving on frozen St
Lawrence River or country roads near
Quebec; one in Russian forest setting

42 Sleigh Race – Habitant and Bourgeois
(17) 1852–71
Habitants in sleigh or standing on sled
racing bourgeois cutters on shoreline in
Quebec City region [figs. 55, 60, 144]

43 Frozen River – Laval Mountains (19)
1861–71
Habitants, sometimes with farmhouse,
often with loads of firewood, rocky en-
trance opening out from gorge; one
example with bridge; Jardin de Caribou
region; some with trail into hills [fig.
138]

44 Woodcutters at Sunset (5) 1859–61
Habitants driving line of sleighs loaded

with cordwood across frozen lake at
sunset

45 Habitant with Firewood, Quebec City
(1)
Habitant driving sled loaded with fire-
wood on ice before Quebec Citadel

46 Habitants at Lumber Camp (5) 1862–7
Exterior and interior of lumbermen's
shanty in winter on St Maurice River,
and lumbermen's ferry in summer
[figs. 87, 91]

47 St Lawrence River Timber Trade
Scenes (8) 1862–7
Timber trade rafts on Ottawa River at St
Lawrence River, and in Sillery Cove
timber docks; mostly based on W.H.
Bartlett engravings [figs. 86, 89, 90]

48 Woodcutter (4) 1857–8
Habitant with axe and saw walking in
winter landscape outside home

49 Portrait Heads (36) 1855–60
Male habitant head, wearing tuque,
knotted handkerchief, blanket cloth
coat, sometimes smoking clay pipe
[figs. 81, 100]

50 Berry Seller – Summer (5) 1859–60
Habitant with staff walking in land-
scape; large basket filled with small bas-
kets on back [fig. 83]

51 Poacher – Winter (5) 1860–2
Habitant, elderly, with game bag over
shoulder, walking in winter landscape
or on St Lawrence River ice [fig. 82]

52 Woman – Marketing – Winter (4)
1860–2
Woman, dressed in best clothes, on
snowy country road, usually with basket
on arm [fig. 85]

53 Borrower – Summer or Winter (4) 1859
Derelict habitant, approaching notary
for loan, and refused [figs. 141, 142]

54 Country Inns – Winter (7) 1851–72
Exterior of country inns with sleighs or
rowdy crowd in daylight or at night,

variously named White Horse Inn,
Jolifou [figs. 1, 64]

55 Royal Mail Boat on St Lawrence – Dis-
tant View (13) 1861–3
Habitant river men operating one or
two mail boats over ice of St Lawrence
River from Quebec City to Lévis

56 Royal Mail Boat on St Lawrence –
Close-up View (6) 1859–60
Habitant river men operating boat with
bourgeois passengers over ice of St Law-
rence River from Lévis to Quebec [fig. 5]

Indian Subjects

Montreal Region

57 Indian in Canoe in Rapids (3)
Single Indian in canoe shooting Lachine
Rapids

58 Fur Trader to Indians (2)
Fur trader in toboggan, dog team, In-
dian driver, on river ice, figures in dis-
tance [fig. 14]

59 Encampment – Bark Teepee – Summer
(28) 1847–51
Caughnawaga Indian encampment,
sometimes with stream or lake, teepee,
family group around campfire with
seated man [figs. 40, 42, 44]

60 Encampment – No Teepee – Summer
(1)
Woman with basket of berries, standing
woman, children, canoe, waterfall

61 Encampment – Teepee – Waterfall –
Summer (5)
Campfire with Indian family, birchbark
teepee, by divided waterfall (probably at
Shawinigan)

62 Encampment – Teepee – St Lawrence
River Shore (5) 1851
Campfire with Indian family, teepee on
shoreline with silhouette of Mount
Royal and islands in distance, beached
canoe [fig. 122]

63 Encampment – Thousand Islands –
Summer (3)
Campfire on island in St Lawrence
River, probably based on Currier and
Ives lithograph

64 Encampment – Night – Grave (2)
Figures and teepee silhouetted by
campfire, grave, moonlight on water
beyond, based on W.H. Bartlett en-
graving

65 Encampment – Night – Campfire (4)
Figures around campfire in woods,
dancing or reclining by fire, moonlight,
waterfall, or lake

66 Spearing Fish by Torchlight (8)
Two figures in canoe, torch reflected in
water, spearing fish, lights in distance
[fig. 49]

67 Chieftains – Portraits – Summer Land-
scapes (3)
Single figures, standing with elegant
dress, portrait studies of Red Jacket,
Eclipse (Tanaghte) [figs. 50, 52]

68 Woman of Caughnawaga – Summer
Landscape (3)
Woman with blanket over head,
clutching moccasins or purses, full or
half length

69 Woman with Cradle Board – Summer
Landscape (3)
Single woman, cradle board supported
on knee or on back

70 Male Head – Voyageur or Indian (2)
Man with blanket cloth coat, tuque, and
pipe, unrelated technically to other
Krieghoff paintings

71 Indians – Group of Four – Winter
Landscape (6)
Man and women, standing in fore-
ground on snowy plain, figures in
distance and St Lawrence River beyond,
Caughnawaga [fig. 47]

72 Indians – Group of Two or Three –
Winter Landscape (11)

Man and one or two women on snowy plain with St Lawrence River beyond, setting of no 71, Caughnawaga

73 Hunter on Trail – Winter (2)
Hunter on snowshoes with tuque and gun, walking in snowy plain, evergreen woods in distance

74 Hunters with Toboggan – Caughnawaga(?) – Winter (6)
One to four hunters on snowy plain, pulling toboggan, usually with load, sometimes with packs on back

75 Woman – Standing – Winter (9)
Single Indian woman from Caughnawaga, blanket over head or with black hat, carrying moccasins or baskets, snowy plain or Montreal street [fig. 3]

Quebec City Region

76 Hunter Wearing Tam – Winter (43) 1858–60
Single man on snowshoes, flat tam and gun over shoulder, walking in snowy landscape; sometimes sold as pair with woman moccasin seller [figs. 117, 139]

77 Hunter Wearing Tuque – Winter (15) 1853–63
Single man on snowshoes, tuque, holding gun, usually in woodland setting, sometimes with companion [fig. 102]

78 Hunter by Water – Summer (3)
Single man, hunting, standing or kneeling by lake or river, summer setting

79 Woman Moccasin Seller – Winter (14) 1858–9
Woman, blanket over head, walking on ice, probably near Quebec, carrying moccasins for sale, sometimes with cradle board on back; sometimes as pair with no 76 [fig. 139]

80 Woman Moccasin Seller – Winter – Quebec (11) 1857
Woman, blanket over head or black hat, walking on ice with Quebec Citadel silhouette behind, sometimes with cradle board

81 Woman Moccasin Seller – Winter – Rural (5) 1861
Woman, blanket over head, walking in rolling landscape, carrying moccasins for sale and cradle board

82 Woman Moccasin Seller – Summer – Rural (6)
Woman, blanket over head, flat straw hat or black hat, walking on country trail, carrying moccasins or basket

83 Woman Basket Seller – Summer (29) 1860
Woman, black hat or blanket over head, sometimes with cradle board, climbing hill and seen in silhouette [fig. 116]

84 Woman Basket Seller – Winter (2)
Woman, wearing black hat, with cradle board, in rural landscape

85 Woman Berry Picker – Summer (2)
Woman, sitting or standing with basket of berries, in rural landscape

86 Group Meeting on Frozen Lake – Winter (9) 1865–7
Several men, women, and children, meeting on snow-covered ice of lake surrounded by woods and hills, Lake St Charles

87 Group Meeting in Rolling Country – Winter (3)
Five figures (similar to no 86) on snow-covered knoll, with woods

88 Shooting Rapids in Canoe – Autumn (16) 1855–62
One to three Indian men in birchbark canoe shooting rapids, probably Montmorency River [fig. 123]

89 Canoe on St Lawrence River (1)
Three Indians paddling canoe in centre of river [fig. 126]

90 Portage Trail – Grand'Mère Falls – Autumn (13) 1858–62
Three Indians landing canoe at end of portage trail below Grand'Mère Falls, brilliant autumn foliage [figs. 53, 118, 119]

91 Portage Trail – St Maurice River – Autumn (6) 1858–64
Similar to no 90 but rapids replacing waterfalls

92 Portage Trail – River Bank – Autumn Storm (5) 1859–60
Indians landing canoe in violent storm at mouth of stream, high hills on left, seeking shelter; one example with artist sketching [fig. 115]

93 Portage Trails – Various Locales – Autumn (23) 1854–67
One or two Indians with birchbark canoe, paddling or hauling ashore at commencement of portage trail, brilliant foliage, various locales along shores of lakes or broad stream

94 Council Meeting (3) 1855–60
Nine to twenty-three Indians encircling chieftain in summer or autumn landscape [fig. 120]

95 Winter Cabin (10) 1856
Cabin, door closed with blanket, usually set among evergreens on hill, Indian family outside in various activities, and with toboggan and snowshoes, frozen lake or river in distance [fig. 48]

96 Encampment – Night – Campfire – Summer and Winter (6) 1858–67
Figures around campfire in woods, moonlight, sometimes with waterfalls; similar to no 65

97 Encampment – Open Glade – Summer (7) 1854–8
Three to five Indians reclining in depression socializing, with background of trees or rocky knoll, summer colouring

98 Encampment – Flat Area (6) 1856–7
Three to five Indians, canoe, on flat camping site, socializing

99 Encampment – Beach with Rocky
 Background (2) 1860–71
 Two to five Indians by campfire on nar-
 row shoreline backed by rocky wall,
 probably on St Maurice River [fig. 125]

100 Hunters in Canoe – Summer and
 Autumn (15) 1855–68
 Indians in canoe, creeping along river
 or lake shore, screened by foliage, deer
 or caribou on shore or swimming in
 water, green summer foliage or bril-
 liant autumn colouring [fig. 121]

101 Big Rock – Vista on Right – Autumn
 (23) 1858–64
 Two to five Indians around campfire
 by large rock, with canoe and caribou,
 socializing [fig. 124]

102 Big Rock – Centred in Canvas – Au-
 tumn (4) 1865
 Three to five Indians around campfire
 to front or left of large rock, no canoe
 or water, socializing

103 Big Rock – Vista on Left – Autumn
 (11) 1857–66
 Two to five Indians around campfire
 by large rock, often with canoe and
 caribou, socializing

104 Encampment with Squat Teepee –
 Summer or Autumn (19) 1854–67
 Squat teepee, shoreline sloping to lake
 or river, various locales, domestic ac-
 tivities

105 Bartering with Fur Trader (2) 1854
 Trader displaying blanket to Indians,
 rolling summer landscape

106 Miscellaneous subjects (2) 1857
 Indian maiden by waterfall, the 'Last of
 the Mohicans' [fig. 128]

107 Railway Line (1)
 Indians watching railway train from
 hill

108 Copies of Prints – Miscellaneous (4)
 Paintings copied from lithographs by
 Coke Smyth

Bourgeois Life: English Sportsmen, Officials, and Army Officers

See also nos 41 and 42, Landscapes for set-
ting of bourgeois life, and Portraits

Longueuil and Montreal Region

109 Gentlemen's Sleighs – Frozen St Law-
 rence River (15) 1847–8
 One, two, or four-horse English-type
 sleighs with gentlemen and ladies
 driving on ice of St Lawrence or
 along shoreline, Longueuil region
 [figs. 38, 39]

110 Sportsmen Camping at Night (1)
 Four hunters around campfire with
 caribou, similar setting to nos 65 and 96

111 Officer's Room (1) 1846
 Room in officer's quarters of Montreal
 barracks [fig. 17]

Quebec City Region

112 Sportsmen Hunting – Winter (16)
 1853–62
 Sportsmen in winter camp or on trail,
 hunting deer, moose, or caribou, in
 rolling wooded and partially wooded
 landscape [figs. 97, 98, 99, 101]

113 Sportsmen Hunting – Wounded
 Caribou – Blizzard (6)
 Silhouette of hunters trailing wounded
 caribou in thick snowstorm or beside
 downed caribou

114 Sportsmen on Trail – Winter – Above
 Lake (10) 1858–65
 Sportsmen with Indian guide on trail
 above Lake St Charles (and Lake
 Famine) at sunset, sometimes with
 killed game [figs. 94, 135]

115 Sportsmen on Trail – Winter – On
 Frozen Lake (4) 1863
 Line of caribou hunters crossing Lake
 St Charles at sunset [fig. 95]

116 Sportsmen Camping – Night – Sum-
 mer (1) 1861
 Four sportsmen camping under trees,
 Jacques Cartier Falls, fishermen
 spearing salmon

117 Anglers by Lake – Autumn (13)
 1860–7
 Two or more anglers with canoe or
 raft, generally at Lake St Charles [figs.
 107, 137, 143]; see also nos 135, 147

118 Canoeing on Lake (7) 1861–2
 Canoeists wearing straw hats, canoeing
 on lake north of Quebec in autumn

119 Duck Hunters (5) 1860–2
 Hunters on shore, ducks in water

120 Sleighing Turnouts – Tandem
 (3) 1858
 Tandem team with English cutter on
 frozen St Lawrence River near Quebec
 City [fig. 62]; English sleighing turn-
 outs appear in various winter scenes at
 Quebec, such as nos 42, 138

121 Racehorse (1) 1854
 Racehorse with jockey, Plains of Ab-
 raham [fig. 96]

122 Ice Boating (1)
 Sportsmen sailing ice boat on St Law-
 rence River ice by Quebec [fig. 59]

123 Couple Walking (1)
 Man and woman strolling in winter
 landscape, Quebec environs

124 Tobogganing – Quebec Citadel (6)
 1863
 Men and women tobogganing on
 citadel slopes [fig. 58]

Landscapes

Montreal Period

125 Views in Montreal region (4)
 Montreal from mountain, Bank of
 Montreal, Notre-Dame Church, Fort
 Chambly

126 Country Houses – Commissioned (3)
 1846–8

Houses near Sherbrooke, St Francis River, Sainte-Anne-de-la-Pérade [fig. 15]

127 Niagara Falls – Copies (6)
Panoramic views copied from lithographs and paintings by H.S. Davis and F. Lock

Quebec City Period

See also no 90 (Grand'Mère Falls)

128 Quebec City – Panoramic Views, Summer, Autumn (5) 1853–71
Views from Lévis shore [fig. 133]

129 Houses – Autumn – Quebec Suburbs (2) 1857
Country houses of the artist and of Captain Walker [fig. 16]

130 Steamship before Quebec City (1) 1853
Steamship *Quebec* in St Lawrence River leaving Quebec [fig. 2]

131 Railway Line – Countryside – Valley (1)
Railway winding through valley; see also no 107

132 Chaudière Falls, Quebec (2) 1855–8
Autumn view, sightseers, railway bridge

133 Chaudière Falls, Ottawa (1) 1858
View of falls, possibly a copy

134 Les Chats Falls, Ottawa River (1)
View after W.H. Bartlett engraving

135 Jacques Cartier River, Dery's Bridge (2) 1863
Bridge with fisherman or artist by pool

136 La Puce (Sault-à-la-Puce, Jumping Flea) (2) 1854
Waterfall near Château Richer, figures in foreground [fig. 111]

137 Lorette – Waterfall – Indian and French Villages (4) 1853–7
Waterfall in foreground, Indian village, and Indian or sightseers, French village upstream with school

[figs. 108, 109]

138 Montmorency Falls – Winter (6) 1852–60
Waterfall, frozen, with ice cone and holiday-makers on ice [fig. 61]

139 Montmorency Falls – Autumn (3) 1854–60
View with sightseer standing in foreground

140 Montmorency Falls – Natural Steps and Gorge (4) 1853
Summer view of rocky gorge above waterfall with natural steps

141 Niagara Falls – Summer (1) 1856
Panoramic view from heights on Canadian shore

142 Ste Anne River – Brink of Waterfall – Autumn (5) 1854–62
River flowing over bare rocks, brink of falls beyond, thunderstorm breaking in forest [fig. 114]

143 Ste Anne River – Rapids (1)
Man gazing into rapids, evidently near waterfall

144 Ste Anne River – Waterfall from Gorge – Autumn (5) 1855–60
View looking up deep gorge to waterfall with man climbing sides, autumn foliage

145 St Fériole Waterfall – Ste Anne River (4) 1854–61
View from front of waterfall, spilling over rocky ledge, burst of light, breaking storm, autumn [figs. 112, 113]

146 St Henry's Falls – Etchemin River – Autumn (1) 1858
Waterfall from front, railway bridge, children playing on road [fig. 132]

147 Shawinigan Rapids and Waterfall – Autumn (10) 1858–61
Rapids, log jam, some with fishermen and artist, distant watershoot upstream, brilliant autumn colouring

[fig. 106]; see also 90, 91

148 Lake Beauport – Picnic Rock (7) 1854–61
Holidayers around picnic rock overlooking Lake Beauport, summer and autumn colours; see also no 153

149 Lake Laurent (now Lake Delage) – Autumn (5) 1860–2
Miscellaneous views, canoe on lake, road, fishermen

150 Lake Magog – Autumn (4) 1862
Miscellaneous views, generally with canoe on water

151 Lake Memphremagog – Shoreline – Autumn (8) 1861–2
Shoreline with canoe, holiday-makers, rocky scenery [fig. 104]

152 Lake Memphremagog – Owl's Head – Autumn (4) 1859–61
Panoramic view from Skinner's Cove of mountain [fig. 105]

153 Lake St Charles – Distant View – Autumn (3) 1861–2
Road with figures in foreground and lake in far distance [fig. 110]; some confusion exists as to the locale – it may be Lake Beauport; see also no 117 for anglers at Lake St Charles

154 Bears in Woods – Autumn (8) 1856–60
Various settings, some by cliff, others by derelict log cabin; one example with cabin, bears omitted, artist sketching [fig. 136]

Miscellaneous Subjects

Toronto and Montreal

155 Portraits from Life (7) 1847
Wm. Williamson, Mrs Williamson, Sir R. le M. McClure, Judge Fletcher, Mrs Fletcher, J. Budden, G. Oswald [figs. 12, 19]

156 Portraits – Copies (4) 1847

Queen Victoria (Sir G. Hayter), Baron Metcalfe (A. Bradish), Queen Victoria (Comte d'Orsay), Earl of Elgin (T. Hamel)

157 Still Life – Flower and Fruit (3) 1844–6
Canvases related to eighteenth- and nineteenth-century Dutch paintings

158 Dog Studies (2)
Airedale dog with dead rat

159 Landscape and Genre – Copies of Identified European Canvases (19) 1846–52
Paintings after H. van Avercamp, Sir A.W. Callcott, Sir C. Eastlake, F. Ferrière, J.F. Herring, J. Hopkirk, E.-M.-E. Lepoittevin, 'Meyer,' G. Morland, Rembrandt, G. Reni, A.A. Staunton, D. Teniers, P. Wouwerman

160 Landscape and Genre – Copies (14) 1845–8
Miscellaneous works, presumably copies of European canvases but sources not traced

Quebec City Period

161 Still Life 1854–62
Compositions of game, vegetables, and dogs on table [figs. 56, 103]

162 Portraits from Life (6) 1854–5
J. Bicknell, Mrs Bicknell, Col. J.F. Turnbull, J. Budden (medallion), A.J. Maxham, self-portrait [fig. 4]

163 Portraits – Copies (3) 1857
Viscount Monck, unlocated; J.F. Turnbull, after S. Palmer; Evangeline, after T. Faed [fig. 130]

164 Landscape and Genre – Copies of Identified European and American

Canvases (17) 1854–69
Paintings after J.-A.-D. le Camus, W. Hope, G. Cattermole, W. Collins, Sir E. Landseer, A. van Ostade, E.-M.-E. Lepoittevin, E. Pritchett, G.C. Stanfield, P.G. Wickenberg, J.P. Hasenclever [fig. 8]

165 Drinkers and Readers – European Types (6)
Genre-type figures of peasant drinkers, revenue man drinking, beggars, man reading; some probably copies

166 Landscape and Genre – Copies (5) 1854–69
Miscellaneous works, presumably copies of European prints – wrecks, stable scenes, astrologer, alchemist, King Alfred burning cakes, antiquarian [fig. 18]

B / PAINTINGS IN WATERCOLOUR

The following examples that have been inspected appear to be from the artist's hand.

1 Portraits (2 examples)
Pair of head and bust portraits, man and woman, apparently of early Montreal period

2 Indians (3)

Portrait of chieftain, c. 1848 [fig. 51]; standing woman (unsigned), c. 1862 [fig. 157]; encampment with man, teepee, canoe by water

3 Habitant Life – Winter (5)
'Boys go to town'; horse and sled on ice road to Longueuil (similar to oils of c. 1858); milk seller with dog and sled in

village street [fig. 158]; habitants driving sled in blizzard; 'bilking the toll' (unsigned)

4 Miscellaneous Views – Winter (3)
Tandem sleigh driven on St Lawrence ice before Quebec; man and woman walking on snowy road (version of an oil); Royal Mail sleigh on ice before Quebec

C / LITHOGRAPHS FROM KRIEGHOFF PAINTINGS

[Winkworth], *Scenes in Canada, C. Krieghoff*, gives full details and illustration of prints nos 1 to 20 below

1 Indians and Squaws of Lower Canada
C. Krieghoff del.; on stone by C.G. Cre-

hen; Lith. and printed in colors by G. & W. Endicott, New York; published and sold by John McCoy, Great St James Street, Montreal; entered according to act of Congress in the year 1848 by Long & Brother, in the Clerk's Office of the dis-

trict court of the Southern dist. of N.Y. Announced as for sale in Montreal 15 July 1848
34.5 × 47.3 cm

2 French Canadian Habitans Playing at Cards

Painted by C. Krieghoff; lith. by A. Borum in Munic; printed by Th. Kammerer; published under the patronage of the Right Hon. The Earl of Elgin & Kincardine, Governor General of British North America
No 1 in a series of *Life in Lower Canada*, published and sold by R. & C. Chalmers, Great St James Street, Montreal, 1848; the entire series of four are numbered 2 to 5 in this list; the first two prints were offered for sale in Montreal on 12 October 1848
34.3 × 49.1 cm

3 Indian Wigwam in Lower Canada
Inscribed as in no 2 above
34.3 × 48.8 cm

4 Place d'Armes à Montreal
Inscribed as in no 2 above [fig. 13]
34.5 × 48.6 cm

5 Sledge Race near Montreal
Inscribed as in no 2 above [fig. 37]
33.5 × 48.6 cm

6 Ice Cutting
C. Krieghoff, del.; lith. of Sarony & Major, N.Y.
One of a series of four lithographs numbered 6 to 9 in this list, probably all issued in 1849
16.8 × 24.8 cm

7 Sugar Making in Canada
See no 6 above
17 × 24.5 cm

8 Hunter, Two Squaws and Papoose
See no 6 above
17.2 × 24.5 cm

9 Indian Portaging a Canoe
See no 6 above
17.2 × 24.6 cm

10 French Church, Place d'Armes, Montreal
C Krieghoff, del.; lith. of Sarony & Major, New York; issued between 1849 and 1857

43 × 32.1 cm

11 The Ice Cone at the Falls of Montmorency near Quebec, Lower Canada, in 1853
C. Krieghoff, del.; W. Simpson, lith.; London, pubd. for the artist by Ackermann & Co., 96 Strand, Dec. 1853; Day & Son, Lthrs. to The Queen [fig. 159]
40.2 × 58.7 cm

12 Untitled
Lithograph based on *French Canadian Habitans Playing at Cards* (no 2 above), published in 1857, plate 39 in *Book of the World*, Hoffman's Publishing House, Stuttgart
19.2 × 15.6 cm

13 Pour L'Amour du Bon Dieu
Chromolithograph; published in London and sold by B. Dawson and Son, no 23, Great St James Street, Montreal
Sale announced 29 October 1859; one of a pair with no 14
27 × 23 cm

14 Va au Diable
Chromolithograph; one of pair with no 13
27 × 23 cm

15 Indian Hunter, Calling
Chromolithograph; published by Wm. Scott, Montreal; lithographed by Burland & L'Africain, Montreal (active 1861–74): see M. Allodi, 'Focus,' *Rotunda*, Toronto, Royal Ontario Museum (Summer 1973), 3
One of pair with no 16
27.8 × 22.9 cm

16 Hunter on Snowshoes
Chromolithograph; one of pair with no 15
27 × 21.6 cm

17 Indian Chiefs
C Krieghoff, delt.; published by John Weale, London, 1860; Kell Bros., Lithrs. Castle St., Holborn; illustration

opposite p. 9 of *Construction of the Great Victoria Bridge* [1860]
One of pair with no 18
20.3 × 28.8 cm

18 Passengers and Mail, Crossing the River
One of pair with no 17; illustration opposite p. 78 of same book
19.5 × 27.8 cm

19 View of Quebec, Canada. From the Railway Station Opposite Quebec, the City.
C. Krieghoff, pinxt.; M. & N. Hanhart, lith.; London, published Jany 26th 1862 by Moore, McQueen & Co., 26 Berners St.; lithograph of canvas [fig. 133]
41.2 × 60.3 cm

20 Quebec
Quebec, J. Brandart, M. & N. Hanhart; lithograph based on no 19 above used as illustration for a *Quadrille* by Ricardo Linter, London, Joseph Williams (sheet music)
27.7 × 20.7 cm

21 Canada
Lithograph of Indian hunter on snowshoes used as illustration in Thomas Milner's *Gallery of Geography* by McFarlane & Erskine, Lithographers, Edinburgh; published by W.R. MacPhun, 2 vols., 1863
19 × 12.5 cm

22 The First Commissioner of Excise
Chromolithograph published by Clay-Cosack Lithographing Co., Buffalo, N.Y. (active 1864–78); based on painting known as *Un p'tit Coup* or *Habitant Drinking* in Public Archives of Canada
One of pair with no 23
27.5 × 22.5 cm

23 Habitant Head (untitled)
Chromolithograph; one of pair with no 22
27.5 × 22.5 cm

D / PAINTINGS ON CHINA

Dr Douglas's Collection of Plates,
from Barbeau, *Krieghoff* (1934), 151

1 Montmorency Falls (a man in fore-ground)
2 Waterfalls, Ste Anne or St Fériole
3 Quebec seen from Point Lévis [fig. 131]
4 Beauport Asylum (rotunda and trees)
5 Dr Douglas's house (?)
6 Canyon of Montmorency
7 Beauport Asylum
8 Lake (with canoe and scenery)
9 Grounds of Beauport Asylum (stream and field)
10 Wolfe Monument
11 Wolfe and Montcalm Monument
12 Natural Steps, Montmorency
13 Bridge on grounds of asylum
14 Quebec, Martello Tower
15 Wolfe and Montcalm Monument (Duf-ferin Terrace)
16 Citadel and town of Quebec seen from Lévis' wharf
17 Old Dufferin Terrace
18 Natural Steps, Montmorency
19 Montmorency Canyon (beaver in fore-ground)
20 On Montmorency River (two ladies with crinolines)

Photographic Credits

The numbers that follow refer to the figure numbers used in the text and captions:

Art Gallery of Ontario, Toronto 10, 97, 146

Beaverbrook Art Gallery, Fredericton 64, 130

Christie's, London 27

Continental Galleries Inc., Montreal 14, 85, 141, 142

Dominion Gallery, Montreal 9, 83, 89, 101

Inventaire des Œuvres d'Art, Quebec City 63

Walter Klinkhoff Gallery, Montreal 50, 60, 72

McCord Museum, Montreal 134

Museum Boymans-van Beuningen, Rotterdam 57

Brian Merrett and Jennifer Harper, Inc. 1, 2, 5, 6–8, 11, 12, 15–17, 20, 22, 30–1, 33, 36, 43, 46, 47, 52, 55, 56, 59, 61, 62, 65–9, 70, 73, 75, 78–80, 84, 87–8, 91, 93–5, 98–9, 103, 106–10, 112, 113, 115–21, 123–5, 128, 132, 133, 135–9, 143, 147, 148, 150, 151, 154

National Gallery of Canada, Ottawa 4, 19, 21, 24, 29, 39, 71, 76, 96, 105, 111, 131, 144

National Museums of Canada, Ottawa 32, 54

New York Historical Society, New York 77

Notman Photographic Archives, Montreal 23, 25, 38, 58, 86, 90, 102, 104, 122, 126

Nova Scotia Museum, Halifax 129

Philadelphia Museum of Art 28

Public Archives of Canada, Ottawa 26, 157, 159–63

Musée du Québec, Quebec City 34

Peter W. Richardson, Oshawa 82

Sigmund Samuel Collection, Royal Ontario Museum, Toronto 40–2, 44, 45, 92, 100

Sotheby Parke Bernet (Canada) Inc., Toronto 35, 140

Tate Gallery, London 127

Ron Vickers Ltd., Toronto 53

Williams & Son, London 48, 114

Peter Winkworth 13, 37

The following paintings were gifts to the institutions which have permitted their publication: to the Art Gallery of Ontario, Toronto, fig. 10, Gift of Mrs Lorraine Dingman, 1975; fig. 97, Gift from the Reuben and Kate Leonard Canadian Fund, 1927; fig. 146, Gift of Mrs J.H. Mitchell in memory of her mother Margaret Lewis Gooderham, 1967; to the National Gallery of Canada, Ottawa, figs. 21, 29, Gift of Miss Geneva Jackson, Kitchener, Ontario, 1933; fig. 71, Bequest of Edward F. Murphy, Ottawa, 1939; fig. 76, Gift of the estate of the Hon. W.C. Edwards, Ottawa, 1928; fig. 105, Vincent Massey Bequest, 1968; to The Robert McLaughlin Gallery, Oshawa, fig. 82, Gift of Dorothy and Douglas Henderson, 1974 [1974.кс.87].

Index

Typesetting
UNIVERSITY OF TORONTO PRESS

Colour separation and film preparation
EMPRESS LITHO PLATE LTD

Technical co-ordination
M.P. GRAPHIC CONSULTANTS LTD

Paper
Rolland Renaissance 160 M

Lithography
MCLAREN MORRIS AND TODD LIMITED

Binding material
Joanna Kennett

Binding
THE HUNTER ROSE COMPANY LIMITED

Design
WILLIAM RUETER RCA